# SPEEDLITER'S HANDBOOK
## LEARNING TO CRAFT LIGHT WITH CANON SPEEDLITES

SYL ARENA

Peachpit
Press

# Speedliter's Handbook
## Learning to Craft Light with Canon Speedlites

Syl Arena

Peachpit Press
1249 Eighth Street
Berkeley, CA 94710
510/524-2178
510/524-2221 (fax)

Find us on the Web at www.peachpit.com

To report errors, please send a note to errata@peachpit.com
Peachpit Press is a division of Pearson Education

Editor: Ted Waitt
Production Editor: Lisa Brazieal
Indexer: James Minkin
Cover Design: Mimi Heft
Interior Design: Syl Arena
Cover Image: Syl Arena
Back Cover Images: Syl Arena

ISBN-13   978-0-321-71105-2
ISBN-10      0-321-71105-X

9 8 7 6 5 4 3 2 1

Printed and bound in the United States of America

**Dedicated** to the many
family members, friends, mentors, teachers, and
complete strangers who helped me down the path
as a photographer during the past 40 years.

# Sincere *thanks* are owed to many.

*Thank you*, first and foremost, to Joe McNally. Joe, thank you for being my friend, mentor, and sounding board. Thank you for letting me tag along on so many shoots. Thank you for the introduction to Peachpit Press—without which this book would not exist. Finally, thank you for sharing your stories, photographs, and inspiration with the global community of photographers.

*Thank you* to MD Welch—my friend on many great photo adventures. Thank you for saying, "Just push the H-button dummy!" Your succinct introduction to high-speed sync truly altered the path of my career as a shooter.

*Thank you* to Zack Arias, for your boundless friendship and for showing the world that we don't need a truckload of expensive gear to create great light or a great life. The voice of your *OneLight* philosophy sounds off every time I head down the path burdened with too much gear. Okay, I'll admit that—sometimes—I run down the path with my hands over my ears. Still, *OneLight* continues to be an important grounding rod for my journey as a photographer.

*Thank you* to my friends at Canon USA who gave me their insights about the Speedlite system—especially Rudy Winston, who answered my dozens of emails promptly and with more depth than I ever expected.

*Thank you* to my friends across the Atlantic at and formerly at Canon Europe and Canon UK for also sharing your insights—especially to Brian Worley, who proactively reached across the ocean to let me know that *My Canon Speedlite Wishlist* had been seen by the right people.

*Thank you* to the team at Peachpit Press for your support and patience during the year it took me to produce the *Handbook*. A special shout of thanks is owed to my editor, Ted Waitt. Thank you Ted for your mastery at focusing my thoughts and for tirelessly coaxing me back onto my bike those many times when the training wheels fell off.

*Thank you* to the legions of Canonistas around the globe who shared their enthusiasm—both online and in-person. Knowing that you are out there, waiting for the *Handbook*, provided fuel for my efforts when my energy flagged.

*Thank you* to my Dad for your support of my photo habit throughout my youth and for not flinching too much when I said that I wanted to study photography in college. I know it's been close to three decades—but now you finally have something to hold up and say, "Hey guys, look what my kid did after all those years in photo school!"

*Thank you*, most sincerely, to my childhood sweetheart Amy and our three boys: Tom, Vin, and Tony. Despite the year of havoc that the *Handbook* brought into our home and the extended periods of time that the project took me away from home, all of you supported this project enthusiastically and without hesitation.

A final time, *thank you* to all who helped turn a dream into the *Speedliter's Handbook*.

Paso Robles, California
December, 2010

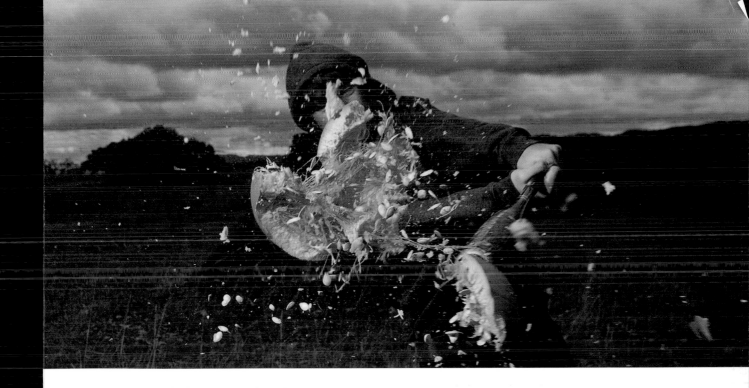

# PART 2
## Speedlites Fundamentally

# PART 3
# Gear For Speedliting

## CHAPTER FIFTEEN
# Get A Grip ......................................... 204

## CHAPTER SIXTEEN
# Keeping The Energy Up ......................................216

# PART 4
# Speedliting In Action

**Random ideas** for every photographer.

You can be touched by light, but you can't touch it.

To create interesting light, you have to create interesting shadows.

There are two types of photographers—documentarian and pictorialist.

You are not remembered for the gear you used, but by the photographs you created.

Choose to be a photographer and not a retoucher.

Your best photograph is still out there.

## WELCOME SPEEDLITER!

If you shoot with a Canon camera and want to learn how to use Speedlites, then welcome to the *Speedliter's Handbook*. Since we're going to be spending a lot of time together, I want to share my perspective on the book.

### This is a book about how I shoot.

The *Handbook* presents my approach to lighting with Canon Speedlites and the techniques I use in my work. If you've been shooting for any length of time, don't be surprised if occasionally you think, "I'd do this differently." Ask any three experienced photographers how they would approach a situation and you'll likely get five answers. We're just this way.

For the record, this project was not supported by, nor is it endorsed by, Canon. Sure, I occasionally received technical information from friends in various divisions at Canon. If you've ever read a Canon user manual, you'll understand why I had questions.

Know from the outset that while I'm proud to be a Canonista, I'm not shy about sharing my criticism of the Canon system when it could be better. Likewise, I am not hesitant to share praise when it's warranted. There are many things that Canon Speedlites do brilliantly.

### The How and Why of the Handbook.

The *Handbook* is a book you should have if you want to thoroughly explore the vast potential of Canon's Speedlite system. If you are looking for a quick read, I'm not your guy.

That said, it's best if you do not try to read the *Handbook* cover-to-cover. Rather, I encourage you to pick it up and put it down many times.

If you are a novice with Speedlites, then start with Chapter 0, *Quick Start Guide To Speedliting,* so that you can start shooting as you work your way through the book. If you know the basics and want to jump into a single topic, then dive right in to that specific chapter.

### I am a photographer, not a retoucher.

The *Handbook* is a book about flash photography and not a book about lighting via Photoshop. Unless an image specifically states that it has been retouched in post-production, you can assume that it is as it came from my camera.

My view is that I am a photographer who happens to use Lightroom and Photoshop. I'm not really great at either—nor do I feel that I need to be great at driving software. I am a photographer. I hope you decide that you are too.

### Pay attention to the sidebars.

Throughout the *Handbook*, you will find bits of information tucked into sidebars. There are three main types of sidebars, which you can tell apart by their colors.

---

### SPEEDLITER'S TIP

#### —Insights I Share With Friends—

I hope that you will read every Speedliter's Tip. My goal is to provide direct insights into how I shoot. When you are just flipping through the book, feel free to just stop at the red boxes.

---

### SPEEDLITER'S JARGON

#### —The Lingo Every Speedliter Needs To Know—

Learning photography is like learning a foreign language. If you stick with it long enough, you will become fluent. Along the way, there are many words you need to know. I've placed the big concepts in the green boxes.

For all the other words I think you should know, head straight back to Appendix 1: *Gang Slang For Speedliters.*

---

### GEEK SPEAK

#### —Random Technical Bits—

A Geek Speak provides technical insights that you'll want to explore if you need to know every last detail. If you prefer to avoid technical jargon, then feel free to skip them.

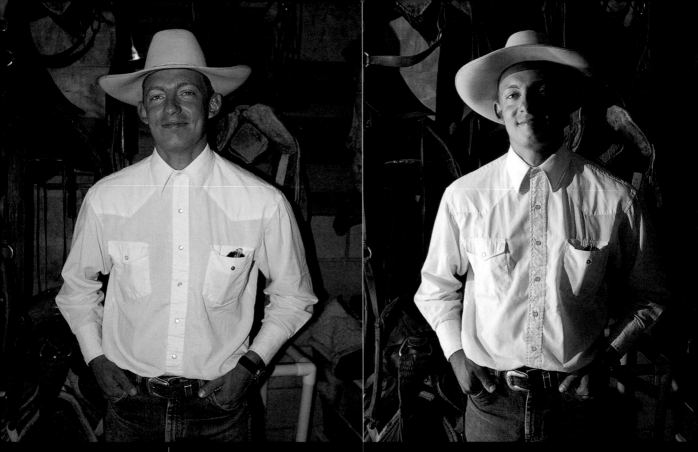

# CHAPTER 0 | QUICK START GUIDE TO SPEEDLITING

**Figure 0.1**

*Modern camera and flash technology is built largely on the premise that the photographer does not know what he is doing—so there is an emphasis on automatic features. The shot at left was made in Program (P) mode with the 7D's pop-up flash. For the shot at right, I used a 430EX II off-camera.*

## The Short Version

When I teach a seminar or workshop, I have the students introduce themselves and tell me why they are there. Photojournalists, wedding photographers, college teachers—I'm happy to see all of them. The student that always gets me to pause is the one who says, "I just want to know how to make good photos of my kids." As the father of three amazing lads, I take that student's needs as reverently as any of the other attendees.

When you're starting out, it can be hard to know where to begin. This chapter will point you down the right path. Virtually all the concepts and topics will be expanded on throughout the book. There's so much I want to share with you.

So, if learning all the details can wait, and your immediate goal is to start making good photographs with flash, here are what I consider to be the most important concepts for Speedliting.

## WHY POP-UP AND HOT SHOE FLASH DO NOT CREATE INTERESTING LIGHT

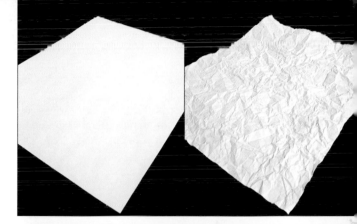

Light by itself has no depth. Stare at a blank piece of paper and tell me what you see. You see an even field of white. Now crumple the paper into a ball and then unfold it as smooth as you can. What do you see? You now see the texture of the paper because you now see shadows. So, remember this—light enables you to see the object, shadows enable you to see its depth.

Here is my number one thought on lighting:

> *To create interesting light, you also need to create interesting shadows.*

From your camera's perspective, shadows that go straight back are invisible. That's what happens with the pop-up flash or a Speedlite in the hot shoe: the shadows go straight back. Making shadows that the camera can see means that they have to go across the photo—your Speedlite needs to be somewhere to the side of your camera and not right on top. We'll get into how to do this shortly.

The second essential truth about Speedliting that you need to know is this:

> *If everything in your photo is lit evenly, then nothing will stand out.*

This is what happens with on-camera flash—light is thrown at everything, so nothing stands out. Moving the Speedlite off-camera means that you can angle it so that it hits the subject and not the background.

### When To Use On-Camera Flash

Your camera cannot record the range of brights and darks that you can see. When your camera is pointed at a scene with a bright background, chances are that the subject will be recorded as a silhouette.

This is the time to use on-camera flash. Canon cameras are very smart when it comes to adding fill flash to brighten the shadows.

**Figure 0.2** *Left, there is no depth or shape to see in a flat piece of paper. Right, it is the shadows that enable you to see the crumpled texture of the paper.*

**Figure 0.3** *The light from a 580EX in my camera's hot shoe flies straight forward and creates an image with little depth (left). Moving it off-camera adds depth by throwing shadows across the face (right).*

**Figure 0.4** *The camera captured the background light and left the subject in the dark (left). Using an on-camera flash adds light to fill the shadows (right).*

## DEAL WITH THE AMBIENT LIGHT FIRST

A Speedliter deals with two types of light—the light that is already there (the *ambient* light) and the light that he creates (the *flash*). I think about and manage them separately.

### You Can't Dim The Sun

Ambient light comes from countless sources—the sun, lamps in a room, candles on a birthday cake, etc. Typically, ambient light cannot be changed or modified to any great extent. For instance, I've yet to find a dimmer switch that will dial down the sun's intensity.

That said, you don't have to accept ambient light as it comes from the source. So, here's another essential truth about Speedliting:

> *Even though you can't control an ambient light source directly, you can use your camera's settings to control how bright or dark it appears in the photograph.*

### SPEEDLITER'S TIP

#### —Say Goodbye To The Green Box—

 I often shoot with my camera in Av mode—Aperture Priority. I do this when I want to control the depth of field through the aperture and let the camera figure out the shutter speed.

If you want to shoot in another automatic mode, you can use Tv—Shutter Priority—in which you set the shutter speed and the camera chooses the aperture. For a while longer, it will even be okay for you to use P mode—Program—in which the camera will choose both the aperture and shutter speed. Like Av and Tv, P mode allows you to override the camera's choices about the exposure. (Just know that you will have to take the training wheels off someday and move beyond P mode.)

The two modes you can no longer use as a Speedliter are the Green Box and CA—Creative Auto. These are both fully automatic modes that do not allow you to make essential adjustments and overrides. So, if necessary, take a deep breath and turn that knob on the top-left corner of your camera to either Av, Tv, or P. Adios, green box!

### Get The Ambient Light You Want

The first thing that I want to know when I'm making a new photograph is how the camera sees the ambient light. Further, I want to settle on an ambient exposure before I start dealing with flash. So, without turning the Speedlite on, I will do the following:

1. Switch my camera's mode into Av (Aperture Priority).
2. Dial in the aperture I need based on the depth of field that I want (see pages 24–25 for details).
3. Fire off a test shot.
4. If necessary, override the camera's decision about the shutter speed by dialing in an Exposure Compensation (EC) adjustment to increase or decrease the amount of ambient light that is recorded.
5. Repeat steps 3 and 4 until I like how the ambient is recorded by the camera.

For reasons that we will go deep into later, know that the camera meters the world differently than I see it. Further, the camera has no idea what is actually in front of the lens. Nor does it have any idea about my visual intentions. So, it is not uncommon for me to disagree with how the camera wants to expose the scene.

If the scene is brightly lit, often I will underexpose the ambient—making the portion of the picture not lit by the Speedlite a bit dark—because I want to direct the viewer's eye to the subject.

Now, if the scene is dimly lit, a camera operating in Av will typically overexpose the background. Remember, the camera has no idea what it's seeing. So, it will use a long exposure to gather what it thinks is enough ambient light. In this situation, I will also dial the exposure down to reduce the amount of the ambient.

Now, if you find that your backgrounds are consistently black in dim light, check your camera manual to see what it says about "Flash Sync Speed In Av Mode."

## Exposure Compensation—The Way To Brighten / Darken The Ambient Light

Exposure Compensation (EC) allows you to override the automatic exposure set by the camera when you are shooting in Av, Tv, or P. There is no exposure compensation in the fully automatic modes—either Green Box or CA—which is why it's "fully automatic." Nor is there exposure compensation in Manual mode, but you get the same effect by dialing the shutter speed to be faster or slower yourself.

The specific steps for adjusting EC vary by camera model. So check your camera manual for the exact details. The following generic steps will get you started for most models*:

1. Make sure the camera mode is either Av, Tv, or P.

2. Switch on the Quick Control Dial (the big wheel on the back—Figure 0.5). There is an angled line on the back of your camera that points to it. Turn the switch to that angled line.

3. Turn the Quick Control Dial left to adjust the EC down and right to adjust it up.

4. In the viewfinder the EC scale appears between the aperture and the ISO display. Push the shutter button halfway to see it. You can also see the EC scale on the top LCD panel (Figure 0.6) and the rear LCD panel (Figure 0.7).

[*On Rebel/xxxD cameras, press the Av ± button and simultaneously turn the Main Dial as shown in Figure 0.8.]

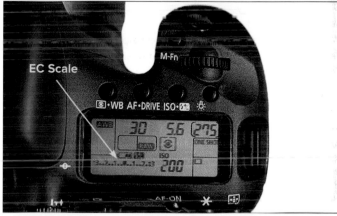

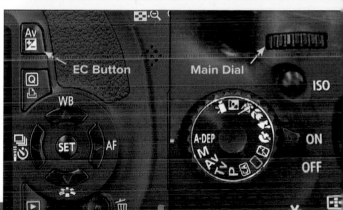

*Figure 0.5* The Quick Control Dial on the back of the camera, shown here on a 7D, is used to adjust Exposure Compensation.

*Figure 0.6* One place to see the EC scale is at the bottom-left corner of the camera's top LCD panel.

*Figure 0.7* Another place to see the EC scale is on the main LCD panel.

*Figure 0.8* On Rebels (a.k.a. xxxD cameras outside the US), you hold down the Av ± button on the back with your thumb and simultaneously turn the Main Dial with your index finger to adjust EC.

## WHO IS IN CHARGE—YOU OR YOUR SPEEDLITE?

My Speedlite workflow is a continuation of my ambient workflow. After determining the proper exposure for the ambient light, I start firing the Speedlite(s) and resume the exploration. Just as I want to determine how much ambient light I need to fit my vision, I have to determine how much flash is needed for the same goal.

### Controlling The Power

*There are many factors to determining the power level at which a Speedlite should fire. The main two are the flash-to-subject distance and the reflectivity of the subject.*

E-TTL is Canon's proprietary system where the camera and flash work together automatically to set the power level on the flash. It's fantastic technology. It's also a source of great frustration when the camera makes decisions that you don't understand or agree with.

In Manual mode, you turn the power level up or down via controls on the back of the Speedlite. The 430-series go from $1/1$ (full power) down to $1/64$ power. The 580-series run from $1/1$ down to $1/128$.

### Manual Flash ≠ Manual Exposure

Manual flash is not the same as Manual (M) exposure on your camera. You can shoot your camera in Av and control the power of your Speedlite manually. Conversely, you can set the exposure on your camera manually and fire your Speedlite in E-TTL. You'll learn reasons to do both later in the *Handbook*. Just remember for now that they are not the same; nor is there a direct link between the two.

### E-TTL And Manual Both Have Their Strengths

E-TTL is amazing technology. I use it anytime the distance between the subject and the Speedlite(s) is dynamic. I also use it when I want to control the power of off-camera Speedlites via Canon's built-in wireless system. The biggest downside to E-TTL is that the system does not tell you the power level of the Speedlite. So, it can be hard to learn mechanics of lighting in E-TTL. Likewise, it can be more challenging to de-bug problems in E-TTL.

Manual is great for situations where the distance between your Speedlite and subject doesn't change. I use Manual mode when I'm shooting tabletop (still-life, food, product, etc.). Manual is also the best mode to learn the mechanics of controlling and shaping flash.

For now, just to get you out the door, use your Speedlite in E-TTL. Conveniently it will start up in E-TTL after you load in a fresh set of batteries. Then, as you gain some momentum with Speedliting, work in Manual so that you can learn the nuances of controlling light. Hopefully, you will get to the point where you can jump freely between the two modes as I do.

### Fine-Tuning E-TTL With Flash Exposure Compensation

The camera, as smart as its little circuits are, has no more idea about your vision as a photographer when a Speedlite is fired than it does with straight ambient light. So, when shooting in E-TTL, you will sometimes disagree with the amount of flash. Don't sweat it.

Just as you can use Exposure Compensation to increase or decrease the amount of ambient light in your shot, you can use Flash Exposure Compensation (FEC) to increase or decrease the amount of flash in your shot.

There are three ways to set FEC:

- on the Speedlite itself
- through the camera viewfinder
- on the camera LCD

The fastest place to set FEC is on the Speedlite.

## Setting FEC On A 580EX Or EX II

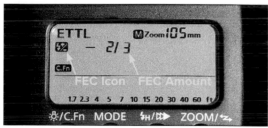

*Figure 0.9* Setting FEC at −⅔ stop on the 580EX II.

1. Confirm that the Speedlite is set to E-TTL.
2. Push the Set button at the center of the wheel on the back of the Speedlite. You will see the FEC icon and +0 flash on the left side of the LCD.
3. Turn the wheel to set the FEC.
4. Push the Set button to confirm FEC.

## Setting FEC On A 430EX Or EX II

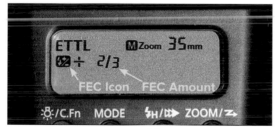

*Figure 0.10* Setting FEC at +⅔ stop on the 430EX II.

1. Confirm that the Speedlite is set to E-TTL.
2. Push the Set button at the center of the half-moon buttons on the back of the Speedlite. You will see the FEC icon and +0 flash on the left side of the LCD.
3. Push the left half-moon button to decrease FEC. Push the right button to increase FEC.
4. Push the Set button to confirm FEC.

*Figure 0.11* Inside the barn at Harris Stage Lines—the ambient as my camera captured it. This is 0 EC.

*Figure 0.12* To convey the sense of the light in the barn, I dialed in −1 EC to dim the ambient.

*Figure 0.13* To create the effect of a beam of sunlight, I gelled my Speedlite with CTO and fired it in E-TTL. Tom's face is overexposed by the flash.

*Figure 0.14* By dialing in −1 FEC, Tom's face is no longer blown out. I have the shot that I want. It was only a coincidence that both EC and FFC were −1.

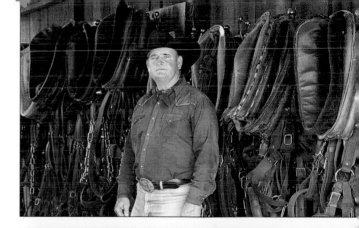
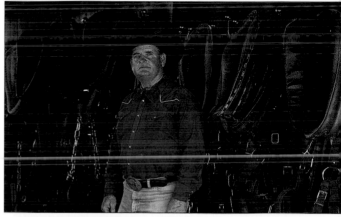
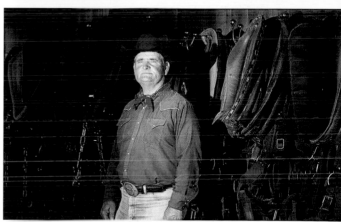
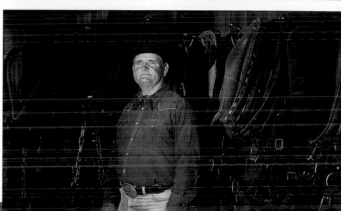

## MORE ESSENTIAL TRUTHS ABOUT SPEEDLITING

As you work your way through the *Handbook*, we'll delve deep into a broad range of topics. For now, here are a handful of other essential truths about Speedliting. Rest assured that we will circle back through this territory again and again throughout the *Handbook*.

### Your Speedlite Can Do Different Jobs

It can be the key light, the fill light, or a separation light. As the key light, your Speedlite can be the main light on the subject. As the fill light, your Speedlite can fill in the shadows that otherwise would be too dark for the camera to record. As a separation light, your Speedlite can come from somewhere behind your subject for the purpose of creating a bright line of light along one side of your subject so that it stands out from the background.

### The Size Of The Light Source Determines The Character Of The Shadows

The front of your Speedlite is smaller than most things that you will point it at—like someone's face. When the light source is small relative to the size of what's being photographed, the shadows will be hard (meaning that they have distinct, sharp edges). Don't fret—this is not your Speedlite's fault.

The sun is huge but seems relatively small in our sky due to Earth's distance from it. When you walk down a sidewalk on a sunny day, you have a hard shadow. If a layer of clouds drifts in, then those clouds become the apparent light source. Now, because the clouds are much bigger than you, the light will come at you from many angles and your shadow will be very soft.

If you want to make your Speedlite seem bigger, you will have to modify it. You can do this by bouncing it off a ceiling or wall. You can fire it into an umbrella or softbox. There are loads of things you can do to make your Speedlite seem bigger—check out Chapters 13 and 14.

### Aperture Controls Flash Exposure. Shutter Speed Controls Ambient Exposure. Say This 1000 Times

Here is a secret that should not be a secret: the power level of your Speedlite is really the duration of the flash. The difference between $\frac{1}{1}$ (full-power) and $\frac{1}{8}$ is that the electrons flow through the flash tube at $\frac{1}{1}$ for a longer period of time than at $\frac{1}{8}$. It's not that the flash gets brighter—it just stays lit longer.

At $\frac{1}{1}$, a 580EX fires for about $\frac{1}{850}''$. At $\frac{1}{64}$ that drops to about $\frac{1}{4200}''$. So it does not matter if the shutter is open for $\frac{1}{160}''$ or for $\frac{1}{2}''$, the flash still flies through in an instant. As long as the *sync speed* for your camera is not exceeded, then shutter speed has no effect on flash exposure. Sync speed is the fastest shutter speed that your camera can use normally to make a flash photo.

When it comes to ambient light, shutter speed has a direct effect. Ambient light is continuous light: from the sun, lights in the room, and so forth. If you go from a shutter speed of $\frac{1}{30}''$ to $\frac{1}{60}''$, you have just cut the amount of ambient light getting through the lens by half.

Aperture has a huge effect on flash exposure. At any given power level, if you go from f/8 to f/11, you have just cut the amount of flash getting through the lens by half. Likewise, if you go from f/8 to f/5.6, the amount of flash getting through has just doubled.

In a practical sense, the thing to remember is that if you want more ambient light in your exposure, then you have to use a longer (slower) shutter speed. If you want to dim the ambient more, then you have to use a shorter (faster) shutter speed. In either instance, your flash exposure would not change significantly.

## Don't Try To Change Too Many Things At Once. In The Beginning, Two Is Too Many

New Speedliters often make the mistake of trying to change too many things at once: moving the light stand, resetting the power level, and zooming the flash. Then, when the resulting pic does not look like the expectation, it's hard to know what to change.

Build your shots in steps. Find the exposure for the ambient light. Set your Speedlite. Worry about its position and modification first. Get it to go where you want and give it the shadow quality that you want. Then play with the power level

If you are using multiple Speedlites, go for your ambient exposure. Set and tune your key light. Work on the fill light next, and then work on the rim/separation light.

It's not uncommon on a professional shoot to do all of this with an assistant standing in for the subject. Then the subject is called from his busy schedule, stands for the shots for just a few minutes, and heads back to what seem to be more important matters.

## The Best Way To Start Learning Photography Is By Making Mistakes—Lots Of Them

Many new Speedliters do not try things because they are afraid of making a mistake or afraid of making a bad photo. I cannot count the number of times that I've screwed up and then said, "Hey, look at that. How interesting." There is plenty to learn from mistakes and accidents. Often an unexpected result will be a shortcut to a completely new way of seeing.

I'll wager that you're like me: you learn faster from your mistakes than you do from your successes. Of course, creating a good shot feeds our self-esteem.

I'm not saying that you should avoid making great photos. On the contrary, I'm saying that you'll make more great photos if you are not afraid of making bad photos, too.

### —The Two Essential Accessories—

You don't need a load of gear to start making great photographs as a Speedliter—you just need to have the right gear. Beyond a camera, Speedlite, and batteries, there are two accessories that I think every novice Speedliter should have.

*Off-Camera E-TTL Cord—* I've said it already and I will say it many more times throughout the *Handbook*. "To create interesting light, you have to create interesting shadows."

This means that you have to get your Speedlite off the top of your camera. The fastest way to do this is with a cord—an E-TTL cord. Canon makes the OC-E3, which stretches to about 3′. There are many third-party E-TTL cords that will do the same job at a more affordable price.

The key is that you get an E-TTL cord. There are other cords that may look similar but do not carry the full E-TTL communication between the camera and Speedlite. These cords will fire your flash in Manual mode only—so should be avoided.

To start, get the short coiled cord. Eventually, you will also want to get an extra-long E-TTL cord—which should be straight rather than coiled. For now, you just want to get your Speedlite a short ways off-camera.

*Plastic Dome Diffuser—* this is not the only modifier that you will want, but it is the first one that you should buy. Sto-Fen is the brand that I use. They are custom molded for specific models—so be sure to buy the one that fits your Speedlite.

The dome diffuser works by redirecting some of the light that is flying forward and sends it out sideways. This is helpful when working indoors as you can bounce a bit of light off the walls or ceiling.

For more insights on Speedliting gear, head to the chapters in Part 3: *Gear For Speedliting*.

# PART 1 | BEFORE SPEEDLITES, THERE WAS LIGHT

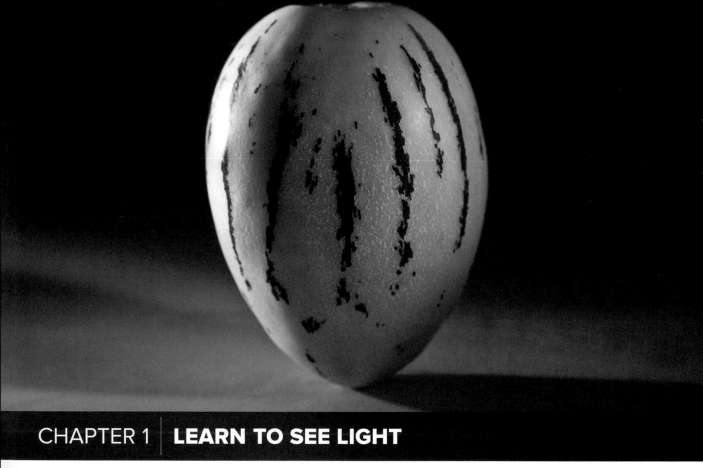

# CHAPTER 1 | LEARN TO SEE LIGHT

## The Short Version

Speedliting is about far more than knowing how to push buttons and turn dials. Speedliting is about vision and light. It's about knowing how to see the light around you and then, if needed, using your gear to create the light for the image you want.

> *The most important skill you can develop as a Speedliter is the ability to light with intent.*

In order to light with intent, you must start by truly seeing the light around you. You have to understand a bit about where light comes from in our world and a bit about how it behaves. Most importantly, you need to know that you should be evaluating the light around you all the time.

**Figure 1.1**
*Light and shadow dance around a Pepino Dulce. The egg-sized, rare melon originated in Peru. I photograph many objects so that I have an excuse to play with light.*

## THE POETRY OF LIGHT

Light shimmers. Light dances. Light falls, skips, bashes, and blinds. Light lifts us up. Light beats us down. In the end, some have said, it is toward the light we go.

Regardless of the type of photographer you are or the type of photographer you want to become, you must always be a student of light. Eventually, once you gain a keen perception of and deep appreciation for light, you'll also be a connoisseur. Even then, you'll want to remain a student and continue to learn to see light's broad and subtle role in our lives.

Look at the light around you right now. I am not saying, "Look at the things around you." I am saying, "Look at the light." What surrounds you really does not matter. It's the light I want you to look at.

Now, what words describe the light around you? Is the light bright or dim, soft or hard, warm or cold, comforting or depressing, calm or energetic?

Decode the light you see. Think about why the shadows are the shape they are and point the direction they do. Think about how the light accentuates or flattens the shape of objects. Think about where the light is coming from and what it is bouncing off of.

As the harvesters of light, we photographers are both blessed and cursed. We are blessed to be on the front line of light's majesty, beauty, and power. To the same degree, we are cursed by our limited means to capture and portray what we see.

For it is always through some bit of technology that we must transport and eventually display our captured light on paper or screen.

Look at light just as you open your eyes in the morning and just before you close your eyes at night. Beauty and emotion is found in the merger of light and dark. Learn to decode the light you see.

**Figures 1.2–1.5** *Examples of moments when I have been captivated by light.*

13

## CHARACTER OF LIGHT

When learning how to look at light, remain open to lessons coming at any moment. You will see light that strikes you in a way that you can't explain. When those moments arrive, snap a photo—as I did for the images on these two pages.

Along the way, you'll also need to develop a vocabulary so that you can catalog what you see and then communicate it to others. Don't worry that the reasons behind many of the concepts listed below are not explained here. For now, we're just concerned with learning how to see them. Throughout the rest of the *Handbook*, we'll explore how you can craft many different styles of light.

### Intensity

Look at how much light is falling on the various objects or people on your set. Is the intensity bright or dim? A long exposure with dim light can make the scene look bright or it can capture light in a way that you can't even see. Likewise, a very fast exposure under bright light can accentuate the intensity of the shadows.

### Direction

Consider where the light is coming from and the angle at which it hits your subject. Does it come from the right or left, front or back, above or below? Is its angle of approach steep or shallow?

### Path

Does the light hit the subject directly or is it reflected? Reflected light is usually less intense and softer than direct light. Often, a Speedliter will bounce light off a card or reflector as fill light to reveal details that would otherwise drop to black in the shadows.

*Figures 1.6–1.13 I'm fond of taking snapshots of light when it stirs something inside me. Here is a small collection of some of my favorites.*

### Temperature

We know that sunlight looks different at sunrise and sunset than it does during the middle of the day. We say that yellowish light is warm and bluish light is cool.

### Shadowline

Look at the edges of the shadows. Are they sharply defined or blurry? Hard light hits the subject from a single direction and creates shadows with defined edges. Soft light hits the subject from multiple directions and creates shadows with blurry edges.

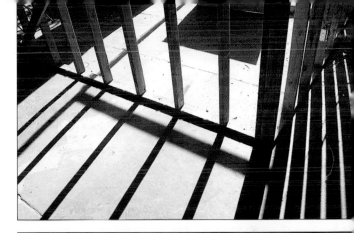

### Contrast

Look at the range of light between the brightest brights and the darkest darks. In a high-contrast scene—such as a white car parked on black asphalt at high noon—there is a huge difference between the two. In a low-contrast scene, there is a narrow difference between the brights and the darks.

### Consistency

Is the range of light on your subject even? Sunlight streaming through an open window is even. Sunlight streaming through a lace curtain will appear dappled. Also consider whether the range of light is steady or changing.

### Highlights

Look at the brightest parts of the scene. Specular highlights are seen as small dots and lines of light that help define details—such as a glint of light from a diamond. Glare occurs when the highlights are broad and detail is blocked—such as an unwanted reflection in eyeglasses.

### Chiaroscuro

The drama of light is often determined by how it transitions into darkness. In a scene with a high degree of chiaroscuro, the light transitions from bright to dark quickly. A portrait of a woman sitting by a window where the hair and clothing quickly merge into the shadows is filled with chiaroscuro.

15

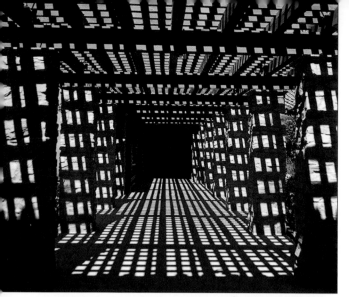

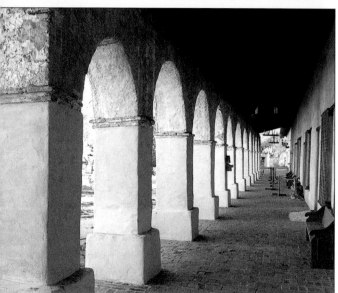

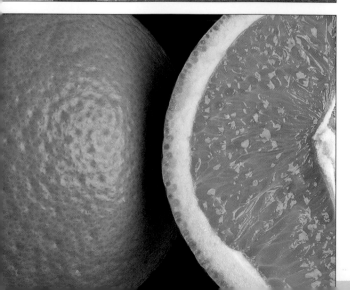

## HOW YOU SEE VS. HOW YOUR CAMERA SEES

Many photographers seldom consider how their vision differs from that of their cameras. Yet every photographer has made a photograph and afterward thought, "That doesn't look like what I saw." The difference between the experience and the photograph is often due to the difference between the photographer's vision and the camera's vision.

### You Have Two Eyes, Your Camera Has One

I know this sounds obvious, but many photographers take our stereoscopic vision for granted. The separation of our eyes is what enables us to see depth.

To get a sense of what your camera sees, close one eye and watch how the world flattens. Geometry (the patterns in a frame) and lighting (the shadows in the frame) are the two ways that a photographer can add depth back into a scene.

Shadows give us a tremendous amount of information about shape and depth.

If you want a strong shadow, use a hard light. If you want a subtle shadow, use a soft light.

Beyond lighting, relative size and converging lines provide clues about position and shape. You know intuitively that if two items appear to be the same, but one is smaller, that the smaller one is farther away. Yet, your camera records this relationship as shape and light alone. The photograph is flat. You decode depth partially by light/shadow and partially by shape/position.

*Figure 1.14* By reducing the lattice, pillars, and shadow to a flat, geometric pattern, the camera stripped away the sense of depth I experienced on location.

*Figure 1.15* The repeating pattern of arches gives this photo an easy-to-understand sense of depth.

*Figure 1.16* Even though you know from personal experience that oranges are round, it is the subtle shadow and highlight that render the orange as a sphere in this photo.

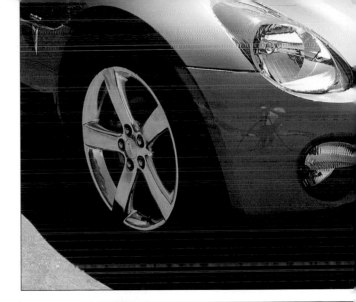

## You See Brighter Brights And Darker Darks

Go out at high noon and look at a parked car on the street. You can see details in the highlights on the fenders. You can also see details in the shadows around the wheels and on the asphalt underneath. Now point your camera at the same car and take a picture. What happens?

It's likely that the brightest part of the fenders will be blown out (go to white and lack any detail). It's also likely that the tires will be hard to distinguish from the wheel wells and that the grooves in the tread and detail in the asphalt will merge into black.

> *It's important to understand that we can see a much broader range of tonality than even the most technologically advanced cameras. The maximum range of bright and dark that a camera can record is its dynamic range.*

If the dynamic range of your scene is more than your camera can record, or put another way, if the contrast of your scene is too wide, then your camera will either blow out (overexpose) the highlights, compress the deep shadow details into black, or do a bit of both. You can see this in Figure 1.17. The detail that I could see in the tire tread and asphalt has been recorded by the camera as black.

As a Speedliter, you can bring the contrast range of the scene back within the limits of your camera through lighting. Specifically, you can add fill light to the shadow areas and expose for the highlights. In Figure 1.18, you can see how the addition of two Speedlites has enabled me to capture detail in the wheel that was previously lost. Notice also that the sunlit part of the fender and headlight is virtually the same in the two shots. The difference is the addition of fill light from a pair of 580EX IIs.

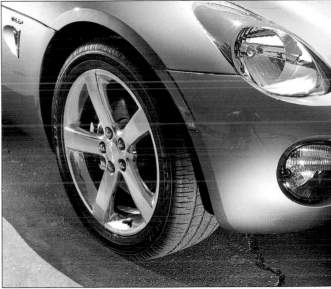

*Figure 1.17 In straight sunlight, important details about the tire are lost to black.*

*Figure 1.18 The use of two Speedlites brought the contrast range within the capabilities of the camera.*

*Figure 1.19 The set shot shows where I positioned the two Speedlites. The master flash is on the left.*

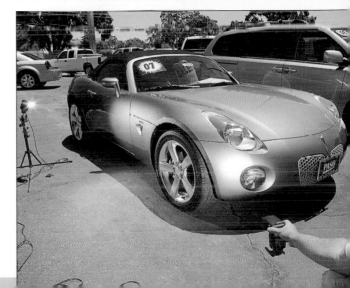

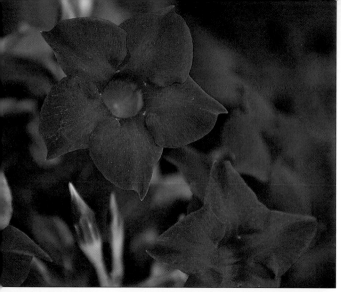

## You Can Distinguish Many More Colors Than Your Camera Can Record

There is now a generation of photographers who have never shot any significant amount of film. Those of us who came of age during the film era will remember that our choice of film greatly affected the look of our photos. If you used Kodachrome, you'd get rich, warm tones and saturated reds. If you used Ektachrome, you'd get deep, cool tones that favored the greens and blues. We understood that film did not capture the full range of colors that we saw. This detail has been largely forgotten in the digital era.

The fact remains that we can see a far wider range of color than our digital cameras can record. The problem continues with our monitors, the vast majority of which cannot display the full range of colors recorded by our cameras. The color funnel continues to get smaller. You should know also that when you look at a beautifully saturated image onscreen, you will not get the full range of color that you see out of most printers. The good news is that each generation of monitors and printers continues to expand the gamut of color that they can display/print.

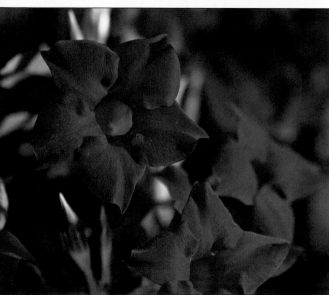

An understanding of this limited color gamut can inform how we light. Shooting a deep red dress or flower? Light it with a hard light that casts shadows across the surface. The shadows add contrast and a sense of texture or depth. If the fabric or petals are translucent, then also try backlighting as a way to bring out a greater sense of depth.

*Figure 1.20* *There are many saturated colors that the camera cannot record. In the case of this mandavilla blossom, there were many shades of red that I could see that the camera could not record. This shot, made in open shade, appears flat because the range of reds is very limited.*

*Figure 1.21* *Firing a Speedlite through a Sto-Fen diffuser from camera-right adds depth by creating shadows. Note that the shadows are shades of red.*

*Figure 1.22* *Another option—firing the Speedlite through the petals—creates a different sense of depth and adds a bit of rim light.*

## Your Brain Adjusts Various Light Sources To White; Your Camera Might Not

All light is not white. We just think that it is because our brains adjust it automatically. In the days of film, photographers had to match their film to the predominant source of light. Tungsten (incandescent) lights are really orange. So tungsten film has a strong blue bias to offset the orange cast of the light. Use tungsten film outdoors under the midday sun and the whole scene goes very blue. Digital cameras are the same—except that the white balance settings are inside the circuits.

Speedlites are balanced to the color of sunlight at midday. If you mix your Speedlite with other types of light—such as using your flash for fill light in a room lit with incandescent lamps—you'd best cover your flash with an amber-colored gel (known as a "CTO"). Otherwise, the portion of the scene lit with your flash will have a blue cast. As described in Chapter 20, *Gelling For Effect,* these differences in white balance can be played to great theatrical effect as well.

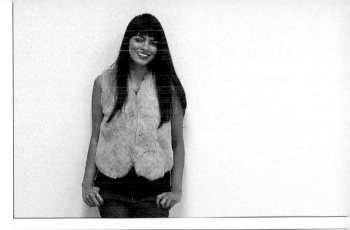

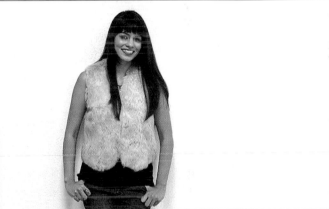

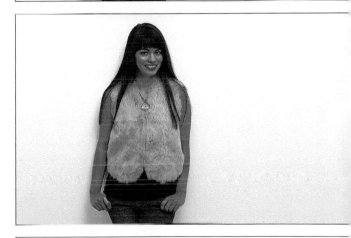

*Figure 1.23* This is how the camera records the fluorescent office light (using Daylight as the white balance). Notice the light yellow-green cast to Mallory's skin.

*Figure 1.24* When the white balance of the camera is switched to Warm Fluorescent, it records the scene with a neutral tint.

*Figure 1.25* When the camera is set to Daylight white balance, it records the tungsten (incandescent) light with a distinctive amber cast. As you can see, it gives Mallory an artificial pumpkinesque tan.

*Figure 1.26* When the white balance of the camera is switched to Tungsten, it records the scene with a neutral tint.

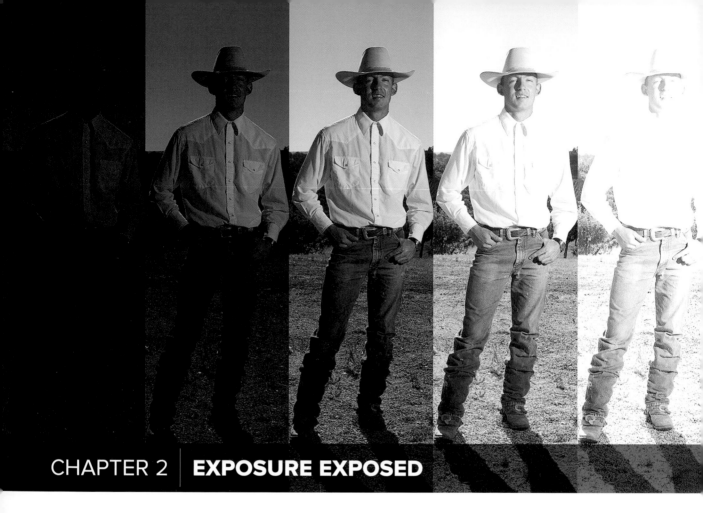

# CHAPTER 2 | EXPOSURE EXPOSED

### Figure 2.1

*Salvaging a shot from an under- or overexposed capture is a second-rate approach. It's far better to get the exposure right in the camera. Ultimately, the best exposure is the one that fits your vision for the shot.*

## The Short Version

Getting the best digital capture possible during the shoot should always be the Speedliter's #1 goal. "I'll fix it in Photoshop" is the slogan of those who don't know how to light.

Knowing the mechanics of exposure and using them creatively are essential to the craft of Speedliting. In flash photography we often want to increase or decrease the amount of light coming from the Speed-lites or the amount of ambient light that is captured by a specific amount.

Remember this: the more you use flash, the more you need to grasp the mechanics of exposure and how your camera records what it sees.

## THE TRINITY: ISO, SHUTTER SPEED, AND APERTURE

ISO, shutter speed, and aperture are directly linked. Change any one and your overall exposure changes. That's fine if you're trying to correct for an over- or underexposed setting. However, if you switch to a faster shutter speed because you want to freeze action and you want to keep the overall exposure the same, you'll need to change the ISO or aperture in the opposite direction. Knowing which way to go—and how much—is why understanding the Trinity is so important.

Shutter Speed

ISO ⟷ Aperture

*Figure 2.2 There are many possible combinations of ISO, shutter speed, and aperture for a given amount of light. The most suitable combination is determined by the photographer's vision.*

### ISO

Think of ISO as the volume of the signal from the camera's sensor. The higher the ISO, the higher the volume. Technically it is not correct to say that changing the ISO setting on a DSLR changes the sensitivity of the sensor (because the light sensitivity of the sensor in a digital camera is fixed). Still, it's helpful to think this way. When switching from ISO 100 to ISO 200, think "The sensitivity is twice as much." When switching from ISO 1600 to ISO 800, think "The sensitivity has been halved."

Whole stops of ISO are typically expressed as multiples of one hundred: 100, 200, 400, 800, 1600, 3200....

Generally, shooting at the lowest ISO possible is the best choice. Just as turning the volume up on a stereo can lead to distortion coming from the speakers, turning the ISO up on your camera can lead to noise—which is seen as random flecks of color in the dark tones.

In the days when film reigned, photographers only had shutter and aperture to manipulate from frame to frame. The film's sensitivity—once expressed as ASA and now as ISO—was fixed until a different roll of film was loaded into the camera. While new shooters take the manipulation of ISO as a standard practice, old-school shooters need to understand that on a digital camera ISO can be used for creative ends as much as shutter speed and aperture.

### Shutter Speed

Shutter speed is the length of time that the sensor is exposed to light. In a DSLR the shutter is made of two curtains that move vertically in front of the sensor. In a point-and-shoot camera the shutter is electronic—meaning that it essentially turns on and off for the brief duration of the exposure.

Shutter speeds are expressed in fractions or multiples of one second. Changing the shutter by one stop means that the duration of time the light hits the sensor has been either doubled or halved. Shutter speeds, in whole stops are 1", 1/2", 1/4", 1/8", 1/15", 1/30", 1/60", 1/125", 1/250", 1/500".... Commonly shutter speeds range on DSLRs from 1/8000" to 30".

When a photographer refers to "a higher shutter speed," he's referring to a "faster shutter speed." You can remember this because 500 is a higher number than 250 and 1/500" is faster than 1/250".

## Aperture

Think of aperture as the pupil inside the lens. Just as the pupils in your eyes contract to a small diameter under bright light, a small aperture in your lens reduces the amount of light passing through.

Apertures are described in f/stops, a term that originated back in the day when everything about photography was manual. The aperture was set by sliding a lever or turning a ring on the lens to a specific spot or "stop."

The range of whole f/stops, from widest to narrowest, is f/1, f/1.4, f/2, f/2.8, f/4, f/5.6, f/8, f/11, f/16, f/22, f/32, f/45, f/64, and f/128. Going from one f/stop to the next whole stop means that the area of the aperture and hence the amount of light going through the lens is either halved or doubled—depending on which way you're going.

If you want to impress your fellow photographers, remember that f/stop is a dimensionless measurement—meaning that f/8 isn't the same size on a 28mm lens as it is on a 135mm lens.

> **An f/stop expresses the relationship of the aperture's area to the focal length of the lens.**

So, the diameter of the aperture on a 28mm lens set to f/8 is much smaller than the diameter of the aperture on a 135mm lens set to f/8.

### SPEEDLITER'S JARGON

#### —Stopping Down & Opening Up—

When you change your aperture to a smaller f/stop, say from f/5.6 to f/8, you are stopping down. This refers to the fact that the actual size of the aperture gets smaller. When you make the aperture larger, as when heading from f/16 to f/11, you are opening up.

## Apertures At Whole F/Stops

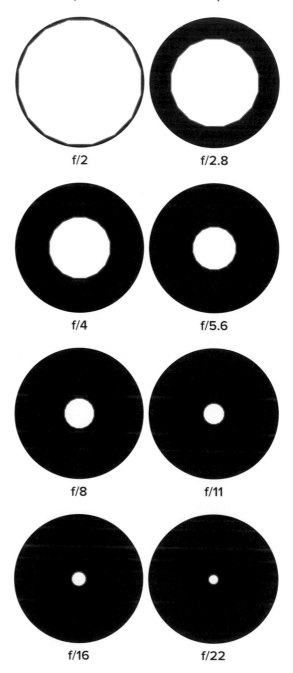

**Figure 2.3** *The difference in the size of one whole f/stop to another can be seen easily in this chart. The area of the aperture at f/2 is twice as large as the area of the aperture at f/2.8, which is twice as large as the area of the aperture at f/4 and so on.*

## Whole, Half, And Third Stops

It's critical to understand whether your camera breaks up f/stops into halves or thirds. Many digital cameras can go either way. If you have the choice, I suggest that you set your camera for third-stops as it gives you just a bit more control.

| WHOLE STOPS | HALF STOPS | THIRD STOPS |
|:---:|:---:|:---:|
| f/1 | f/1 | f/1 |
| | | f/1.1 |
| | f/1.2 | |
| | | f/1.2 |
| f/1.4 | f/1.4 | f/1.4 |
| | | f/1.6 |
| | f/1.7 | |
| | | f1.8 |
| f/2 | f/2 | f/2 |
| | | f/2.2 |
| | f/2.4 | |
| | | f/2.5 |
| f/2.8 | f/2.8 | f/2.8 |
| | | f/3.2 |
| | f/3.3 | |
| | | f/3.5 |
| f/4 | f/4 | f/4 |
| | | f/4.5 |
| | f/4.8 | |
| | | f/5.0 |
| f/5.6 | f/5.6 | f/5.6 |
| | | f/6.3 |
| | f/6.7 | |
| | | f/7.1 |
| f/8 | f/8 | f/8 |
| | | f/9 |
| | f/9.5 | |
| | | f/10 |
| f/11 | f/11 | f/11 |
| | | f/13 |
| | f/13 | |
| | | f/14 |
| f/16 | f/16 | f/16 |
| | | f/18 |
| | f/19 | |
| | | f/20 |
| f/22 | f/22 | f/22 |

*Figure 2.4* The important point to remember when changing apertures is that the numbers changing in your viewfinder or LCD are partial and not whole f/stops.

### —The Geometry Of F/Stops—

Ever wondered why whole f/stops follow the pattern of alternating between multiples of 1 and 1.4? It has to do with a bit of geometry and the square root of two—which happens to be 1.4142136.

You know that opening the aperture by one f/stop means that the area of the aperture has been doubled. From high school geometry, you might remember that the area of a circle is pi times radius squared ($\pi \cdot r^2$).

So, if the radius of the aperture is 1, then the area of the aperture is ($\pi \cdot 1^2$) = 3.14. If we double the radius of the aperture to 2, then the area of the aperture is ($\pi \cdot 2^2$) – 12.56 —which is four times 3.14, not twice.

*Here's the math:* to double the area of the aperture, instead of increasing by a factor of 2, the radius has to increase by a factor of 1.4142136 (which photographers round off to 1.4).

*Here's the proof:* $\pi \cdot 1.4142136$ = 6.28, which is twice what you get from $\pi \cdot 1$ = 3.14. So, to get the progression of whole f/stops—1, 1.4, 2, 2.8, 4, 5.6, 8, 11, 16, 22, 32, 45, 64, 90, 128—you multiply the preceding f/stop by 1.4 (with a tiny bit of rounding along the way) to get the next stop.

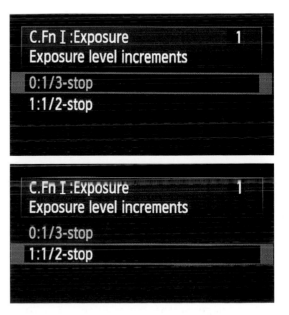

*Figure 2.5* Check to see if your camera has the option to set the increment of the aperture. For precise control, set it to the smallest increment available. Shown above are the menu options for the Canon EOS 5D Mark II

## DEPTH OF FIELD

*Depth of field* (DOF) is the term photographers use to describe how much of the image, front to back, appears to be in focus.

*In order to express your vision as a photographer, it is important to understand the mechanics of DOF.*

Three main factors affect DOF: aperture, focal length, and focusing distance.

### Aperture And Depth Of Field

The main reason that photographers choose one f/stop over another has to do with depth of field. As shown at right, wide apertures (a.k.a. f/stops with lower numbers) yield a shallow depth of field. As the apertures get narrower (meaning that the f/stop numbers get larger), the depth of field becomes deeper.

More often than not, I will build my exposure around the aperture that will give me the depth of field that I desire—meaning that I'll go for shallow, moderate, or deep.

As for seeing the difference between f/5.6 and f/8 or between f/16 and f/22, I will look at the LCD through a strong loupe. If focus is critical (and my paycheck depends upon it), I'll tether my camera into my laptop so that I can enlarge the images on screen.

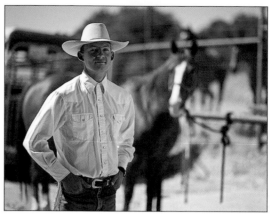

***Figure 2.6*** *At f/1.4, the depth of field from this 85mm lens is very shallow—the horses in the background put Jaime in context but do not compete visually.*

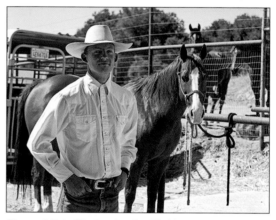

***Figure 2.7*** *At f/8, the depth of field is moderate—the near horse appears sharp, yet the two in the back sill do not compete with Jaime for attention.*

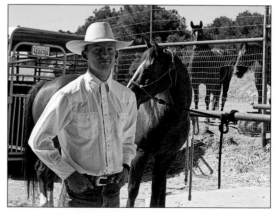

***Figure 2.8*** *At f/16, the depth of field is as deep as it will get. Everything appears equally sharp—so it is not apparent that this is a portrait of Jaime.*

### SPEEDLITER'S TIP

#### —Remembering Depth Of Field—

When it comes to depth of field, if you think of the f/stops as numbers along the side of a swimming pool, you'll remember that the depth of field at f/2.8 is shallow and the depth of field at f/22 is deep. Now isn't that easy to remember?

f/2.8    f/5.6    f/11    f/22

Depth of Field

## Lens Focal Length And Depth Of Field

Shallow depth of field is more pronounced on long lenses than it is on wide-angle lenses. This is because the infinity point gets farther from the camera as the focal length of the lens increases. Put another way, a wide-angle lens appears to have much deeper depth of field than a long lens.

The four photos at right were created with two different lenses at their widest and smallest apertures. The top two were shot at 24mm on the 24–70mm f/2.8L and the bottom two were shot at 182mm on the 70–200mm f/2.8L II IS. (I know it was 182mm because Lightroom pulled this out of the metadata—a small benefit of shooting digital.)

If you compare the top two images, you'll see that there is very little difference between the depth of field at f/2.8 and f/22. Now compare the bottom two shots. You can see that the left-most columns at f/2.8 are very much out of focus. Yet, at f/32, they appear sharp.

Another major difference between the top and bottom pairs, of course, is perspective. For the wide-angle shots, it was easy for me to get all of the columns in the frame. The wide-angle perspective provides a sense of the space between the columns and the depth of the area behind Mark.

For the telephoto shots, because the angle of view is so narrow, I had to swing to the right a bit in order to get the entire run of columns in the frame. If you had not seen the wide-angle view, you would not have a sense of the space between the columns. There is no sense of space behind Mark. The trait of long focal lengths to flatten out the background is known as *compression*.

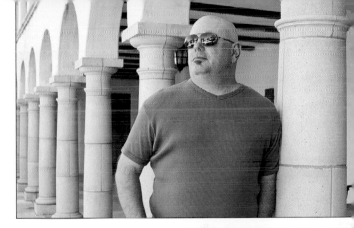

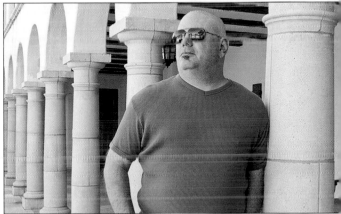

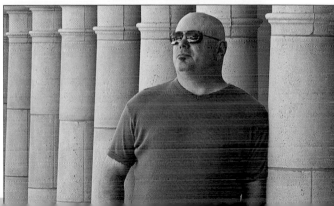

*Figure 2.9* 24mm on a 5D Mark II, f/2.8.

*Figure 2.10* 24mm on a 5D Mark II, f/22.

*Figure 2.11* 182mm on a 5D Mark II, f/2.8.

*Figure 2.12* 182mm on a 5D Mark II, f/32.

## EQUIVALENT EXPOSURES

For any given amount of light, there are many combinations of ISO, shutter speed, and aperture that will yield the same exposure. If you come to understand this concept inside and out, vast horizons of creativity will open up to your Speedliting.

### ISO Watches As Shutter And Aperture Dance Together

Of the three members of the Trinity, most often you'll change the shutter speed and/or the aperture while leaving the ISO alone. As mentioned earlier, you should use the lowest ISO possible as a way to minimize digital noise in your captures. That said, it's better to increase the ISO than to get shaky, handheld images in low-light situations (unless, of course, you want shaky, handheld images).

### Strategies For Choosing Shutter And Aperture

For the moment, think of aperture as the diameter of a pipe and shutter speed as the amount of time needed to fill up a bucket. If you have a narrow pipe, you'll need more time to fill up a bucket than you will with a wide pipe.

**Shutter Speed:**

- Fast shutter speeds will capture action. The speed of the action determines how fast the shutter should be.

- Slow shutter speeds can create a sense of motion: waves turn into blurry foam, a race car into a blur.

- As you'll read in detail in Chapter 21, the use of Speedlites imposes limitations on the shutter speeds available.

**Aperture:**

- Your desired depth of field is the primary reason for choosing a wide or narrow aperture.

- Use a wide aperture (lower f/ number) for shallow DOF.

- Use a narrow aperture (high f/ number) for deep DOF.

### Matching An Exposure To Your Vision

Let's assume for a moment that you have a good exposure but you're not happy with the outcome—say the level of light is fine but you want more depth of field. Here's where you can use equivalent exposures to express your vision.

> *Think of shutter and aperture on opposite ends of a teeter-totter. You'll find it easy to remember that when one goes up, the other must go down.*

Let's say your exposure is set at 1/250", f/2.8, ISO 100. You want a lot more depth of field, so you want to shoot at f/16. From Figure 2.4, on page 23, you can count that to get from f/2.8 to f/16, you have to close the aperture down five f/stops. Since a smaller aperture lets in less light, you'll have to slow your shutter speed down by five stops to balance. Here are the equivalent exposures along the way:

| Aperture | f/2.8 | › f/4 | › f/5.6 | › f/8 | › f/11 | › f/16 |
|----------|-------|-------|---------|-------|--------|--------|
| Shutter | 1/250" | › 1/125" | › 1/60" | › 1/30" | › 1/15" | › 1/8" |
| ISO | 100 | 100 | 100 | 100 | 100 | 100 |

Now the problem is that you can't get a super-sharp image when handholding a shot at 1/8" (and you've left your tripod at home). This is the perfect reason to increase your ISO. As you can see below, increasing your ISO from 100 to 800 will enable you to shoot f/16 at 1/60".

| Aperture | f/16 | f/16 | f/16 | f/16 |
|----------|------|------|------|------|
| Shutter | 1/8" | › 1/15" | › 1/30" | › 1/60" |
| ISO | 100 | › 200 | › 400 | › 800 |

## Exposure Values

An exposure value (EV) expresses all the equivalent exposures (combinations of shutter speed and aperture) for a given amount of light.

As a point of reference, EV 15 is about the brightness of the noon sun on a clear day. If you look across the row for EV 15 in Figure 2.13 (below), you'll see a range of shutter speeds that, when combined with the aperture at the top of the column, will yield equivalent exposures for direct sunlight when your camera is set to ISO 100. For instance, $\frac{1}{2000}''$ at f/4, $\frac{1}{500}''$ at f/8, and $\frac{1}{125}''$ at f/16 are all equivalent exposures for EV 15.

EVs can be positive or negative. The scale starts with EV 0 being f/1 for 1" at ISO 100. As you go up or down one EV, you are changing by one stop.

Professional lighting directors rely on an EV table as the foundation for many of their lighting designs.

*As a Speedliter, you must remember that for any given amount of light (any EV) there are a number of equivalent exposures.*

Choosing the right combination of shutter speed and aperture largely depends on your vision and objectives.

| EV | f/1 | f/1.4 | f/2 | f/2.8 | f/4 | f/5.6 | f/8 | f/11 | f/16 | f/22 | f/32 |
|---|---|---|---|---|---|---|---|---|---|---|---|
| -2 | 4″ | 8″ | 15″ | 30″ | 60″ | 2 m | 4 m | 8 m | 16 m | 32 m | 64 m |
| -1 | 2″ | 4″ | 8″ | 15″ | 30″ | 60″ | 2 m | 4 m | 8 m | 16 m | 32 m |
| 0 | 1″ | 2″ | 4″ | 8″ | 15″ | 30″ | 60″ | 2 m | 4 m | 8 m | 16 m |
| 1 | ½″ | 1″ | 2″ | 4″ | 8″ | 15″ | 30″ | 60″ | 2 m | 4 m | 8 m |
| 2 | ¼″ | ½″ | 1″ | 2″ | 4″ | 8″ | 15″ | 30″ | 60″ | 2 m | 4 m |
| 3 | ⅛″ | ¼″ | ½″ | 1″ | 2″ | 4″ | 8″ | 15″ | 30″ | 60″ | 2 m |
| 4 | 1/15″ | ⅛″ | ¼″ | ½″ | 1″ | 2″ | 4″ | 8″ | 15″ | 30″ | 60″ |
| 5 | 1/30″ | 1/15″ | ⅛″ | ¼″ | ½″ | 1″ | 2″ | 4″ | 8″ | 15″ | 30″ |
| 6 | 1/60″ | 1/30″ | 1/15″ | ⅛″ | ¼″ | ½″ | 1″ | 2″ | 4″ | 8″ | 15″ |
| 7 | 1/125″ | 1/60″ | 1/30″ | 1/15″ | ⅛″ | ¼″ | ½″ | 1″ | 2″ | 4″ | 8″ |
| 8 | 1/250″ | 1/125″ | 1/60″ | 1/30″ | 1/15″ | ⅛″ | ¼″ | ½″ | 1″ | 2″ | 4″ |
| 9 | 1/500″ | 1/250″ | 1/125″ | 1/60″ | 1/30″ | 1/15″ | ⅛″ | ¼″ | ½″ | 1″ | 2″ |
| 10 | 1/1000″ | 1/500″ | 1/250″ | 1/125″ | 1/60″ | 1/30″ | 1/15″ | ⅛″ | ¼″ | ½″ | 1″ |
| 11 | 1/2000″ | 1/1000″ | 1/500″ | 1/250″ | 1/125″ | 1/60″ | 1/30″ | 1/15″ | ⅛″ | ¼″ | ½″ |
| 12 | 1/4000″ | 1/2000″ | 1/1000″ | 1/500″ | 1/250″ | 1/125″ | 1/60″ | 1/30″ | 1/15″ | ⅛″ | ¼″ |
| 13 | 1/8000″ | 1/4000″ | 1/2000″ | 1/1000″ | 1/500″ | 1/250″ | 1/125″ | 1/60″ | 1/30″ | 1/15″ | ⅛″ |
| 14 | ** | 1/8000″ | 1/4000″ | 1/2000″ | 1/1000″ | 1/500″ | 1/250″ | 1/125″ | 1/60″ | 1/30″ | 1/15″ |
| 15 | ** | ** | 1/8000″ | 1/4000″ | 1/2000″ | 1/1000″ | 1/500″ | 1/250″ | 1/125″ | 1/60″ | 1/30″ |
| 16 | ** | ** | ** | 1/8000″ | 1/4000″ | 1/2000″ | 1/1000″ | 1/500″ | 1/250″ | 1/125″ | 1/60″ |
| 17 | ** | ** | ** | ** | 1/8000″ | 1/4000″ | 1/2000″ | 1/1000″ | 1/500″ | 1/250″ | 1/125″ |
| 18 | ** | ** | ** | ** | ** | 1/8000″ | 1/4000″ | 1/2000″ | 1/1000″ | 1/500″ | 1/250″ |
| 19 | ** | ** | ** | ** | ** | ** | 1/8000″ | 1/4000″ | 1/2000″ | 1/1000″ | 1/500″ |
| 20 | ** | ** | ** | ** | ** | ** | ** | 1/8000″ | 1/4000″ | 1/2000″ | 1/1000″ |

**Shutter Speed At Various Exposure Values (ISO = 100)**

*Figure 2.13* Shutter speeds at various levels of light (expressed as EV) for various apertures. ISO = 100.

## EXPOSURE MODES

When it comes to making decisions about the specific settings for an exposure, your DSLR will provide you with several options. You can do it all, your camera can do it all, or you can split up the duties. Here's a quick rundown of the various exposure modes that are available on most Canon DSLRs. I've listed them in the order of how useful I find each one.

 **Av—Aperture Priority**

I set the aperture and the ISO. The camera chooses the shutter speed for the amount of light in the scene. I use Aperture Priority more than any other exposure mode because I'm usually interested in getting a specific amount of depth of field. So, by shooting in Av, I can control whether the shot has shallow or deep depth of field.

 **Tv—Shutter Priority**

I set the shutter speed and the ISO. The camera chooses the aperture. I use Shutter Priority when I'm concerned about freezing or portraying motion. By shooting in Tv, I can control whether the shutter speed is super fast (for freezing action) or slow (for conveying motion through blur).

 **M—Manual**

When in Manual mode, I'm in total control and set everything. As a Speedliter, I find myself in many situations where I want to use Manual. The most common is that I'm shooting in low light and I want to control the amount of ambient light that comes in to help illuminate the background.

 **B—Bulb**

The same as Manual except that the shutter stays open as long as you hold down the shutter button. I use Bulb on dark nights when I have my camera locked onto a tripod so that I can paint the landscape with multiple pops from a Speedlite—see Figure 2.17.

 **[C1, C2, C3]—Camera User Settings**

As you become an advanced Speedliter, you'll want to record Camera User Settings (if your camera has this feature). Essentially this is a way to record the exact settings on your camera at a particular point in time: ISO, shutter speed, aperture, white balance, etc.

 **P—Program**

Many joke that the P stands for "professional." I try to get shooters to think of it as "party" mode—like when you're at the office Christmas party and you've had a few too many, you switch the camera into Party mode. Program mode automatically sets the shutter speed and aperture based on the amount of light and the ISO set that you set.

 **"Green Box"—Full Automatic**

In "Green Box" mode, the camera sets everything: ISO, shutter speed, aperture, focusing, and drive modes. Full Auto is designed for people who don't know anything about cameras—which excludes you because you're reading this book, right?

**[CA]—Creative Automatic**

The Creative Automatic mode is a half-step from Full Automatic. Theoretically it enables someone to change the depth of field and brightness without specifying the shutter and aperture. My thinking is that if someone is smart enough to learn the CA interface, then she is smart enough to learn the basics of exposure. I've never had the desire to shoot in CA.

**Figure 2.14** Aperture Priority (Av) lets me specify a wide aperture when I want shallow depth of field and a narrow aperture when I want deep depth of field. At left I shot at f/2 and at right I shot at f/22.

**Figure 2.15** Shutter Priority (Tv) lets me specify a slow shutter speed when I want to emphasize motion or a fast shutter speed when I want to freeze motion. At left I shot at 1/30″ and at right I shot at 1/8000″.

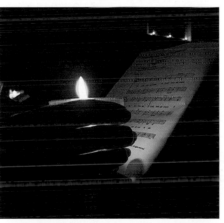
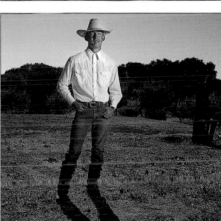

**Figure 2.16** Manual (M) lets me control both the ambient (via the shutter) and depth of field (via the aperture). In dim light, I can use a slow shutter speed to collect more ambient. In bright light, I can use a fast shutter to dim sunlight for a dramatic daytime portrait.

**Figure 2.17** Bulb (B) lets me shoot in the dark and make photographs that otherwise could not be created—such as this 32′ exposure under the stars in Joshua Tree National Park (left) or this 30″ exposure of fireworks (right).

## METERING, METERING ZONES, AND METERING MODES

The first thing to know about how a camera meters light and tries to determine the proper exposure (based on the exposure mode you've selected) is that it has no clue what's in your viewfinder. It does not know, for instance, if you are photographing a man in a black tux standing in the snow, a white dog standing against a black curtain or a red tomato on a green plate. The camera does not know what your subject is, nor does it know what your intentions are for the photograph. All it knows is to take a measurement of the light coming through the lens at the instant that you press the shutter button halfway.

The second important thing to know is that the camera is programmed to assume that the reflectance of what's in the frame is that of middle gray. As shown in Figure 2.18, if you fill the frame with a white foamcore or black velvet, the camera will come up with exposures that deliver very similar results—namely, a middle gray tone. From our perspective, the camera underexposed the white foamcore and overexposed the black velvet. From the camera's perspective, it did a fine job.

Interestingly, as shown in the lower half of Figure 2.18, if you have the camera to take a reading from an 18% gray card, then the exposures for the black velvet and for the white foamcore are very accurate.

**Figure 2.18** *On the top row, we see a piece of black velvet and a sheet of white foamcore each photographed with the meter's suggested exposure. The bottom row shows the same material when the exposure was manually set based on the camera's reading of an 18% gray card.*

### Metering Zones

Your Canon DSLR has either 35 or 63 metering zones. It varies by camera model (see figure captions for details) and cannot be changed.

Depending on the *metering pattern* that you select (see next page), all or some of these zones will be used to measure the light in the camera's frame.

**Figure 2.19** *The 35-zone meter used by the 40D, 50D, 5D, 5D Mark II and all Rebels not listed below in Figure 2.20.*

**Figure 2.20** *The 63-zone meter used by the Rebel T2i, 7D, 1D- and 1DS- cameras.*

## Metering Patterns

Although your Canon DSLR has 35 or 63 metering zones, it does not always use all of them to take a meter reading. A metering pattern is the way that your camera takes readings from certain zones and not others. Matching the correct pattern to the scene in front of you can be a huge help.

### Evaluative

This is the "all-purpose" metering mode. It considers data from all 35 or 63 metering zones equally. If the overall level of light in the scene is similar, this is the metering mode I use. However, if the scene is strongly backlit, or the light on the subject is radically different that the background, I will switch to Spot metering. Also, any time that you shoot stills in Live View (from your camera's LCD), the camera switches to Evaluative metering regardless of the mode you have selected.

### Spot

When I find myself in a challenging situation, at least in terms of light, I switch to Spot metering. Rather than evaluate a broad range of zones, the spot meter reads the zone(s) within the viewfinder's center circle. I can take a meter reading from the part of the frame that I think is most important—for example, by putting the center circle on the subject's face—and then, by pressing the AE Lock button, hold that meter reading so that I can recompose the frame and shoot. When Speedliting, Spot metering is also very

useful. As discussed on page 113, it is the basis for how I use Flash Exposure Lock (FEL).

### Partial

I think of Partial metering as a fatter version of Spot metering. It reads the center circle, plus the zone around it. I'm sure that some engineer had a good reason for inventing it. I just haven't discovered it. I use either Evaluative or Spot and jump right over Partial.

### Center-Weighted Average

I think of Center-Weighted as a combination of Partial and Evaluative. The camera first reads the zones in and around the center circle and then looks at the rest of the zones. As with Partial, I still haven't found a compelling reason to use Center-Weighted mode.

---

**SPEEDLITER'S TIP**

#### —Dial In Some Exposure Compensation—

I don't expect that my camera will give me a perfect exposure setting every time. In fact, "perfect" is always relative because it refers to my vision as a photographer more than how the world in front of me looks at that moment.

As discussed on page 5, and in many of the shoots later in the *Handbook*, I routinely dial the exposure settings up or down via Exposure Compensation (EC). This increases or decreases the camera's metered exposure by the amount that I specify.

## WHITE BALANCE

White balance is not a direct component of exposure in the same manner as ISO, shutter speed, or aperture. Yet, it is a critical part of making a digital capture. And, like ISO, shutter speed, and aperture, white balance settings can be changed intentionally for creative purposes. (See Chapter 20, *Gelling For Effect*, for details.)

To start, know that human vision has the re-markable ability to see white as white under many different sources of light. Digital sensors are not so versatile. You must either tell the camera what kind of light you are shooting under or you can let the camera try to figure it out with Automatic White Balance.

## White Balance Settings

Here's a quick look at the white balance settings available on most Canon DSLRs.

**AWB** **Auto:** An easy way to start. I often leave my camera set to AWB.

**Daylight:** Often used when shooting with gels during the day. 5200° K

**Shade:** Adds a warm cast. 7000° K

**Cloudy:** Adds a slight warm cast. A good setting for portraits with ungelled Speedlites. 6000° K

**Tungsten:** The setting to use for old-school lightbulbs. 3200° K

**White Fluorescent:** Office and home fluorescents are tough to balance. This is a best-guess. 4000° K

**Flash:** 6000° K

**Custom:** Create a white balance by shooting a white target.

**K** **Specific:** Allows you to set a specific color temperature, used by pros.

## White Balance In Action

If the white balance in the camera does not match the color temperature of the light being photographed, you will see a color cast. Here is the X-Rite ColorChecker photographed under full sun in different white balance settings.

*Figure 2.21 Daylight white balance in daylight.*

*Figure 2.22* Flash white balance in daylight.

*Figure 2.23* Tungsten white balance in daylight.

*Figure 2.24* Fluorescent white balance in daylight.

*Figure 2.25* Shade white balance in daylight.

## When To Set White Balance

Canon has had great Auto White Balance technology for a number of years. Many photographers leave their cameras set to AWB and never explore the other settings. If you are starting out, this is fine—except for the "never" part.

I always shoot in RAW (okay, sometimes RAW + JPEG, but never JPEG only), which means that I can easily adjust the color temperature in Lightroom as part of my post-capture workflow. So, I often shoot in AWB and make slight adjustments in post when needed. (If you are a JPEG-only shooter, please read the Speedliter's Tip on the previous page.)

There are two situations where I always move out of AWB and select a specific white balance:

- When I want to create a color effect—like turning the world blue by shooting daylight with a Tungsten white balance (see Chapter 20, *Gelling For Effect*, for details).

- When I have clients in the studio or on location who want to go home with the captures on a disk right then and there so that they can choose the hero shots for publication. I give them JPEGs from the camera and then deliver their selections as files derived from my RAW captures.

## EXPOSURE EVALUATION FOR FLASH PHOTOGRAPHY

Digital photography has delivered an entirely new way for me to evaluate my exposures. Even though I still carry a light meter, I do so largely for sentimental reasons.

### Why Light Meters Are Old School

In the dark ages of film, I shot my commercial work on medium-format roll film in a Mamiya 67RZ or on sheet film in an Arca-Swiss view camera. For flash, I always used a Minolta Flashmeter IV F and frequently shot Polaroids via special camera backs.

**Figure 2.26** *I've carried a Minolta Flashmeter IV F for years. In the film days, it was invaluable. Today it is mostly a keepsake from the past.*

All the flash meter and Polaroids really did was help educate me about the guesses I had to make about camera exposure and flash power. The ultimate guideline was the image on the film itself—which I couldn't see until it was developed. So, to spread my bets, I often bracketed my exposures and burned through lots of film.

A traditional flash meter measures how much light is falling on your subject (i.e., it measures incident light). It does not differentiate between light falling on a piece of black velvet from light falling on a field of fresh snow. Instead, it is programmed to measure the amount of incident light and then give an exposure suitable for photographing the scene as if it was an 18% gray card.

Ultimately, it is the amount of light reflecting off your subject and getting through the lens that matters to your camera. Compared to the film era, digital photography provides a huge advantage because we now get immediate feedback on our composition, lighting, and exposure. I still carry my flash meter but haven't used it in years. It remains in my bag, I suspect, largely for sentimental reasons.

### Bad Idea: Use The Image On Your Camera's LCD To Judge The Exposure

The addition of the LCD to the back of a camera was one of the best and worst things to happen in the evolution of photo technology. The LCD is great because it can give you immediate insight on your digital capture. Unfortunately, it also has the power to greatly misinform.

The first thing to know about your camera's LCD is that the screen's brightness can change. My 5D Mark II offers an Auto and Manual brightness. The funny thing—at least I think it's funny—is that I did not know that there is a light sensor that controls the LCD auto-brightness until long after I had covered it with the SylArena.com label that I put on all my gear.

**Figure 2.27** *Some cameras have a light sensor to adjust LCD brightness. I did not know this when I applied this sticker to my 5DM2. The sensor is right underneath the .com. Oops.*

The changes in LCD brightness—whether intentional or unintentional—have no direct relationship to the exposure I just made. I turn the brightness down—the image appears darker. I turn the brightness up—the image appears lighter. Yet nothing changed in the exposure itself. That's one of the reasons I say the LCD can "greatly misinform."

The second thing to know about the LCD image is that it is a JPEG preview. Even if you are shooting RAW (which I always do), the screen image is still the JPEG preview.

This means that the data is not an accurate representation of what you would see if you viewed the image on a high-quality computer monitor. Nor should it be taken as a close approximation of what you would get if you printed the image.

The bottom line is that you can't rely on the LCD image as the basis for judging exposure. I've often looked at the LCD and thought, "That exposure is dead on." Then, after checking the histogram, I learned that I was a stop or more underexposed.

### Good Idea: Use The Image On Your Camera's LCD To Check Lighting

What is that LCD image good for? It is certainly a great way to check composition. I am always grateful to learn that a corner of the softbox is sticking into the frame while I still can do something about it (rather than discovering it after I return home). True confession: this actually happens to me a lot because I like to push my softboxes in as close to the frame as I can.

I also think that the LCD image is useful for checking the distribution of light within your image. I'm not talking about exposure. I'm talking about where the light is and isn't in the frame.

For instance, when shooting portraits, I generally want my sitter's face to be the brightest element in the photo. The LCD image is a perfect way to confirm that my snooted Speedlite is hitting her face rather than her shoulder.

Shadow placement is another lighting element that the LCD is well qualified to display. If I'm shooting product or still-life work, I'll move the lights around through a series of test shots until they are positioned in the perfect spots (often based on where their shadows fall). I'm happy to make this decision based on what I see on the LCD.

So, although I am not willing to trust my LCD to evaluate exposure, I am willing to trust that it represents the relationships of light sources within the frame.

### Your Camera Has A Built-In Flash Meter—The Histogram

I want you to think of the histogram—that curious graph that shows up on the back of your camera—as a built-in flash meter. Unlike an old-school flash meter, the histogram won't say, "Shoot $\frac{1}{125}$" at f/16." Rather, the histogram will tell you something much more valuable—it will indicate whether you are over-, under-, or properly exposed. It will also indicate whether the dynamic range of light in your scene is too great for the sensor to capture without clipping.

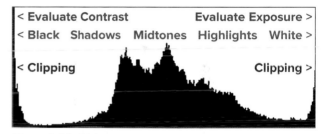

**Figure 2.28** *A histogram is the digital photographer's light meter. It shows highlight information on the right and shadow information on the left.*

Here are two things to remember when using the histogram as a flash meter:

- The right endpoint tells you about your exposure.
- The left endpoint tells you about your contrast.

When evaluating a histogram, consider the right side first. This represents how the brightest part of the image (the highlights) has been recorded.

## Five Things Your Histogram Can Tell You

1. **Good Exposure Range** A histogram without a spike at either end indicates that the camera has captured a broad range of tonal values without clipping of shadows or highlights. Ideally you want the right endpoint to come very close to the right edge without hitting it.

2. **Underexposed Image** A gap between the right endpoint and the right side of the histogram means that the image is underexposed, in which case you need to let more light in. The difference between underexposed and too much contrast is that in the the latter (#4) the right side extends all the way into the highlights.

3. **Overexposed Image** A histogram with a spike or pile on the right side means that the image has been overexposed, meaning that you need to stop down and/or use a faster shutter speed.

4. **Too Much Contrast** A histogram with a spike or pile on the left side means that shadow details are being lost. What you likely see as very dark tones in the scene are being recorded by the camera as pitch black. In this case, you will want to add light to fill in the shadows—via fill flash or a reflector.

5. **Low Contrast** A histogram with a gap between the left endpoint and the left side of the histogram means that the camera has room to record more shadow detail. If the histogram is close to the right end without clipping, then a large gap to the left is not a problem.

### Don't Worry About The Shape Of The Histogram

Now, don't read this wrong—I'm saying *don't worry about the shape of the histogram*. I'm not saying don't worry about where the endpoints fall. As we just discussed, the positions of the endpoints are critical in terms of evaluating exposure and lighting.

The shape of the histogram tells you about the range of tones in the photo. You can have a mountain in the middle. You can have a valley in the middle. You can have a mountain on the right or left that tapers off quickly towards the other end. What matters is the location of the endpoints—not the shape.

### What The Histogram Can't Do For You

Understanding what your histogram is telling you is a key to becoming a skilled Speedliter. Know, however, that it is not the only compass you need to find your way. For instance, the histogram:

- **can't tell you if your light is in the right place**. You can have a perfect exposure and a good dynamic range, but still have your Speedlite pointing to the wrong parts of the photo. An example would be a shot in which the background is very bright but the subject in the foreground is underlit to such an extent that she is a silhouette.

- **can't tell you if the quality of light enhances or clashes with your subject**. For instance, using hard light on the face of an older woman might not be a good pairing if your goal is to create a beauty shot that minimizes wrinkles.

Remember that, although the histogram can give you valuable information about an exposure, it provides no insight on creative matters. Having a great-looking histogram is no guarantee that you'll have a great-looking photograph.

## DETERMINING PROPER EXPOSURE

As a final thought in this chapter on exposure, I want you to understand that ultimately you, the Speedliter, are the final voice on what a "proper exposure" should be. The measure is how well your photo expresses your vision and intentions.

Compare the photos below. Neither is right or wrong. They are different interpretations of the same scene. The only difference is the shutter speed— $\frac{1}{200}$" above and $\frac{1}{3}$" below

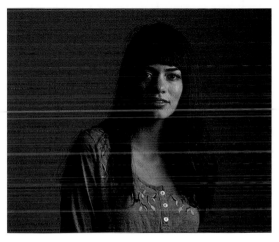

*Figures 3.29–3.30 You, as the photographer, have creative control over what you want to portray. As you can see above, the same scene can be photographed to deliver two completely different feelings.*

# CHAPTER 3 | MECHANICS OF LIGHT

## The Short Version

Light follows some pretty specific rules about how it bounces around the universe. Speedliters don't need to be physicists, but understanding a few basic principles will help you understand why your Speedliting looks or doesn't look how you want it to.

*Figure 3.1*

*Three Speedlites, one each gelled with pure red, pure green, and pure blue, are fired into the corner of my studio ceiling—as a demonstration of the additive primaries. At the center, you can see patches of cyan, magenta, and yellow—the subtractive primaries, which are created when red, green, and blue merge.*

## COLOR...PRIMARILY

Time to set the record straight on several accounts. First—and contrary to what you learned in kindergarten—red, blue, and yellow are not the primary colors. Second, there actually is no such thing as white light. Don't worry; revealing the truth won't cause the world to implode. It's been this way forever.

### Are We Talking About Light Or Pigment?

When talking about primary colors, you need to decide if you are talking about light or pigment—as in "Are you photographing a landscape or painting it?" Light and pigment each have their own set of primaries. Red, blue, and yellow are not found as a group in either.

The *additive primaries* relate to the color of light. They are red, green, and blue. As you'll read in a moment, we can mix various combinations of red, green, and blue light to come up with all the colors in the rainbow.

The *subtractive primaries* relate to the color of pigments (paint, ink, dyes, etc.). They are cyan, magenta, and yellow. Cyan is a bright blue, bordering on turquoise. Magenta is ultra-pink. Yellow is, well...at least they got that right in kindergarten.

> *Additive and subtractive primaries, which is which? To keep the two groups of primaries straight, just ask yourself what you have to do to get to white.*

If you have no light, it's black, right? So, to create white light, you *add* equal parts of red, green, and blue. When you do, as shown in Figure 3.2, you get light that we perceive as white.

Now what happened in kindergarten when you smeared your red, blue, and yellow fingerpaint all together? You got a messy shade of brown or gray—which would have been black if the pigments had been pure shades of cyan, magenta, and yellow. So, what do you have to do to get from black paint back to white paper? You have to remove (subtract) all the colors. Now you can remember that cyan, magenta, and yellow are the subtractive primaries.

## Additive Primaries = Red, Green, and Blue

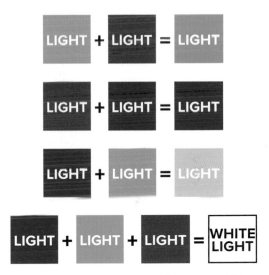

**Figure 3.2** *The additive primaries—red, green, and blue—are the primary colors of light. You can remember that the additive primaries relate to light because when added together, they create white light.*

## Subtractive Primaries = Cyan, Magenta, and Yellow

**Figure 3.3** *The subtractive primaries—cyan, magenta, and yellow—are the primary colors of inks. You can remember that the subtractive primaries relate to pigment because when subtracted completely, you have white paper.*

## TAKING COLOR'S TEMPERATURE

For the most part, as far as I see it, a piece of white paper looks white regardless of whether I'm viewing it by candlelight, noon sun, or in open shade. Yet film or the sensor in your digital camera could record the white of the paper differently. Making white appear white has to do with the *color temperature* of the light source, and how that color temperature is recorded by the camera.

### There's A Good Reason To Think About Color Temperature

As Speedliters we'll spend a lot of time talking about *white balance*. What we're really talking about is matching our camera settings to the color temperature of our light sources.

You know that the color of daylight is different just before sunset than it is at noon. This is an example of an easy-to-see difference in color temperature.

Many times the difference in color temperature is more subtle, but recognizing that difference is very important in terms of making a well-crafted photograph. Did you also know that the color temperature of daylight is different when you're looking at something in full sun than when you're looking at it in full shade? In shade, the color of daylight is a bit bluer than direct sunlight because the light in the shady area has arrived there indirectly after bouncing off the molecules in the atmosphere.

### Color Temperature Is A Matter Of Degrees

Color temperature is measured on a precise scale that describes the warmth or coolness of the light produced by a given source. The increments of color temperature are *Kelvins*, a.k.a. *K* (it's not proper to say "degrees Kelvin").

Lower numbers, those below 5000K, represent warmer (orange) colors. Higher numbers, those above 5000K, represent cooler (blue) colors. The farther below or the higher above 5000K you go, the more intense the warmth or coolness becomes. Light in the middle of the scale is not particularly warm or cool.

Now don't get confused. The way to remember that lower Kelvins are warm colors and higher Kelvins are cool colors is to think about the color of a candle flame. At its base (the lower part), the candle flame is yellow. At the top of the flame (the higher part), it burns blue.

### Getting To White, It's A Matter Of Balance

As Speedliters, we need to know about the color temperature of our light source—either because we need to neutralize its effect or because we want to re-create it.

Unless you want to dive off into the depths of color theory, there are just a few reference points you need to remember about color temperature. On Canon DSLRs:

Shade = 7000K
Flash = 6000K
Cloudy = 6000K
Daylight = 5200K
White Fluorescent = 4000K
Tungsten = 3200K

When you set the white balance on your camera to a specific setting, the camera tries to keep white looking white by adding the opposite color bias to the file. For example, tungsten light is more orange than daylight. So when you change your camera to a tungsten white balance, it actually adds a blue cast to the image to compensate. The difference between Flash and Cloudy is that Flash adds a very subtle shift towards magenta that Cloudy does not.

## Creative Manipulation Of Color Temperature

As a Speedliter, always remember that the color temperature of your Speedlites is about the same as daylight. As you'll read in Chapter 20, *Gelling For Effect*, you can use this knowledge for creative purposes.

Here's an example. You just read that the tungsten white balance setting of your camera adds a blue cast to the image. This helps white appear white under the orange tint of tungsten lights. What happens if you shoot under sunlight with a tungsten white balance? (For my fellow old-schoolers, I'll ask: what would happen when you shot tungsten film outdoors?) The whole image has a blue cast to it, right?

Okay. So what would happen if we then came back with our camera still set to a tungsten white balance and lit our main subject with a tungsten light source or, since we are Speedliters, with an orange-tinted (CTO) gel over our daylight-balanced Speedlites? We end up with a good white balance on our subject and a super-blue sky.

Take a look at the three images at right. The differences between them were created by changing the white balance in the camera and by adding a gel to the Speedlite

- Figure 3.4 is in balance with the camera set to daylight white balance and an un-gelled Speedlite.
- Figure 3.5 is out of balance. The camera has been changed to tungsten white balance and the Speedlite remains ungelled.
- Figure 3.6 is in balance. The camera is still in tungsten white balance. A CTO gel has been added to the Speedlite which shifts it to the color of tungsten light.

*Figure 3.4* Daylight white balance, Tom (son #1) lit with bare Speedlite. Color balance appears neutral.

*Figure 3.5* Tungsten white balance and bare Speedlite. Tom has a blue cast due to the color imbalance.

*Figure 3.6* Tungsten white balance and CTO gel over Speedlite. Tom appears neutral and the sky is a rich blue—known as tungsten blue.

**Figure 3.7** *By keeping the umbrella high enough to come in to Tom's face at a 45°, I was able to keep the reflection out of the large sunglasses.*

**Figure 3.8** *When I dropped the umbrella too low, it appeared in the sunglasses. Also note how Tom's face appears flat because it lacks strong shadows.*

## INCIDENCE INCIDENTALLY

Knowing that light bounces off an object at the same angle it came in from is a valuable insight for Speedliters. This simple principle helps us create or avoid reflections of light sources in our photos.

### Light On The Straight And Narrow

Photographers should always think that light's direction is straightforward. For the vast majority of us who are not advanced physicists, it's safe to say that light travels in a straight line. Einstein and his academic descendants would say that light travels in a wave when it's not acting like a particle, and that it can be bent by gravity. But hey, we're photographers, not physicists, so let's stick with the straight-line approach.

> *Light will travel in a straight line until it hits something. When it hits an object, light will bounce off it or be absorbed by it—or do a bit of each.*

### Mirror, Mirror...

The handy thing about light always traveling in a straight line is that it's easy to predict. When light bounces off an object, it does so at the same angle that it came in at. Technically stated, the *angle of reflection* equals the *angle of incidence*.

An easy way to understand this is to stand in front of a mirror. When you are exactly in front of it, what—actually, who—do you see in the mirror? Now, step a little bit to the side and what do you see in the mirror? Now, step farther to the side and what do you see? The change of what you see in the mirror is a clear demonstration of how the angle of incidence (the light heading in) is the same as the angle of reflection (the light heading out).

Here is a real-world example you will experience again and again as a Speedliter—eyeglasses. If you're doing a headshot and the eyeglasses fill with glare, then you need to change the angle of incidence to remove the reflection. You can move the light source, tilt the head or glasses just a bit, or move the camera so that it does not see the reflection.

## Direct Vs. Diffuse Reflection

It's easy to understand how light bounces off a reflective surface like a mirror. What about a matte surface, like a piece of paper? Does the angle of reflection still equal the angle of incidence? More specifically, why are you not blinded when reading a newspaper outdoors in full sun?

The answer lies in the surface of the paper. If you look at it microscopically, you would see that it is rough. The light is still reflecting off at an angle equal to the angle of incidence. It's just that the text of the paper gives it surfaces that face many directions.

The shots at right provide a good example of the difference between *direct reflection* and *diffuse reflection*. Figure 3.9 was lit directly by an incandescent bulb in a silver reflector. In fact, you can see it reflecting in the surface of the olive oil. The liquid surface of the oil and the metallic surfaces of the knife and plate all create direct reflections.

Figure 3.10 is the exact same shot with the addition of a Lastolite Skylite panel between the light and the plate (as shown in Figure 3.11). I'm sure you've noted that the glare on the olive oil, silver knife and gold plate is no longer a problem. The 42" diffusion panel replaced the 6" reflector as the light source—sending light from multiple angles rather than just one.

Just as important, did you also notice in the upper corners of the photos that the brightness of the tablecloth did not change? It remains the same tone of medium-gray. This is because the textured surface of the fabric provides a diffuse reflection—even when lit directly.

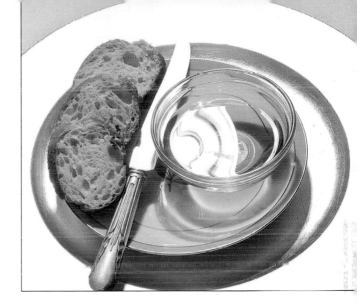

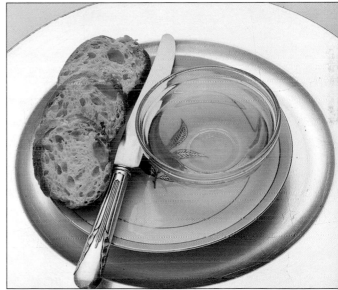

*Figure 3.9* Direct reflection creates glare in the surface of the liquid and metallic surfaces.

*Figure 3.10* By inserting a diffusion panel in front of the light, the direct reflection has been tamed. Notice also in both shots that the tone of the tablecloth remains the same. Even when lit directly, the fabric provided a diffuse reflection.

*Figure 3.11* The placement of the 42" Lastolite Skylite panel with diffusion fabric.

When it comes to controlling the look of light you create, the size of your light source should be your first consideration. It's more than possible to make large sources seem small and small sources appear large. Remember that size is relative; it changes as the distance between the source and the subject changes.

### Consider Your Shadow's Edge

The sun is the largest object in our solar system, yet Earth's distance from it makes it appear relatively small in our sky. On a sunny day, your shadow has a hard edge. That defined edge to your shadow is created because the sunlight hitting you is coming from a single direction. Another way to say it is that you have a hard shadow because the sun's rays are parallel when they hit you.

What happens to your shadow on a cloudy day? It gets fuzzy or disappears completely. Why? When a layer of clouds moves across the sun, the sunlight hits the clouds and they effectively become your light source. Since they are much bigger—relative to your size—the light hits you from many angles. A shadow created by light coming from one angle is filled by light coming from another angle. The more angles of approach, the softer the shadows become.

*Figure 3.12* Direct sunlight creates a dark shadow with sharply defined (hard) edges. Notice also that the contrast between the black shoes and the glare off the concrete is beyond the dynamic range of the camera. The subtle tones of the stockings and black leather are compressed into a sillhouette.

*Figure 3.13* The placement of a Lastolite Skylite panel creates very soft shadows because the light is now coming at the shoes from many angles. Notice also that the subtle difference in dark tones between the stockings and shoes has been captured.

*Figure 3.14* The set after the diffusion panel was placed. The lone Speedlite (at left) was positioned extra high to provide a bit of fill light that fell off sharply.

## Big Is Not Always Big

If you are familiar with a softbox, you know that it is a big light source. When you use it up close, it creates soft light. What happens if you move a softbox far away? Its apparent size relative to the subject becomes smaller.

As the apparent size of a light source gets smaller, the directionality of its light increases. Move a large source far enough away and it will eventually become a small light source. Again, the sun is an example of how distance from a large source can make its apparent size become much smaller.

### Making Speedlites Appear Larger Is A Big Part Of Speedliting

Don't fret. Despite the fact that the face of a Speedlite is just a few square inches, there are many ways to make it seem bigger. Here are a few:

- Bounce your Speedlite into a reflective umbrella
- Fire your Speedlite through a satin umbrella
- Shoot your Speedlite through a softbox
- Fire it through a diffusion panel
- Bounce it off your hand, a wall, or a ceiling
- Fire several Speedlites together from different angles

*Figure 3.15* In this shot, the Lastolite Ezybox Speed-lite was actually just inside the frame. (You don't see it because it was black.) Notice that the neck shadows are extremely soft. Also notice that that there is a dramatic difference between the cheek highlights and the skintones across the collarbone. This chiaroscuro happens when the light source is pushed in very close.

*Figure 3.16* Moving the softbox out to about 12′ reduces its apparent size and increases the hardness of the light slightly. Notice that the shadows on the neck are sharper. Also, because of the greater distance, the light is more even across the face (see pages 48–49 for more information on why).

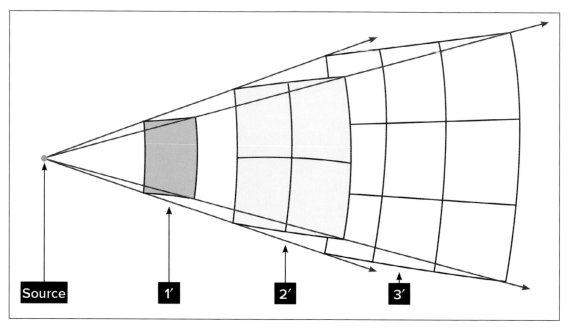

**Figure 3.17** *The Inverse Square Law, as intimidating as it may sound, helps photographers understand why light gets dimmer as it gets farther from the source. In the illustration above, the intensity of the light at 2′ is ¼ as bright as it is at 1′. Likewise, the intensity of the light at 3′ is ⅑ as bright as it is at 1′.*

## FALLING OFF, OR HOW TO LOVE THE INVERSE SQUARE LAW

Do not repeat after me: "The intensity of light from a point source falling upon a subject is inversely proportional to the square of the distance from the source."

The Inverse Square Law has intimidated and befuddled more photographers than any other aspect of our craft. You don't have to understand the math. You do need to know what it means.

### A Way To Visualize The Inverse Square Law In Action

Put yourself in this image. You are in a huge, empty room. No. Bigger than that. I mean really huge. There is no light, except for a lone light bulb magically shining in the middle of this huge space. Equally magical is your ability to move anywhere in this room you want with ease. Yes, I mean you can fly.

So, fly up to the bulb and pull out that handy 12″ square white tile you've been carrying around in your pocket. Take a look at how bright the tile is when you are close to the bulb. Now, fly a good distance away. You can barely see the tile.

Being the curious sort that you are, you fly to the bulb and away from the bulb in all directions. You discover that the phenomenon is the same no matter what direction you head. Near the bulb, the tile is bright. Far away, your tile is hidden in darkness.

What happened to the light? You've just witnessed the Inverse Square Law in action. As light spreads out, it gets dimmer.

The funny thing is, because of the way our eyes are wired to our brain, we don't always see the loss in brightness because our pupils dilate as the light dims—so the appearance of brightness remains. Your camera works differently. Unless you open up the aperture, slow the shutter, or increase the ISO, it will record the light as being dimmer.

**Figure 3.18** *Your white tile with the magic light bulb 1′, 2′, and 3′ away.*

## The Inverse Square Law Is Trying To Tell Us Something

What happened to the light from the magic bulb as you moved away is that it spread out. As it spread out, the photons got farther and farther apart. When there were fewer photons hitting your tile, it looked darker and darker as you moved away from the light source.

The Inverse Square Law tells us how much darker the tile will be as you move away. Here we go with a little math. If you think of the math as a shot at the doctor's office, it won't hurt that much. You know, "just a little prick."

Specifically, if you look at the 12″ x 12″ white tile when it is one foot from the light and then look at it when it's 2′ from the light, you will see that it is one-fourth as bright. Move the tile out to 3′, and you'll see that it is one-ninth as bright as it was at 1′. I know, the numbers sound crazy.

There's a reason that the difference from 1′ to 2′ away is one-fourth as bright and not one-half as bright, as you'd expect: the light has to spread vertically as well as horizontally at the same time. You can see this happening in Figure 3.17 on the opposite page.

So the photons that were hitting your 12″ x 12″ tile 1′ from the light spread out to a 24″ x 24″ square when they are 2′ from the source. As they moved another foot away, the photons spread out to a 36″ x 36″ square. At every step of the way, the photons spread farther apart. As photons spread apart, light gets dimmer.

### —The Subject-To-Light Distance Matters Most—

This may sound a bit strange—the distance between your subject and the lights is what determines the exposure, not the distance between the subject and your camera.

Now, I should say that I'm assuming that you did not skip over Chapter 0, *Quick Start Guide To Speedliting*. So you know how I feel about on-camera flash. Put another way, I'm making the assumption here that the main light source hitting your subject is not parked on top of your camera.

Let's say that I have two Speedlites, each on their own stand, on either side of my subject. I get everything dialed in for a nice, tight headshot. I'm standing, as you can see below, just a few feet from the subject.

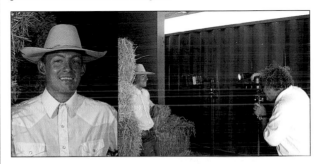

Then, for the heck of it, I back up 15′ and take another shot. You'll note that the Speedlites on the stands are still where they were—only the camera has moved. So, I zoom in and take virtually the same headshot at the exact same exposure. See, there's no need to change the exposure if the distance between the subject and lights does not change.

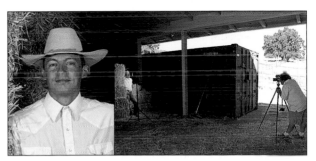

So why, if I'm shooting in an automatic mode, like Av, does the camera sometimes think that it needs to change the exposure when I move my position? Well, it's not because I changed position—it's because I changed the composition. When I moved, but zoomed back to the previous crop, then the exposure did not change. If I make a significant change to the scene, then the camera sees new data when metering.

## THINKING ABOUT FLASH-TO-SUBJECT DISTANCE AS STOPS

Here is the Inverse Square Law in action: when you double the distance between the light and the subject, the illumination is one-fourth as bright. So, in terms of stops, what is the difference in brightness when a light is 3′ versus 6′ away? It's two stops.

Did you say one stop? Remember, every time the light is cut in half, that is a one-stop change. One-fourth as bright is a two-stop difference because the brightness is cut in half twice. Full power x 50% = ½ power (first stop of reduction). Moving on, ½ power x 50% = ¼ power (second stop of reduction).

### 1.4—The Photographer's Magic Number

Since you've hung in this far, would you like to know how far you have to move a light to get a one-stop reduction in light? The quick answer is 1.4 times your current distance. Huh? It has to do with the square root of 2, which is 1.412421.... If you're not a math fan, just remember the 1.4 part.

So, if you measure the light 1′ from the source, then at 1.4′ it will be one stop dimmer. Using the round numbers that photographers are so fond of, you'll be at the next full-stop reduction at 1.4′ x 1.4, which is 2′, then 2.8′, then 4′, then 5.6′, then 8′, then 11′.... Have you picked up on the pattern? They are the same intervals as full-stop apertures on your camera. I've laid it out to scale for you just below in Figure 3.19.

*Figure 3.19 (below) The F-Stop Yardstick will help you visualize how quickly or slowly light falls off. For instance, if your subject's cheek is 1′ from the light, then at 1.4′ (about 17″), the light will be one stop darker. At 2′, the light will be two stops darker.*

### The F-Stop Yardstick

Here is another reason to memorize the whole-stop increments listed on page 23 in Figure 2.4—you can used them as a yardstick (meter stick for my friends overseas). Memorize the whole f-stops and apply them to any increment you want—inches, feet, or meters. You will have a valuable lighting tool for making important decisions.

The F-Stop Yardstick, shown below, will help you visualize how quickly or slowly light falls off. You can see that if your subject's cheek is 1′ from the light, then at 1.4′ (about 17″), the light will be one stop darker—that's a change in distance of only 5″. Conversely, if your subject is 11′ from the light, then it takes another 5′ for the light to fall off one stop.

### Putting The Inverse Square Law To Work...Creatively

If you remember nothing else about the Inverse Square Law, remember this:

> *The closer your light source is to your subject, the more dramatic the falloff will be. Likewise, the farther you place your light from the subject the more even the light will be.*

*Figure 3.20 (opposite, top) Conscripted once again, my three boys—Tom, Vin, and Tony—demonstrate the F-Stop Yardstick. In this shot, the lone Speedlite is 4′ from Tom. As you can see, when the light finally gets to Tony, it has dimmed considerably. If you check the F-Stop Yardstick below you can see that the falloff from 4′ to 9′—the width of the lads—is more than 2-stops across.*

*Figure 3.21 (opposite, bottom) For this shot, I pulled the Speedlite out to 16′—which reduced the falloff to less than a stop. I did have to increase the power of my Speedlite by 4 stops to accommodate the falloff between it and the boys. This was a fair trade for the improvement in the light.*

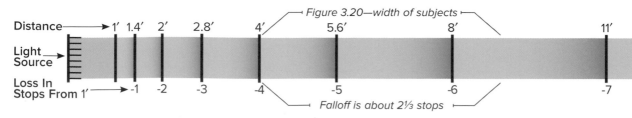

| Distance | 1′ | 1.4′ | 2′ | 2.8′ | 4′ | 5.6′ | 8′ | 11′ |

Figure 3.20—width of subjects

Light Source

Loss In Stops From 1′: -1, -2, -3, -4, -5, -6, -7

*Falloff is about 2⅓ stops*

### —Proving That 1.4 Is The Magic Number—

You can prove for yourself that 1.4 is the photographer's magic number with a tape measure, a Speedlite, a flash meter, and two stands.

Set your Speedlite up on one stand and your flash meter on the other. They should be at the same height. Stretch out a long tape measure and center the Speedlite over the end. Now center the flash meter at 1'. With your Speedlite in Manual mode at full power, fire away. I used the non-cord mode on my Minolta Flash Meter IV. If the reading is too high for the meter, either lower the ISO setting on the meter or lower the power on the Speedlite. I worked the power down so that at 1' the f/stop on the meter was f/64.

Now move the flash meter stand and center it on each of the intervals listed on the F-Stop Yardstick. Fire the Speedlite at the same power level as before (consistency is really important for this demonstration). The flash meter reading will drop in one-stop increments. You've just proved that a 1.4x increase in distance equals a one stop decrease in light.

For best results, I suggest that you do this in an open field at night rather than indoors so that you're getting the light directly from the flash and not off a wall.

Figure 3.21—width of subjects

16'          22'

-8          -9

Falloff is about ¾ stop

# CHAPTER 4 | LIGHT OF THE WORLD

## The Short Version

We do not often think about the light around us. We usually take it for granted, as in, "The sun comes up, crosses the sky, and goes down." Or we may be concerned with other matters, as in, "I'm supposed to get milk, eggs, and bread. Now where does this store hide the bread?"

*Ambient light*, the light around us, comes from many sources. Ambient light also shapes our emotions and sense of time. Developing a keen awareness of the light around you is a critical skill to becoming a Speedliter.

### Figure 4.1

*There are two types of light in a flash photograph—the light that is already there and the light produced by the Speedlite. In this photo, the sun is providing the ambient light and a pair of Speedlites are providing the flash. Can you tell which is which? The sunlight is behind Tony on the left side of the frame. The Speedlites are behind the camera and provide a quality of light that blends naturally with the sun. To read the details about how this photo was made, head to page 304.*

## THE ROLE OF AMBIENT LIGHT

The light in our world greatly influences how we feel, act, and think. The same is true of the light in our photographs. Whether natural or created, the look of ambient light can be a powerful communication tool. Likewise, it can be an unwanted part of the scene we want to photograph.

### Sources Of Ambient Light

Ambient light is everywhere. It is the light that you find in the scene already. There's a huge range of ambient light sources that you can use either in or as a light source for your photographs: the sun, fluorescent lights in a grocery store, the lamp on a bedside table, car headlights, or a cake covered in birthday candles.

While most ambient light comes from continuous sources, you can also find ambient light from intermittent sources. The blinking lights on roadside construction barricades, a strobe light in a modern dance performance, and the bulbs that appear to race around a marquee in Time Square also provide ambient light.

### The Clues Of Ambient Light

Ambient light goes a long way toward informing your viewer about the feeling and time of your photograph. So knowing the look of ambient light enables you as a Speedliter to create a feeling in your photographs—even when the light you need isn't present.

Through our own experiences, we associate certain emotions with different types of ambient light. A smiling child lit by morning light streaming in through a window suggests comfort. A couple lit by the glow of candlelight suggests romance. The beam of a flashlight cutting into a dark cave creates a sense of suspense. A lone figure lit overhead by a street lamp portrays a sense of loneliness or foreboding. A pair of bright lights heading straight at us suggests panic.

Just as ambient light provides clues to the emotion of a photograph, it can also tell the viewer much about the time of day in the photograph. Long shadows and a warm cast to sunlight indicate that it is either early morning or late afternoon. Conversely, steep shadows in brilliant light indicate that it's noon. A warmly lit room interior with only black in the windows tells us that it is night.

### Ambient Light Does Not Always Appear Ambient

As your skills as a Speedliter develop, you'll come to understand that ambient light does not always have to be the *key light* (a.k.a. "main source") in your photo. In a portrait session outdoors, you can position your subject so that the noon sun falls on her back and shoulders to create a *rim* or *separation* light and use Speedlites as the key light.

In the first of the two photos opposite, we can see that the noon sun was lighting the subject frontally, meaning that it was at my back during the shoot. The combination is perfectly lousy. The shadows are steep. My subject squints his eyes. There is no clean separation between my subject and the background.

In the second image, we switched positions so that now the sun was coming over his shoulders. To create this shot, I used a pair of Speedlites—one as a key light and the other as a fill light.

When shooting toward a light source, it's important that the front of the lens is shaded. I used both my lens hood and a separate flag on a lightweight stand to prevent stray light from entering the lens.

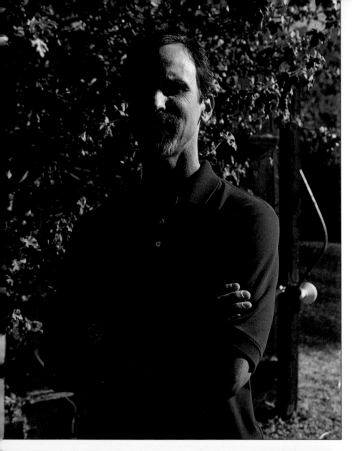

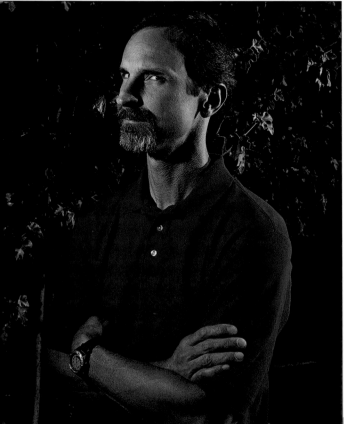

## Ambient Light Is Not Always Wanted

As much as ambient light can create a sense of emotion or time in a photograph, there will be times when you have to shoot with ambient light that is totally counter to your desired end. This is an opportunity to—dare I say—let your skills as a Speedliter shine.

Consider the situation of having to photograph a suspense writer for a magazine cover, and the only time that he is available during a book tour stop is 15 minutes during the afternoon. The photo editor for the magazine doesn't care about the challenges imposed by the author's schedule; his job as photo editor is to obtain photographs that support the article. My job as the photographer is to deliver the photographs that I've been hired to create.

As you can see in Figure 4.2, there's hardly anything suspenseful about photographing an author in broad daylight. Sure it's a portrait of the author—but not one that conveys his dark persona.

It's up to me to create a quality of light that conveys the author's persona. By using high-speed sync, a technique that we'll discuss at length in Chapter 22, *Dimming The Sun*, I used my Speedlites to dim the sun and effectively shoot night at noon. I think you'll agree that the portrait in Figure 4.3 fits the subject's persona as a mystery writer.

Don't worry about how I made this shot. For now, just know that as Speedliters we don't have to accept the ambient light at all.

*Figure 4.2* *This is how the camera wanted to record the ambient light in the scene. In order to preserve the highlights created by the late afternoon sun, the camera let the shadows go dark.*

*Figure 4.3* *By using two bare Speedlites in high-speed sync, I was able to significantly underexpose the ambient sunlight by shooting at 1/1000″—effectively turning noon to night and creating a portrait that fits the subject's persona as a writer of suspense novels. This exposure ( 1/1000″, f/8, ISO 100) was 2.5 stops darker than the exposure used in Figure 4.2.*

## CONTROLLING AMBIENT IN FLASH EXPOSURES

As a Speedliter, there will be times when you want to accentuate the role of ambient light in your photographs, and there will be times when you want to minimize the role of ambient light in your photographs.

If you can come to understand the following, you will have mastered one of the hardest concepts about flash photography:

> *Use the shutter to control the ambient exposure.*
>
> *Use the aperture to control the flash exposure.*

If you overthink it, you'll fall into the trap that has confused legions of photographers. So, if you can't get your head around it, then just accept these truths and get on with shooting. The key is to use a faster shutter speed if you want to dim the ambient and a slower shutter speed when you want to collect more ambient (typically in dim light).

### Why Shutter Does Not Control Flash Exposure

I know it's hard to believe, but it's true: as long as you are shooting at or slower than the *sync speed* for your camera, then shutter speed has no control over the amount of Speedlite flash hitting your digital sensor. If you shoot faster than your camera's sync speed, you are *not* reducing the amount of Speedlite flash hitting the sensor; rather, you are only reducing the portion of the sensor that is exposed.

Here's why the shutter has no effect on the amount of flash getting through: a Speedlite's longest duration of flash is produced at full power—which is reported by Canon to be ⅛₀₀″. This is much faster than your camera's sync speed (typically ¹⁄₂₅₀″).

Take a look at Figure 4.4. The width of the black box represents ¹⁄₂₅₀″—the sync speed of many Canon DSLRs. The green line is the flash duration of a 580EX II at ½-power The red line is the flash duration at ¹⁄₁₂₈-power. The first

thing you should notice is that the higher the power setting, the longer the flash burst. The second thing you should notice is that the each is just a sliver of the width of the frame. Full power, although longer than ½-power, is still much narrower than the camera's sync speed.

**Figure 4.4** *Two flash durations of a 580EX II as measured on an oscilloscope. The green line is ½-power. The red line is ¹⁄₁₂₈-power. The width of the frame is ¹⁄₂₅₀″—the sync speed for many DLSRs.*

So it does not matter if you're shooting at ¹⁄₂₅₀″ or ½″, the flash from your Speedlite is flying through the lens for a mere fraction of the entire exposure. (If you want to shoot faster than ¹⁄₂₅₀″, you'll have to switch your Speedlite over to high-speed sync, which changes the game completely. For now, we're keeping it basic.)

### Why Aperture Controls Flash Exposure

Aperture, on the other hand, limits all the light coming through a lens. If the shutter speed is 1″ or ¹⁄₈₀₀₀″, it does not matter. All the light, ambient and flash, must pass through the aperture.

---

**SPEEDLITER'S TIP**

**—Say "Safe" To Remember—**

I know that it's hard under the pressure of a shoot to remember what to change to increase or decrease the amount of ambient light in your photo. So, just say "safe" for this mnemonic:

SAAF = Shutter Ambient, Aperture Flash

---

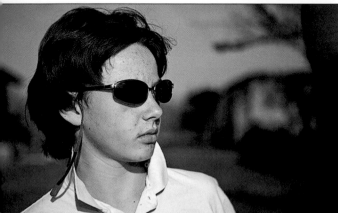

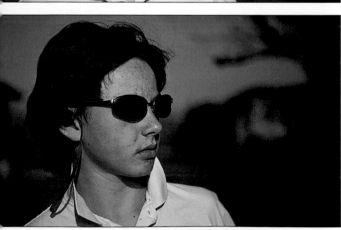

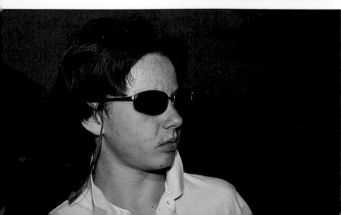

So aperture has a direct effect on the amount of flash hitting the sensor. If you are at full power and still need more flash, open the aperture by a stop or two. Then, to keep the ambient light the same, speed up the shutter speed by the same number of stops. Just remember, you can't exceed the sync speed for your camera without using high-speed sync.

### Why Shutter Speed Controls Ambient Exposure

You already know that if you switch your shutter speed from ½50″ to ½500″, you've just reduced the amount of sunlight getting to the sensor by half—you have reduced the amount of ambient exposure by half.

It does not matter if the ambient light is sunlight, room lights, or firelight—the shutter controls how much of it gets through the camera.

Now don't get hung up on the fact that the aperture also affects the ambient exposure. The thinking here is that if the aperture is set to control the flash exposure, you can adjust the shutter to control the ambient exposure.

As Speedliters, we will typically want to change the amount of ambient light in one of two ways:

- In brightly lit scenes, we will want to reduce the amount of ambient so as to make the subject (lit by flash) more prominent.
- In dimly lit scenes, we will want to collect more of the ambient light from the background so that the subject (lit by flash) is not standing against a black background.

Let's take a detailed look at each of these scenarios. In the first series, you can see that changing the shutter speed in this outdoor shot has helped saturate the sky and increase the separation between Tony (son #3) and the

**Figure 4.5** The baseline shot at f/9, ½00″, ISO 100.

**Figure 4.6** f/2.8, ⅟₁₆00″—⅔ stops darker than 4.5.

**Figure 4.7** f/2.8, ⅟₆400″—1⅔ stops darker than 4.5.

**Figure 4.8** f/9, ⅟₁₆00″—3 stops darker than 4.5.

background. Note in each of these photos that the power of the Speedlite, its distance to the subject, and the aperture have stayed the same. The only thing changing is the shutter speed.

Now we'll look at a series of shots made 45 minutes after sunset. Here, I've locked the camera down on a tripod to facilitate longer exposures. At ⅟₁₅" it's definitely a night shot.

*Figure 4.9* ⅟₁₅"—*definitely a night shot.*

*Figure 4.10* ½"—*3 stops more ambient than 4.9.*

*Figure 4.11* 2"—*5 stops more ambient than 4.9.*

*Figure 4.12* 8"—*7 stops more ambient than 4.9*

At 8″ the scene looks almost like daylight. By using slower shutter speeds—sometimes described as "dragging the shutter"—I'm able to collect more of the ambient light from the background.

### ISO Affects Flash And Ambient Equally

The ISO setting affects the "volume" of the signal coming from the digital sensor. It does not distinguish between flash and ambient light. If you double the ISO, then you've increased the exposure to ambient and flash by one stop.

Remember, in order to keep digital noise to a minimum, it's best to shoot at lower ISOs than higher ISOs. So think of ISO as a way to get your exposure into a range that you want:

- If you want to shoot at a smaller aperture to increase depth of field and have your Speedlite at full power, you can increase the ISO.
- If you need to get the shutter speed to a point that you can handhold without camera shake, you can increase the ISO.

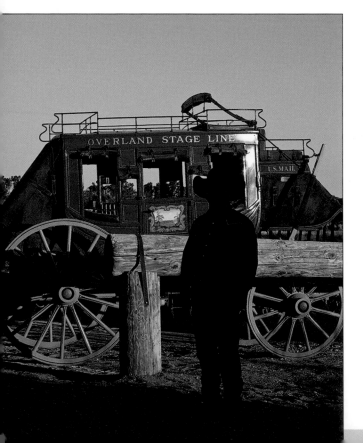

### Strategies For Aperture And Shutter With Flash

Now if you are thinking, "Why not just change the power setting on my Speedlite and not worry about the aperture?" it's because you will encounter situations where changing the aperture is preferable to changing the power setting.

Let's say that your Speedlite is at full power and you want to increase the effect of the flash on your subject while keeping the ambient at its current level. If you open up the aperture, you'll allow more of the flash to get through the lens. Then you can change the shutter speed by an offsetting amount (i.e., make it faster) to keep the ambient exposure the same.

Likewise, if your Speedlite is at minimum power and you still want less flash on your subject (a common situation in macro photography), you can close down the aperture to reduce the amount of flash getting through the lens. Again, you'll have to change the shutter speed by an equivalent amount (this time by going to a slower shutter speed) to keep the ambient exposure the same.

Another situation where it's easier to change the aperture than the power setting is when using Speedlites off-camera in manual mode. For example, you've set up an off-camera Speedlite for the new couple's walk down the aisle. As they enter the zone you're lighting with your Speedlite, you realize that you forgot to change the power setting on the flash. With no time to run over and change the power level, what can you do? That's right: quickly change the aperture to get the correct amount of flash, and change the shutter by an offsetting amount for the ambient.

*Figure 4.13* *When it was time to make a quick portrait of Tom Harris, owner of Harris Stage Lines, at sunset, the sun had dropped behind the barn, putting Tom in shade. This is the scene with only ambient light.*

## OPTIONS FOR BLENDING AMBIENT AND FLASH

You will know that you're catching on as a Speedliter when it's not evident that you've lit a photo with flash. This means that your flash has the same character and subtlety as the ambient light.

### Matching The Direction Of Your Ambient Light

The shadows tell all in a sunlit photo. They point to the direction of the sun—just line up the tip of a shadow with the tip of the object that created it and you'll know where the sun was. They also tell you the time—long shadows mean that it's early or late, and short shadows mean that it's midday.

There's only one sun in our sky. So there should only be one direction for the shadows in your photograph. Often, though, photographers forget about this and cross-light their subject. This means that the shadows on the subject are going in a different direction than the shadows in the background.

In Figure 4.13, opposite, you can see the situation I found myself in for a late-afternoon portrait—the optimal spot for my subject was in deep shade. Although you may not have noticed it at first, the Speedlite position in Figure 4.14 is creating cross-light. Tom's shadow is at a different angle than the shadows on the stagecoach. In Figure 4.15, I moved the Speedlite so that it was between Tom and the sun. This makes the shadows from the flash blend in with the shadows created by the sun.

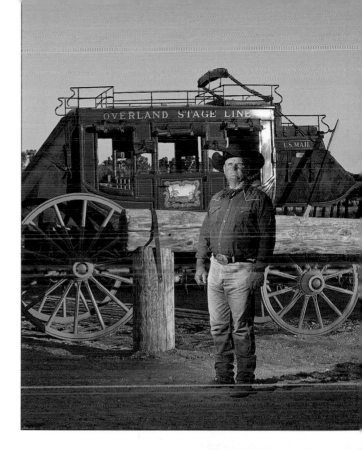

*Figure 4.14* To recreate the look of late-afternoon sun, I gelled a 580EX II with a full-cut of CTO. It is a subtle point, but this shot is cross-lit. The Speedlite hitting Tom is on the left. The sunlight is coming from the right. The shadows go in different directions.

*Figure 4.15* By moving the Speedlite over so that it is in line with the sun, Tom's shadows now align with the natural shadows on the stage coach. The flash in this shot blends well with the ambient light.

## Matching The Color Of Your Ambient Light

Your Speedlites cast a flash that approximates the color of sunlight during midday (about 5500K). Yet everyone knows that when the sun is near the horizon the color of daylight is much warmer (about 2500K to 3200K).

So, if you are lighting a subject at the beginning or end of the day and want your flash to seem realistic, you'll need to use a CTO gel over your Speedlite to make the flash appear natural. The use of gels for color correction and for theatrical effects is covered in Chapter 20, *Gelling For Effect*.

For now, just consider how the color temperature of your Speedlite can leave a big clue that your subject was lit with flash.

**Figure 4.16** *Minutes before sunset—the sunlight is very warm and the shadows are very long. This shot is straight sunlight. There is no fill flash.*

**Figure 4.17** *The addition of a Speedlite about 8' to the left of Mallory opens up the shadows. If you look at the highlight on her cheekbone, you can see how cool the Speedlite appears in comparison to the warmth of the sun.*

**Figure 4.18** *The addition of a full-cut CTO gel to the Speedlite adds much needed warmth to the fill light. Now the fill light blends naturally with the sunlight.*

## Practical Thoughts For Faking Ambient With Flash

In the movie world, any household lamp is called a "practical fixture." As a general rule, any shot that shows a light fixture within the frame should have light coming from that fixture. You may even want to light your set so that it appears that all the light is coming from that fixture.

If your set has a "practical" within the viewfinder's frame, chances are that the incandescent bulb will be too dim or too bright for your purposes. So you'll need to match the light coming out of the "practical" with the overall light of your shot.

One option is to change out the bulb—if you happen to have one of the right wattage. Another option—often more handy for the Speedliter—is to remove the bulb and use a Speedlite inside the shade.

Here are four quick considerations for faking the look of a practical with a flash:

- You'll need to trigger the flash wirelessly or via a long sync cord that is taped to the backside of the lamp.
- A diffuser, like the Sto-Fen Omni Bounce or the Flashpoint Q-series Dome, will help spread the light around.
- A full or partial cut of CTO gel will create the warm look that's associated with incandescent light.
- You can dial the power setting of your Speedlite up or down to give you the amount of light you need.

As shown at right, "real light" can look more harsh than well-crafted flash. I used two Speedlites—one in the lamp and one at camera-left that I bounced off the wood paneling. Both were gelled with a ½-cut CTO.

*Figure 4.19* Lit by a single CFL bulb in the lamp, the scene had too much contrast for the camera.

*Figure 4.20* Rather than try to color balance a fill flash to the fluorescent, I removed the bulb entirely. The gelled Speedlites provided a warm cast to the light and preserved the feeling of what I saw in front of the camera.

# CHAPTER 5 | **THINK GLOBALLY, LIGHT LOCALLY**

**Figure 5.1**
*The difference between these two images is the placement of the Speedlite. For the left frame, the 580EX II was in the hot shoe. For the right frame it was moved to about 60° left on the Lighting Compass and paired with a fill flash at 90° right. Going off-camera creates shadows which add a sense of depth and shape.*

## The Short Version

If a photograph is entirely white or black, can you see anything in it? The same is true for a photograph that is entirely red, blue, green, or any other color. Without contrast between tones and hues, there is virtually nothing to see.

Shadows and highlights are the most important visual guides for the viewer when she is trying to decode your two-dimensional photograph into her three-dimensional reality. As a Speedliter, you will quickly understand that the position of the camera, your subject, and the light(s) determine how the shadows and highlights dance in your photos.

When thinking about light position, we need to understand the importance of both horizontal and vertical placement.

## THE LIGHTING COMPASS

As a kid, I spent a lot of time In the Boy Scouts and a lot of time in geometry classes—and actually enjoyed both immensely. The common link between the two was that I could play with a compass: in Scouts to find my way, and in geometry to draw circles. Photography has brought them together.

### Every Light Has An Angle

When I started teaching lighting, I came up with the idea of the "Lighting Compass" as a model to understand how the horizontal position of a light relative to the subject affects what the camera sees. As shown in Figure 5.2, my Lighting Compass measures the angle between the camera and a light source using the subject as the center of the circle.

If a Speedlite is bolted into the camera's hot shoe, I say that it is at 0° on the Lighting Compass. A flash that is exactly to the left or the right of the subject is at 90°. A flash that is opposite the camera is at 180°. Again, these refer to the Speedlite's horizontal position. We'll deal with its vertical position in the next section.

### You Can Tell A Lot About A Light By Its Angle

The significance of a light's position relative to the camera and the subject has to do with the shadow that it casts. A Speedlite that is parked on top of your camera will cast virtually no shadow across the face of someone right in front of your lens.

Here is the secret to making a perfectly lousy driver's license photo: Make the light equal on both sides of the face so that it appears flat, like a cardboard cutout. This is why you were so disappointed with your early Speedlite photos: Everyone and everything was lit evenly.

Now, take a peek at the photos on pages 62 and 63. In this series of headshots, I placed the Speedlite level with the model's head. In each frame, it is the same distance from the model and fired at the same power setting. The only

**Figure 5.2** *The Lighting Compass shows the position of Speedlites in a circle around the subject when looking from above. The angle between the camera and the flash is measured at the subject.*

difference between the shots is that I moved the Speedlite to the right around the Lighting Compass.

See how the depth of the face changes as the Speedlite's position moves from the camera toward 90°? The length of the shadow increases across the face until one half of the face is virtually in darkness. (If you're getting antsy with the thought that a fill card would really help, you're right. Try to hold on until we cover the details of fill cards in Chapter 18, *Portraits With One Speedlite*.)

**Figure 5.3** *The Lighting Compass for Figures 5.4–5.8.*

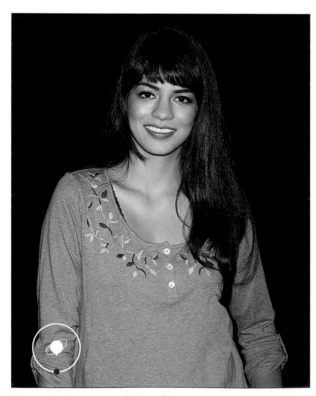

**Figure 5.4** *On-camera flash – 0°.*

## Things Get Brighter When The Light Comes At You

Then, as we move past 90°, there's an interesting phenomenon that occurs when the Speedlite's position moves from 90° to 180°—its apparent brightness increases.

Look at Figures 5.4 (0°), 5.5 (45°), and 5.6 (90°) again. The brightness of the light on the face is very similar—it's just the amount and direction of the shadows that have changed.

Now compare Figures 5.5 (45°) and 5.7 (135°). If your subject has a full head of hair, as Mallory does, then a Speedlite in the rear quadrant becomes a hair light. Notice how her hair in Figure 5.7 reflects more light than in any other shot. Yet, without fill light, neither Figure 5.7 or 5.8 are very useful.

If your subject has short hair or hair that is pulled back, then the light from a Speedlite in the rear quadrant will glance off the cheek and appear very bright to the camera. This is a distinctive look that, when balanced with an adequate fill light, can produce a dynamic image.

You'll have to remember that as you move your Speedlite around to the back half of the Lighting Compass a lower power setting might be necessary. In a way, this is easy to remember because a Speedlite that's pointing straight into the lens is as bright as it can get.

As for the usefulness of a Speedlite that's 180° from the lens, it depends largely on the altitude of the light and on the size of what's between it and the lens. It should suffice to say that if the subject is significantly larger than the flash, then the light will be totally obscured. However, if the Speedlite is raised above the subject, then some interesting light can happen—which we describe as a rim or hair light.

*Figure 5.5* *Speedlite at 45° to right.*

*Figure 5.6* *Speedlite at 90° to right.*

*Figure 5.7* *Speedlite at 135° to right.*

*Figure 5.8* *Speedlite at 180°.*

## ON-AXIS AND OFF-AXIS LIGHT

The combination of the Lighting Compass and the Lighting Inclinometer (discussed in a moment) will help us understand that it's not always a bad thing to have light coming straight from the camera.

### Defining On-Axis Flash

Any light that points at the subject from the same angle as the lens is an on-axis light. On the Lighting Compass, any light at 0° is, by definition, an on-axis light. So a Speedlite parked in your camera's hot shoe is an on-axis light.

However, the light source does not have to be attached to your camera to be an on-axis light. It could be a light above or below your camera. The light could be in front of or behind your camera. The defining factor is that the light points toward your subject from the same perspective as the lens.

Now don't get confused and think that any light that points at the subject is on-axis. Remember that the axis is the defined by the direction of the lens.

When viewed through the camera, on-axis light hits both sides (left and right) of the subject equally.

---

### Off-Axis Flash Is Easy

It's an easy step to understand that all other lights that don't point at the subject from the same direction as the lens are off-axis.

When viewed through the camera, off-axis light hits one side of the subject more than it hits the other. By doing so, an off-axis light casts a shadow across the subject.

Generally, it's much easier to make an interesting portrait with an off-axis light than it is with an on-axis light.

### Putting On-Axis Flash To Work

There can be good uses for on-axis flash, though. In fact, on-axis fill flash is a great idea because you eliminate the risk of cross-lighting your subject. Remember, it's easy to spot a cross-lit headshot because the nose casts two shadows. Definitely a no-no for skilled Speedliters.

Check out the photos opposite. Figure 5.9 is a single Speedlite on-axis and about 10″ above the camera. To soften the light a bit, I fired it through a Lastolite Ezybox Speed-Lite. The light is flat. The main difference between this shot and Figure 5.4 is that here the light is higher, so the jaw is defined by a shadow.

Figure 5.10 shows how dramatic the light can become when it's moved off-axis. In this shot, the Speedlite is swung around the Lighting Compass 45° to the right. Now there's a defined sense of shape, but the shadows are too deep on the left.

Figure 5.11 shows the addition of a second Speedlite at 45° left—fired through a Lumiquest Softbox III at the same height as the key light. Since the fill is 2 stops below the key, there are still shadows to help define shape.

Figure 5.12 shows the fill light moved back onto the camera's lens axis. Since it is 2 stops below the key in power, it fills the shadows without flattening the light like Figure 5.9.

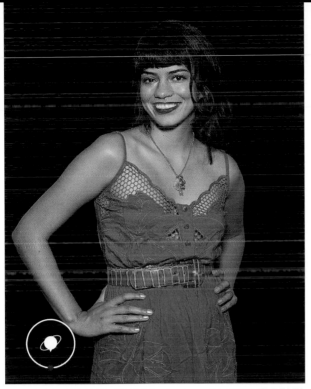

*Figure 5.9* On-axis flash, 10″ above the lens — key at 0°.

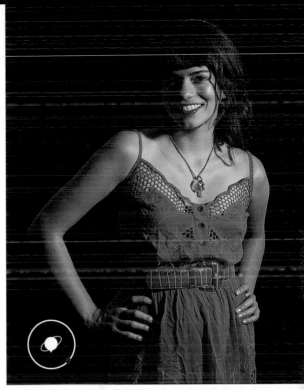

*Figure 5.10* Off-axis flash — key light at 45° right, no fill.

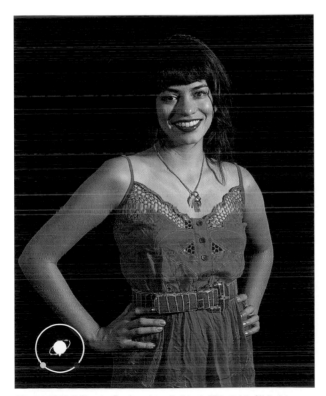

*Figure 5.11* Off-axis flash — key light at 45° right, fill light at 45° left.

*Figure 5.12* Off-axis and on-axis flash — key light at 45° right, fill light at 0°

## LIGHT FROM ABOVE...AND BELOW

In addition to thinking about the horizontal position of Speedlites, it's important to understand how the position of a Speedlite (or Speedlites) above or below the subject affects the size and angles of the highlights and shadows.

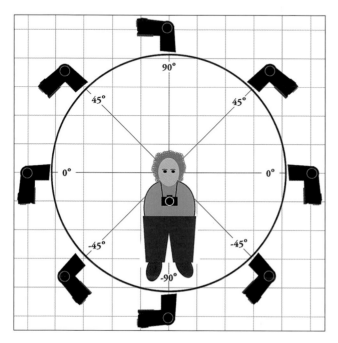

**Figure 5.13** *The Lighting Inclinometer shows the angle of the position of a Speedlite above or below the subject.*

## The Lighting Inclinometer

If you tipped the Lighting Compass from horizontal to vertical, you'd have my Lighting Inclinometer. Now we're thinking about the angle of the Speedlite above or below the subject. If you are photographing a person or group, consider the face(s) to be the horizon line.

A light that's level with the subject is at 0°. A light that is straight above the subject is at 90°. A light that is below the subject and aimed straight up is at –90°.

## Shadows Fall...Usually

You intuitively know that light comes from above most of the time. The sun arcs above us. The lamps in our homes are above us. So if all our principal light sources come from above, this also means that shadows usually fall. As a Speedliter, you will want to remember this subtle fact.

Sure, sunlight can skip off almost any flat surface, like a lake or a parking lot, and reflect up. But when it's doing this, the majority of the light is still coming from above and the reflected light is acting as a fill light.

Since we expect that light will generally come from above, we also expect that shadows will fall. As shown in Figures 5.14–5.16 opposite, there's a striking difference in the feel of shadows that fall and shadows that rise.

In Figure 5.14, I've positioned the Speedlite level with the model's head. In Figure 5.15, I've moved it to 45° above the model. In Figure 5.16, the Speedlite points up from 45° below the model...scary.

For comparison, I have included photos to the right that were made with a fill flash coming from 45° left on the Lighting Compass.

**Figure 5.14** *Left, key flash level with head – 0°. Right, same with fill light coming from 45° left on Lighting Compass.*

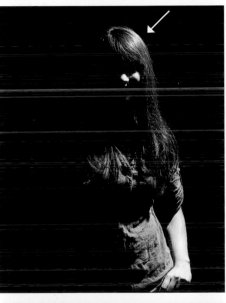
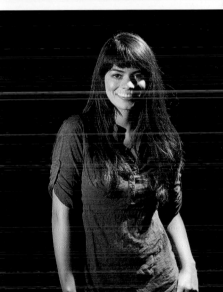

**Figure 5.15** *Left, key flash 45° above head. Right, same with fill light coming from 45° left on Lighting Compass.*

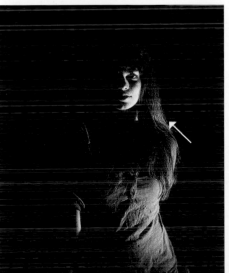
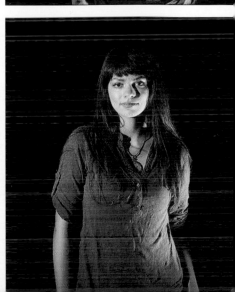

**Figure 5.16** *Left, key flash 45° below head. Right, same with fill light coming from 45° left on Lighting Compass.*

# PART 2 | SPEEDLITES FUNDAMENTALLY

## CHAPTER 6 | MEET THE SPEEDLITES

*Figure 6.1*
*Canon's current family of Speedlites includes (left to right) the 580EX II, the 270EX, and the 430EX II.*

### The Short Version

The current members of the Canon Speedlite family are the 580EX II, the 430EX II, and the 270EX. Other Speedlites still in wide use include the 580EX, the 430EX, and the 220EX. Occasionally, a 550EX will pop up in someone's camera bag.

Although not officially labeled "Speedlites," Canon currently offers two specialty flashes for macro photography: the Macro Ring Lite MR-14EX and the Macro Twin Lite MT-24EX. Both of these flashes can be used to command Speedlites in wireless mode.

## DISSECTING A BURST OF FLASH

At a basic level, a Speedlite is a device that makes precisely controlled explosions. The purpose of the explosion, of course, is to generate light and to broadcast that light—also in a precisely controlled way. So, Speedlites are about many different types of precise control.

### Batteries, Capacitors, And A Flashtube, Oh My

As for the explosions of light, three main components are working together inside a Speedlite:

- Batteries
- Capacitor
- Flashtube

Of course, we understand the purpose of batteries. They store electricity for an extended period and release it relatively slowly. All Canon Speedlites use two or four AA batteries. Several models also can have additional power supplied by an external battery pack.

The capacitor is an electronic circuit that also stores electricity. In a way, a capacitor is the opposite of a battery. A capacitor holds onto its charge only for a short while, and it releases that charge almost instantly.

The flashtube consists of a tungsten filament running through an atmosphere of xenon gas that is encased in a shatterproof glass tube. Xenon is one of the noble gasses. (Neon and argon are relatives.) When electricity passes through xenon, it glows brilliant blue.

## You Can't Make Blinding Any Brighter

When a Speedlite fires, the capacitor dumps a load of electrons that race through the filament. The filament glows red hot and excites the xenon gas. The xenon, in turn, creates a blinding flash of light.

Now here is an important fact about Speedlites:

> *The power setting on a Speedlite controls how long the flashtube fires, not how bright it burns.*

When the Speedlite's flashtube fires, it fires at the same blinding intensity. There is no way to make it brighter. It is the duration of the explosion that changes. The longer the burn, the more light that is produced by the Speedlite. As we'll see in Chapter 21, *Slicing Time With High-Speed Sync*, if we want to freeze super-fast action, we can use low-power bursts from our Speedlites.

---

### GEEK SPEAK

#### —Naming A Speedlite—

Canon's names for its Speedlite models reveal a lot of information. The 580-, 430-, and 270- are the metric Guide Number of the flash multiplied by ten.

EX denotes a Speedlite that works with Canon's proprietary E-TTL/E-TTL II system, which uses a pre-flash to calculate the proper amount of flash exposure.

EZ Speedlites determine flash exposure by measuring the amount of light reflecting off the film (yes, it's that old) via flash sensors built into the camera body. That's why EZ Speedlites are not compatible with DSLRs.

II tells us that this is the second-generation model of the 580EX.

**A quick look:** The 580EX II is the flagship flash for Speedliters. It is a high-powered unit that is loaded with features. If you want to move into wireless E-TTL flash, you can use a 580-series as the Master (the Speedlite that sends the commands out to the Slave Speedlites). This Speedlite also works reliably as a Slave unit (an off-camera Speedlite that receives instructions from a Master). I carry at least three in my bag at all times.

### The Flagship Of Canon Speedlites

1.  **Flashhead**—Contains the flashtube and the zoom mechanism that pushes it forward and backward. The 580EX II automatically senses the focal length of compatible EOS lenses and adjusts the position of the flashtube to match—from 24mm to 105mm.

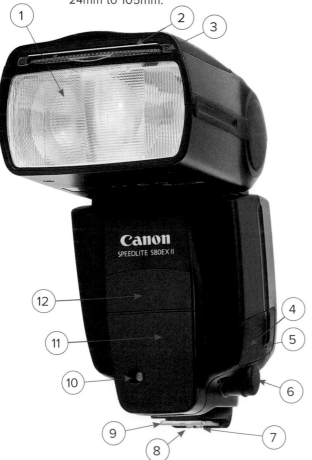

2.  **Catchlight panel**—A plastic card that pulls out with the wide-angle panel. When bouncing flash off a ceiling, the catchlight panel will throw a tiny amount of light forward, theoretically into the subject's eyes.

3.  **Wide-angle panel**—A plastic diffuser that pulls out. Spreads the flash to about the field of a 14mm lens.

4.  **External power socket**—A valuable tool for power Speedliters. The Canon Compact Battery Pack CP-E4 plugs in here.

5.  **Bracket fitting**—A threaded socket that, unfortunately, is not sized for the industry-standard ¼"-20 thread.

6.  **Screwlock PC terminal**—This was a great addition to the 580EX II design. It provides the ability to move your 580EX II off-camera with a direct sync cord connection to your camera or to fire it wirelessly with an optical slave (both in manual mode or the 580EX II's external automatic mode—see #10 below).

7.  **Contacts**—These five pins connect to the terminals on an EOS camera's hotshoe.

8.  **Locking pin**—The pin drops down into a receiver when the locking lever is moved. It is spring-loaded so that it will also work with generic hotshoes.

9.  **Mounting foot**—Upgraded from plastic to metal with the EX II design. A much-welcomed change.

10. **External metering sensor**—A feature that was added to the EX II that enables it to meter flash externally (meaning the light bouncing off the subject) rather than metering through-the-lens (TTL). This is essentially an old-school thyristor eye.

11. **AF-Assist beam emitter**—In low-light or low-contrast situations, the 580EX II can emit a red pattern on which the camera will try to focus. The approximate range is 2′ to 33′ at the center and 2′ to 16′ along the edges of the Speedlite's illumination area.

12. **Wireless sensor**—When the Speedlite is working as a Slave, this sensor receives signals from the Master.

13. **LCD panel**—This will seem a bit cluttered and confusing when you start out. Once you know how to read it, the LCD panel tells you everything you need to know about the current settings.

14. **Bounce angle**—The flashhead can be tilted upward to 90°. There are detents (notches) at 45°, 60°, 75°, and 90°. Between 0° and 45° the head can be positioned by hand, but not locked.

15. **Flashhead release button**—Pressing this button enables the flashhead to tilt –7° to 90° and to pan 180° right and left.

16. **Battery compartment**—The 580EX II holds four AA batteries: alkaline, nickel-metal hydride, or lithium.

17. **Zoom/wireless button**—Press this button quickly and the Zoom control menu is activated. Press and hold for 3 seconds to activate the Wireless control menu.

18. **High-speed sync/second-curtain sync button**—Press this button to activate the high-speed sync. Press it again to activate second-curtain sync. Press it once more to return to first-curtain sync.

19. **Power switch**—Simply On and Off. In the future, I hope that Canon adds Master-On and Slave-On settings to the switch.

20. **Locking lever**—Slide this lever to the right to lock the Speedlite into the hotshoe. Press the button and slide to the left to release. Much improved over the original 580EX.

21. **Weather sealing**—This was added to the EX II. When mounted onto cameras with compatible hotshoes (1D Mark III, 5D Mark II, 7D, etc.), it creates a seal that is resistant to rain and dust.

22. **Select dial**—Turn this dial to rotate through various menu options.

23. **Set button**—Press this button to select a menu option.

24. **Flash exposure confirmation lamp**—When shooting in E-TTL mode, this lamp glows green for 3 seconds if a good exposure has been obtained. If it does not glow after the flash fires, either the shot was underexposed or the batteries are too low for reliable E-TTL control. The lamp is inactive when shooting in Manual or Multi-Stroboscopic mode.

25. **Pilot lamp/button**—This button has four functions. It glows red when the flash is fully charged and ready to fire. It glows green when the flash is partially charged and capable of a Quick Flash. Press it to fire a test flash. If the Speedlite is working as a Wireless Master, pressing it will also test-fire Slaves by Group. (Don't worry; all the jargon about wireless Speedliting is explained in Chapter 11.)

26. **LCD panel light/custom function button**—A quick press turns on the LCD backlight. Press and hold for 3 seconds to activate the Custom Function menu (see Appendix 3 for complete details).

27. **Mode button**—Press the button to cycle through the three Speedlite shooting modes: E-TTL (Chapter 9), Manual (Chapter 8), and Multi-Stroboscopic (Chapter 25).

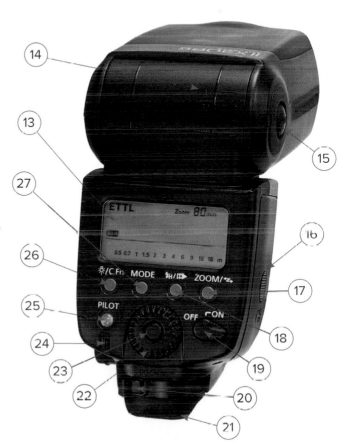

## SPEEDLITE 430EX II

**A quick look:** The 430EX II is a great Speedlite to use if you are just starting out. It is simple to operate but includes features that you'll appreciate as your skills grow. Although it cannot command other Speedlites as a Master, it can be configured as a Slave. So there's always a use for it as you expand your Speedlite kit. If you already have a 580EX or 580EX II, the 430EX II is handy if you need to add an additional Speedlite at an affordable price. At maximum power, it is about ⅔-stop dimmer than a 580EX II.

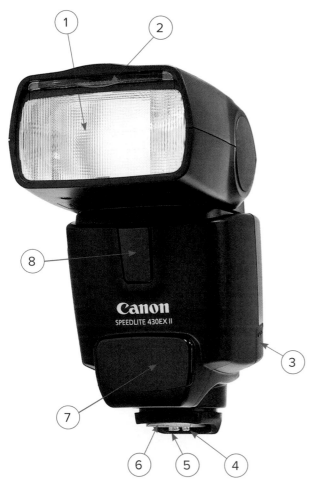

## A Great Starter Speedlite

1.  **Flashhead**—Contains the flashtube and zoom mechanism that pushes it forward and backward. The 430EX II automatically senses the focal length of compatible EOS lenses and adjusts the position of the flashtube to match—from 24mm to 105mm.

2.  **Wide-angle panel**—A plastic diffuser that pulls out. Spreads the flash to about the field of a 14mm lens.

3.  **Bracket fitting**—A threaded socket that, unfortunately, is not sized for the industry-standard ¼"-20 thread.

4.  **Contacts**—These five pins connect to the terminals of an EOS camera's hotshoe.

5.  **Locking pin**—The pin drops down into a receiver when the locking lever is moved. It is spring-loaded so that it will also work with generic hotshoes.

6.  **Mounting foot**—Upgraded from plastic to metal with the EX II design. A much-welcomed change.

7.  **AF-Assist beam emitter**—In low light, the 430EX II can emit a red pattern to create contrast that enables the camera to focus.

8.  **Wireless sensor**—When the Speedlite is working as a Slave, this sensor receives signals from the Master.

9.  **LCD panel**—This screen will seem a bit cluttered and confusing when you start out. Once you know how to read it, the LCD panel tells you everything you need to know about the current settings.

10. **Bounce angle**—The flashhead can be tilted upward to 90°. There are detents (notches) at 45°, 60°, 75°, and 90°. Between 0° and 45° the head can be positioned by hand but not locked.

11. **Flashhead release button**—Pressing this button enables the flashhead to tilt upward to 90° and to pan 90° right and 180° left.

12. **Battery compartment**—The 430EX II holds four AA batteries: alkaline, nickel-metal hydride, or lithium.

13. **Zoom/wireless button**—Press it quickly and the Zoom control menu is activated. Press and hold for 3 seconds to activate the wireless control menu.

14. **High-speed sync/second-curtain sync button**—Press this button to activate the high-speed sync. Press it again to activate second-curtain sync. Press it once more to return to first-curtain sync.

15. **Power switch**—Simply On and Off. In the future, I hope that Canon adds a Slave-On setting to this switch.

16. **Set button**—Press this button to select a menu option

17. **Select +/- buttons**—Use this to rotate through various menu options.

18. **Locking lever**—Slide this lever to the right to lock the Speedlite into the hotshoe. Press the button and slide to the left to release. Much improved over the original 430EX.

19. **Flash exposure confirmation lamp**—When shooting in E-TTL mode, this lamp glows green for 3 seconds if a good exposure has been obtained. If it does not glow after the flash fires, either the shot was underexposed (to correct, turn the ISO up or move closer) or the batteries are too low for reliable E-TTL control. The lamp is inactive when shooting in Manual or Multi-Stroboscopic mode.

20. **Pilot lamp/button**—This feature has three functions. The lamp glows red when the flash is fully charged and ready to fire. It glows green when the flash is partially charged and capable of a Quick Flash. Press the button to fire a test flash.

21. **LCD panel light/custom function button**—A quick press turns on the LCD backlight. Press and hold for 3 seconds to activate the Custom Function menu (see Appendix 3 for complete details).

22. **Mode button**—Press the button to cycle through the two Speedlite shooting modes: E-TTL (Chapter 9) and Manual (Chapter 8). Note: The 430EX II will fire in Multi-Stroboscopic mode, but only as a Slave (Chapter 25).

## —Deciding Between The 580EX II And 430EX II—

If you are starting out as a Speedliter, the 430EX II is a perfect flash for you. It offers both manual and E-TTL control. With the flexibility of an off-camera cord, you will be able to use your 430EX II to create many types of great light. While the 430EX II is happy to work as a slave, it cannot control other Speedlites as a master.

At nearly twice the price, the 580EX II provides: 2/3-stop more power, adds Multi (stroboscopic) mode, and can control off-camera slaves as a master flash. So, if you are looking to get into wireless Speedliting, you will need either a 580EX II, a 580EX, a 550EX, or an ST-E2 to use as the master. If you have the 7D, the pop-up flash will work as a master too.

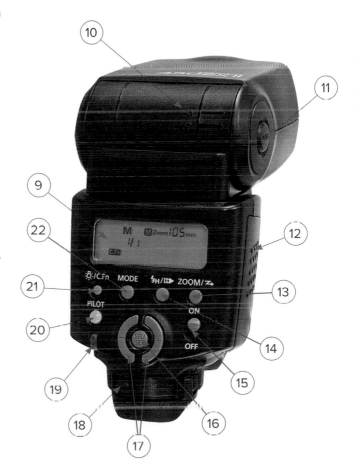

## SPEEDLITE 270EX

**A quick look:** This is a tiny flash that pairs well with the Canon pocket cameras, like the PowerShot G-series. It can also be a good starter flash for those looking to take a small step beyond the realm of pop-up flash. (However, if finances allow, I recommend taking a larger step and starting with the 430EX II as it has a better feature set.)

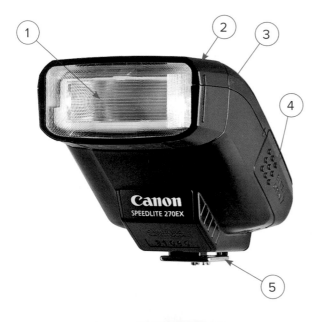

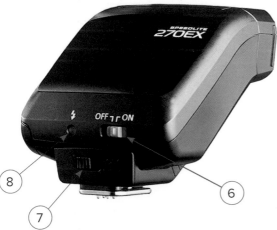

## A Compact Speedlite For Small Cameras And Spaces

1. **Flashhead**—The position of the flashtube in the 270EX is fixed. In the normal mode, the front diffuser spreads the light to about the coverage of a 28mm lens. The head can be pulled out to concentrate the flash to about that of a 50mm lens.

2. **Manual zoom**—The flashhead can be pulled out to zoom from 28mm to 50mm.

3. **Bounce angle**—The flashhead can be tilted upward by hand from 0° to 90°. It has detents at 60°, 75°, and 90°. Unlike the 580- and 430-series Speedlites, the 270EX does not pan to the right or left.

4. **Battery compartment**—The 270EX requires two AA batteries.

5. **Mounting foot**—Like the EX II Speedlites, the 270EX features a durable metal mounting foot.

6. **Power switch**—A simple Off/On slider switch.

7. **Locking lever**—Slide this lever to the right to lock the Speedlite into the hotshoe.

8. **Ready light**—Glows red when the flash is recharged and ready to fire. Unlike the 580- and 430-series, it does not double as a test-fire button.

**Features controlled via the camera's LCD**— Unlike the 580- and 430-series Speedlites, the 270EX does not have an LCD. Yet, there are several settings that can be controlled via your camera's LCD (if it is a 40D or newer model). These features are:

- Manual flash from full to 1/64 (7 stops)
- Sync Mode: 1st-curtain, 2nd-curtain, or high-speed
- AF-Assist: on or off
- Flash Exposure Compensation: amount determined by range of camera
- Quick Flash: on or off
- E-TTL Metering Mode: Evaluative or Average

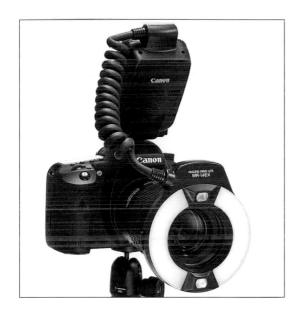

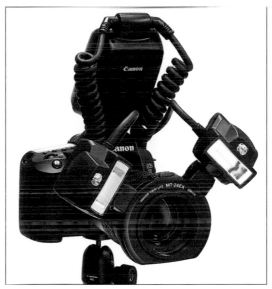

## MACRO RING LITE MR-14EX

Canon's Macro Ring Lite MR-14EX is a specialty flash that connects to the front of your macro lens with an appropriately sized adapter ring. The benefit of this position is that it throws nearly shadowless light onto macro subjects.

The MR-14EX consists of two flashtubes behind translucent ring diffusers. The ring spins, so you can adjust the position of the lights. You also have the ability to control the ratio of light from each side.

The MR-14EX is fully compatible with the Canon E-TTL II system. It can be used as a master but will not work as a slave.

## MACRO TWIN LITE MT-24EX

The Macro Twin Lite MT-24EX builds upon the front-of-lens concept behind the MR-14EX. The difference in design is that the MT-24EX has a pair of movable strobe heads rather than flashtubes contained in a ring diffuser.

The advantage is directionality. Each head can be rotated over an 80° range around the lens. The brackets enable the heads to be tilted in or out. Either or both can also be removed completely from the bracket and handheld or attached to special macro lighting brackets, such as the one shown below in Figure 6.2.

In terms of functionality, this unit has full ratio control and E-TTL II compatibility. It can be used as a Master to wirelessly control 580- and 430-series Speedlites. This can be helpful if you are trying to avoid the overly dark backgrounds of many macro shots. The MT-24EX will not work as a slave.

*Figure 6.2 (at left)* The MT-24EX can be used on special macro lighting rails, such as the B-Series flash bracket from Really Right Stuff (photo courtesy of Really Right Stuff, reallyrightstuff.com).

# SPEEDLITE TRANSMITTER ST-E2

**A quick look:** The Canon ST-E2 Speedlite Transmitter can be used instead of a 500-series Speedlite to control Slaves. The advantages are: (1) price (about $200 less than a new 580EX II), (2) lower profile (easier to see over than a 580EX II), and (3) easy ratio control for A/B groups. That said, you should read *Resist The ST-E2 Temptation* on page 79.

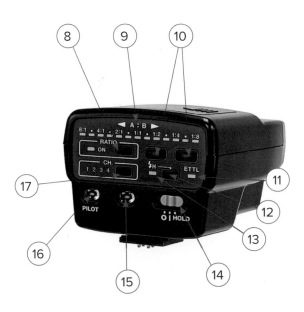

## A Low-Profile Transmitter For Wireless Speedlite Control

1. **Transmitter** — The ST-E2 emits an infrared pulse that is invisible to the human eye. The range is about 26' outdoors and 39' indoors. The spread of the beam is approximately 80° horizontally (40° from center) and 60° vertically (30° from center).

2. **AF-Assist beam emitter** — In low light, the ST-E2 emits a red pattern to create contrast that enables the camera to focus.

3. **Mounting foot** — This is a plastic fitting, so use extra care when attaching the ST-E2 to your camera.

4. **Locking pin** — The pin drops down into a receiver when the locking lever is moved.

5. **Contacts** — These five pins connect to the terminals of an EOS camera's hotshoe.

6. **Shoe lock slider** — Slide this forward to drop the locking pin down into the hotshoe receiver.

7. **Battery compartment** — The ST-E2 uses one lithium 2CR2 (6 volt) battery. It's best to keep an extra in your bag. You can find them when you don't need them, but when you do need them, it may be a different story.

8. **Ratio button** — If ratio is Off, all Slaves will fire at the same flash power lever. If ratio if On, all Slaves will be fired according to the ratio setting.

9. **Ratio indicator** — An LED indicates the ratio setting from 8:1 to 1:8, in half-stops.

10. **Ratio adjustment buttons** — Push these buttons to move the ratio in one direction or the other.

11. **E-TTL indicator** — This light glows when the ST-E2 is attached to an E-TTL-compatible camera, which includes all Canon DSLRs.

12. **High-speed sync button** — Push this button to activate or deactivate high-speed sync. The ST-E2 will control the Slaves accordingly.

13. **High-speed sync indicator** — Glows when high-speed sync (HSS) is activated.

14. **Power switch** — O turns the power off; I turns the power on. The Hold button locks the settings so that you cannot change them accidentally while shooting.

15. **Flash exposure confirmation lamp** — When you are shooting in E-TTL mode, this lamp glows green for 3 seconds if a good exposure has been obtained. The lamp is inactive when shooting in Manual or Multi-Stroboscopic mode.

16. **Pilot lamp/button** — The lamp glows red when the ST-E2 is fully charged and ready to fire. Press the button to fire a test flash, which will fire Slaves by Group (A then B). This lamp does not indicate that the Slaves are ready to fire.

17. **Channel select button** — Push this button to choose the operating channel: 1, 2, 3, or 4. All slaved Speedlites must be on the same channel. If a nearby photographer is shooting Canon Speedlites via wireless, you must be on different channels.

## Resist The ST-E2 Temptation

Many Speedliters are fond of using the ST-E2 Speedlite Transmitter instead of a master Speedlite. I am not among them. In fact, I discourage people from getting the ST-E2.

The thinking in favor of the ST-E2 is that it is about half the price of a 580-series Speedlite. I concur: about half the price and less than half the functionality.

My experience has shown that the range of the ST-E2 is shorter than a 580EX, both indoors and out. This is due to the fact that the flashtube on a 580EX is much stronger than the small tube inside the ST-E2. Further, the range of the ST-E2 flashtube is impeded by the thick red plastic panel that is there to block the visible portion of the flash. (If it was not blocked, it would add uncontrolled light to the exposure.)

In terms of flexibility, the ST-E2 literally has none. Unlike a 580EX, which can pan 360°, the ST-E2 will only control Speedlites that are within an 80° angle in front of the lens. In contrast, by panning the head on a 580EX, I can hit a slave that is to the side or behind me. The flexibility of the 580EX is a huge advantage when it comes to creative Speedliting.

A third limitation of the ST-E2 is that it can only control groups A and B. Given the extra steps

needed to run Group C, this is not a huge downside. On the positive side, the ST-E2 provides the A:B ratio control quite easily via a sliding lever. So, for novice Speedliters, this trade-off is fine.

A fourth limitation, and one that looms larger as I become more accustomed to controlling my Speedlites via the LCD screen on my camera, is that the ST-E2 (like the original 580EX) cannot be controlled by the camera LCD. When you are starting out, this shortcoming will not seem like an issue. As you become an advanced Speedliter, you will learn to appreciate the convenience of controlling your Speedlites via the camera LCD.

*Gear recommendation #1:* If economy is a concern, start with a 430EX and an extra-long E-TTL cord. Many people think that they need to spend $250 on an ST-E2 to get their one Speedlite off-camera. I say spend $65 on an E-TTL cord instead. Not only will you save a big chunk of dough, you'll be able to control the Speedlite via the camera LCD (assuming you have an EX II Speedlite and a compatible, late-2007 or newer camera).

*Gear recommendation #2:* While you are learning to master your first Speedlite, start saving for a 580EX II. Then, when you want to start shooting with multiple lights, you can buy a 580EX II and use it as an off-camera master (thanks to the extra-long E-TTL cord you bought earlier). Now you have a 580/430 combo for about the same price as two 430s and an ST-E2. I've no doubt that you'll find the versatility and power of the 580EX II + 430EX II + extra-long E-TTL cord to be far greater than a pair of off-camera 430s that have to remain in front of the lens.

So what if you already have an ST-E2? When you eventually outgrow it, there is always eBay.

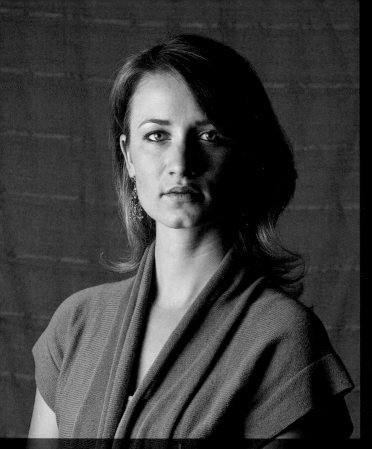
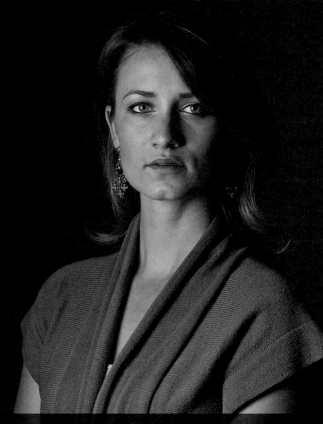

# CHAPTER 7 | **CONTROL YOUR SPEEDLITE**

## The Short Version

Creative Speedliting requires that you make many decisions. Among the choices that you will consider are how, when, and where your Speedlite fires.

The how is mode: Manual, E-TTL, or Multi/Stroboscopic. The when is sync: 1st-curtain, 2nd-curtain, high-speed, or slow-speed. The where is the spread (zoom) and direction (tilt/pan) of the flashhead.

This chapter introduces you to these control options. Many other chapters in the *Handbook* explore these features in detail.

**Figure 7.1**
*The distinctive difference between these two images is due to a simple pan of the Speedlite. In the left frame, the Speedlite was pointed directly at Sophia. In the right frame, it is was panned so that most of the light flew in front of her.*

## MODE—DECIDING HOW THE POWER LEVEL IS SET

The mode has to do with how the power level of the Speedlite is set. There are three main choices:

- Manual—you set the power yourself
- E-TTL—the camera sets the power
- Multi—you set the power and the number of flashes to be fired (500-series only)

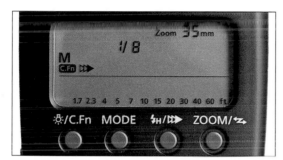

**Figure 7.2** *Manual mode. The Speedlite will fire at ⅛ power.*

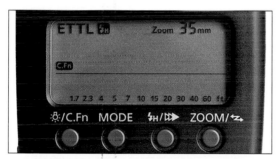

**Figure 7.3** *E-TTL mode. The camera will set the power level automatically.*

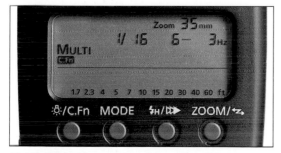

**Figure 7.4** *Multi mode. The Speedlite will fire at ¹⁄₁₆-power, 6 times, at 3 flashes per second.*

## Manual—Setting The Power Yourself

In Manual mode, you control the power level of the Speedlite. The range of power settings between full power and minimum power depends on your Speedlite.

> *The 580-series has: ¹⁄₁ (Full), ½, ¼, ⅛, ¹⁄₁₆, ¹⁄₃₂, ¹⁄₆₄, and ¹⁄₁₂₈.*

> *The 430- and 270-series have: ¹⁄₁ (Full), ½, ¼, ⅛, ¹⁄₁₆, ¹⁄₃₂, and ¹⁄₆₄.*

Keep in mind that the amount of flash you get from your Speedlite at full power depends on the model. The 580- is more powerful than the 430-, and the 430- is more powerful than the 270-.

Between the full-stop increments listed above, you will have either half-stop or third-stop increments. I prefer third-stop because they offer a finer degree of control. All current model Speedlites have the ability for third-stop settings. Depending on your camera model, you may only have the option of half-stop increments.

For the 580- and 430-series, you can set both the mode and power level on the Speedlite's LCD and on the LCD of cameras with compatible sensors.

For the 270EX, because there is no LCD, you must activate Manual mode and set the power via the camera's LCD (which is only possible on compatible cameras—see the list on page 87).

Chapter 8, *Flashing Manually*, covers the mechanics and use of Manual mode in detail.

---

### SPEEDLITER'S TIP

#### —Start Speedliting In Manual—

When first learning how to Speedlite, many assume that E-TTL is the best mode in which to work. After all, that's the option at the top of the list on the Speedlite's LCD. And any cheap flash can be operated in Manual—only Canon Speedlites have E-TTL. So E-TTL is the way to start, right? Wrong.

If you are just starting out with Speedlites, I suggest that you work in Manual mode until you grasp what's going on. There is less confusion. E-TTL appears simple until you want to figure out why you are not getting the light you want. Then it's complicated.

## E-TTL—Having The Camera Set The Power

E-TTL is Canon's proprietary system of automatic Speedlite control. In E-TTL mode, the camera, lens, and Speedlite(s) work together to determine the proper amount of flash.

The quick explanation of E-TTL is that the camera measures the light coming back from the subject as the Speedlite(s) send out a pre-flash; the camera then tells the Speedlite(s) what power setting to use during the actual exposure. All of this happens in a tiny fraction of a second immediately before the camera opens the shutter.

As you read earlier, the flash output in Manual remains the same from shot to shot. In E-TTL it can change with each shot. This can happen if:

- The subject changes within your frame— your first shot of a bride and groom was mostly of the bride in her white dress and the second shot is mostly of the groom in his black tux. The difference between the two is that the bride's dress reflects most of the light that hits it back into the camera. The groom's black tux is a well-styled black hole as far as the camera is concerned.

- The distance from the flash to the subject changes. If this surprises you, think about it this way—it is the distance between the subject and the light source that controls the apparent brightness of the source, not the distance between the subject and the camera. If someone shines a flashlight right into your face from a few feet away, it seems very bright. If you walk several steps away and then look, the flashlight does not seem as bright.

All Canon Speedlites with the EX designation in their model name can operate in E-TTL. This includes the 220EX, 270EX, 430EX, 430EX II, 550EX, 580EX, and 580EX II.

For the vast majority of my Speedlite work, I work in E-TTL. Chapter 9, *E Is For Evaluative*, covers the mechanics and use of E-TTL mode in detail.

## Multi—Flashing Again & Again & Again

The 500-series Speedlites (550EX, 580EX, and 580EX II) have an additional mode setting: Multi. This is a specialized setting that literally turns your Speedlite into the equivalent of a disco strobe. In Multi you can make one-frame time-lapse photos, such as shown in Figure 7.5.

**Figure 7.5** *Multi flash creates the stroboscopic effect of time lapse photography in a single frame.*

As for the details of the how and why, you can jump ahead to Chapter 25, *Strobo, Strobo, Strobo*. For now, the short version is that you specify the power level, the rate at which the Speedlite repeats (how many times per second), and the number of flashes.

The shutter speeds for stroboscopic images are relatively slow (because the Speedlite has to fire multiple times). For the best effects, your stroboscopic images should be shot against a dark background and without much ambient light.

## Changing From One Mode To Another

How you change the mode depends on your Speedlite and camera models. The 580- and 430- series have a dedicated Mode button on the Speedlite. On the 270EX, you can only change the mode via the camera's LCD—which requires a 40D or newer camera (see the list of compatible cameras on page 87).

## SYNC—DECIDING WHEN TO FIRE THE FLASH

Sync refers to how your camera synchronizes the firing of the flash with the opening and closing of the shutter. The type of sync you use gives you a variety of creative options. There are four types of sync:

- 1st-curtain
- 2nd-curtain
- High-speed
- Slow-speed

### Sync Begins With A Pair Of Curtains

In a DSLR, your camera has two metal curtains that work together as the shutter mechanism. The curtains essentially are an assembly of hinged metal blades that keep your sensor in the dark until just the right moment.

When you press the shutter button, the second curtain flies open, then the first curtain flies open—exposing the sensor to the light coming through the lens. At the right moment, the second curtain closes—ending the exposure. The difference between the timing of the opening of the first curtain and the closing of the second curtain is the shutter speed.

At many shutter speeds there is a moment where the first curtain is completely open before the second curtain begins to close. If your flash fires during any of these shutter speeds, then the sensor will be illuminated completely.

> The "sync speed" for a DSLR is the fastest shutter speed at which the first curtain is completely open before the second curtain closes.

At faster shutter speeds, the second curtain begins to close before the first curtain is completely open. Essentially the shutter becomes a slit moving across the sensor. So, if you could fire your Speedlite at any of these shutter speeds, there would be a dark bar in the photo because a portion of the sensor is covered by either the first or second curtain. High-speed sync, discussed in Chapter 21, gets around this shutter speed limitation.

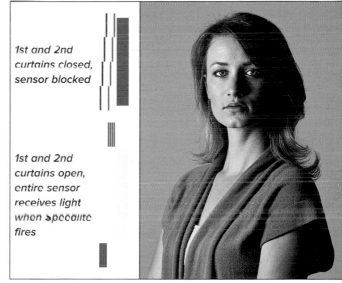

**Figure 7.6** *The sync speed for a camera is the fastest shutter speed where the first curtain has completely cleared the sensor before the second curtain begins to close. On most Canon cameras, the sync speed is 1/250". As shown above, if the shutter is set to the sync speed (or a slower speed), then the Speedlite will illuminate the entire sensor.*

1st and 2nd curtains closed, sensor blocked

1st and 2nd curtains open, entire sensor receives light when Speedlite fires

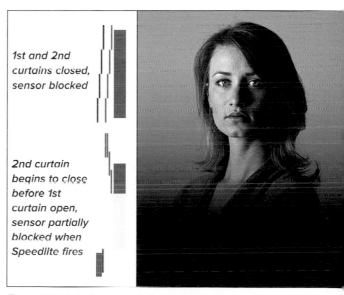

**Figure 7.7** *At shutter speeds faster than a camera's sync speed, the second curtain begins to close before the first curtain is completely open—effectively creating a slit that travels across the sensor. As shown above, if the shutter speed is faster than the sync speed and the Speedlite fires, then a portion of the frame will be dark.*

1st and 2nd curtains closed, sensor blocked

2nd curtain begins to close before 1st curtain open, sensor partially blocked when Speedlite fires

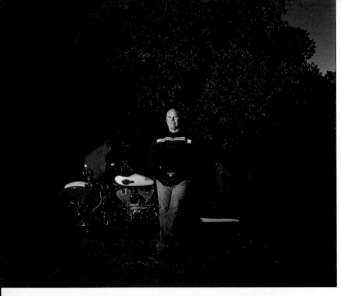

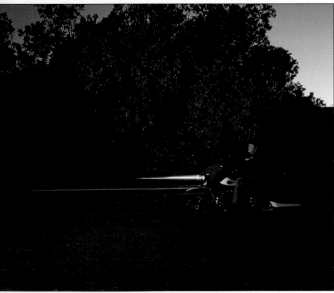

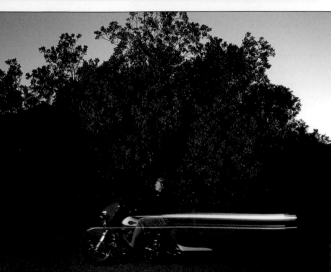

## 1st-Curtain: The "Default" Sync

The key to understanding sync is to know that the duration of the flash is much faster than your shutter speed (unless you are in High-Speed Sync, which we'll talk about soon).

If you flip back to page 53 in Chapter 4, *Light Of The World,* you will see that at any power level, the duration of the flash is much faster than the sync speed. So, the timing of that flash within the wider window of the shutter speed gets down to creative choices.

The normal (default) setting for flash sync is 1st-curtain sync. This means that the flash fires immediately after the first curtain is completely open. For most situations, 1st-curtain sync is fine.

However, if you are shooting a moving object at a slow shutter speed, you might want to use 2nd-curtain sync.

## 2nd-Curtain: The "Motion" Sync

If 1st-curtain sync fires the flash just after the 1st-curtain opens, then when does 2nd-curtain sync fire the flash? Hopefully you did not think, "Right after the 2nd-curtain opens." The correct answer is that 2nd-curtain sync fires the Speedlite the moment before the second curtain begins to close.

So what's the big difference between 1st- and 2nd-curtain sync? It primarily has to do with the shutter speed and whether the subject or other elements in the frame are moving.

If there is nothing moving in the frame, then the difference between 1st- and 2nd-curtain sync is negligible. For instance, in Figure 7.8, it would not have mattered if the Speedlite fired

*Figure 7.8 If your subject is stationary, then it does not matter if your Speedlite fires in 1st- or 2nd-curtain sync. For comparison, all three of these shots were done at ½" with the camera locked on a tripod.*

*Figure 7.9 The tell-tale sign of 1st-curtain sync on a moving object is the light trails in front.*

*Figure 7.10 Thanks to 2nd-curtain sync, the trailing lights make more sense visually.*

at the end of the ½" exposure (2nd-curtain sync) rather than at the beginning (1st-curtain sync). My friend Matt was not moving.

Now take a look at Figure 7.9 where I caught Matt driving by in 1st-curtain sync. The streaks of light in front of the motorcycle are the headlights. Matt and the motorcycle were frozen by the Speedlite. Then the headlights continued to burn in as he moved by the camera—which I had locked down on a tripod. Visually the lights preceding the vehicle do not make sense.

For Figure 7.10 I switched my Speedlite into 2nd-curtain sync. The streak of the headlights shows how far the motorcycle moved during the ½" exposure. By firing the Speedlite in 2nd-curtain sync, Matt and his Harley are recorded when the flash fires just before the 2nd-curtain snaps shut. With the lights trailing behind, the sense of motion is communicated.

### Activating 2nd-Curtain Sync

On 580- and 430 series Speedlites, you can go in and out of 2nd-curtain sync with the push of a button. The third button from the left, the one with the trio of triangles, activates 2nd-curtain sync. Press it once and you have activated high-speed sync. Press it again and you are in 2nd-curtain sync. Press it once more and you've returned to 1st-curtain sync.

Additionally, if you have a compatible camera (40D or newer) and an EX II Speedlite, you can activate 2nd-curtain sync via the camera's LCD.

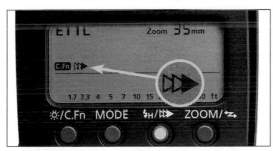

*Figure 7.11* *You can activate 2nd-curtain sync quickly via the third button from the left on the Speedlite. Press it repeatedly until you see the three-triangles icon. See the sidebar at right for more details.*

**GEEK SPEAK**

**—2nd-Curtain Sync At Fast Shutter Speeds—**

You may have noticed on your Speedlite that 2nd-curtain sync is on the same button as high-speed sync. I think this is no coincidence. There is no such thing as 2nd-curtain sync at fast shutter speeds. If fact, the Canon system defaults to firing in 1st-curtain sync at all shutter speeds faster than ⅟₃₀".

If the ambient light is dim, I often keep my Speedlite set to 2nd-curtain sync just in case I shoot a subject in motion. Visually it just makes sense to have the motion blur happen behind a moving subject. There's no downside to keeping 2nd-curtain on—if I shoot at a faster shutter speed, the camera fires the Speedlite at the optimal time In 1st-curtain. Then, when I slow the shutter again, I'm back in 2nd-curtain sync automatically.

That said, if I head the other direction and activate high-speed sync so that I can shoot at a very fast shutter speed, then 2nd-curtain is turned off completely. A single press of the button that activated HSS gets me back into 2nd-curtain sync.

**SPEEDLITER'S TIP**

**—Off-Camera 2nd-Curtain Sync—**

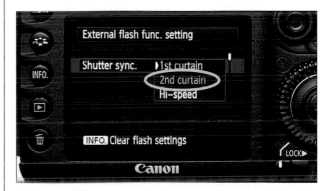

Foremost of the mysteries about the Canon Speedlite system is why 2nd-curtain sync is not available when the wireless system is activated. I have no explanation for this limitation. Nikon offers it on their system. For Canonistas, PocketWizard facilitates wireless 2nd-curtain sync through their Mini/Flex and MultiMAX radio triggers. Yet, on the screen above, 2nd-curtain is not available in wireless mode.

My solution, which I employed for the shots on page 84, is to move my Speedlite off-camera via an extra-long E-TTL cord. Effectively the camera still thinks that the Speedlite is in the hotshoe, so 2nd-curtain sync remains an option.

## High-Speed Sync

High-Speed Sync (HSS) enables you to shoot at any shutter speed you want. It does this by changing the way your Speedlite fires. Rather than producing one big burst of flash, your Speedlite becomes an ultra-fast strobe light for a small fraction of a second.

> *The ability to shoot at any shutter speed in HSS is a Speedlite-only mode that cannot be duplicated by other types of flash. Go Speedliters!*

In HSS, the pulses of light are so close together (in the range of 30,000 Hz) that it appears to us that the Speedlite is still sending out one burst rather than several thousand (literally) mini-bursts.

The downside to HSS is that in order to recycle the electronics so rapidly, the power of the flash must be turned down greatly. My tests have determined that the power hit when switching the Speedlite into HSS is a loss of 2.5 stops of light.

HSS is critical to my work as a Speedliter. The cover photo of this book was shot in HSS. Chapters 21 and 23 go deep into the how-to and when-to of High-Speed Sync.

### SPEEDLITER'S TIP

### —Push The HSS Button—

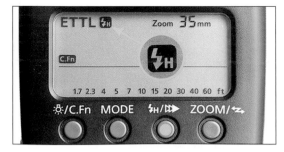

Unless I specifically want to use 2nd-curtain sync because I'm shooting in low light, I keep High-Speed Sync active on my Speedlites at all times. Why? So I do not have to think about setting it during a shoot. When my shutter speed is faster than the sync speed for my camera, the Speedlite fires in HSS. When the shutter speed is slower than the sync speed, it fires in normal mode.

## Slow-Speed Sync / Dragging The Shutter

Slow Sync is really a misnomer. It does not affect the timing of the flash during the exposure. Rather, it controls how long the shutter will stay open to capture the ambient light of dimly lit environments.

Night scenes can be problematic. If the camera is programmed to limit the shutter speed with flash to a speed that can be handheld without shaking, typically 1/60", then the background may appear very dark and the flash will be obvious. You can see this effect in Figure 7.12.

The solution is to *drag the shutter*, which means to use a slow shutter speed so that the camera can collect an adequate amount of the ambient light from the background.

*Figure 7.12 The background in this night shot is dark because the camera was programmed to fire at a maximum shutter speed of 1/60".*

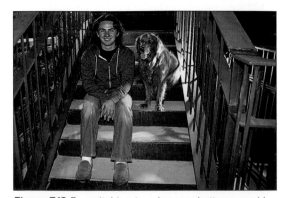

*Figure 7.13 By switching to a longer shutter speed I was able to collect the ambient light from the background. Yes, I used a tripod for this 1/4" shot.*

If your camera (not the Speedlite!) is operating in Manual exposure mode, you can select a shutter speed that is long enough to bring in the amount of ambient light from the background.

If your camera is operating in Aperture Priority (Av) mode, it may or may not slow the shutter speed to a point where it will collect enough ambient. This depends on the settings in your camera for Slow Sync/Slow Synchro.

Whether Slow Sync is on or off—and where you set it—is completely dependent on your camera model. On my PowerShot G10, the camera gives me the option of "Slow Synchro: On/Off" under the Flash Control menu.

On my 5D Mark II, Slow Sync is not labeled as such. Under Custom Function I, I found Exposure, Flash Sync. Speed in Av mode. The options are:

- Auto (meaning that Slow Sync is on and the shutter speed will be as long as the camera thinks is necessary to fill the background with ambient)
- $\frac{1}{200}"$–$\frac{1}{60}"$ Auto (meaning that the shutter speed will be within this range)
- $\frac{1}{200}"$ Fixed (meaning that the shutter speed for all flash shots will be $\frac{1}{200}"$)

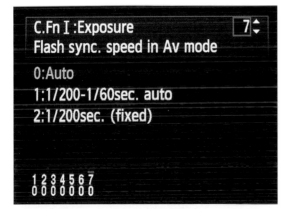

*Figure 7.14 The Custom Function menu on a 5D Mark II provides three options for setting the sync speed when in Aperture Priority (Av) mode. I prefer to leave mine at Option 0 so that my Speedlite will fire at slow shutter speeds. Check your user manual to see what options are available on your camera.*

## —Use the Camera's LCD Monitor Instead—

If you have a **580EX II**, **430EX II**, or **270EX** and a compatible camera, you can use your camera's LCD monitor to control virtually every function of the Speedlite. This is a unique aspect of the Canon system—meaning that other camera brands do not offer this full range of on-camera control.

When shooting wireless, you will find that the control options are much easier to understand on the camera's LCD than on the Speedlite's LCD. Further, this on-camera control enables you to put a Speedlite inside of a softbox and control it from your camera via an extra-long E-TTL cord. If you have multiple Speedlites, you can control the master from your camera's LCD via the E-TTL cord and have it control the other Speedlites inside the softbox as slaves.

There are two small shortcomings to the system. First, the menu location and structure is different on virtually every camera. Second, the system returns to the top of the menu hierarchy rather than to the last menu screen you visited. So you'll have to run back through the sub-menus to return to the last control you used. Still, once you get the hang of the menu system, you can go in and out with ease.

Here's a list of Canon cameras that have this capability:

- EOS-1D Mark IV
- EOS-1D, 1Ds Mark III
- EOS 5D Mark II
- EOS 7D
- EOS 60D, 50D, 40D
- EOS Rebel T2i, T1i, XSi, XS
- PowerShot G12, G11, G10, G9
- PowerShot SX 1 IS, SX 10 IS, SX 20 IS

## ZOOM—DECIDING WHERE TO FIRE, PART 1

The engineers have one idea about why the flashtube in a Speedlite should zoom. I have entirely another. Their view is that the coverage of the Speedlite should match the view of the lens as much as possible. My view is that the Zoom is actually a built-in light modifier that can be used for creative purposes. We're both right, of course. I'll let the engineers go first.

### Automatic Zoom

When paired with a compatible EOS lens, the 580- and 430-series Speedlites will move the flashtube backward or forward so that the spread of the light matches the viewing angle of the lens as closely as possible. The usable range is 24mm to 105mm on a full-frame DSLR. If you are shooting on an APS-C camera, the usable range is 15mm to 65mm.

You will know that the lens and Speedlite are talking through the camera when you see the ▦ symbol on the Speedlite LCD.

If you are shooting with a zoom lens, Auto Zoom will automatically move the flashhead as you adjust the focal length. If you are shooting with a prime (fixed focal-length) lens, the flashhead will zoom to the proper position for that lens.

---

### SPEEDLITER'S TIP

#### —Light Loss Through Zoom—

One of the effects of zooming a Speedlite is that it appears to get brighter as you zoom to a longer focal length. For instance, in the photos opposite, 24mm (Figure 7.16) seems less bright than 105mm (Figure 7.18).

What's really happening is that the same amount of light is being spread over a greater area at 24mm than at 105mm. This has the effect of making the center look less bright at wider angles.

---

### Manual Zoom

I am very fond of using the Zoom button on the right side of the 580EX- and 430EX- Speedlites as a built-in light modifier. Rather than allow my Speedlite to zoom to match the lens, I want to control the spread of light manually.

Limiting the Speedlite to just a portion of the image enables me to control where the viewer's eye settles. Generally, the spot on which the viewer concentrates is the brightest part of the photograph.

There are seven positions for Manual Zoom: 24mm, 28mm, 35mm, 50mm, 70mm, 80mm, and 105mm. Frankly, there's not much difference between 24mm and 28mm, 35mm and 50mm, or 70mm and 80mm. So, I think of the Speedlite as having four zones for zoom.

In the photos opposite, I've photographed the first of each of these close pairs. The column at left shows the flash from a side perspective. The column at right shows the flash from the perspective of the camera.

### Pull-Out Diffuser

Tucked above the flashtube on the 580-, 550- and 430-series Speedlites, you will find the pull-out, wide-angle panel. Let me go on record to say that I'm not a fan of this prismatic panel.

If you pull it out and then do not slide it back in 100% of the way, meaning that 99.99% is not far enough, then the sensor will not allow the Speedlite to operate normally. The diffuser panel will look like it's parked in its garage properly. But the Speedlite won't see it that way. So, if your Speedlite becomes non-functional, try pulling the panel out and pushing it back in firmly.

The other reason that I don't like the wide-angle panel is that I never have the need to throw light everywhere. Instead, I'm almost always shooting with my Speedlite at 105mm to concentrate it. Take away the wide-angle panel and give me more zoom (like 150mm and 200mm) and I'd be a happier Speedliter.

## Various Zooms—Sideview

## Various Zooms—Camera View

*Figure 7.15* 580EX II with wide-angle panel pulled out.

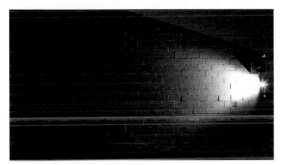

*Figure 7.16* 580EX II zoomed to 24mm.

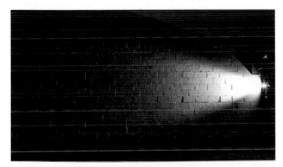

*Figure 7.17* 580EX II zoomed to 50mm.

*Figure 7.18* 580EX II zoomed to 105mm.

## PAN AND TILT—DECIDING WHERE TO FIRE, PART 2

There are many reasons to pan and/or tilt the head of your Speedlite. The most important is that you can make the Speedlite seem much bigger and greatly soften the shadows, especially if you bounce the light off a ceiling or wall. Another reason is that doing so can improve the communication between a Master and Slave when shooting wireless E-TTL.

### The Range Of Pan And Tilt

How far the head of your Speedlite can pan (rotate sideways) or tilt (angle up or down) depends on the model you have.

The 580-series can pan 180° to the right or left (but it cannot be spun in a full circle). The 430-series can pan 90° to the right and 180° to the left.

When it comes to up and down, the 580-series can tilt from −7° to 90°. The 430-series can tilt up to 90°. The ability of the 580-series to tilt down may be helpful when photographing objects that are close to the lens.

*Figure 7.19* The flashhead of the 500- and 400-series Speedlites can be tilted and panned to send the light in the exact direction you need it to fly.

### Basics Of Bounce

As we discussed in Chapter 3, *Mechanics Of Light,* light has the predictable habit of bouncing off a surface at the same angle from which it approached. This is good news for Speedliters who need to soften the look of flash in their photographs.

Bouncing your Speedlite off a ceiling, wall, shirt, reflector, paper—virtually any light-colored surface or material—will increase the apparent size of the light source and soften the shadows.

As a general rule, you will want to point the head of the Speedlite at a spot on the ceiling/wall that is about halfway between you and your subject. If your back is close to a wall, you can point the Speedlite behind you to hit the spot where the ceiling and wall meet. The same is true for corners.

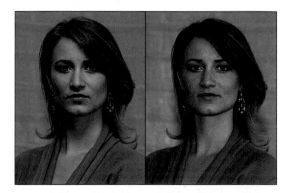

*Figure 7.20* The headshot at left was lit with a Speedlite bounced off an office ceiling. It suffers from a lack of light in the eyes. For the shot at right, I corrected this by holding my left hand behind the Speedlite to bounce a bit of the light forward. As you can see, the eyes are brighter and the skin tones are warmer.

If your subjects are close to you and the Speedlite is pointed upward at a steep angle, you will likely create deep shadows in their eye sockets and under their chins. One solution is to bounce off a wall rather than a ceiling. If the wall is too far away and you must go off the ceiling, then place your hand behind the Speedlite to throw just a bit of light forward. I find this to be a better and faster solution than pulling out the little catchlight panel.

## Flying The Light Over Or Around

There will be times when your subject is adequately lit but the background needs help. One option is to bounce your Speedlite over the top of or around your subject to throw light onto the background.

When doing this, watch out for any spill of light hitting your subject. Many times it is not a problem. If it is, use your hand or a card next to the Speedlite to keep the light from hitting your subject (a.k.a. flagging the Speedlite).

## Beyond Bounce—Feathering

Any time that you angle the light away from your subject you are "feathering the light." Another valuable use of the pan and tilt is to feather the edge of the light from your flash.

As you saw in the Zoom examples on page 89, the edge of the Speedlite has a graduated rather than a sharp edge between dark and light. You can use this to your advantage by placing that edge on your subject.

Sure, there are light modifiers that can do the same thing. But, if you're on the run and all you have is your Speedlite, it's nice to know that you can use just the edge of the light with good results.

**Figure 7.21** *The difference between these two shots is that for the shot on the left, the Speedlite was pointed directly at Sophia, and for the shot on the right, the Speedlite was feathered so that most of the light flew in front of her. Essentially, I feathered the flash so that the Speedlite would light Sophia, but not the background.*

## Pan And Tilt When Shooting Wireless

When you are shooting Canon E-TTL wireless flash, it is critical to maintain a line-of-sight connection between the master and slave(s). Since I generally do not use on-camera fill when shooting off-camera flash, I will often pan the head of my master Speedlite so that it is pointing directly at the slave. If there are multiple slaves, I will try to pan the head (and maybe tilt a bit, too) so that I optimize their view of the master Speedlite's commands.

You can also pan and/or tilt the slave Speedlites so that their wireless sensor (on the front of the flash) is pointing at the master while the flashhead points at the subject.

**Figure 7.22** *When shooting wireless, if my master Speedlite is not firing during the actual exposure, I will pan it towards the slave(s). See Chapter 11, Wireless Speedliting, for all the details.*

**Figure 7.23** *To assure that the slave can see the master, I always pan the body of my slave so that the sensor (located on the front of the Speedlite) faces the master.*

# CHAPTER 8 | FLASHING MANUALLY

## The Short Version

If you're wondering, "Does 'manual flash' mean that I have to follow the instructions in the manual?" let me be the first to say, "Welcome to Earth." If manuals were so handy, I'd be out of a job right now, wouldn't I?

Manual flash is the basic mode of operation where the power level (a.k.a. output) of the flash is set by the photographer. Canon Speedlites can operate in Manual, E-TTL (Canon's proprietary automatic mode), or Multi mode. Larger strobes, like monolights and studio strobes, are always operated as manual units.

*Figure 8.1*
*Manual flash is well-suited for any situation that requires repeatability. In the domino shot above, the precise shadows required that I adjust the power level manually.*

## MANUAL FLASH—A WAY TO GET STARTED

If you're just learning how to Speedlite, I suggest that you start with your flash in Manual mode. Manual is the simplest mode of flash. You set the power level on your Speedlite. The camera fires it at the right moment.

Sure, I'm a huge fan of E-TTL. I use E-TTL far more often than I use Manual. That's largely because I shoot in situations where E-TTL is better suited. The challenge with a bad exposure in E-TTL, though, is that it can be difficult to know what happened because the camera is making virtually all the decisions.

Manual simplifies the workflow. Many great photographers master manual flash and never feel the need for E-TTL. Hopefully, you will become proficient at both and move from one to the other with ease.

### To Start, Just Play With Manual

Manual flash may seem intimidating because you, the photographer, have to set the power. How do you know if you should be at 1/1, 1/16, or 1/64 power?

My suggestion—seriously—is to just take a guess on a power level and fire. Make a mistake. In fact, make a load of mistakes regularly.

*You will learn faster if you are not afraid of making mistakes.*

The nice thing about manual flash is that if there is too much flash, you will know what to do about it—turn the power down and take another test shot. If your exposure is close, turn it down a little. If your frame looks like it was made during an atomic blast, then turn the power down a bunch.

As a matter of practice, any time you have to make a change to your Speedlite's power level, I encourage you to start with big steps rather than small steps. I find it easier to go too far and jump back rather than to try to creep to my solution in baby steps. Actually, you won't know that you've gone too far until you see

### SPEEDLITER'S TIP

#### —If Your Speedlite Won't Go Into Manual—

If your Speedlite won't switch into Manual mode, check to make sure that your camera is not in Full Auto ("green box") mode. If it is, switch your camera into M, Av, Tv, or P. You'll then be able to switch your Speedlite into Manual mode.

that you have. So, I say, get to the other side quickly and then work your way back.

Once you understand where too much and too little is, then you know that the optimal power setting is somewhere in between. If you are way overexposed, reduce the Speedlite power by three or four stops (1/1 > 1/2 > 1/4 > 1/8 > 1/16 = four-stop reduction). Now, if the flash is much too dim, go back halfway toward your first power setting.

I like the idea of making each jump back half the size of the previous jump (4 stops > 2 stops > 1 stop > half-stop). Each time you jump, you're taking smaller steps and getting closer.

As for deciding the power level: what's right? It's not what some flash meter says. It's not what shape the histogram has. "Right" is getting the light to look like you want it to. You are the photographer. You get to decide.

Of course, you're thinking, "That's it? There has to be more to Manual." And you are right.

### SPEEDLITER'S JARGON

#### —Power Levels—

The *power level* refers to the amount of flash emitted by the Speedlite when it is manual mode.

The 580-series has whole-stop power levels at: 1/1, 1/2, 1/4, 1/8, 1/16, 1/32, 1/64, and 1/128. The 430- and 270-series have: 1/1, 1/2, 1/4, 1/8, 1/16, 1/32, and 1/64. Remember to think of the difference between one power level and the next as one stop of light.

Also, there are intermediate power levels at 1/2- or 1/3-stop increments. Whether it is 1/2- or 1/3-stop depends on the camera and the custom settings.

## WHEN TO USE MANUAL FLASH

When deciding between Manual and E-TTL, I think about the situation in which I'm shooting. Both have their strengths and challenges.

In broad strokes, if the relationship of the subject to the Speedlite(s) is fixed (like when I shoot food or products), then I will work in Manual. If the distance to or position of the subject is dynamic (like when I'm shooting an event), then I will work in E-TTL.

### Manual vs. E-TTL

In case you haven't peeked ahead, the entire next chapter is devoted to E-TTL. While I don't want to get too far into E-TTL here, it's important that you have an understanding of how Manual differs from E-TTL. Figure 8.2 at right provides a quick summary of the differences.

### The Best Way To Learn The Basics

As I stated earlier, I think Manual mode is the best way to learn the basics of flash photography. You make a decision, you take the action, you see the results. When it does not work the way you expected, you repeat the process and learn a bit more. Again, I do most of my Speedlite work in E-TTL, but Manual is the best place to start.

### When The Distance From Subject To Flash Is Fixed

If you are shooting in a controlled situation, where the distance between the subject and the flash is fixed, then Manual mode is great.

I use Manual for tabletop work (food, still-life, and product). This type of work requires precision and repeatability. Manual gives me the ability to fix the power level so that it does not vary from shot to shot. This is very helpful when you are doing repetitious product photography.

| | Manual | E-TTL |
|---|---|---|
| **Power set by** | Photographer | Camera |
| **Criteria for determining power level** | Many options<br><br>• test shots<br>• histogram<br>• flash meter | Automatic<br><br>1. Speedlite pre-flashes at 1/32 power<br><br>2. Camera takes exposure reading<br><br>3. Camera sends power setting to Speedlite<br><br>4. Camera fires Speedlite |
| **Consistency** | Same from frame to frame, until power level is changed by photographer | Can vary from frame to frame, especially if composition changes or distance between Speedlite and subject changes |
| **Best For** | • Learning Basics of flash<br><br>• Situations where distance between subject and flash does not change.<br><br>• Situations where subject will pass through preset zone<br><br>• Maximizing flash output | • Dynamic shooting situations where relationship of subject to Speedlites(s) changes<br><br>• When the photographer wants quick way to control Speedlites remotely from camera<br><br>• Minimizing flash output |

*Figure 8.2* *A comparison of Manual to E-TTL*

## When The Subject Will Pass Through A Preset Zone

Manual is also perfect for situations when a moving subject will pass through a preset zone. For instance, at a wedding, you know that the bride and groom will come down the aisle after the ceremony, so you can preset your lights in Manual mode before the ceremony starts. The dramatic contrast of the bride's white gown and the groom's dark suit is better handled in Manual than E-TTL.

Any sport with a net can be another situation where you will know that the subject is going to pass through a preset zone. The net in a basketball game provides the opportunity to preset your flash and adjust the power before the game starts. For instance, climb a ladder at home or climb on the roof and shoot junior practicing his slam dunks. (Just be careful when you do...it's not the fall that breaks gear; it's the sudden stop at the end.)

Sports that involve jumping are also good situations for Manual flash. Motocross and BMX racing always have track obstacles that will send the rider into the air. Hurdlers and high jumpers at a track meet provide the opportunity to know where a fast-moving subject is likely to pass. Of course, for safety reasons, it is essential that the event organizer and participants have pre-approved your flash work.

## Maximizing Your Speedlite's Power

Another consideration in deciding between Manual and E-TTL comes up when you need to get either the absolute maximum or minimum power from your Speedlite.

When you need to squeeze every bit of power from your Speedlite, switch it to Manual mode. In E-TTL, the Speedlite uses a bit of its power for the pre-flash. By switching to Manual, you eliminate the pre-flash and send all the juice straight out in one big burst.

Conversely, if you are shooting in Manual at the lowest power setting and still have too much light, switch over to E-TTL. The pre-flash will suck up a bit of power and thereby reduce the intensity of the flash. The change will be small, but it might be just enough.

## Triggering Off-Camera Flash With Optical Slaves

We'll jump into the use of optical slaves in Chapter 10, *Move Your Speedlite Off-Camera*. For now, just know that an optical slave is a device that can trigger your Speedlite when it sees a quick burst of light.

There are very affordable optical slaves designed to work specifically with Canon Speedlites. When using them, you have to shoot in Manual mode. These simple devices will be tricked by the E-TTL pre-flash and prematurely fire the off-camera Speedlite. So Manual is the only way to go when using basic optical slaves.

There are special optical slaves designed to de-code the E-TTL pre-flash—but the advanced circuitry comes with an expensive price tag. These E-TTL slaves units are best suited for use when combining monolights or studio strobes with E-TTL. This is covered in Chapter 12, *Mixing Canon Speedlites With Other Lights*.

---

### SPEEDLITER'S JARGON

#### —Manual Mode—Two Ways—

When you hear a photographer say, "I'm shooting in Manual," it's important to clarify which Manual mode. Both your camera and your Speedlite have Manual modes.

In the case of your camera, Manual mode requires that you set both the shutter speed and aperture. In the case of your Speedlite, Manual mode means that you set the power level at which it fires.

There is no direct connection between the two Manual modes. You can set the exposure on your camera manually and have your Speedlite fire in E-TTL. Conversely, you can have your camera pick the exposure in Aperture Priority (Av) while you set the power level of your Speedlite manually.

## SETTING POWER MANUALLY ON CANON SPEEDLITES

### 580EX II / 580EX Via Speedlite LCD

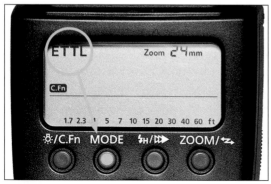

**Figure 8.3** *If M does not show in the center left side of LCD, press the Mode button repeatedly to cycle through E-TTL → Manual → Multi until M shows.*

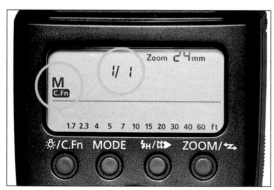

**Figure 8.4** *A fraction will appear in the top center of the screen when you are in Manual mode. This fraction indicates the power level. Here it is full-power.*

**Figure 8.5** *Press the Set button in the center of the Select Dial. The fraction will blink (which lets you know it can be changed).*

**Figure 8.6** *Turn the Select Dial to change the fraction. It will change in either ½- or ⅓-stop increments. As shown, the power level is two-thirds of a stop below half-power.*

**Figure 8.7** *When the fraction is dialed to your desired setting, push the Set button again. The fraction will stop blinking (which lets you know that it is set). As shown, the Speedlite has been set to quarter-power.*

---

### SPEEDLITER'S TIP

#### —Start At ⅛ Power—

When starting a test shot with the Speedlite in Manual mode, I find it handy to set it at ⅛ power.

On a 580-series Speedlite, the power ranges from ¹⁄₁ to ¹⁄₁₂₈ power. So ⅛ is slightly above the mid-point. On the 430-series and 270EX, the power ranges from ¹⁄₁ to ¹⁄₆₄ power. So, ⅛ is exactly halfway.

From the midpoint, you can move the power towards either end, depending upon whether your first test shot is over- or underexposed.

## 430EX II / 430EX Via Speedlite LCD

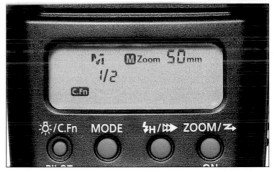

**Figure 8.8** *If M does not show near the upper left left side of LCD, press the Mode button to cycle from E-TTL to Manual. A fraction will appear just below the M when you are in Manual mode. This fraction indicates the power level.*

**Figure 8.11** *When the fraction is dialed to your desired setting, push the Sel/Set button again. The LCD will stop blinking (which lets you know that it is set). As shown, the Speedlite is set to half-power.*

**Figure 8.9** *Press the Sel/Set button in the center of the Plus/Minus buttons. The fraction will blink (which lets you know it can be changed).*

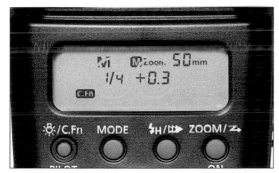

**Figure 8.10** *Push the Plus/Minus buttons as needed to change the fraction. It will change in either ½- or 1/3-stop increments. Here it is quarter plus one-third*

---

### SPEEDLITER'S TIP

#### —Manual Power Math—

If your Speedlite is set to Manual increments of ⅓-stop, as you start dialing your Speedlite's power down from ½, the display will say ½ −0.3, then ½ −0.7, then ¼. If you then dial the power back up from ¼, you will see the LCD display ¼ +0.3, then ¼ +0.7, then ½.

In Canon's world, the manual increments are shown as the last whole-stop fraction you passed through plus or minus 0.3 or 0.7, depending on the direction you are heading. I know this seems crazy. (It's no different with Nikon—except that a fraction is used instead of the decimal.)

Once you get the hang of it—once you understand that ½ −0.7 is the same as ¼ +0.3—then it seems simple.

| ½ | ½ |
|:-:|:-:|
| ↓ | ↑ |
| ½ −0.3 | ¼ +0.7 |
| ↓ | ↑ |
| ½ −0.7 | ¼ +0.3 |
| ↓ | ↑ |
| ¼ | ¼ |

## 580EX II Via Camera Menu

If you have an EX II Speedlite and a compatible camera body (see the sidebar on page 87 for the complete list), then you can control the Speedlite from your camera. Shown below are the steps for the 7D. Consult your user manual for the specific steps for your camera.

In this series of steps, we will change the Speedlite mode from E-TTL to Manual and then set the power to ⅛.

Figure 8.14 *Use the Joystick to navigate to the Camera 1 menu. (The menu screen will vary, based on the model of your camera.) You are looking for the menu list with "Flash control" or something similar.*

Figure 8.12 *Confirm that the camera and Speedlite are connected and that the power switch is in the On position on each. If you see the screen above, reset the Speedlite and toggle the power switch.*

Figure 8.15 *Use the Select Wheel to dial up/down to "External flash func. setting."*

Figure 8.13 *Press Menu on the camera (upper-left corner). The menu will illuminate to the last menu selected. As shown in the screen above, the last task I did via the LCD was to format a CF card.*

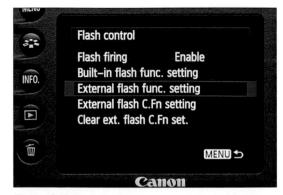

Figure 8.16 *Push the Set button in center of Select Wheel to enter the External Speedlite control submenu.*

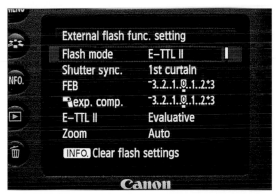

**Figure 8.17** *This screen shows the current configuration of the the Speedlite. To change the mode from E-TTL to Manual, push the Set button to select "Flash mode" menu.*

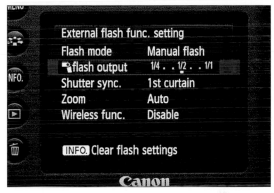

**Figure 8.20** *Turn the Select Wheel until "Flash output" is highlighted. Press the Set button to confirm the selection.*

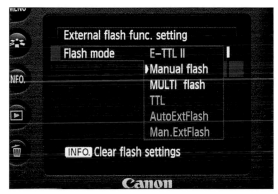

**Figure 8.18** *Turn the Select Wheel to highlight "Manual flash." Push the Set button to confirm your selection.*

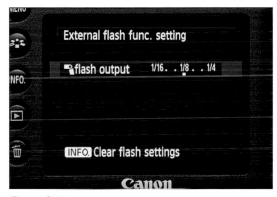

**Figure 8.21** *Turn the Select Wheel until the desired power level is selected. Press the Set button to confirm your selection.*

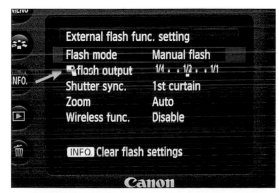

**Figure 8.19** *The LCD changes its configuration. Note that the "Flash output" line has been inserted above "Shutter sync." This indicates the manual power level for the Speedlite.*

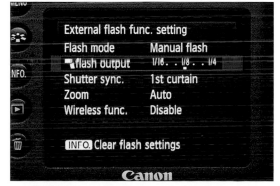

**Figure 8.22** *The LCD returns to the main flash menu screen. You are ready to start shooting.*

## MY WORKFLOW: USING ONE SPEEDLITE IN MANUAL MODE

Describing a workflow is tricky business. There can be so many variables that jump up during a shoot. Take the following as a general recipe for working with one Speedlite in Manual mode.

### Camera Mode (Varies By Situation)

- **Subject still or not moving much:** I will shoot in Aperture Priority (Av) because I want to control depth of field. I start in Av 90% of the time.

- **Subject in motion:** It's difficult to shoot in Shutter Priority (Tv) with a Speedlite in Manual. If I want the shutter to either freeze action or convey motion, I will shoot with the Speedlite in E-TTL rather than Manual—see the *Speedliter's Tip* below.

- **Very low light:** When the ambient is dim, I will shoot the camera in Manual (M) so that I can use the shutter to control how it is captured. In Av, the camera will often overexpose the scene (as shown in Figure 8.23 on the opposite page).

### Decide On The Role Of The Speedlite

I decide whether I will use the Speedlite as a key (main) light or a fill light. If the Speedlite is the key light, I will move it off-camera to create good shadows and good light. See Chapter 10, *Move Your Speedlite Off-Camera,* for the many options to trigger an off-camera Speedlite.

---

### SPEEDLITER'S TIP

#### —Avoid Shutter Priority (Tv) And Manual Flash—

Shooting with your camera in shutter-priority (Tv) and your Speedlite in Manual should be avoided. As you will recall from page 53, shutter controls the ambient exposure and aperture controls the flash exposure. In Tv, you specify the shutter speed and the camera chooses the aperture. The problem with Tv and Manual flash is that as you change the shutter, the flash power needs to change to compensate for the change in aperture. This happens automatically in E-TTL, but not in Manual. So, when when you want to control how motion is captured by shooting with flash in Tv, switch your Speedlite to E-TTL.

---

If I'm using the Speedlite to fill shadows, it can be either on- or off-camera. If it's on-camera, then I'm likely shooting in E-TTL rather than Manual because Canon's system is great at automatic fill flash calculations.

### Evaluate Ambient Light

First and foremost, for every shoot, I want to know how my camera sees the ambient light. So, I start by taking a test shot without flash to evaluate the quality and intensity of the ambient. If I'm shooting in Av, I make sure that the Exposure Compensation is zeroed. Figure 8.23 shows my first ambient test shot for a midday portrait session at a local skatepark.

> *Regardless of the flash mode that I'm shooting in, I want to know how my camera sees the ambient light. So I start my flash work with the flash turned off.*

Then, with the Speedlite still turned off, I will adjust the exposure setting so that the ambient is where I want it to be. I do this by using exposure compensation if I'm shooting in Av or via shutter and/or aperture if I'm shooting in Manual. So, in Figure 8.24, I've manually dialed the shutter speed down by two stops to add a bit of saturation to the sky.

I take additional test shots as needed until an exposure is found where the ambient fits my vision. Yes, I am using the camera LCD to make this decision—as long as I am not crashing the highlights into the right side of histogram, I'm doing okay.

### Setting Up The Speedlite

Once I've settled on my ambient exposure, *then* I'll turn on the Speedlite. Based on nothing more than a pre-visualized guess about what the light needs to look like, I will modify the Speedlite (zoom, tilt, pan, flag, snoot, etc.) and then position it.

If I expect that I will need a big burst of light, I will set the power to full ($1/1$). Otherwise I will set the power to $1/8$ and take a test shot. The benefit of using $1/8$ is that it is halfway down

the power scale. If the light is too dim, then I'll jump to ⅟₁. If the light is too bright, then I'll jump to ¼ and take another test shot.

> *My goal when setting up manual flash is to quickly find the boundaries of what is too bright and too dark. Then I can start fine-tuning the power level.*

Although I will rely upon the histogram to tell me if my highlights are clipping, I am happy to use the camera LCD to evaluate the Speed-lite's modification and position. I will also evaluate the intensity of the flash relative to the ambient via the LCD's image.

I will continue to change the power, modify the Speedlite, and/or reposition it until I get the quality of flash I am after. Along the way, I rely upon the histogram to tell me if I am overexposing the highlights. As long as I am not blowing out the highlights, I continue to use the camera LCD to look at the quality of the flash relative to the ambient. If a significant gap exists on the histogram between the right endpoint and the right side, I will dial up the overall exposure of both the ambient and the flash until the right endpoint is close to (but not clipping) the right edge.

In the series at right, I captured an ambient study shot with the camera in Aperture Priority. I then dialed the exposure down in Manual by three stops to minimize the background. In the third frame, I fired the Speedlite at ⅛ power with the head zoomed to 105mm. By the time I finished, I had repositioned the flash, gelled it with a full-cut of CTO, increased the power to ¼, and had Vin lean forward. All together I shot 24 photos between the first and last frame.

*Figure 8.23* The camera's idea, in Aperture Priority, of the proper exposure for this shot in open shade.

*Figure 8.24* The ambient light after I dialed the exposure down manually by three stops.

*Figure 8.25* My first flash frame—⅛-power with the Speedlite's head sideways and zoomed to 105mm.

*Figure 8.26* I eventually arrived at my hero shot after raising the flash, panning it left, adding a full-cut of CTO, shifting Vin, and increasing the power to ¼.

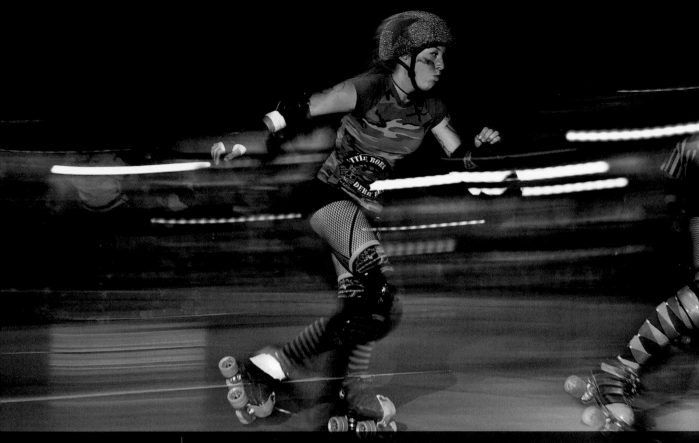

# CHAPTER 9 | E IS FOR EVALUATIVE

## The Short Version

There are two great reasons to have the power level of your flash controlled automatically:

- You don't know enough to do it yourself.

- You're shooting in a situation where the distance between the subject and flash changes constantly.

Canon's *Evaluative Through-The-Lens* (E-TTL) flash metering system is simple enough to serve the novice and robust enough to serve the professional.

*Figure 9.1*
*E-TTL is the perfect flash mode for a shoot where the distance between the subject and the Speedite changes constantly—such as a fast-paced women's roller derby bout.*

## E IS FOR EVALUATIVE

In contrast to running your Speedlite in Manual mode, where you set the power level by hand, Canon's E-TTL flash metering system calculates the flash exposure and then sets the Speedlite at the appropriate power level.

### The Purpose Of E-TTL

Thanks to the Inverse Square Law, we know that the farther a Speedlite is from the subject, the dimmer It appears. So if your subject moves toward and then away from and then toward your Speedlite, the power level needs to change accordingly. Otherwise, your subject will be overexposed in some shots and underexposed in others.

Making these changes to the Speedlite's power level by hand is time-consuming and, for most of us, very imprecise. E-TTL turns the camera into a flash power calculator and handles everything automatically.

### Early TTL Flash Metering

In a bygone era, TTL flash metering dealt with the issue of when to turn the flash off. It was a question that could not be answered until after the flash was firing.

Early TTL flash metering largely consisted of metering the light bouncing off the film inside the camera. (Yes, I mean "bouncing off the film.") In its day, this was a high-tech approach; there was actually a little light sensor inside the camera pointed at the film plane. When enough light had bounced off the film, the flash was shut off.

The assumption here was that the subject is medium-toned (essentially having the same reflective qualities as an 18% gray card). If you were shooting on a sandy beach at midday or in a dim concert hall, your results could be skewed (underexposed in the first case and overexposed in the latter). Hence, bracketing of flash exposures was common in the film era.

### The Evolution Of E-TTL

In 1995, Canon introduced Evaluative Through-The-Lens flash metering. The revolutionary concept of E-TTL was that the camera would measure the light coming back through the lens from a low power preflash emitted by the Speedlite and then set the power level on the Speedlite—with all of this happening a few thousandths of a second before the Speedlite fired.

One of the benefits of the E-TTL preflash is that it happens only when the shutter button is pressed all the way down. A predecessor to E-TTL, called A-TTL (the A was for "Advanced"), fired a preflash every time the shutter button was pushed down halfway. Now there's a good way to bug people: Keep popping them with flash every time you focus the lens.

Another benefit of E-TTL is that it only meters light coming through the lens. The earlier A TTL, in contrast, measured light coming back from the preflash via a sensor on the front of the Speedlite. This external sensor had no idea what the camera was actually seeing.

Finally, E-TTL meter readings are done with the same sensor used to measure the ambient light. So a comparison, or evaluation, of the ambient reading (done just before the preflash) and the flash metering (done during the preflash) lets the camera better determine the effect of the flash.

### E-TTL Today Is Really E-TTL II

The original version of E-TTL tied the flash meter reading to the selected AF (auto-focus) point. So, if you dialed the AF target to the leftmost point, then the flash metering would be weighted to that side. If there was a highly reflective object on the left side, the camera would be overwhelmed by it and grossly underexpose the flash.

In 2004, Canon's introduction of the second-generation E-TTL II brought two important changes. First, the metering is done across all the metering zones. Second, the camera also considers the subject's distance from the

lens (assuming that a compatible lens is being used). These two changes greatly improve the accuracy and reliability of E-TTL flash.

We'll jump into the mechanics of E-TTL II in the next section. For now, know that all Speedlites with EX in the model name are E-TTL compatible.

Understand also that the model of camera determines whether you are shooting E-TTL or E-TTL II. All EOS cameras introduced since the 1D Mark II in early 2004 have used E-TTL II technology.

From this point forward in the *Handbook*, all references to E-TTL actually refer to E-TTL II. Canon does the same thing on the Speedlite LCD. There is no difference on the LCD when the Speedlite is parked on a camera with E-TTL II technology or on a camera with the original E-TTL technology. Both just say "ETTL."

So saying "E-TTL" when you mean "E-TTL II" is fine. But don't fall into the habit of saying "TTL" when you mean "E-TTL." TTL flash is old-school technology. Nor should you say "TTL" when you are referring to modern versions of automatic flash in general. Canon's version is E-TTL. Nikon's version is I-TTL. Be specific.

---

## GEEK SPEAK

### —E-TTL II Camera Bodies—

E-TTL II is actually a feature found in camera bodies rather than Speedlites. Any Speedlite with EX in the model will operate in E-TTL II when connected to a compatible body. If you have a camera with the original E-TTL technology, then your EX Speedlite will fire in E-TTL rather than E-TTL II. Here's a list of E-TTL II cameras.

- PowerShot G6, G7, Pro 1, G9, G10, G11, G12
- Rebel XT (350D), Rebel XTi (400D), Rebel XSi (450D), Rebel T1i (500D), Rebel T2i (550D), Rebel XS (1000D)
- 20D, 30D, 40D, 50D, 60D
- 5D, 5D Mk II, 7D
- 1D MkII, 1D MkIIN, 1D MkIII, 1D MkIV
- 1DsMk II, 1DsMkIII

---

## MECHANICS OF E-TTL

E-TTL is automatic technology. So it's not critical that you know how it works. However, an awareness of what E-TTL is doing will help you avoid common mistakes (and give you an extra bit of authority at the next Speedliter's Meet-up).

### Ambient And Flash Metering Done Separately

One of the great benefits of E-TTL is that the camera meters ambient and flash exposure separately. When you push the shutter button halfway, your camera makes an exposure reading of the ambient light (described below).

When you press the shutter button completely, the E-TTL system activates and performs its work in microseconds.

### E-TTL Begins With The Preflash

The key to automatic flash metering is to measure the return of light from the subject. E-TTL does this by having the Speedlite fire a preflash at $1/32$ power.

The preflash is a baseline of light that the camera uses to measure the reflectivity of what the lens sees. It is fired by pressing the shutter button completely.

The preflash happens so fast that normally you will not see it separately from the main flash. If you want to see the preflash, just to be sure it's there, check out the sidebar on the opposite page, *Seeing The Preflash*.

### E-TTL And Metering Zones

As you push the shutter button halfway, your camera makes an exposure reading of the ambient light. When the shutter button goes all the way down, the preflash fires and the camera measures the light coming back.

Your camera has a number of metering zones. If you're shooting a Mark III or Mark IV version of the 1D / 1Ds or a 7D camera, you have 63 zones. If you're shooting most others, your camera has 35 zones.

In the original E-TTL, emphasis was given to the metering zone around the selected Auto-Focus point. In E-TTL II, the camera does not care which AF point is selected. It takes a look at the light coming back from all the zones.

## The Evaluative Part Of E-TTL

Since the camera knows the power level of the preflash, it can evaluate the difference between the ambient meter reading and the flash meter reading with accuracy. The purpose of the evaluation is to determine the nature of the scene in front of the camera.

Essentially the camera is trying to sort out where the subject is so that it can provide proper flash for just that subject.

When the preflash is fired, metering zones that don't show a return of the preflash are assumed to be distant background—meaning that these zones will be ignored.

For those zones that did reflect the preflash back, emphasis will be given to adjacent metering zones that provide most of the information.

If your Speedlite is on-camera and you're shooting with a compatible lens (typically a Canon USM lens), then an E-TTL II camera will also factor in the camera-to-subject distance. This distance information is used by the camera to more precisely calculate the appropriate power level for the Speedlite. However, if you tilt or pan the head, the camera disregards the distance data because it does not know the geometry of your bounce shot. Also, if your on-camera Speedlite is a wireless master, then the camera will disregard the camera-to-subject distance because it does not know the distance of the subject to the slave(s).

## How E-TTL Handles Fill Flash For Backlight

One of the scenarios that E-TTL handles quite well is that of backlighting. As you will recall from Chapter 1, *Learn To See Light*, your camera cannot record the same range of brights and darks that you can see.

If your subject is backlit and the exposure is held so that the background details do not blow out to white, then the side of your subject seen by the camera will be recorded as deep shadows. Essentially the photo of your children at the beach becomes a photo of three silhouettes standing in front of the ocean.

When the camera sees the scene as mostly bright, it will anticipate that the role of the Speedlite is to provide fill flash on the subject. In doing so, E-TTL reduces the power of the Speedlite through Automatic Fill Reduction so that the role of the flash is to fill the shadows rather than provide the main light on the subject. The effect is that the lighting looks more natural.

If you think that the amount of fill flash is too little or too much, you can dial in an adjustment via Flash Exposure Compensation (discussed later in this chapter).

---

### SPEEDLITER'S TIP

#### —Seeing The Preflash—

Since the preflash happens a microsecond before the actual flash, you won't see it as a separate flash. To see it, do this:

- Set your camera to Manual mode with a shutter speed of 1 second or longer. The aperture does not matter.

- Set your Speedlite to 2nd-Curtain Sync by pushing the button with three triangles above it.

- Push the shutter button. You'll hear the shutter open and see the preflash fire almost simultaneously. Then you'll see the flash just before you hear the shutter close. Now you've seen the preflash.

## LIMITATIONS OF E-TTL

E-TTL is a powerful tool that can produce amazing images. It's important to know about the limitations of the E-TTL system and what to do about them.

### E-TTL On-Camera Flash Will Still Look Like On-Camera Flash

One key thing to remember is that as good as E-TTL is, it does not replace the laws of physics. So, if your Speedlite is on-camera, you are going to get on-camera light.

In the case of simple, on-camera fill flash for backlit subjects, E-TTL flash will provide a significant improvement over the loss of detail in shadows. But if you're trying to create a sense of depth or shape by creating shadows with your Speedlite, you still have to move your Speedlite off-camera.

### E-TTL Does Not Factor In Your Visual Intent

In E-TTL, your camera and Speedlite work together to determine the proper amount of flash power. That is to say, "proper" as defined by a computer algorithm.

Your camera does not know what you are photographing, nor does it know what your visual intent is. Fortunately, as you'll read later in this chapter, you can adjust the E-TTL calculations via Flash Exposure Compensation so that the system quickly delivers light that fits your vision.

### E-TTL And Hyper-Fast Blinkers

Some people are hyper-fast blinkers. You'll know who they are when you see that their eyes are always closed in your E-TTL shots. What's happening is that they are blinking at the preflash.

The best way to deal with this is to push the FEL button (described later in this chapter). When you push the FEL button, the preflash fires and the blinker blinks. Wait a brief moment, and then fire the shutter. Chances are that you'll get the blinker with her eyes open.

### E-TTL And Optical Slaves

The E-TTL preflash confuses traditional optical slaves because they fire the Speedlite upon seeing a bright burst of light.

If you are doing simple, multi-Speedlite work, switch over to the built-in wireless system, discussed at length in Chapter 11, *Wireless Speedliting, The Canon Way*.

If you're using optical slaves because some of the units you are trying to fire are non-Canon speedlights, you'll have to switch from E-TTL over to Manual mode.

If you are trying to fire Speedlites in E-TTL and monolights or studio packs, see Chapter 12, *Mixing Canon Speedlites With Other Lights*.

**Figure 9.2** *Even an experienced model will blink occasionally in response to the E-TTL pre-flash. The hardest ones to see on the camera LCD are the half-blinks, as shown at bottom.*

## E-TTL AND CAMERA MODES

How the shutter and aperture are set factors into the settings made by E-TTL. In a few situations, your camera may not adequately fire your Speedlite because of the shooting mode you've selected on your camera.

### Program AE (P) Or Full Auto [ ]

In these modes, the camera sets the shutter speed between 1/60" and the camera's sync speed (typically 1/200"). The camera also sets the aperture.

If 1/60" is not long enough to capture enough ambient light from the background, you will have a black background. In Program AE or Full Auto, the way to correct this is to either move closer to the subject or increase the ISO. Remember, though, that a high ISO can create noise in your images—seen as speckles in the shadows.

### Shutter Priority (Tv)

You select the shutter speed and the camera sets the aperture. If the aperture display blinks, the background will be under- or overexposed. You can use a faster or slower shutter speed to adjust the amount of ambient light captured—which is what lights the background.

If your shutter speed is set faster than the sync speed for your camera, the camera will shoot at the sync speed rather than the speed you dialed in. For instance, if you've set the shutter for 1/1000" and your camera's sync speed is 1/250", then your camera will fire at 1/250".

To shoot faster than the sync speed for your camera, you'll need to switch the Speedlite into High-Speed Sync mode—which is the subject of Chapter 21, *Slicing Time With High-Speed Sync*.

*Figure 9.3 Aperture Priority will often overexpose a scene lit with dim ambient light as the meter is programmed to see the world as medium-grey.*

*Figure 9.4 The same scene with the exposure dialed in manually captures the scene more naturally.*

### Aperture Priority (Av)

You select the aperture and the camera sets the shutter speed. In dimly lit situations, the camera prioritizes the exposure for the ambient light in the scene. If your subject is standing against a wall, the wall will be lit as well. If your subject is standing away from the background, the background may go black. The challenge of using Av in low light is that you will often get excessively long shutter speeds. To avoid this, I switch to Manual mode.

### Manual (M)

Many photographers confuse Manual mode on their camera and Manual mode on their Speedlite. Let's not be among them, okay? When your camera is in Manual mode, you set both the aperture and the shutter speed. Your camera will be perfectly happy to set the flash exposure through E-TTL even though you are controlling the shutter and aperture directly.

# FLASH EXPOSURE COMPENSATION

Flash Exposure Compensation (FEC) is a feature that I use in almost every E-TTL shot I make. I consider FEC to be an essential Speedliter skill. You should think this way too.

## Express Your Vision Via FEC

As smart as E-TTL technology is, it cannot know your vision as the photographer. FEC gives you the ability to increase or decrease the power of an E-TTL flash by an amount you specify. So, if there is not enough flash, I dial FEC up. If there is too much flash, I dial FEC down.

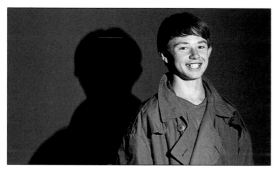

**Figure 9.5** *The shot as metered by the camera. You could call this 0 FEC.*

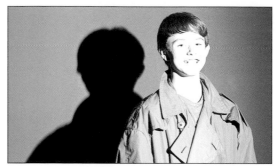

**Figure 9.6** *The shot with +2 FEC.*

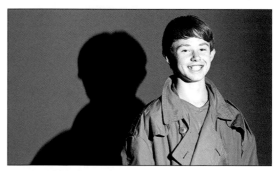

**Figure 9.7** *The shot with +1 FEC.*

**Figure 9.8** *The shot with −1 FEC.*

**Figure 9.9** *The shot with −2 FEC.*

## FEC Increments

The default increment for FEC is ⅓-stop. However, if your camera's exposure compensation is in ½-stop increments, then the FEC will also be in ½-stop increments.

You can determine if your camera is set to ⅓-stop or ½-stop increments by looking through the viewfinder at the bottom of the frame when you are in Av mode. If there are two small ticks between the long ticks, then you are in ⅓-stop increments. If there is only one small tick, then you are in ½-stop increments. Consult your user manual to determine how to change from one to the other.

## Setting FEC Via Your Camera

There are two places to set FEC:

- on your Speedlite
- on your camera

Sorry, setting them both does not make the FEC cumulative. If FEC is set in both places, the setting on the Speedlite takes priority—even if the FEC in the camera is greater.

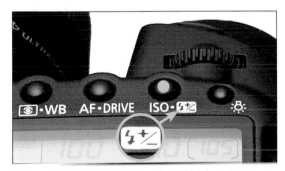

*Figure 9.10* *You can change the FEC without taking your eye from the viewfinder by pushing the FEC button and then turning the Quick Control Dial.*

I generally set the FEC via my camera. The fastest way is to push the FEC button and turn the Quick Control Dial—the big wheel on the back—while looking at the scale in the viewfinder. Train your right index finger to find the FEC button while you are looking through the viewfinder. It will save precious seconds when you are shooting on the fly.

*You don't want to be fumbling with the Speedlite or camera LCD when the sun is crashing below the horizon and you need to fire off that perfect wedding sunset shot. So learn to adjust FEC while you are looking through the viewfinder.*

If you are shooting a newer model body and a 580EX II, 430EX II, or 270EX, you can also set the FEC via the External Flash menu on the camera's LCD screen. I prefer to do it through the viewfinder or on the Speedlite's LCD because I find it to be faster.

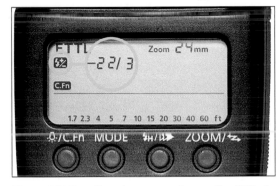

*Figure 9.11* *Even though you can change the FEC of an EX II Speedlite from the LCD of a compatible camera, I find it faster to change it through the viewfinder or on the Speedlite LCD. Here the FEC is set to 2⅔.*

## Setting FEC Via Your Speedlite

Another benefit of setting the FEC on the Speedlite is that the FEC available on the camera may have a smaller range than the Speedlite itself. It depends upon the camera model.

For instance, my 5D Mark II has an FEC range of +/– 2 stops. So if I want more than 2 stops of FEC, I have to set it through the Speedlite (although I can still do this via the camera's LCD by accessing the Speedlite's menu).

Check the specs on your camera. Your camera may have more than 2 stops of FEC. The 7D, for instance, has +/– 3 stops available. So, with the 7D, setting the FEC via the camera viewfinder is faster than setting it through the Speedlite LCD or Speedlite menu on the 7D's LCD.

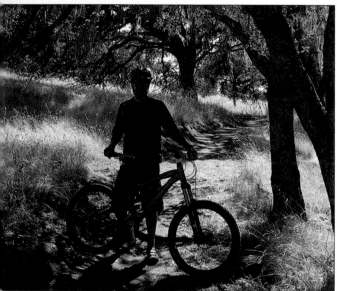

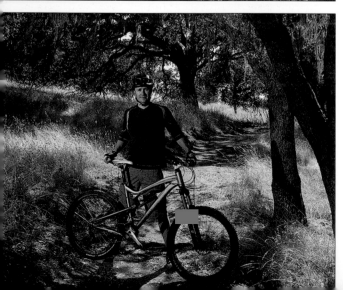

## Using FEC And EC At The Same Time

When your camera is in P, Av, or Tv mode, you can override the camera's ambient exposure calculation by a specific amount via Exposure Compensation (EC). (If you are controlling your camera in Manual mode, you just change the shutter or aperture to change the exposure.)

A unique feature of Canon's Speedlite system is that FEC is controlled independently of EC. This is not true for some other camera brands.

There is no direct correlation between an EC move and an FEC move. For instance, if I dial the EC down –1 to underexpose the ambient a bit, I do not have to dial the FEC +1 to compensate. I think of EC as the control for the ambient exposure and FEC as the control for flash exposure. I use both independently.

*Here is the secret to my E-TTL workflow:* I settle on the ambient exposure before I turn on the Speedlite.

*Figure 9.12* *Here's my friend and talented wedding shooter Colin Michael as the camera saw him—0 EC.*

*Figure 9.13* *Although the intense afternoon sun created beautiful backlight, I toned down its strength by dialing in –1 EC.*

*Figure 9.14* *Then I turned on the Speedlite for the first test shot at 0 FEC. This is how the camera wants to meter the flash.*

*Figure 9.15 (below)* *I wanted Colin's face and jersey to compete with the bright spots in the grass. So I dialed +1 FEC into the Speedlite.*

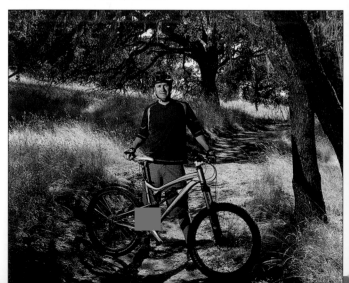

## Setting FEC Directly On The 580EX II

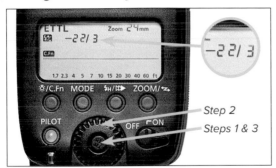

*Step 2*

*Steps 1 & 3*

1. Press the Set button so that the FEC icon is displayed on the left side of the LCD. You will see that the FEC icon and the FEC amount will blink.

2. Use the Select Wheel to specify the desired amount of FEC. Turn it left to reduce the FEC. Turn it right to increase the FEC. If you want to remove FEC entirely, set it to +0.

3. Press the Set button to confirm your choice.

---

### GEEK SPEAK

#### —Sensor Size—

A *full-frame sensor* is one that has the same 24mm x 36mm dimensions of a 35mm film frame. Canon's 1Ds- and 5D-series DSLRs feature full-frame sensors.

An *APS-H sensor* measures 28.1mm x 18.7mm. Canon uses APS-H sensors in the 1D-series. An APS-H sensor has the effect of multiplying the focal length of the lens by a factor of 1.3. For example, a 50mm lens on an APS-H camera is equivalent to that of a 65mm lens on a full-frame sensor.

An *APS-C sensor* measures 22.3mm x 14.9mm. Canon DSLRs with APS-C sensors include: 7D, xxD-series (50D...), and the xxxD/Rebel series. With a 1.6x multiplier, the angle of view of a 50mm lens on an APS-C camera is equivalent to that of an 80mm lens on a full-frame sensor.

Full-frame Sensor

APS-H Sensor

APS-C Sensor

---

## Setting FEC Directly On The 480EX II

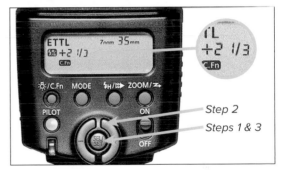

*Step 2*

*Steps 1 & 3*

1. Press the Set button so that the FEC icon is displayed on the left side of the LCD. You will see that the FEC icon and the FEC amount will blink.

2. Use the Select buttons (the C-shaped buttons on either side of the Set button) to specify the desired amount of FEC. Press the left Select button to reduce the FEC. Press the right Select button to increase the FEC. If you want to remove FEC entirely, set it to +0.

3. Press the Set button to confirm your choice.

---

### SPEEDLITER'S TIP

#### —Use Focus Targets To Reframe Accurately—

To maximize the benefit of FEC, it's important to recompose each frame to match the one before. This can be hard if you take the camera away from your eye so that you can find the right buttons.

I use the focusing targets in the viewfinder as a way to recompose my shot close to the framing that I had before. In this shot, I noticed that the middle-right target lined up with Sophia's nose. So, every time I brought the camera back up to my eye, I placed that focus target back on her nose. Note: I am not necessarily using this target to focus. I am just using it to line up the frame so that there is consistency from shot to shot in this series.

## FLASH EXPOSURE LOCK

One of the challenges of E-TTL flash is that the flash power can change if the frame is recomposed significantly. Think of it this way—if you change the composition enough so that the camera meters the scene differently, then the output of the flash will likely change. Sometimes switching from a vertical to a horizontal shot is enough to trigger the change.

Another challenge comes when you're shooting an extremely wide lens and you want to meter for a specific element of the frame. If you don't know what's going on, a lack of flash consistency in these situations can be maddening.

Flash Exposure Lock will help you in both of these situations.

### Metering Via Flash Exposure Lock (FEL)

Flash Exposure Lock (FEL) temporarily switches your flash metering from Evaluative to Spot. Regardless of which metering mode you are in, as soon as you toggle FEL, the camera switches the flash to Spot metering. (Technically, some cameras, like the Rebels, have Partial Spot metering rather than true, Spot metering. The effects are so similar that I treat them as the same here.)

With FEL, the camera meters flash only from the zones contained within the viewfinder's center circle—rather than the whole frame.

**Figure 9.16** *FEL meters flash from the center area of the viewfinder. Consult your camera manual for the exact zone.*

### Activating FEL

How you activate FEL depends on your camera model. For most newer xxD, 5D, 7D, and Rebel cameras, it is the AE Lock button ✱ on the back. Effectively, when you attach a Speedlite to your camera and turn it on, the AE Lock button becomes the FEL button.

For the 1D-series cameras, there is a dedicated FEL button on the top of the camera body, near the shutter button.

### You Have 16 Magical Seconds

FEL locks the ambient and flash exposures into the camera for 16 seconds so that you can recompose your photograph and fire off a shot. After you take a shot, the camera automatically switches back to your specified metering pattern. Also, if 16 seconds goes by without a photo being made, then the camera switches back to your specified metering pattern.

You can extend the FEL metering by keeping your finger on the FEL button. As long as you hold it down, the camera will hold the exposure settings in memory.

Unfortunately, on most cameras, there is no way to lock the camera in FEL mode so that you can take multiple shots with one set of FEL readings. Instead, you have to return to your meter target and hit the FEL button for every shot. 1D and 1Ds cameras hold the FEL setting for 2 seconds after the exposure.

### Putting FEL To Work

To use FEL, you point the center of your viewfinder at the part of the subject that you want to use as your metering target and press the FEL button. The camera will fire the preflash and display "FEL" in the viewfinder for a half-second. If the subject is too far away for a good exposure, you'll see a blinking flash/bolt rather than FEL.

After you press the FEL button, recompose your frame and fire away. For consistency when combining FEC and FEL, be sure to return the center circle to the same spot for each meter reading.

## Use FEL When Shooting Alternate Compositions

Any time that you are shooting for publication or shooting stock images that you hope will be used in a publication, it is very important to create alternate images. You need to do this so that the designer can place titles and text on or around your photo.

Since you will likely not know the layout at the time that you are shooting, once you settle on your main composition and get your hero shot(s), you should make a number of alternate compositions very quickly.

If you are shooting tight, zoom out or back up. If you are shooting wide, move in close. If you are shooting vertical, shoot horizontal. If you are shooting with the subject on the left, switch the symmetry and shoot with the subject on the right. You can do all of this in literally a few moments at the end of the shoot.

To assure that your exposures are consistent across this series of shots, center the view-finder on the same spot and hit the FEL button. Then recompose and fire. This ensures that your exposures are the same even though your composition is changing significantly.

*Figure 9.18* When my hero shot is wide, I'll zoom in or step towards the subject to create a tighter shot.

*Figure 9.19* When my hero shot is horizontal, I will turn my camera and shoot vertical for several frames.

*Figure 9.17* Here is the hero shot that I've made with the ambient and flash exposures dialed in to my taste via EC and FEC. I will return to this composition every time I want to meter via FEL. It is my "target shot."

*Figure 9.20* If the subject is to the left in my hero shot, then I'll pan the camera and move her to the right.

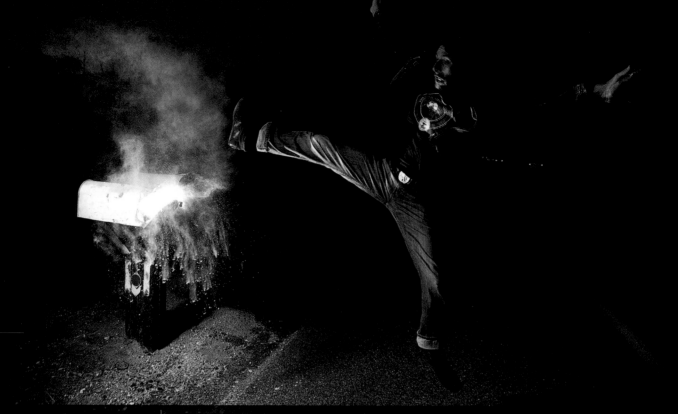

# CHAPTER 10 | MOVE YOUR SPEEDLITE OFF-CAMERA

### Figure 10.1
*For this fun shot, two Speedlites were placed inside the mailbox and a third was fired into a gold umbrella at camera left. A handful of Fuller's Earth created the smoke effect.*

## The Short Version

Moving your Speedlite off the top of your camera is a fast way to take a huge step forward as a photographer. Why? We see shape and depth in a photo based on the shadows. When your main light source is right on top of your camera, the light is very flat. Moving the Speedlite even a short distance away can help add depth by adding shadows.

This chapter runs through the many options that are available for off-camera Speedite control. The next chapter, Chapter 11, *Wireless Speedliting, The Canon Way* goes deep into Canon's built-in wireless system—which is the basis for most of my Speedliting.

## YOUR CAMERA IS A LOUSY PLACE TO PUT A SPEEDLITE

I'll admit that a Canon camera and Speedlite, when working together in E-TTL, are much better at math than I am. Their ability to fire a pre-flash, measure the light, and calculate a power level in a small fraction of a second boggles my mind.

### Physics Is Physics

Kudos are owed to the Canon engineers for creating this amazingly fast technology. But, the fact remains, that the top of a camera is a perfectly lousy place to park a Speedlite. You can't blame that on the Canon engineers.

It's the nature of light that's the problem. The fact is that, when your Speedlite is on top of your camera, the light flies straight forward (as all light does) and illuminates the left and right sides of your subject equally.

You've already read my mantra, but it is worth repeating.

> To create interesting light, you have to create interesting shadows.

While Canon technology can do a brilliant job of calculating the power level for a Speedlite, it cannot do anything about the fact that an on-camera flash does not create interesting shadows.

To create interesting shadows, you have to move your Speedlite off-camera—you have to get it off the axis of your lens. When your Speedlite is somewhere to the side of your camera, then the lens will see shadows on your subject and your lighting will become much more interesting.

## OPTIONS FOR CONTROLLING OFF-CAMERA SPEEDLITES

There are six ways to trigger an off-camera Speedlite. For convenience, I've divided them into the options for E-TTL control (where the camera sets the power lever on the flash) and the options for manual control (where you set the power level on the flash).

### Options For Off-Camera E-TTL Control

The advantage of E-TTL control of off-camera Speedlites is that you can change the settings of your off-camera Speedlite(s) from your camera. This is a great help when you are working several off-camera Speedlites. It is also very handy when your Speedlite is in a hard-to-reach spot—like the inside of a softbox.

There are three ways to control an off-camera Speedlite in E-TTL. I've listed them in order of their complexity:

- E-TTL Cord
- Canon Built-in Wireless
- E-TTL Radio Triggers

### Options For Off-Camera Manual Control

Off-camera manual control is a bit of a misnomer—as manual control has a vocabulary of exactly two words: "Fire now!" Everything else, such as activating high-speed sync or changing the power level, must be done by hand on each of the off-camera Speedlites.

> A distinct advantage of off-camera manual control is that you can fire virtually any brand of small flash. If you are shooting with multiple speedlights, they do not even have to be the same brand.

Another compelling draw to off-camera manual control is affordability. Every one of the following solutions is much less expensive than the same approach in E-TTL:

- Sync Cords and Hot Shoe Adapters
- Optical Slaves / Infrared Triggers
- Manual Radio Triggers

An E-TTL cord is the easiest way to move your Speedlite off-camera while still maintaining all the benefits of E-TTL communication. I am a huge fan of E-TTL cords and use them frequently. They range in length from 2′ to more than 30′. While more expensive than a plain-vanilla sync cord, an E-TTL cord is far less expensive than an E-TTL radio trigger.

+ Camera calculates the flash exposure
+ You can increase or decrease flash from the camera
+ High-speed sync available
+ With long cord, can move Master to better spot
− Long cord can create tripping hazard
− Long E-TTL cord is not suitable for events or crowded areas

### Canon Off-Camera Cord OC-E3

Canon understands the importance of getting a Speedlite off-camera. They make a special

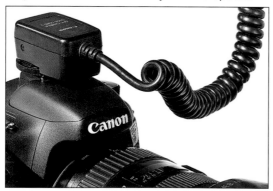

*Figure 10.2* Canon Off-Camera Cord OC-E3.

cord for it. The Canon OC-E3 Off-Camera Flash Cord enables you to hand-hold your Speedlite or to mount it to a flash bracket—virtually anywhere within three feet of the hot shoe.

If you need to go a bit farther, you can add a second cord to the first cord. For a short cord or two, I prefer a coiled design. For longer cords, I use straight cords.

There are many different manufacturers of off-camera cords. If you're on a tight budget, you have lots of options to buy a third-party cord. You will likely find, though, that the savings are mainly in the quality of the parts.

### Flash Brackets With Off-Camera Cord

*Figure 10.3* The WPF-1 Wedding Pro Flash Bracket by Really Right Stuff keeps the Speedlite centered over the top of the lens in both orientations.

If you are a wedding or event photographer, an easy way to get your Speedlite off-camera while still maintaining portability is to mount it on a flash bracket.

My favorite is the WPF-1 from Really Right Stuff. Its unique design enables it to keep the Speedlite oriented with the viewfinder, yet the Speedlite is always above the camera when you go from horizontal to vertical.

### Handholding A Speedlite Connected To An Off-Camera Cord

Don't forget that your body came with a built-in flash bracket—your left arm. While a real flash bracket is handy for extended use, when I find myself in situations where I did not bring it, I'll just hold the Speedlite at arm's length in my left hand. This will seem awkward at first, but with a bit of practice, you will get the hang of it. When you need two hands to change a setting on your camera, cradle the Speedlite on your shoulder as you would the handset of a desk phone. Believe me, hand-holding a corded Speedlite is better than using the hot shoe.

## Long And Extra-Long E-TTL Cords

*Figure 10.4* *The secret to much of my off-camera lighting is that I connect a Speedlite to an extra-long E-TTL cord.*

The most useful piece of off-camera gear in my bag is my extra-long E-TTL cord (source: OCFGear.com). It uses the Canon-style hot shoe connectors for the camera and Speedlite that are found on Canon's OC-E3 cord. The two ends are permanently tied together by a long length of heavy-duty sync cord.

The one I have is over 30′ long. Now, I know that 30′ sounds like a lot, but when you figure in 5′ or so for the cord to drop down the length of the light stand and 5′ or so for the cord to run from the floor up to the photographer's eye, all of a sudden a 30′ cord really equates to about 20′ of mobility. If you want a shorter length, other common lengths are 16′ and 24′.

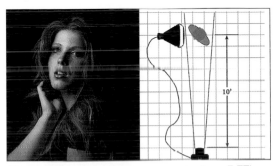

*Figure 10.5* *One Speedlite on an extra-long E-TTL cord can create beautiful light.*

As you'll see throughout the chapters on shooting, this cord is one of my primary off-camera tools. If you have just a single Speed-lite, it allows you to move it in a large circle around the camera. Take a look at Figure 10.5. This was a single Speedlite portrait with the flash tethered directly to the camera via my extra-long E-TTL cord.

Another huge benefit of this cord is that it allows me to move my master Speedlite to an off-camera location so that it can communicate with slave flashes that would otherwise not be able to see it.

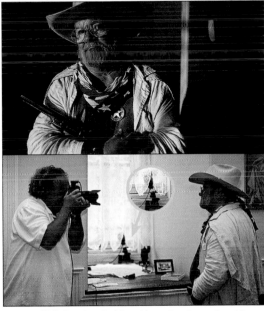

*Figure 10.6* *For the Golden Hour Anytime shoot I was able to move the master to a window so that it could communicate with Speedlites outside the window.*

For the *Golden Hour Anytime* shoot, shown above and discussed in detail on pages 288–289, I created the effect of a setting sun by gelling two Speedlites outside the building with a half-cut CTO (an amber-colored piece of plastic) and firing them via a master Speedlite at the bottom of the window.

When you buy an extra-long E-TTL cord, I suggest that you get a straight one rather than a coiled one. For a short cord, like the Canon OC-E3, the coil is a convenient way to keep it from getting tangled. With an extra-long cord, the opposite is true. A coiled cord will swing through the air rather than lie on the ground.

## CANON BUILT-IN WIRELESS

Built into Canon Speedlites is the capability of a master Speedlite to communicate with slave Speedlite(s). Also, the ST-E2 Wireless Transmitter can be substituted for a 580-series Speedlite as Master.

+ Virtually no cost after Speedlite(s) purchased
+ Many Speedlites can be controlled from the camera
+ Slaves can be separated into groups
+ Groups can fire at different power levels
− Limited to about 30′
− Must have line-of-sight connection
− Effectiveness reduced in full sun
− Canon user interface complicated

I use Canon's built-in system as a standard part of my shooting workflow. For complete details, see Chapter 11, *Wireless Speedliting, The Canon Way*, which is coming up next.

## E-TTL RADIO TRIGGERS

The technology to convert a Speedlite's E-TTL code into a radio signal was invented only in the past few years. This exciting new technology combines the best of camera-based flash control via E-TTL and the wall-penetrating ability of radio waves. The technology has revolutionized how photographers shoot with Speedlites on location. This is particularly true among wedding photographers who benefit greatly from on-the-fly E-TTL control without the worry of maintaining line-of-sight.

+ Full E-TTL control of off-camera Speedlites
+ Slave units do not have to see the Master
+ All functions (e.g., high-speed sync) available
− Expensive, averages $200+ per Speedlite
− Must have a receiver for every Slave flash

Today, there are only two contenders in the E-TTL radio trigger market—RadioPopper and PocketWizard. Competing ideas, of course, are good for us, the consumer. I encourage you to remember, though, that this is still emerging technology when deciding which path to follow.

### RadioPopper PX

**Figure 10.7** *The RadioPopper PX is my preferred E-TTL radio trigger. I like the small size, ease of attaching to the Speedlite, and reliability. The transmitter is shown at left and the receiver at right.*

I have long been a fan of the Cinderella start-up company RadioPopper. It is not widely known, but the first E-TTL radio trigger was invented by Kevin King, a wedding shooter who taught himself electronics and created the RadioPopper prototype in his living room.

Today, the RadioPopper PX—the second generation of RadioPopper technology—continues to prove itself among photographers. There are two parts: the PX transmitter that sits on top of the master Speedlite and a PX receiver that is parked directly in front of each Slave Speedlite with an ingeniously designed bracket. Both pieces take literally two seconds to connect.

The RadioPopper PX is a pro-grade and pro-priced solution. If you have multiple slaves, you must have one PX receiver for each. Also, you must use a 500-series Speedlite or an ST-E2 as a master with the PX transmitter on top. I use a LiveStrong bracelet to attach it temporarily because I hate adhering velcro to my gear.

With all due respect to the technical marvels that they are, RadioPoppers have a simple job. The PX transmitter senses the electromagnetic pulse of the master flash's pre-flash commands and then sends that code via radio wave. The PX receiver then decodes the radio message into a series of infrared pulses that the Slave Speedlite then sees as instructions sent directly by the Master Speedlite. All of this happens literally at the speed of light.

> *RadioPopper did not reinvent Canon's F-TTL code; they just figured out a way to transmit it via radio waves.*

I have used RadioPoppers since shortly after the introduction of the first-generation P1. In fact, the cover of this book was shot with a dozen Speedlites—all triggered by RadioPopper P1s. See pages 323–325 for the details.

### PocketWizard ControlTL: MiniTT1/FlexTT5

*Figure 10.8* PocketWizard's MiniTT1 (left) and Flex TT5 (right) can both be used as an E-TTL radio transmitter. The FlexTT5 can also be used as a receiver.

For many years, PocketWizard has been the unquestioned leader of manual radio triggers. So, after the introduction of the RadioPopper, it was not a surprise when PocketWizard announced their entry into the E-TTL radio trigger market. Their ControlTL system currently consists of the MiniTT1 transmitter, the FlexTT5 transceiver, and the AC3 ZoneController.

PocketWizard's approach is distinctly different from RadioPopper in that they intercept the camera's instructions as they come up through the hot shoe and translate the instructions to a proprietary code that is transmitted to the receivers. This gives the ControlTL system the ability to add functionality beyond Canon's own.

One advantage is that you do not need to have a Speedlite dedicated as a master. Another unique advantage is the AC3 ZoneController which, when added to the TT1 or TT5, provides the ability to shut a group down completely and the ability to segregate groups into E-TTL and manual with full control from the camera. Yet another advantage of ControlTL is the ability to fire strobes via the Plus II or MultiMax triggers while you fire Speedlites with the TT1 or TT5.

The Achilles heel of the ControlTL system is that when used with certain Canon Speedlites (the 580EX II, 580EX, and 430EX), the range is limited due to radio interference with the Speedlite. This seems to be a US/Canada-only problem as PW's frequencies in North America are different than in other parts of the world.

PW's response has been to develop a series of add-ons—such as the AC5 RF Soft Shield, which is literally a metallic sock that is stretched around the slave Speedlite and then tied into a hot shoe filter. Compared to the few seconds it takes to set up a RadioPopper, the need to install the AC5 to get maximum range seems like a kludge. However, if you don't need more than 40' or so of range, then you don't have to hassle with the AC5.

### Are E-TTL Radio Triggers Necessary?

If you are an event or wedding photographer who needs the convenience of wireless control without the inconvenience of maintaining a line-of-sight link, E-TTL radio triggers are a valuable tool that are absolutely worth the cost. If, however, you are not a professional who routinely shoots around crowds, you'll do just fine with an extra-long E-TTL cord.

When looking at radio E-TTL solutions, the question becomes—do you want the simplicity of the RadioPopper PX system or the expanded functionality of the ControlTL system?

Now we'll switch to the manual-only off-camera solutions. Moving your Speedlite off-camera can be as simple as running a sync cord from the side of your camera to your Speedlite. ("Sync" is short for "synchronization.") The sync-cord approach is the least expensive way to start learning off-camera flash.

+ Relatively inexpensive

+ Fast way to start learning off-camera flash

− Cords present tripping hazards on the set

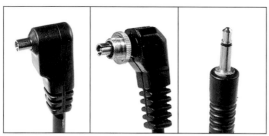

**Figure 10.9** *Three Different Sync Fittings: the choice of your sync cord and adapter(s) largely depends on the connections on your camera and Speedlite. There are three basic plug styles (left to right)—PC, Screwlock PC, and Miniphone.*

## PC

A PC sync cord is old-school, but still useful, technology. Years ago—many years ago—Prontor and Compur were the most popular shutters on view- and medium-format cameras. The standard that enabled the shutter to mechanically synchronize with the flash was called "PC sync." The legacy of a PC sync socket on cameras has been carried forward for decades.

The point to remember about PC connections is that they can be finicky. A PC connection is literally push-on. It is held in place by friction. If the outer ring of the connector becomes loose, your Speedlite may not fire. There are little gadgets you can use to tidy up loose PC fittings. However, the best way to avoid a loose PC fitting is to use one of the two newer connectors.

## Screwlock PC

The Screwlock PC is an updated version of the PC connector. As the name suggests, it has a threaded collar that literally screws into a threaded fitting on the camera, Speedlite, or adapter. The great benefit of the Screwlock PC is that the electrical connectors are relieved of the need to also maintain a friction fit. Since the threaded collar assumes the burden of holding things together, the reliability of the connection is greater.

Canon has been putting Screwlock PC ports on their cameras for many years. Here's a quick summary of the DSLRs with a Screwlock PC port:

- 30D, 40D, 50D, 60D, 7D
- 5D, 5D Mark II
- 1D, including Mark II, IIN, III, and IV
- 1Ds, including Mark II and III

## Miniphone

The miniphone is a ⅛"/3.5mm jack. It resembles the jack on a set of pocket headphones, but it is mono rather than stereo. This is important to remember because stereo cords and plugs will give you fits during a shoot.

The miniphone is the most reliable of the three sync connections. You can twist it until you're dizzy. It will maintain a solid connection.

Many popular pieces of Speedliting gear use miniphone connections, among them Radio-Poppers, PocketWizards, and Skyports.

## Hot Shoe Adapters

Unless your sync cord has a hot shoe built into the end, you'll need a hot shoe adapter to connect the sync cord to your Speedlite. (The 580EX II is the exception here, as it has a Screwlock PC socket built into the side, so a PC-cord will plug directly into it.)

There are two types of hot shoe adapters: those intended to sit in your camera's hot shoe and those intended to sit under the distant Speedlite. The only real difference is in the design of the foot.

As shown in Figure 10.10, a camera hot shoe adapter will have a spring-loaded button at the center of the foot so that it can make a connection to the camera's flash terminals. A flash hot shoe adapter will have a ¼"-20 thread at the center of the foot so that you can screw it into a stand. In a pinch, you can also use a camera hot shoe adapter under a Speedlite. You'll just have to figure out a way to connect it to your light stand.

If you have two Speedlites, you have several options when using hot shoe adapters.

- As shown in Figure 10.11, you can slip a Speedlite on top of the camera hot shoe adapter and run a sync cord over to the flash adapter. As you'll read in Chapter 19, *Portraits With Two And Three Speedlites*, an on-camera Speedlite can provide valuable fill light if it's used at a low power setting.

- As shown in Figure 10.12, you can run sync cords off both sides of the camera hot shoe adapter to put Speedlites to the right and left of the camera.

- As shown in Figure 10.13, you can run a sync cord out from one side of the camera-mounted adapter and then another sync cord through the other side of a flash hot shoe adapter so that you have Speedlites to the side and behind your subject.

When purchasing hot shoe adapters, you should spend the extra dollar or two and get the adapters with multiple connections. I also prefer adapters with metal feet (rather than plastic).

Of course, you must also match the ports on the adapter to your sync cord and/or optical slave (covered in the next section). A final option to look for is a test button, which will allow you to confirm that your Speedlite is operating when connected to the adapter.

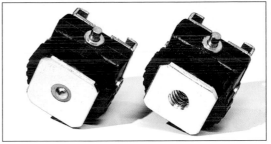

*Figure 10.10* A camera hot shoe adapter (at left) has a connector button in the bottom of the foot. A flash hot shoe adapter (right) has a ¼"-20 thread in the bottom of the foot. These are the #0064 and #0015 adapters from Flash Zebra.

*Figure 10.11* Close-up of hot shoe adapter on camera with Speedlite installed and cord running out side.

*Figure 10.12* Close-up of hot shoe adapter on camera with sync cords running out each side.

*Figure 10.13* Close-up of flash hot shoe adapter on lightstand with Speedlite mounted and sync cords running out each side.

## OPTICAL SLAVES AND INFRARED TRIGGERS

An optical slave is an electronic eye that will trigger a Speedlite when it sees a large burst of light. Since an optical slave literally works at the speed of light, it will fire an off-camera Speedlite at essentially the same time that your on-camera Speedlite fires.

+ Can mix Speedlites and other flashes
+ Relatively inexpensive
+ Eliminates cords from running through the frame
+ Enables Speedlite to be concealed within the scene
+ No batteries required
- Most optical slaves are not Canon-compatible
- Range limited to about 30′
- Must have clear line-of-sight between on-camera flash/trigger and slave
- Can be fired by other nearby cameras

### Optical Slaves: The Basics

The triggering burst for an optical slave can come from a pop-up flash or from a Speedlite or infrared trigger mounted to your camera. So, think of the optical slave as a receiver and the pop-up flash, Speedlite, or infrared trigger as the transmitter.

An optical slave is an inexpensive way to trigger an off-camera Speedlite when you want to avoid the hassle of cords and connections. They are also handy when you want to fire Canon and non-Canon flashes together.

Keep in mind, though, that an optical slave will only trigger a Speedlite. It won't set the power level. So you'll have to shoot in Manual mode rather than in E-TTL mode. (For E-TTL you can use Canon's built-in wireless system, which we will discuss at length in Chapter 11, *Wireless Speedliting, The Canon Way*.)

If you have a 580EX II, you can connect an optical slave with a PC-male sync jack directly to the Speedlite. For the rest of the pack, you'll have to attach the optical slave to a flash hot shoe adapter.

### E-TTL Confuses Optical Slaves

There are two caveats to using optical slaves with Canon Speedlites. The first is that, unless you use a special (think "expensive") digital slave, you'll have to operate your Speedlites in Manual mode. This is because optical slaves don't think. They just connect the circuit and trigger the flash when a burst of light comes along. When you are shooting E-TTL or with red-eye reduction activated, there is a pre-flash before the actual exposure. The pre-flash causes the optical slave to fire the Speedlite prematurely. All Canon pop-up flashes always emit a pre-flash—except the 7D when in Manual flash mode.

### Canon Speedlites Need A Special Optical Slave

The other issue has to do with the working voltage of Canon Speedlites. An optical slave gets its power from the Speedlite rather than from a battery. With Canon Speedlites there is the peculiarity that the voltage does not drop far enough after the flash exposure to release the typical slave circuit. Essentially, the slave thinks that the Speedlite is still firing. With ordinary optical slaves, the result is that they will fire a Speedlite once and then lock up. Fortunately, there is an optical slave with an added circuit that is made just for Canon Speedlites. And, luckily, this technology is not expensive.

### Sonia's Canon EX-Compatible Optical Slaves: Think Green

Sonia is a leading manufacturer of optical slaves. As Canonistas, the key for us is to buy the green ones. The standard yellow and orange versions are not for us. The secret to the green slaves is that they have the additional circuit that makes them compatible with the power cycle of Canon Speedlites.

Sonia offers Canon EX-compatible slaves in both mono miniphone and PC-male. The PC-male can be plugged directly into the PC socket on a 580EX II or into hot shoe adapters with PC-female ports. The mono miniphone version can be used with any hot shoe adapter that has a miniphone jack. Flash Zebra is the best source that I've found for the Sonia green optical slaves.

*Figure 10.14* Sonia's Canon EX-compatible optical slaves have a green base. The orange and yellow slaves will not work reliably with Canon Speedlites.

*Figure 10.15* Sonia's Canon EX-compatible slaves come in miniphone (left) and PC-male (right) jacks.

*Figure 10.16* The PC-male version of Sonia's optical slave will plug directly into a 580EX II. For other models, you have to also use a hot shoe adapter.

## Infrared Triggers

An infrared trigger is an alternative to firing optical slaves with an on-camera flash. While we can't see Infrared, optical slaves can.

If you have an optical slave and a hot shoe adapter already, an infrared trigger can be an inexpensive way to start with wireless flash. Another benefit—when compared to firing optical slaves via a camera-mounted Speedlite—is that the infrared trigger eliminates the look of on-camera flash.

The two downsides to infrared are that infrared does not work well outdoors in bright sun and infrared has a limited range—approximately 15'–30'. At least the infrared triggers themselves are relatively inexpensive—when compared to the cost of radio triggers.

Unlike Canon's wireless system, which relies upon a series of pulses to send detailed instructions to the slaves, an infrared trigger sends a single pulse that essentially says "fire now!" So, you cannot use an infrared trigger to communicate with Canon Speedlites directly.

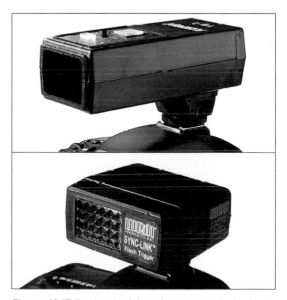

*Figure 10.17* Flashpoint (above) and Wein (below) are two manufacturers of infrared triggers. The Wein is about twice the price of the Flashpoint and offers more robust construction. Both activate optical slaves with reliability.

A manual radio trigger consists of a transmitter and a receiver. The transmitter connects to the camera via the hot shoe or a sync cable. The receiver connects to the Speedlite via a hot shoe adapter or a sync cable. Their range and price seem to be directly linked. The more you pay, the farther the signal will travel.

+ Freedom from cords

+ Freedom from line-of-sight communication

+ Can fire multiple brands of flash together

− Works in manual mode only, no E-TTL

− Can be moderately to very expensive

− Often requires special batteries

### Why Speedlites Sometimes Need X-Ray Vision

*Figure 10.18 Hiding a Speedlite in a small space often requires the use of a radio trigger.*

You don't have to be Einstein to know that light can go through glass but can't go through a brick wall. What do you do when you need to trigger an off-camera Speedlite and there is a brick wall, or a tree, or a horse between you and the Speedlite? (For now, let's say that using an extra-long cord is not an option.)

Sometimes—particularly indoors—you can do a bankshot off a lightly colored wall and bounce the flash or infrared to the slave. Outdoors, in the sun, it is almost impossible.

Further, if your Speedlite is inside something (like a mailbox), it certainly won't be able to be triggered via an optical slave or the wireless system built into your Speedlites.

Fortunately, radio waves have the ability to go through brick walls, trees, horses, mailboxes, and most of the other things around you.

### Selecting A Manual Radio Trigger

There are several considerations that go into choosing a manual radio trigger system. Here's a sampling:

■ *Price*—you have to buy at least one transmitter and one receiver. The price range goes from $45 to over $500 for a set.

■ *Range*—generally, the more you pay, the stronger the signal. It's not only the distance to consider, sometimes it's the thickness of walls.

■ *Compatibility*—think about your future. RadioPopper's JrX will work with their PX triggers, PocketWizard's Plus and MultiMAX will work with their Mini/Flex, Elinchrom's Skyports will control their portable and studio strobe systems.

■ *Other functions*—RadioPopper's and PocketWizard's manual triggers can be used to fire a camera.

### Flashpoint Radio Trigger Set

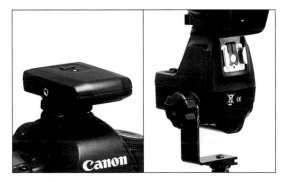

*Figure 10.19 Typical price: $45 for the set. If you are looking to try out wireless, off-camera flash without spending a bunch of money on gear, this Flashpoint Radio Trigger Set is an economical way to get started. The transmitter slips right into the hot shoe on your camera. The receiver has a metal L-bracket, which threaded so that you can screw it right onto a light stand. The swivel mount means that you don't need an umbrella swivel adapter to adjust the angle of the flash. Of course, for the price, they are not as durable nor do they have the range of more expensive triggers. Still, they are a fine way to start.*

### RadioPopper JrX

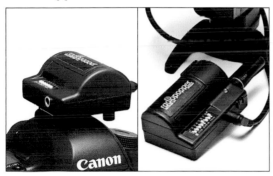

**Figure 10.20** *Typical price: $140 to $160 for the set. The JrX is a practical and affordable system. There are two flavors of the JrX receiver: Basic and Studio. The studio version enables power lever control over some popular studio strobe systems and, with an RPCube, the power levels on Canon or Nikon flashes us well. Also, if you already have the RadioPopper PX system, you can add JrX receivers to manually fire non-Canon flash, monolights, and studio packs along with PX-controlled E-TTL Speedlites.*

### Elinchrom EL Skyports

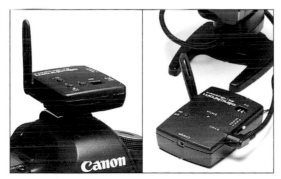

**Figure 10.21** *Typical price: $180 for the set. Skyports have a very low profile, making it easy to see over the transmitter. Uniquely, they offer four flash groups—a feature not found on most radio triggers. This enables you to do test shots with just a single group enabled. Beyond Speedliting, Skyports work with Elinchrom's larger location strobes like the mid-power Quadra RX and the high-power Ranger RX. The Skyport transmitter requires a special, single-use battery and the receiver has a rechargeable battery.*

### PocketWizard Plus II / MultiMAX

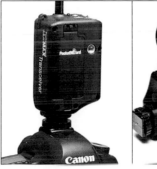

**Figure 10.22** *Typical price: $170 for each Plus II, $295 for each MultiMAX. PocketWizard's unique approach to radio triggers is that each unit is both a transmitter and receiver (a.k.a. transceiver)—so that you won't show up on location with a bag of receivers and no transmitter. These guys can be fired at a sustained rate of 12 frames per second (much faster than Speedlites can recycle). With a special cable, either can be used to fire your camera—very handy when shooting wildlife and sports. MultiMAX adds the ability to assign lights to specific zones (same as the "group" feature on the much more affordable Skyports), as well as options for 2nd-curtain sync, multiple pops, and time delay.*

### Making The Connection Between A Speedlite And A Radio Trigger

Radio triggers generally have a miniphone jack. If you have a 580EX II, buy a miniphone-to-Screwlock PC. For other models, you will have to mount your Speedlite in a hot shoe adapter. My preference is to use a hot shoe adapter that has the miniphone jack wired directly in.

**Figure 10.23** *I prefer a hot shoe adapter that is pre-wired with a miniphone jack. Using the ¼"-20 thread on the bottom, I attach it directly to the spigot on an umbrella adapter (a.k.a. swivel adapter).*

# CHAPTER 11 | WIRELESS SPEEDLITING, THE CANON WAY

## The Short Version

Canon's built-in wireless communication system allows multiple off-camera Speedlites to work together in sophisticated ways.

Although the benefits of E-TTL begin to shine in a wireless setup, you can also control your off-camera Speedlites in Manual mode. There's even a way to fire some Speedlites in E-TTL and others in Manual at the same time.

*Figure 11.1*
*Mastering Canon's wireless system takes practice. If you stick with it, your efforts will be rewarded many times over. So, call up a friend and practice, practice, practice.*

## CANON'S BUILT-IN WIRELESS SYSTEM

Beyond the speed and convenience of E-TTL, one of the best features of Canon Speedlites is the wireless system that is built into the 430- and 580-series. This system enables you to control any number of off-camera Speedlites from your camera.

### E-TTL Is The Foundation Of Canon's Wireless System

Canon's wireless system is built around the automatic capabilities of E-TTL. What is not widely known about the Canon system is that it is also possible to mix Speedlites in E-TTL and manual modes together or to control all of the Speedlites in manual mode.

The common denominator among all three approaches is that all the Speedlites must be E-TTL compatible. For situations where you want to mix Canon and non-Canon flash, you'll have to rely on sync cords, optical slaves, or radio triggers, as you learned in Chapter 10.

### Capabilities And Limitations Of Canon Wireless

*Pros*

+ no cost, built into EX-series Speedlites
+ no limit to number of Speedlites that can be controlled (provided all can see the flash coming from the master Speedlite)
+ can control different groups of Speedlites at different power levels by ratio
+ high-speed sync available via wireless
+ stroboscopic available via wireless

*Cons*

– must have line of sight between master and slaves
– bright daylight can blind slaves
– range limited to 15'–50'
– 2nd-curtain sync not available
– must have E-TTL Speedlite
– user interface tough to decipher on Speedlite LCD panel

## THE MASTER: ONE SPEEDLITE HAS TO BE IN CHARGE

A key concept of wireless Speedliting is that there is one master and one or more slaves. The master is attached directly to the camera—either via the hotshoe or an E-TTL cord. The slaves are remote Speedlites that receive instructions from the master.

### Units That Can Be A Master

For a master, you must use one of the following:

- 580EX II Speedlite
- 580EX Speedlite
- 550EX Speedlite
- ST-E2 Wireless Transmitter
- 7D pop-up flash
- Macro Ring Lite MR-14EX
- Macro Twin Lite MT-24EX

### How The Master Communicates

The master communicates with the slaves via an ultra-fast series of flashes. All of this happens so fast that it is not visible as a separate action from the actual flash.

If the master is a Speedlite, the 7D, or one of the macro lights, the main flashtube will be used to send the signal to the slaves. If the master is the ST-E2 wireless transmitter, then the instructions will be carried via a near-infrared signal that is not visible to the human eye.

### Range And Coverage Of A 580EX As Master

The 580EX (both versions; see the sidebar on page 129) is the most popular choice for a master. It has the most powerful flashtube, so it reaches farther. If you are indoors or outdoors without bright sun, a master 580EX can approach a range of 45′. If you are outdoors in bright sun, the range will drop to around 30′.

If you are working with a single slave or a few slaves that are close to each other, you can extend the range of the 580EX master by zooming the flashtube to 105mm and panning/tilting the head so that it points directly at the slave(s). This is also helpful when the slave is tucked into a softbox, like the Lastolite Ezybox hot shoe.

The horizontal coverage of the 580EX as master depends on the Zoom setting for the flashtube. If you're controlling a number of slaves that are spread out, you'll want to keep the flashtube zoomed out wide. Do not, however, drop the wide-angle diffuser as this shortens the range. When zoomed to 24mm, the horizontal spread of the 580EX is about 80°.

As discussed in detail toward the end of this chapter, by moving the master off-camera with a long E-TTL cord, you can position it in a spot that maximizes the slaves' ability to see it. This is especially helpful when shooting multiple slaves or when shooting in brilliant sun.

### Switching The 580EX Into Master Mode

1. Move the switch below the Select Wheel from Off to Master.

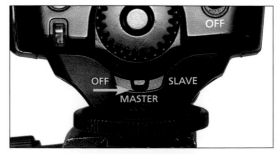

*Figure 11.2* Conveniently the 580EX has an external lever that moves the Speedlite in and out of wireless.

### Turning The 580EX II Into Master Mode Via Speedlite LCD Panel

1. Press and hold the Zoom button for three seconds.
2. If OFF is blinking, turn the Select Dial right one click. If Slave ON is blinking, turn the Select Dial left one click. Press the Set button to confirm your choice.

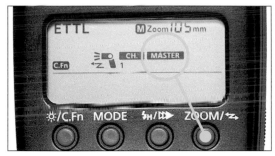

*Figure 11.3* The ZOOM button on the 580EX II is the gateway to the entire wireless menu.

### Turning The 580EX II Into Master Mode Via Camera LCD Monitor

Note: This only works for the 580EX II on a compatible (40D or later) camera. The specific steps vary by camera model—check your manual.

1. Press Menu on the camera to activate the LCD monitor.
2. Find "External Speedlite control," "Flash control," or a similar command and press the Set button.
3. Select "Flash function settings" or similar and press the Set button.
4. Scroll down to Wireless set or similar and press the Set button.
5. Select Enable in Wireless func. and press the Set button.

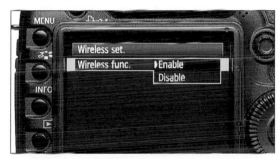

*Figure 11.4* Your camera's LCD menu may differ from this one. Check your camera's manual for details.

### Activating The 7D Pop-Up Flash As Master

The EOS 7D is the first Canon DLSR to enable the pop-up flash as a master. While the range is limited, it does mean that you can start with wireless flash with a 7D and any EX compatible Speedlite.

1. Press the flash-bolt icon to pop up the built-in flash.
2. Press Menu on the camera to activate the LCD monitor.
3. Scroll to "Flash Control" under the left camera tab and press the Set button.
4. Scroll down to "Built in flash func. setting" and press the Set button.
5. Scroll down to "Wireless func.," select the pop-up icon, and then press the Set button.

*Figure 11.5* The 7D can use either the pop-up flash as a master or a 500-series Speedlite.

---

**SPEEDLITER'S TIP**

### —580EX And 580EX II As Master—

For the most part, as far as working as a wireless master is concerned, the 580EX and the 580EX II are the same flash. Unless specifically stated otherwise, in this chapter, a reference to 580EX will mean both the 580EX and 580EX II.

The main difference is that the 580EX has an external master–slave switch (which I find quite useful). On the 580EX II, the wireless menu is activated via an internal menu selection rather than an external switch. I continue to hope a switch will be Incorporated into the EX III, whenever that might be.

On the other hand, when attached to a compatible camera—typically a 40D or newer—the EX II can be controlled via the camera's LCD monitor. With the exception of the lack of a master–slave switch, I find the 580EX II to be easier to control via the camera LCD monitor than the LCD panel on the Speedlite.

## TO FIRE OR NOT TO FIRE: THE MASTER WANTS TO KNOW

One of the issues you have to consider when setting up a wireless shoot is whether the master is *enabled* or *disabled*. By *enabled*, I mean that it will send instructions to the slaves as well as fire during the actual exposure. By *disabled*, I mean that it will communicate with the slaves, but not fire when the shutter is open.

This can get confusing, so I'll say it up front: even if you disable the master, you will see it flash. What you're seeing is the master communicating to the slaves via a series of pre-flashes right before the actual exposure. As you know, the difference between the pre-flash and the actual flash is a very thin sliver of a second.

### Why You Might Want To Disable The Master

If the master is in the hotshoe, you run the risk of killing the quality of light with on-camera flash if it fires at a powerful level. A strong blast from the master will make your picture look like a driver's license portrait.

You know my mantra—if you want to create interesting light, you also have to create interesting shadows. To have shadows that the camera can see means that the main light is coming from somewhere other than the lens axis.

### Why You Might Not Want To Disable The Master

If you are shooting a two-light setup—namely a master and a slave—then you have a legitimate reason to fire the master. If the master is on-camera (as opposed to being moved off-camera with an E-TTL cord), you'll want to use the master as a low-power fill. You do this by making the off-camera Speedlite(s) in Group B the key light and use a corresponding ratio that makes Group B more powerful than Group A ( such as 1:2, 1:4, or 1:8). Remember—the master is always a member of Group A when it is not disabled.

### Canon Makes It Hard To Tell If The Master Is Enabled Or Disabled

It used to be that I could almost see the knees on a ladybug. Today, I'm lucky if I can see the spots on her back. Likewise, it takes really keen eyesight to see the *master enabled* icon on the Speedlite LCD panel.

What you are looking for is whether or not there are three rays (lines) coming from the head of the miniscule Speedlite icon. If you see the three rays, you know the master is enabled. If you don't see the three rays, either the master is disabled or you need to find your reading glasses.

The 580EX gives you the added bit of security in that the flash bolt beneath the miniscule Speedlite icon will blink when the master is disabled. On the 580EX II the flash bolt remains on regardless of the master's status.

**Figure 11.6** *The rays in the top left frame indicate that the master is enabled. The absence of the rays in the bottom left frame indicate that it is disabled. At right is the icon on the LCD of a 580EX II.*

## Disabling/Enabling The Master On The 580EX II LCD Panel

1. Confirm that your Speedlite is set to master.
2. Repeatedly press the Zoom button to cycle through the wireless master options until you see the three rays blinking on the Speedlite icon.
3. The word Off or On will also blink with the three rays.
4. Turn the Select Dial if you need to choose the other option.
5. Press the Set button to confirm your choice.

**Figure 11.7** *Although the menu sequence varies by camera model, once you find the wireless control screen, enabling or disabling the master is easy.*

## Disabling/Enabling The Master Via Camera LCD Monitor

**Note:** This only works for the 580EX II on compatible cameras. The specific steps vary by camera model. These generic steps will get you started.

1. Press Menu on the camera to activate the LCD monitor.
2. Find "External Speedlite control," "Flash control," or a similar command and press the Set button.
3. Select "Flash function settings" or a similar command and press the Set button.
4. Scroll down to "Wireless set."
5. Scroll down to Master flash and press the Set button.
6. Scroll up or down between Enable and Disable. Press the Set button to confirm.

## Disabling/Enabling The Master On The 580EX LCD Panel

1. Confirm that the switch under the Select Dial is set to Master.
2. Repeatedly press the Zoom button to cycle through until you see the three rays blinking on the Speedlite icon. (Channel is the option just before this one.)
3. The word Off or On will also blink with the three rays.
4. Turn the Select Dial if you need to choose the other option.
5. Press the Set button to confirm.

## Disabling/Enabling The 7D Pop-Up Master

1. Press the flash-bolt button on the camera to pop up the built-in flash.
2. Press Menu on the camera to activate the LCD monitor.
3. Scroll to "Flash Control" under the left camera tab and press the Set button.
4. Scroll down to "Built-in flash func. setting" and press the Set button.
5. Scroll down to "Master flash" and press the Set button.
6. Scroll up or down between Enable and Disable. Press the Set button to confirm.

## THE SLAVE: THE WORKER BEE OF WIRELESS FLASH

Although there can only be one master, there can be any number of Speedlites in slave mode. The only limitation is that all of the slaves have to see the flashed commands coming from the master.

### Units That Can Be A Slave

For a slave, you must use one of the following:

- 580EX II / 580EX
- 550EX
- 430EX II / 430EX
- 420EX
- 380EX

You'll note that neither the 220EX nor the 270EX are on the list. Nor are the macro flash rigs. None of these can be used as a slave.

### Location Of The Slave Sensor

On Canon Speedlites, the wireless sensor is hidden behind a black panel on the front of the Speedlite. Many mistakenly believe that it is the large red panel. Actually, this is the home of the Auto-Focus Assist beam. The wireless sensor is the dark panel above.

*Figure 11.8 The slave sensor is the small black panel above the red auto-focus assist panel, shown here outlined in yellow dots on the 430EX II (left) and the 580EX II (right).*

### The Line-Of-Sight Requirement

The Canon wireless system works on a line-of-sight basis—the slave must be able to see the flashes coming from the master. The advantage of the 580EX as master is that it can be zoomed and panned/tilted so that the beam hits the slave. If you have several slaves, panning the master might not be an available option. For these situations, I move my master off-camera with a long E-TTL cord and mount it to a stand in a spot where all the slaves can see it.

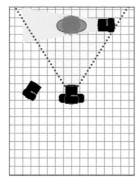 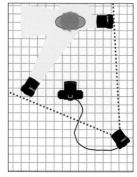

*Figure 11.9 Left: there are many times when I want to place my slaves outside the zone that an on-camera master can cover. Right: a long E-TTL cord enables me to move the master off-camera and position it where it can cover all the slaves.*

Keep in mind that you should pan the head on your slave so that the sensor faces the master and the flashhead faces your subject—especially outdoors in bright sunlight.

Also, if you are shooting indoors in a room with light-colored walls, you might find that the master signal will bounce around objects like furniture or pillars and stairs.

To confirm that a slave can see the master, fire a test flash by pushing the Pilot button. The slaves will respond by firing Group A, Group B, and then Group C.

If a slave does not respond, confirm that it is on the same Channel as the master, that it is powered on, and that it is facing the master.

*Figure 11.10 Press the Pilot button on the master to test fire the slaves by group.*

### Switching A 580EX Or 430EX Into Slave

1. Move the switch below the Select Wheel from Off to Slave.

**Figure 11.11** *The external lever on the 580EX (above) and the 430EX gets the Speedlite into slave mode quickly. Just move it all the way to the right.*

### Turning The 580EX II Into Slave Mode Via Speedlite LCD Panel

1. Press and hold the Zoom button for three seconds.
2. If OFF is blinking, turn the Select Dial right two clicks. If Master ON is blinking, turn the Select Dial right one click. Press the Set button.

**Figure 11.12** *To switch the 580EX II into slave mode, hold the Zoom button down for 3".*

**Note:** You cannot activate a 580EX II as a slave via the camera LCD monitor. The camera assumes that a wireless Speedlite attached to it is always a master—so there is no menu option on the camera to activate a slave.

### Turning The 430EX II Into Slave Mode Via Speedlite LCD Panel

1. Press and hold the Zoom button for three seconds.
2. Press the right Select button until Slave appears in the LCD panel. Press the Set button to confirm your selection.

**Figure 11.13** *To switch the 430EX II into slave mode, hold the Zoom button down for 3".*

### The Slave's Ready Indicator

A slave will let you know that it is recycled and ready to receive by blinking a light through the red panel on the front. I find this a helpful way to confirm that a Speedlite is in slave mode. If the blinking is bothersome, a bit of gaffer's tape will solve the problem. By the way, the master does not blink; just the slaves do.

**Figure 11.14** *The red auto-focus assist panel on the 580EX II (left) and the 430EX II (right) blinks to indicate that the Speedlite is in slave mode.*

## Auto Power Off/Slave Auto Power Off

As a power-saving feature, Speedlites have an Auto Power Off function that turns the power off automatically after a few minutes without use. When using a Speedlite as a slave, this can be a hassle.

As a general rule, I disable the Auto Power Off on all my Speedlites. I do this via the Speedlite Custom Functions (C.Fn.) menu, which is specific to each model:

- 580EX II: C.Fn-01 set to 1–Disabled
- 580EX: C.Fn-14 set to 1–Off
- 430EX II: C.Fn-01 set to 1–Disabled
- 430EX: C.Fn-01 set to 1–Off

Additionally, Speedlites have a slave Auto Power Off timer that puts the slave to sleep after either 10 minutes or 60 minutes of inactivity. I make sure that all my Speedlites are set to the 60-minutes setting:

- 580EX II: C.Fn-10 set to 0–60 minutes
- 580EX: C.Fn-4 set to 0–60 minutes
- 430EX II: C.Fn-10 set to 0–60 minutes
- 430EX: C.Fn-02 set to 0–60 minutes

Even though the feature is Auto Power Off, it really just puts them to sleep. You can reactivate your slaves by pushing the Pilot button on the master, which fires a test flash.

## Zooming A Slave

The master communicates many details to the slave. If you change the master from E-TTL to manual mode, the slave will change to Manual during the next pre-flash. If you activate High-Speed Sync on the master, the slave will do the same.

One detail that is not communicated by the master to the slave is the Zoom setting. By default, when set to slave mode, a Speedlite will automatically zoom its flash head to 24mm. If you manually Zoom the master to 105mm, the slave will not follow. You have to do this by hand. I consider this to be a benefit as it allows me to control the Zoom setting for each Speedlite individually.

## CHANNELS: EVERYONE HAS TO BE THE SAME

There are four channels in the Canon wireless system, simply numbered 1–4. All the Speedlites, both master and slave(s), have to be on the same channel. If your master is on Channel 3 and your slaves are on Channel 4, they will not communicate.

Essentially the purpose of channels is to facilitate a way for up to four Canon shooters to shoot wireless flash in the same area. If you are working in the vicinity of other Canon photographers, introduce yourself and sort out what channel each of you will use. As long as you are on separate channels, you will not interfere with each other's lighting.

If a remote Speedlite does not fire, the first thing to check is that it is in slave mode. The second thing to check is that it is on the same channel as the master.

### Selecting A Channel On The 580EX II Via Speedlite LCD Panel

1. Confirm that the 580EX II is in master or slave mode. If not, follow the appropriate instructions as listed previously.
2. Repeatedly press the Zoom button to cycle through until CH blinks.
3. Turn the Select Dial to 1, 2, 3, or 4.
4. Press the Set button to confirm your choice.

*Figure 11.15* Pressing the Zoom button will cycle through the wireless control options. When CH blinks, turn the Select Wheel to choose the channel, then hit the Set button to confirm your choice.

### Selecting A Channel On The 580EX

1. Confirm that the switch under the Select Dial is set to either Master or Slave.
2. Repeatedly press the Zoom button to cycle through until CH blinks.
3. Turn the Select Dial to 1, 2, 3, or 4.
4. Press the Set button to confirm your choice.

### Selecting A Channel On The 580EX II Via Camera LCD Monitor

**Note:** This only works for the 580EX II as master on a compatible (40D or later) camera. The specific steps vary by camera model. These generic steps will get you started.

1. Press Menu on the camera to activate the LCD monitor.
2. Find "External Speedlite control," "Flash control," or a similar command and press the Set button.
3. Select "Flash function settings" or similar and press the Set button.
4. Scroll down to "Wireless set."
5. Scroll down to Channel and press the Set button.
6. Scroll up or down to the channel of your choice. Press the Set button to confirm your choice.

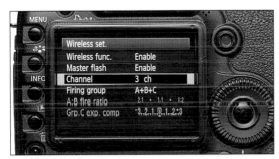

*Figure 11.16* *Although the menu sequence varies by camera model, once you find the wireless control screen, setting the channel is very easy.*

### Selecting A Channel When Using The 7D Pop-Up Flash In Master Mode

1. Press the flash-bolt button on the camera to pop up the built-in flash
2. Press Menu on the camera to activate the LCD monitor.
3. Scroll to "Flash Control" under the left camera tab and press the Set button.
4. Scoll down to "Built-in flash func. setting" and press the Set button.
5. Scroll down to Channel and press the Set button.
6. Scroll up or down to the channel of your choice. Press the Set button to confirm your choice.

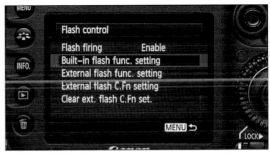

*Figure 11.17* *The 7D is the first Canon DSLR to enable the pop-up to work as a master. All of the wireless settings for the pop-up are controlled via the camera's LCD monitor. This is the screen through which you assess the controls for the pop-up flash—including the wireless functions.*

---

### SPEEDLITER'S JARGON

#### —When Off Does Not Really Mean Off—

On the original 580EX there is a lever labeled "Off–Master–Slave" and on the 430EX there is a lever labeled "Off–Slave." Do not be tricked into thinking that this turns the Speedlite off. In both cases, "Off" means that the Speedlite is working in normal mode and that the wireless mode is turned off.

## GROUPS: ASSIGNING SPECIFIC JOBS TO SPECIFIC SPEEDLITES

One of the benefits of shooting Canon's wireless system is that you can control multiple Speedlites at different power levels. For instance, you can use Speedlites in two different groups so that you can adjust the amount of key and fill light wirelessly from your camera. In another situation, you might want to adjust the power levels separately for the key light hitting your subject and the background light.

Any time that you want Speedlites to operate at different power levels, you assign them to different groups. Canon officially calls them slave ID groups. Everyone else just calls them groups.

The Canon system has three groups: A, B, and C. By default, the master is always a member of group A (so you'll never set a group on a master). Slaves can be in A, B, or C...but don't stop reading right here.

Canon's method of controlling an E-TTL group C is a bit of a workaround. I recommend that, when shooting E-TTL, you use groups A and B and avoid a group C. When shooting all the Speedlites wirelessly in Manual, then group C is as easy to run as groups A and B.

### Selecting A Slave ID (Group) On The 580EX II Via Speedlite LCD Panel

1. Confirm that the 580EX II is in slave mode. If not, follow the appropriate instructions as listed on page 133.
2. Repeatedly press the Zoom button to cycle through until A, B, or C blinks to the right of SLAVE.
3. Turn the Select Dial to choose the desired group.
4. Press the Set button to confirm your choice.

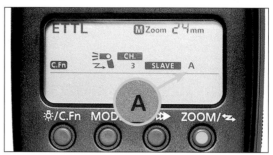

**Figure 11.18** *Pressing the Zoom button will cycle through the wireless control options. When the A, B, or C next to Slave blinks, turn the Select Dial to choose another channel, then hit the Set button to confirm your choice.*

**Note:** If you have a Speedlite attached to a camera, the camera assumes that it is a master. So, in order to set the group on a slave, it should be removed from the camera.

### Selecting A Group On The 580EX

1. Confirm that the switch under the Select Dial is set to Slave.
2. Repeatedly press the Zoom button to cycle through until SLAVE blinks.
3. Turn the Select Dial to change to A, B, or C.
4. Press the Set button to confirm your choice.

### Selecting A Group On The 430EX II Via Speedlite LCD Panel

1. Confirm that the 430EX II is in slave mode. If not, follow the appropriate instructions as listed on page 133.

2. Repeatedly press the Zoom button to cycle through until A, B, or C blinks to the right of SLAVE.

3. Press the left or right Select button to choose the desired group.

4. Press the Set button to confirm your choice.

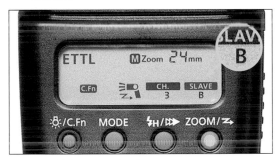

*Figure 11.19* Pressing the Zoom button will cycle through the wireless control options. When the A, B, or C next to Slave blinks, turn the Select Wheel to choose another channel, then hit the Set button to confirm your choice.

**Note:** It is not possible to set slave function via a camera LCD monitor as the camera will always assume that the connected Speedlite is the master.

### Selecting A Group On The 430EX

1. Confirm that the switch under the Select Dial is set to Slave.

2. Repeatedly press the Zoom button to cycle through until SLAVE blinks.

3. Press the left or right Select button to choose A, B, or C.

4. Press the Set button to confirm your choice.

## GETTING RATIONAL ABOUT RATIOS

The whole point of assigning Speedlites to different groups is so that you can fire them off at different power levels. If you are shooting E-TTL, the way to automatically adjust the power levels of your different groups is by a ratio. Essentially, you establish the relationships between the groups and then E-TTL drives the whole power level up or down as needed.

**Note:** Ratios are E-TTL only. If you are shooting in Manual mode, you adjust the power level of each group individually. See pages 146–147 for details.

### In A Simple, Balanced World Where Cats And Penguins Rule

Canon's brief coverage of ratios in the various Speedlite user manuals shows two Speedlites placed symmetrically and equidistant from the subject (originally a cat and later a penguin). The diagrams show two Speedlites the same distance from the subject about 40° left and right of the camera.

I have no problem with this, provided that the exploration of ratios does not stop there. Unfortunately, in the Canon manuals, it does.

Canon's explanations and tutorials are based on the assumption that the Groups A and B are always between the camera and the subject.

As you've likely guessed already, I routinely break these guidelines. So, pay attention to the lighting diagrams for the shoots throughout the *Handbook*. You will see that I often put the slave(s) to the side, or behind me, or behind the subject.

*Figure 11.20* The original Canon wireless cat, circa 1995, and the first-generation Canon wireless penguin, circa 2000.

## The Right And Left Of Ratios

In Canonese, a ratio for two groups is expressed as group A to group B (A:B). So, when you are looking at the ratio scale on the LCD panel of your master Speedlite or on the LCD monitor of your camera, the left side is always group A and the right side is always group B.

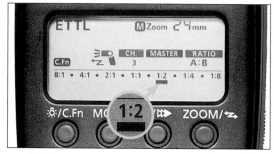

*Figure 11.21* This display on the LCD panel of a 580EX II indicates a ratio of 1:2.

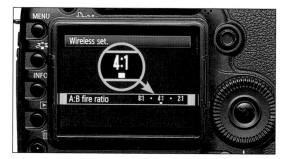

*Figure 11.22* This display on the LCD monitor of a 5D Mark II indicates a ratio of 4:1.

Understand that we're talking about the ratio scale, not the placement of your Speedlites. You are certainly free to place the group B Speedlites on the left side of the subject and the group A Speedlites on the right side (or wherever else you want).

However, when you do this, you have to remember that if you want the left side to be brighter, you have to move the ratio farther to the right on the scale.

I like to keep things simple. So, I always try to have my Group A Speedlites on the left side and my Group B Speedlites on the right side of my subject.

## Converting Ratios To Stops

I concede that Canon's ratio approach is different and that it seems antiquated. I don't care for it. I'd rather have an EV scale. Yet, Canon's ratios are what they are. So, I've learned to decode ratios into stops and quit whining about the jargon a long time ago.

As you can see in Figure 11.21 at left, the ratio scale runs from 8:1 on the left to 1:1 in the center to 1:8 on the right. Simply stated, 8:1 means that Group A is eight times brighter than Group B. 1:1 means that they are equal. 1:8 means that Group B is eight times brighter than Group A.

Now, please, please, please don't fall into the trap of thinking that 8:1 or 1:8 means that one side is eight stops brighter than the other. The truth is that it means one side is three stops brighter than the other. Confused? Don't worry, we'll go through the math slowly.

The first thing to remember when converting ratios to stops is that to change a flash or camera setting by one stop means that you have either doubled the light or cut it in half.

Now, to start with the math, if you have a 1:1 ratio, that means that the illumination from both sources is equal.

*Figure 11.23* In a 1:1 ratio, both sides are equally illuminated.

Now, if you double the illumination on the left side, you have increased it by one stop. Since we have twice as much illumination on the left side as on the right side, we have a ratio of 2:1.

*Figure 11.24* In a 2:1 ratio, the left side is a stop brighter than the right side.

Let's increase the illumination on the left side again by exactly one stop. So what's the new ratio? Did you say 3:1? Sorry. To increase something by a stop, you double it. So double two and you have...four. The new ratio is 4:1, which means that the left side is two stops brighter than the right side.

*Figure 11.25* In a 4:1 ratio, the left side is two stops brighter than the right side.

**Final round question:** If you increase the brightness of the left side again by exactly one stop, what's the ratio? Doubling four is easy. The new ratio is 8:1. From the beginning, how many times have we doubled the light? Three. 1→2→4→8. So 8:1 is a three-stop difference.

*Figure 11.26* In an 8:1 ratio, the left side is three stops brighter than the right side.

By the way, if the ratios are 1:2, 1:4, or 1:8, then the majority jumps to the other side.

## Speedlite Location Affects Precision Of Ratios

While a 1:4 ratio means that group B is emitting four times more light, it does not necessarily mean that four times more light is landing on that side of your subject.

Thanks to the Inverse Square Law, the farther your Speedlite is from your subject, the dimmer it appears. So, if group B is not exactly the same distance away from the subject as group A, the ratio of light hitting your subject won't be exactly 1:4. It could be more. It could be less.

Do I worry about this? Absolutely not. For me, using ratios is not about precision. It's about speed and convenience. If I start at 1:4 and need a bit more light on the group B side, I'll slide the ratio over to the dot between 1:4 and 1:8 (which is 1:6) and shoot another test shot.

## Think Of Ratios As A Way To Increase or Decrease Contrast

A simple model to keep in mind when starting out with ratios is that you can use them to create contrast on a subject. If your Speedlites are equidistant from the subject and from the lens, then at a 1:1 ratio, both sides of your subject will be equally lit.

When you slide the ratio over to 8:1, the left side of the subject will be bright and the right side in deep shadow. You have just used the ratio to create contrast on your subject.

---

### SPEEDLITER'S TIP

#### —Ratios Beyond Three Stops—

The limit of Canon's ratios is three stops. So what if you want to increase or decrease the amount of light to be more than three stops?

One option is to switch the Master to manual mode and then set the power level for each Group accordingly. See pages 146–147 for details.

Another option is to move your Speedlite(s) closer or farther from the subject. This is not as precise as switching to Manual and adjusting the power individually.

---

## A:B RATIOS: SPLITTING UP THE LOAD BETWEEN TWO GROUPS

There are many ways to set up two-group lighting. On this spread we'll look first at a traditional setup with hard lights at the same distance from the subject and 45° on the lighting compass to the left and right of the subject. Then we'll look at the same with soft lights.

### Hard / Soft Light With Ratios For Portraits

The persona of a photograph is often conveyed by the hardness of the light and the contrast across the face. These shots were made with the A and B lights equidistant from the subject. The images on this page were shot with a bare, unmodified flash. The images opposite were shot with a pair of softboxes—specifically 24" Lastolite Ezyboxes.

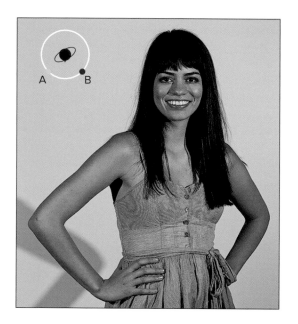

In the hard light series on page 140, notice how the density of the arm shadow in the lower corner increases as the ratio changes.

*Figure 11.27 (opposite, top left) hard light at 1:1.*

*Figure 11.28 (opposite, top right) hard light at 1:2.*

*Figure 11.29 (opposite, bottom left) hard light at 1:4.*

*Figure 11.30 (opposite, bottom right) hard light at 1:8.*

In the soft light series below, notice that there is no arm shadow because the softbox was able to reach around Mallory.

*Figure 11.31 (this page, top left) soft light at 1:1.*

*Figure 11.32 (this page, top right) soft light at 1:2.*

*Figure 11.33 (this page, bottom left) soft light at 1:4.*

*Figure 11.34 (this page, bottom right) soft light at 1:8.*

## Ratio Between On-Camera Fill And Off-Camera Key

If the master is on-camera (as opposed to being moved off-camera via an E-TTL cord), I will almost always disable it so that it does not add a bunch of unflattering on-camera flash to the scene. The only time that I will not disable the on-camera master is when I'm using it to create on-axis fill light.

In these examples, the off-camera key light (Group B) is at 45° right on the lighting compass and the same distance from the subject as the on-camera master/fill flash (Group A).

*Figure 11.35 (top left)* on-camera fill at 1:1.

*Figure 11.36 (top right)* on-camera fill at 1:2.

*Figure 11.37 (bottom left)* on-camera fill at 1:4.

*Figure 11.38 (bottom right)* on-camera fill at 1:8.

## Ratio Between Opposing Off-Camera Speedlites

Interesting light happens when the subject is caught in the crossfire between two lights that are facing each other. (Trade secret: this is one of my favorite lighting setups.) In these shots, the key (group A) is at 45° right on the lighting compass and the rim (group B) is at 135° left.

This means that the key light is in front of the subject and the rim light is behind. Both are equidistant from the subject.

*Figure 11.39 (top left)* crossfire lighting at 1:1.

*Figure 11.40 (top right)* crossfire lighting at 1:2.

*Figure 11.41 (bottom left)* crossfire lighting at 1:4.

*Figure 11.42 (bottom right)* crossfire lighting at 1:8.

## A:B C RATIOS: THREE-GROUP E-TTL

Placing your Speedlites into three groups can provide you with the traditional key, fill, and background lights. If used a bit more boldly, it can also provide you with key, fill, and rim light. If you are willing to experiment, you will discover far more ways to light a penguin than the Canon engineers ever envisioned.

### Canon's View Of Three-Group Photography

Canon's view of three-Group setups is very specific. Groups A and B light the subject. Group C lights the background.

*Figure 11.43* *My homage to the infamous 3-group lighting diagram in the 580EX II user manual—group A is 45° left, group B is 45° right, and group C is on the background. Note: use of a penguin is optional.*

Per the manual, groups A and B are controlled through an A:B Ratio. Group C is controlled via Flash Exposure Compensation, but not the same FEC that controls the overall level of lighting. Are you confused? I totally understand. Let's go through it all, slowly.

You already know about A:B (two-group lighting). So, actually you know about two-thirds of what there is to know about three-group lighting. The first few steps involve getting the light on your subject to look how you want it to look. For that step, you work the A:B Ratio as discussed in the previous section.

The next step is to get the light on the background to look how you want it to look. This is essentially a matter of dialing Flash Exposure Compensation up or down to taste.

There are three ways to set Group C in E-TTL:

- on the master Speedlite LCD panel
- on the Group C Speedlite(s)
- on the camera LCD monitor

### Setting Group C Via Master 580EX II LCD

Setting the Group C FEC directly on the Speedlite can be a bit cryptic. If you have the gear, I suggest that you set it via the camera LCD monitor. If you don't, here are the steps for setting it on the master Speedlite's LCD panel.

1. Press and hold Zoom button for three seconds to activate Wireless menu.
2. Turn the Select Dial so that "Master On" appears. Press the Set button.
3. Press the Zoom button to cycle through the choices. When Ratio blinks, turn the Select Dial so that A:B C appears. Press the Set button.
4. Turn the Select Dial to the desired A:B ratio. Press the Set button.
5. Press the Set button four times. It will cycle through FEC, FEB, A:B Ratio, and then Ratio C. You are looking for "Ratio C" to blink.
6. Turn the Select Dial to the desired FEC for Group C. Press the Set button.

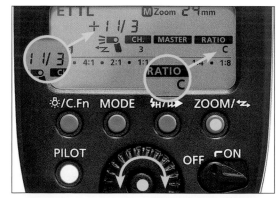

*Figure 11.44* *Step 5—After the ratio mode on the Speedlite is set to A:B C, you first set the A:B ratio as you would for a two-group setup. The key to setting the FEC for group C is to push the Set button four times.*

## Setting Group C Via Slave LCD Panel

This can be much faster than setting the Group via the master. However you have to walk over to the Group C slave(s) and do it by hand. The following works for the 580EX II, 580 EX, 430 EX II, 430 EX.

1. Confirm that the Speedlite is in slave mode and set for Group C.
2. Press the Set button. You will see the FEC icon **⚡** blink.
3. Turn the Select Dial until the desired amount of Group C FEC appears.
4. Press the Set button.

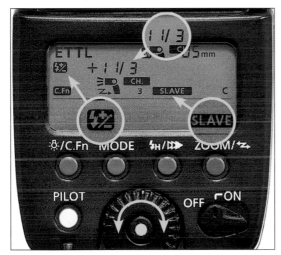

*Figure 11.45 If you don't mind taking a walk, an easy way to set the FEC for group C is to do it manually on each group C speedlite—the same way that you would normally dial in FEC by turning the Select Dial and then hitting the Set button.*

---

### SPEEDLITER'S TIP

#### Running Group C In Manual

The nature of a background light is that the distance between the Speedlite and the background does not vary. So, if you find the A:B C approach to be a bit cumbersome because of all the button-pushing required to get Group C activated and adjusted, consider running the background light in Manual while lighting the subject in E-TTL. To learn how to do this, check out pages 148–149.

## Setting Group C Via Camera LCD Monitor

**Note:** This only works for the 580EX II as master on a compatible (40D or later) camera. The specific steps vary by camera model. These generic steps will get you started.

1. Press the Menu button on the camera to activate the LCD monitor.
2. Find "External Speedlite control," "Flash control," or a similar command and press the Set button.
3. Select "Flash function settings." Press the Set button. (Some cameras do not have this step.)
4. Scroll to "Wireless set." or similar. Press the Set button.
5. Scroll to "Wireless func." Press the Set button.
6. Scroll to "Enable." Press the Set button.
7. Scroll to "Firing Group." Press the Set button.
8. Scroll to "A:B: C." Press the Set button.
9. Scroll to "A:B Ratio." Press the Set button.
10. Scroll to the desired ratio. Press the Set button.
11. Scroll to "Grp.C exp comp." Press the Set button.
12. Scroll to the desired FEC for Grp.C. Press the Set button.

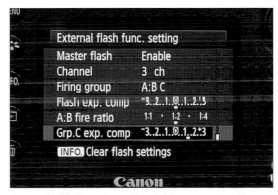

*Figure 11.46 If you have the right gear, setting the FEC for group C is quite easy on the camera's LCD.*

## WIRELESS SPEEDLITING IN MANUAL ONLY

So far, we've spent the entire chapter talking about wireless Speedliting in E-TTL mode. If you prefer to fire your Speedlites in Manual, you can still use Canon's built-in wireless system.

You don't even need to touch the slaves—meaning that you don't have to walk over to each and put it into Manual. As long as they are in slave mode, their settings will change per the master's instructions during the next pre-flash—including the switch from E-TTL to Manual.

So, if you like to work in manual mode, but want to escape the hassle of setting the power levels on several Speedlites by hand, then this will become your favorite wireless workflow.

For a wireless workflow that enables you to fire some Speedlites in E-TTL and others in Manual at the same time, see the next section on *Free-Agent Wireless*.

Also, don't think that wireless Manual is the way to get your Canon Speedlites to fire with other types of gear. It's not. The master still communicates with the slaves via a series of pre-flashes—which will trick optical slaves into firing prematurely.

## Setting Up Wireless Manual Via LCD Panel On A 580EX II Or 580EX

1.  Confirm that the camera-mounted Speedlite is in master mode. If it is not, activate the master per the instructions on pages 128–129.

2.  On the master, press Mode so that M is displayed. The other two options are E-TTL and Multi.

3.  Press the Zoom button repeatedly until Ratio blinks.

4.  Turn the Select Dial to choose either A:B (two groups) or A:B:C (three groups). Press the Set button to confirm your choice.

5.  Turn the Select Dial so that A is underlined. Press the Set button. A will now start blinking.

6.  Turn the Select Dial to the power level you want for Group A. Press the Set button to confirm your choice.

7.  B will now be underlined. Turn the Select Dial to the power level you want for Group B. Press the Set button to confirm your choice.

8.  If you are in A:B:C, C will now be underlined. Turn the Select Dial to the power level you want for Group C. Press the Set button to confirm your choice.

9.  Keep in mind that the master is always part of Group A. If you do not want it to flash, you must disable it. See pages 130–131 for instructions.

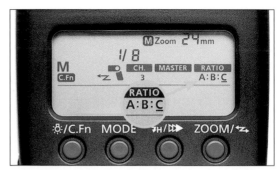

*Figure 11.47 When you switch modes on your master, the slaves will automatically switch during the next pre-flash. Controlling the power level of two or three groups of Speedlites in manual is easy. Here the power level for group C is at 1/8-power.*

## Setting Up Wireless Manual Via Camera LCD Monitor

**Note:** This only works for the 580EX II as master on a compatible (40D or later) camera. The specific steps vary by camera model.

1. Press Menu on the camera to activate the LCD monitor.

2. Find "External Speedlite control," "Flash control," or a similar command and press the Set button.

3. Select "Flash function settings" or a similar command and press the Set button. (Some cameras don't have this step.)

4. Scroll to "Flash mode." Press the Set button.

5. Scroll to "Manual flash." Press the Set button. You'll then jump back to Flash Function Settings.

6. Scroll down to "Wireless set." or similar and press the Set button.

7. Scroll down to "Wireless func." and press the Set button.

8. Scroll to "Enable." Press the Set button to confirm your choice.

9. Scroll to "Firing group." Press the Set button.

10. Scroll to "A+B+C" (one group), "A:B" (two groups) or "A:B:C" (three groups). Press the Set button.

11. Scroll to "Group A Output," press the Set button, scroll to the desired power level, and press the Set button again.

12. Repeat step 11 as needed for B and C.

*Figure 11.48* Step 2—here is External Speedlite control on the 5D Mark II. Your camera may be different.

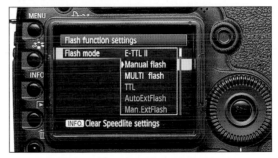

*Figure 11.49* Step 5—select Manual flash as your flash mode under Flash function settings.

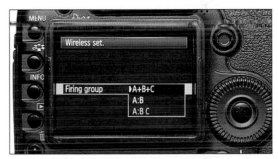

*Figure 11.50* Step 10—select A+B+C for one-group, A:B for two-group, or A:B:C for three-group setups.

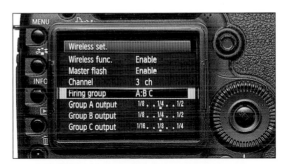

*Figure 11.51* Steps 11 and 12—scroll down to set the power level for each flash group.

*Figure 11.52* Steps 11 and 12—here the power level for Group B is set at ⅛.

## FREE-AGENT WIRELESS: FIRING SPEEDLITES IN E-TTL AND MANUAL TOGETHER

It's not widely known that Canon's built-in wireless system enables you to fire Speedlites in E-TTL and Manual at the same time. In fact, the 580EX II user manual does not even explain this technique.

So, I'll jump in and coin the phrase "free-agent wireless" to describe a shoot that involves the use of both E-TTL and Manual control of Speedlites at the same time.

### Some Ideas About Mixing E-TTL And Manual

As you'll recall, E-TTL is well suited for situations where the distance between the Speedlites and the subject is dynamic. Manual is more suited for situations where the distance between the lights and subject is fixed. What kind of situation would give you the desire to use both E-TTL and Manual at the same time?

A perfect situation is one where you have a background element or prop that you are lighting separately from the subject. Typically, you would want the lighting on this background element to remain consistent.

### Setting Up A Slave For Manual Shooting Via 580EX II LCD Panel

You can use any number of Manual mode Speedlites in free-agent wireless—each at their own power level. Further, you can use any E-TTL wireless mode you desire—A:B, A:B C, or A+B+C. There's nothing you do on the master to shoot free-agent wireless. You just have to activate the Manual mode slave(s) in the following manner:

1.  Confirm that the Speedlite is set to Slave mode.

2.  Hold down the Mode button for three seconds. M will blink on the left side of the LCD panel. Press the Set button.

3.  The M and the power level indicator (1/1) will blink. Turn the Select Dial to the level you want. Press the Set button.

4.  M will continue to blink while it is in free-agent wireless.

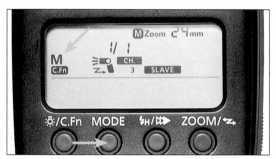

*Figure 11.53* Step 2—hold down the Mode button for three seconds so that the M blinks on the left side of the screen.

---

---

## Comparing Free-Agent Wireless To Three-Group E-TTL

If you find the button sequences to activate and control a Group C to be cumbersome, you may prefer to shoot in free-agent wireless. Besides the ease of setting up manual units for use with E-TTL slaves, free-agent wireless offers additional benefits in a couple of other areas.

Consistent background illumination: In three-group E-TTL, the background illumination can change if you apply Flash Exposure Compensation to raise or lower the power of the group A and B lights. (This is the normal FEC, not the FEC you dialed in specifically to control group C.) So, if you shoot group C in free-agent wireless, the background lighting will not change when you dial the other lights up or down with FEC.

**Power level of manual units:** In three-group E-TTL, you are limited to exactly three different power levels—one each for groups A, B, and C. In free-agent wireless, you can run any number of Speedlites, with each manual unit slaved at its own power level.

*Figure 11.54* The optical slave on a studio pack (shown above) will be tricked into firing by the E-TTL pre-flash.

*Figure 11.55* With a bit of gaffer's tape you can shield the studio pack's slave so that it only sees the flash from the slaved Speedlite in free-agent wireless.

## MOVING YOUR MASTER OFF-CAMERA—WAY OFF CAMERA

I know, in a chapter on wireless Speedliting, it seems like cheating to bring up a corded solution. Yet, I must share a secret. Figuring out that I could move the master off-camera via an extra-long E-TTL cord was a quantum leap for my Speedliting. I now do this all the time when shooting multiple Speedlites.

By extra-long, I mean 20′ to 30′. By E-TTL cord I mean one that maintains full communication between the camera and Speedlite. Here's a round-up of the ways that I've put an off-camera master to work.

### Master As Off-Camera Key Or Fill Light

For the cost of the extra-long E-TTL cord ($50–$75) you can bring the master back into the mix as either an off-camera key or fill light. As I said earlier in this chapter, I almost always disable the on-camera master. So essentially I have a $400+ communicator on top of my camera. Using the long cord enables me to keep the master Speedlite in a spot where it can contribute valuable light to the image.

### Run Master Over To The Window To Talk To Slaves Outside

I learned this from Joe McNally, who connects a couple of coiled Nikon cords together, and then added my favorite cord to make it easier. In every one of Joe's workshops that I've attended as a student, assistant, or producer, he demonstrated a shot where he links three Nikon off-camera cords together (essentially the same as Canon's OC-E3 cord) and fires a master Speedlight out the window at slaves gelled with CTO.

You'll see a number of my shots that were inspired by Joe's technique later in the *Handbook*. For now, know that a long, straight E-TTL cord is much easier to manage than three coiled cords attached end-to-end. The coiled cords want to swing in the air between the camera and Speedlite. A long, straight cord will drop to the floor and stay out of the way. I've even been able to hide the cord and master in frame because of its length and flexibility. Coiled cords just can't do this.

### Control Master And Slaves Inside A Softbox

You'll get softer light anytime that you can fire off a light inside a softbox rather than from the back. Fortunately, there are a number of softboxes that either were designed for or can accommodate two or more Speedlites inside. My two favorites in this category are the FourSquare by Lightware and the Apollo by Westcott—as you will read in Chapter 14.

The challenge becomes how to control any number of Speedlites when the line of sight is broken by the opaque sides of the softbox. Sure, manual radio triggers are an option. But then you have to adjust the power level on each Speedlite by hand. E-TTL radio triggers are another solution, but they're expensive. Now I prefer to control the master inside the softbox via the E-TTL cord and let it control the slaves.

### Positioning The Master Where The Slaves Can See It

It's widely known that I'm a fan of dimming the sun by firing off a bunch of Speedlites in high-speed sync (HSS). The cover of this book is an example. There are two challenges in doing midday HSS with a bunch of Speedlites: (1) the sun can make it difficult for the slaves to see the commands coming from the master and (2) the slaves might be too spread out for an on-camera master to hit them all.

An extra-long E-TTL cord solves both problems. First, I look for a spot that all the slaves can see without being blinded by the sun. Then I move the master to that spot and mount it on a stand.

## RADIO OPTIONS FOR WIRELESS E-TTL

The only real limitation of Canon's built-in wireless system is its reliance on a line-of-sight technology. There are plenty of times when I want to park a Speedlite in a way that breaks the visual connection. Fortunately, in the past few years, radio E-TTL triggers became a reality.

### Situations When Line Of Sight Is A Problem

**Bright sun:** The ability of a slave to see the flashes from a master is reduced when you are shooting in bright sun. If the sun is coming straight over your back, the slaves must look straight into it.

**Distance:** The outer range of a master is 50' or so. It's not often that I need to push a Speedlite out that far, but when I do, I'd prefer to not have to worry if that distant slave fired or not.

**Spread out:** The typical spread for a master Speedlite is 80°. It is not uncommon when shooting close to have the Speedlites positioned over a much wider range of angles. For instance, If you have Speedlites to the right and left of the subject, from the camera's perspective the lights might be 150° or more apart.

**Inside/outside:** If you are shooting indoors and want to create the look of sunlight coming in through a window, the Speedlite(s) must be outside. If you are shooting from a voyeur's perspective outside and want to create the look of roomlight, the Speedlites will be inside. Either way, it is likely that a wall will be in the way.

**Behind a softbox or beauty dish:** When you are shooting with a bulky modifier, such as the Lastolite EzyBox or the Kacey Beauty Reflector, the bulk of the modifier will often break the line-of-sight connection.

**Inside softbox:** The best light from a softbox happens when the light source is inside the softbox. There are softboxes, like the Four-Square and the Apollo, designed specifically to have the lights inside.

**Events:** When shooting an event, the last thing that a mobile photographer wants to worry about is whether his master is pointed at the slave(s).

### Why Radio E-TTL Is Such A Miracle

Canon's wireless system is based on the master sending a binary code to the slaves. A binary code is one where each bit is either "yes" or "no"—In the Speedlite's case, a flash or no flash. The whole message is configured based on the timing of the flashes. If there's even a small amount of delay in the timing, the message can change completely because a no becomes a yes and the problem multiplies down the timeline.

In the case of E-TTL radio triggers, they have to intercept the signal coming from the master, convert it to radio, transmit it, receive it, decode it back for the slave, and then communicate it to the slave—all within a timeline that has microseconds of tolerance for drift. Every time I use E-TTL triggers, I still marvel that they work.

### Comparing An E-TTL Trigger To A Manual Trigger

There are any number of radio triggers that can say, "Fire now!" These manual triggers can compete on price or extremely long range, but they require that you adjust the power level on your Speedlite(s) by hand.

An E-TTL radio trigger, on the other hand, provides the convenience of automatic power calculations, Flash Exposure Compensation, ratios, and so on. Speed and convenience are the two advantages that an E-TTL trigger has over a manual trigger.

CHAPTER 12 | **MIXING CANON SPEEDLITES WITH OTHER LIGHTS**

### The Short Version

Speedlites, by themselves, are versatile light sources. There are times, however, when you will either have to or want to shoot Speedlites with other lights—such incandescent lights, fluorescent lights, or other types of flash.

This chapter takes a look at the how and why of using Speedlites with many other types of light sources. We'll also consider what adjustments you have to make either to the color temperature in your camera and/or with color correction gels on your Speedlite.

*Figure 12.1*
*There are many types of lights that can be used with Speedlites—both flash and continuous. Pictured above are a variety of other flash units that I have around the studio.*

## THIRD-PARTY SPEEDLIGHTS

There are many companies that manufacture speedlights. Pop quiz: did you catch the spelling change? Remember, the name of Canon's brand of small flash ends in l-i-t-e. All other brands end in l-i-g-h-t. Some speedlights are manual-only. Others can also operate in E-TTL.

### Manual Speedlights

The number one reason to buy a speedlight that operates only in manual mode is economy. If you are looking to get into flash photography and cannot afford a Canon Speedlite, then buying a flash that only operates in manual mode is a good way to get started. (I hope you'll recall that, in Chapter 8, *Flashing Manually*, I advocated that you should use manual flash to learn the basics of flash photography.)

Beyond the absence of E-TTL, in exchange for the skinny price tag, you may be giving up other features. So let's take a quick run through the points you should consider.

- **Maximum power**—How can you compare an XYZ speedlight to a Canon model? Look at the Guide Numbers ("GN"). While GN are not used much in digital photography—thanks to the sophistication of E-TTL flash technology—you can estimate the difference between the power of two flashes by comparing their GN. Here are your Canon benchmarks: 580EX II = 190 and 430EX II = 141. For other brands, make sure you are using the GN for full power at 105mm, ISO 100, in feet.

- **Power increments**—Canon Speedlites offer ⅓-stop increments. Most budget speedlights offer full-stop increments. No biggie.

- **Minimum power**—The 580EX goes down to 1/128. The 430EX goes down to 1/64. Some budget speedlights only go down to 1/16 or 1/32. You will appreciate the flexibility of dialing the light down to 1/64 or 1/128.

- **Zoom**—If the head zooms, find out the range and whether you have to do it by hand or if the head is motor-driven. Canon Speedlites zoom from 24mm to 105mm (on a full-sensor camera).

- **Optical slave**—Many third-party speedlights have an optical slave. This is great when shooting mixed brands.

- **Sync options**—It's really handy to have a PC-sync and/or a miniphone jack when you want to connect a sync cord or a radio trigger. Only Canon's 580EX II offers an external port—the old-school PC-sync.

### E-TTL Compatible Speedlights

There are quite a number of marketers who tout the ability of their flashes to work with Canon E-TTL. A key point to remember when considering an E-TTL compatible speedlight as an alternative to the genuine article is that Canon does not distribute the computer code that provides the E-TTL technology. Essentially, every third-party speedlight that works with E-TTL does so because the manufacturer reverse-engineered Canon's code. Is this bad? No, it is quite common in electronics. Still, be prudent and confirm that the manufacturer has a track record of quality products and the ability to service the products they sell.

---

### SPEEDLITER'S TIP

#### —Third-Party Speedlights To Consider—

Manual Only: the LumoPro LP160 is a great value among economy-oriented speedlights. Its power is nearly the same as a 580EX II. The motor-driven zoom has a full range of settings between 24mm and 105mm. The power can be adjusted from 1/1 to 1/64. Brilliantly, the LP160 has an internal optical slave that works with straight manual as well as an E-TTL pre-flash. It also has a PC-sync port and a miniphone jack for maximum connectivity. *Typical price: $165.*

E-TTL Compatible: the Metz 58 AF-1C is fully compatible with Canon's E-TTL II—even to the point that I can control it from the LCD on my 5D Mark II. It has a few features that Canon Speedlites do not have—for instance, it beeps when it is ready to fire. Also, the power range offers one more stop of control as the minimum power is 1/256. *Typical price: $400.*

## GETTING SPEEDLITES TO PLAY WITH OTHER SMALL FLASH

Over the years, I've collected a lot of gear. Photographers are like this. I think it's in our genetics. So, perhaps, you are like me and have a few non-Canon speedlights laying around. Or perhaps you're heading to a strobist meet-up to shoot with some Nikonian buddies. So, what do you have to do to get your Speedlites to play nicely with other small flash?

### Options For Mixing Small Flash In Manual

When mixing Speedlites with other types of small flash, ultimately it always gets down to two things: setting the power level and firing everything at the same time.

The simplest approach to setting the power is to use everything in manual mode. This is typically what happens when Speedlites and speedlights are mixed together.

In terms of triggering different brands of small flash at the same time, there are several options that we have covered already.

- Use sync cords and hot-shoe adapters (Chapter 10, pages 120–121)
- Attach an optical slave to your Speedlite (Chapter 10, pages 122–123)
- Use manual radio triggers (Chapter 10, pages 124–125)

---

### SPEEDLITER'S TIP

#### —Optical Slaves And Canon's Wireless Manual—

As discussed on page 149, when firing Canon Speedlites in manual mode via the built-in wireless system, the master sends instructions to the slaves in a pre-flash code. This pre-flash will trick optical slaves into firing early.

So, if you are mixing Canon Speedlites with other units that have bulit-in optical slaves, you will have to attach all of your off-camera Canon gear to optical slaves (specifically Sonia green-base optical slaves) and fire the master in pure manual—not wireless manual.

---

Many types of speedlights have optical slaves built into them. (Unfortunately no Canon models do.) For instance, Nikon's SB-800 and SB-900 have SU-4 mode that activates an optical slave. Other brands, like LumoPro's LP160, have an external switch that activates the slave.

The trick to making these built-in optical slaves work with Canon flash is the same as when you are using the Sonia slave to fire a Speedlite—you have to fire everything in manual mode. All optical slaves, unless specifically designated as E-TTL compatible, will be tricked by the pre-flash and fire prematurely.

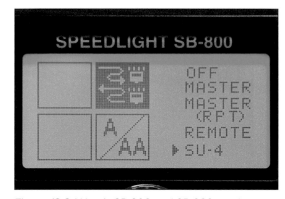

**Figure 12.2** *Nikon's SB-800 and SB-900 can be programmed to work with Canon flash—in manual mode only. The built-in optical slave is activated by switching the Speedlight to SU-4 mode.*

### Options For Mixing Small Flash In E-TTL

There are a few options for mixing E-TTL and manual. You just have to acquire a few pieces of special gear. Now, please don't confuse what we're talking about here with the free-agent wireless techniques discussed in Chapter 11 (on pages 148–149). Those dealt with running Canon Speedlites together in E-TTL and manual. Here we are talking about ways to fire Canon Speedlites in E-TTL together with other brands of flash firing in manual.

### E-TTL-Compatible Optical Slaves

As you know from pages 122–123, a normal optical slave will not work with E-TTL because the pre-flash tricks it into firing early. If you want to shoot E-TTL and fire strobes or non-

Canon speedlights at the same time, you have to attach an E-TTL compatible slave to each strobe/speedlight.

Wein, a leading name in optical slaves for many years, reengineered their entire line so that they are compatible with an E-TTL pre-flash. Specifically, these "digital slaves" are designed to look for the E-TTL pre-flash. If they don't see one, they won't fire. So you have to be in E-TTL mode.

Wein's smallest optical slave, the PND Peanut, will plug directly into a Vivitar 283/285 or can be connected to any flash that accepts a PC sync cord. The Wein XL8D has a twin-blade ("household") plug. The SSL-ED has both a ¼" mono plug (commonly found on studio packs) and a PC sync port. Keep in mind that although these slaves are E-TTL-compatible, they are not designed to trigger a Canon EX Speedlite directly (see page 122–123 for details).

*Figure 12.4* RadioPopper's JrX receivers will fire non-Canon speedlights, monolights, and studio packs at just the right moment when triggered by a PX transmitter that is parked on top of an E-TTL master.

or studio packs. This is a simple solution once you have the hardware. Unlike the three-group solutions discussed in the previous chapter, the PX/JrX combo is transparent to the master Speedlite—it does not know that the PX transmitter is sending a "Fire now!" signal to any JrX receivers that might be in the area. If you have Speedlites in Groups A and B in E-TTL, plus the other flash units in manual, you run the slaves in an A:B ratio and the PX transmitter will automatically fire the manual strobe(s) at the right instant.

*Figure 12.3* Wein makes an assortment of optical slaves that will ignore the E-TTL pre-flash. The slave you need depends upon the connections available on the strobe you will be triggering.

## Mixing E-TTL And Manual Via RadioPoppers

RadioPopper, the small firm that literally invented the first E-TTL radio trigger, has now made it possible to fire Speedlites in E-TTL with other types of strobes in manual—all with the convenience of a radio signal.

The key is using the RadioPopper PX on the master Speedlite as a transmitter and the JrX receiver on the other speedlights, monolights,

## Mixing E-TTL And Manual Via PocketWizards

Without a doubt, PocketWizard makes the most powerful and sophisticated manual radio triggers on the market. They are the industrial-strength radio trigger of choice for pro shooters all over the globe.

The introduction of the Mini TT1 transmitter and the Flex TT5 transceiver has built a bridge between the established base of PocketWizard manual triggers and the E-TTL world—facilitating the mixture of E-TTL and manual.

As I noted on page 119, PocketWizard's Mini/Flex technology continues to evolve. My recommendation is that you check the PocketWizard website for the latest techniques for mixing their Plus and MultiMAX manual radio triggers with the Mini/Flex system.

## SPEEDLITES, MONOLIGHTS, AND STUDIO PACKS

In the middle of a book that dives deep into the world of Canon Speedliting, it is reasonable to pause and wonder why one would want to fire Speedlites alongside studio-sized strobes. The quick answer is that sometimes the big guns cannot be turned down enough to add just a breath of light. Another way—sometimes the use of a studio strobe instead of a Speedlite is like pulling out a flamethrower when a match is all that's needed.

### Monolight And Studio Pack 101

*Monolights* and *studio packs* are both high-powered strobes that are generally powered by A/C, although some portable designs are battery powered.

A *monolight* is a self-contained unit that has the flashtube and power supply in one unit. They range in power from 250 watt-seconds (w/s) to over 1,000 w/s. The advantage of a monolight is the self-contained design. The disadvantage of a monolight is that you have to be able to reach the unit to make adjustments—which can be awkward if it is being used overhead or inside a softbox.

A *studio pack* has a separate power supply and flash heads—connected via a heavy cord. Often one pack will control one, two, or three flashheads, each at its own power level. The advantage of a studio pack is that the flashheads are controlled via the power pack. So, it is easy to use the flashheads inside a softbox or overhead.

Beyond the far greater power, another significant difference between Speedlites and strobes is the shape of the flash tube. In the case of the Speedlite, it is enclosed behind a flat plastic panel—sending all the light forward. In the case of larger strobes, the flash tubes are typically either a cylinder that sticks straight out from the head or a circular doughnut. In both cases, the light flies sideways—this is a great help when using mods like softboxes.

*Figure 12.5* A monolight is a self-contained strobe unit that runs on A/C power. It's convenient to use, until you need to change the power on one that is in a spot that is hard to reach.

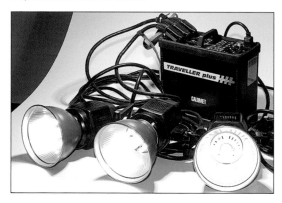

*Figure 12.6* A studio pack separates the flash heads from the power pack. This makes it easy to adjust the power on a head that is inside of a large modifier. They generally have more power than monolights.

*Figure 12.7* An option for occasional portability is to use a monolight with a battery pack like the Vagabond by Paul C. Buff. This unit combines a 12-volt motorcycle battery with a sine-wave inverter.

## My Favorite Battery-Powered Strobes

*Battery-powered strobes* offer the convenience of portability and provide higher power than Speedlites. These systems have a dedicated battery pack that connects to the flashhead via a cord, which means that they look like studio pack rigs. Some units, like the Quantum Qflash, control the power via the head, so they operate like a monolight. Others, like Elinchrom's Quadra RX and Ranger RX, control the power on the battery pack, so they operate exactly like a studio strobe (minus the A/C cord, of course).

*Figure 12.8 The Qflash by Quantum Instruments is popular with wedding and event photographers. It provides up to 150 w/s of power via a cylindrical flashtube and a parabolic reflector. The optional QTTL module provides TTL connectivity with Canon DSLRs. The separate Turbo battery clips onto a belt.*

*Figure 12.9 Elinchrom's Ranger Quadra RX is a mini-sized version of the popular Ranger. Its doughnut-shaped flash tube provides up to 400 w/s of power. There are two power ports in an asymmetric configuration, providing up to 100% power through one outlet and up to 33% through the other.*

## Strategies For Speedlites And Strobes

The main consideration when mixing Speedlites into a shoot that involves larger strobes is how to fire everything at once.

As virtually all monolights and studio packs operate in manual mode, the most affordable approach is to connect a Canon-compatible optical slave to your Speedlite (see pages 122–123 for the details). Then, when your big strobe fires, it will also trigger the Speedlite.

If you're looking to drive your Speedlite(s) in E-TTL, one option is to connect your big strobes to an optical slave that is compatible with the E-TTL pre-flash. When you fire the Speedlite(s), the slave will trigger the big strobe. Wein's digital slaves are the ones I would use in this situation. Also, some systems, like the Quadra, have an optical slave that can be trained to ignore the E-TTL preflash—eliminating the need for an external digital slave.

Another approach, discussed in the previous section, is to use a combination of the RadioPopper PX and JrX triggers or a mix of PocketWizard's Plus II or MultiMAX manual radio triggers with the Mini/Flex system. Both systems will fire the big strobes after the conclusion of the E-TTL pre-flash.

---

### SPEEDLITER'S TIP

#### —Logical Paths Beyond Speedlights—

The two main reasons that one ventures beyond Speedlites and starts using larger strobes are the increased power and the faster recycle time.

If portability is your number one concern—say, because you are a wedding photographer—then a rig like the Quantum Qflash will be a perfect fit.

A close second in terms of portability—second only because its battery won't clip on your belt like the Quantum—is Elinchrom's Quadra RX.

If power and economy are your objectives, then look at the Einstein and AlienBees monolights by Paul C. Buff.

For maximum power in a battery-operated strobe, I'm a long-time fan of Elinchrom's Ranger RX.

---

## NOT GETTING BURNED— SPEEDLITES WITH HOT LIGHTS

A *hot light* is essentially that: any light that gets hot as it produces light. Incandescent lamps of all types are hot lights. You've likely heard of them referred to as tungsten lights, a reference to the main element in the filament that glows inside the lamp or tube. Unlike strobes, hot lights are continuous light sources.

### Tungsten As Ambient Light Source

Hot lights may already exist on the location you are photographing, in which case they are referred to as *practicals*. A desk lamp or a table lamp is a *practical fixture*.

Although compact fluorescent lamps (CFLs) are becoming common in residential and commercial settings, you will still encounter locations lit predominantly by tungsten bulbs. In this case, it is important to consider that your ambient light source has a different color temperature than the light produced by your Speedlites.

### Balancing For Tungsten

The color of an incandescent lamp is very orange—in specific terms, about 3200K. You can see this if you have an incandescent bulb on a dimmer switch and turn it all the way down.

Likewise, as shown in Figure 12.10, if your camera is set to a daylight white balance, it will record the incandescent light as being very orange. Switching the white balance setting on the camera to tungsten will correct for the color cast, as shown in Figure 12.11.

*Figure 12.10* The mismatch between the tungsten light source and the camera's daylight white balance setting makes the shot look overly orange.

*Figure 12.11* Switching the camera's color balance to tungsten restores the color balance back to neutral.

*Figure 12.12* In a tungsten environment, with the camera's white balance set to tungsten, the fill flash from a Speedlite appears very cool.

*Figure 12.13* A CTO gel on the Speedlite restores the color balance.

Also, know that Speedlites approximate the color of midday sun. So, if your ambient light is tungsten and you've balanced your camera to match, the light from your Speedlite will have a very cool tone, as shown in Figure 12.12. The way to correct for this is to use a CTO (Color Temperature Orange) gel on the Speedlite. This matches the Speedlite's color of light with the orange light of the tungsten source, as shown in figure 12.13. (See Chapter 20, *Gelling For Effect,* for more details.)

## Video And Theatrical Hot Lights

Any shoot that requires continuous lights will likely use hot lights. Video shooters have long used small, portable tungsten lights on location. Likewise, on a movie set or in the playhouse, hot lights are the main lighting source.

> *As a still photographer, you should know about the range of hot lights available—often for very reasonable rates from rental houses.*

**Video:** Video lights typically rely upon quartz halogen bulbs to provide a significant amount of light from a small fixture. Some video lights are battery-operated, others require A/C. I am very fond of Lowel video lights.

**Fresnel:** A Fresnel ('FRAnel') lens has concentric ridges that focus light rays into a beam. When you think of a movie light, chances are you visualize a Fresnel light. The handy thing about a Fresnel is that you can move the lens in and out to shape the beam from a flood to a spotlight.

**PAR:** A parabolic aluminized reflector (PAR) works essentially the same way that an automobile light works. The reflector and the lens are sealed together. Unlike a Fresnel, the spread of a PAR cannot be changed. Even though it cannot be focused, a PAR is like a Fresnel in that it has an unfocused edge (a "penumbra") that can be quite interesting when placed on or around your subject.

**Leko:** A leko is a common theatrical light. Technically, it is an ellipsoidal reflector spotlight—meaning that a small tungsten bulb burns in

*Figure 12.14* The 2.5-pound Lowel Pro is a quartz hot light that I carry when I need to throw light across a large area. It zooms from flood to spot. The barn doors allow me to limit what the light hits.

front of a curved reflector that shines the light through a lens at the other end. The unique thing about a leko is that it has a set of aperture blades at the focal point that provides for precise focusing of the beam. Lekos are also commonly called "Source Fours" after their leading manufacturer.

**Dedolight:** A "dedo" is a small tungsten unit that provides a level of control similar to that of a leko. Instead of aperture blades, the dedo has movable lenses that provide a 10:1 range from flood to spot. A model that floods at 40° can spot down close to 4°. All of this is in a very compact package.

---

### SPEEDLITER'S TIP

#### —DIY Hot Lights—

A home improvement center can be a source of inexpensive halogen work lights. Although they lack the color fidelity and control of photo-grade hot lights, for casual work they can be an affordable way to get a lot of light. Just remember to take along heavy-duty extension cords.

I've used a half dozen (about $100) to light up the exteriors of homes for sunset shots. In a garage, a couple work lights bounced off a ceiling can create a nice field of soft light for car shots.

## MANAGING THE GLOW— SPEEDLITES WITH FLUORESCENT

Without a doubt, the energy-saving features of fluorescent lights have made them the predominant light source in residential and office environments. Although this trend is great in terms of conserving resources, it can be tough for photographers. The challenge is that the color temperature of fluorescents varies widely.

### The Color Temperature Of A Fluorescent

A fluorescent lamp—both the traditional straight tube and the more contemporary coiled tube—consists of a glass cylinder filled with mercury vapor. An electric current runs through the vapor to create ultraviolet light. The UV then excites a fluorescent coating on the tube that glows brightly to create the light we see.

The exact color temperature of a fluorescent lamp varies based on the specific mix of mercury vapor and phosphorescent powder used in the tube. In general, you can divide fluorescents into two broad color categories: warm and cool. You will have to sort out which you're working under because the color correction is slightly different for each.

Often you can tell just by looking at the light fixtures. Does it appear warm or cool? Instead of guessing, you can set your camera to Daylight white balance and take a shot without flash—hopefully of a white surface (like a wall or a sheet of paper). I know that the fluorescents that lit Figure 12.15 are warm fluorescents because the white wall appears yellow rather than bluish-white when shot in Daylight WB.

*Figure 12.15* By setting the camera's white balance to Daylight, I determined that the flourescent lamps were warm—rather than cool—fluorescents.

*Figure 12.16* Here is Figure 12.15 with Lightroom's Fluorescent white balance (3800, +21) applied.

*Figure 12.17* Here is Figure 12.15 with a custom white balance (3400, +33) applied.

*Figure 12.18* The color of Rosco gels ½ CTS, ½ Plusgreen, full Plusgreen, and Industrial Vapor.

## Color Correcting Fluorescent

If your entire frame is lit only by fluorescent—meaning that you did not fire your Speedlites—then you can color correct the photo with your image processor. Compare Figure 12.15 to 12.16 and 12.17. The middle image is Figure 12.15 with Lightroom's Fluorescent white balance applied. In the lower image, I created a custom white balance in Lightroom—specifically 3400K, +33.

## Balancing Speedlites For Fluorescent

There are two considerations when balancing Speedlites for fluorescents:

- the difference in their color temperatures
- the typical green spike in fluorescents

If you have warm fluorescents, try starting with your camera in the Fluorescent white balance (which in Canon's system is skewed towards warm fluorescent). Then consider adding one or two gels to shift the color of the flash.

As shown in Figure 12.20, the ½ CTS (Color Temperature Straw) warms the image and adds a slight red cast. In a pinch you can use a ½ CTO, but it will appear more yellow than red. If you want to quietly blend the Speedlite into the warm fluorescent, also add a ½ Plusgreen. As you can see in Figure 12.22, the full Plusgreen is too strong for these particular fluorescents, but it may work elsewhere.

Rosco's Industrial Vapor gel (#3150) combines a full CTS and Plusgreen to convert tungsten lights to sodium vapor lights. It can also help Speedlites like industrial fluorescent lamps.

If you have cool-white fluorescents, then the color temperature of the ambient and your Speedlite will be very similar. So start shooting with the camera's white balance in Daylight. You may or may not need to gel the Speedlite with a half-cut of Plusgreen to blend the flash into the ambient.

*Figure 12.19* Bare Speedlite with Fluorescent WB.

*Figure 12.20* Speedlite gelled with ½ CTS.

*Figure 12.21* Speedlite gelled with ½ Plusgreen.

*Figure 12.22* Speedlite gelled with full Plusgreen.

# CHAPTER 13 | GO AHEAD, MOD YOUR SPEEDLITE

## The Short Version

It's easy to think that with all the buttons and dials on a Speedlite (not to mention the price tag), it should be able to create any type of light you'd need.

The simple truth is that you just can't escape physics. Light coming from a flashhead that's the size of a half-dozen postage stamps just won't look like light filtering through high clouds—unless you modify it.

### Figure 13.1
*Increasing or decreasing the apparent size of a Speedlite is one of the keys to creating great light. Here a pair of Honl Speed Gobos limit the spread of a Speedlite so that I can throw a diagonal slash of light across Kaili.*

## WHY MOD?

As a Speedliter, you should think of your Speedlites as light generators. They produce a bright flash of raw light. It's up to you to direct, shape, and color that light so that it suits your purposes. Fortunately, there is a vast selection of modifiers suitable for Speedliting.

### Two Places For Mods

There are two broad groups of modifiers:

- Modifiers that attach directly to your Speedlite (the subject of this chapter)
- Modifiers to which you attach the Speedlite (the subject of the next chapter)

### Three Purposes Of Mods

There are three basic purposes for modifying the flash coming from your Speedlite:

- To increase the apparent size of your Speedlite
- To limit or constrict the spread of light
- To change the color of the light

As you learned in Chapter 3, *Mechanics Of Light,* if a light source is small relative to the size of the subject, the light rays will hit the subject from a single direction and create hard shadows. If the light source is large relative to the size of the subject, the light rays will come in from many angles and create soft shadows.

And remember, as Joe McNally says, "If you want to make something interesting, don't light all of it." Controlling where your Speedlite goes and does not go is the key to crafting exciting light.

Lastly, Speedlites emit light that is about the same color as midday sunlight. So, if you are shooting indoors with tungsten or fluorescent lights, you may want to shift the color of the Speedlite so that it blends with the ambient sources. Or you may want to change the color coming from your Speedlite so that it looks like a setting sun or has a circus-like effect.

### SPEEDLITER'S TIP

—Deciding To DIY—

David Hobby, the original Strobist, once said in a workshop, "You have to ask yourself which you have more of: time or money. If you have more money than time, buy it. If you have more time than money, do it yourself."

As usual, what David says makes sense. (See Strobist.com for more proof of this phenomenon.) There are many do-it-yourself options when it comes to Speedliting gear. You just have to consider whether taking the time to gather the parts and do the assembly is truly the least expensive alternative.

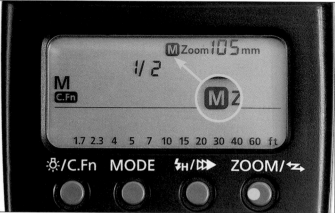

The first way to modify your Speedlite is via the controls on the unit itself. It is easy to look past them, but there are several features that can make its apparent size seem larger or smaller.

### Tilt And Pan

The ability to adjust the direction of your flash-head gives you two options. If you bounce the light off a wall or ceiling, the light will wrap around the subject and the shadows will soften. Or, if you feather the Speedlite so that most of the light just flies by your subject, you can create falloff or a vignette.

### Zoom

Zoom is a Speedlite control that I use frequently. If I'm looking to create a narrow field of light, I will manually zoom the head to its maximum of 105mm. Likewise, when using a diffusion panel or shoot-through umbrella, I may zoom my Speedlite to 24mm.

### Wide-Angle Diffuser

The idea behind the wide-angle diffuser panel is that it will spread the light to the field of view seen by a 14mm lens. It is not a feature that I use very often for its intended purpose. I will pull it out when I want to fan the light out inside of a softbox.

### Catchlight Panel

The 580EX-series has a little white plastic card that pulls out with the wide-angle diffuser. The idea is that it will throw a bit of light forward when you are bouncing the light off a ceiling. Frankly, I think it is too small to be of much use. If you don't have a white card or piece of paper nearby, use your hand instead.

*Figure 13.2* I often pan the head of my Speedlites.

*Figure 13.3* My Speedlite manually zoomed to 105mm.

*Figure 13.4* I seldom use the wide-angle diffuser.

*Figure 13.5* The 580EX catchlight panel is a bit small, so I use my hand to bounce a bit of light forward.

## OPTIONS FOR MOUNTING MODS

I absolutely do not like to stick anything onto my Speedlites that will remain there permanently. For years, manufacturers have and continue to ship their light modifiers with several Velcro patches and instructions to affix the fuzzy side to the head of your Speedlite and the hook side to the modifier. I never did this because I did not want to gum up my Speedlites. Fortunately, there are several removable options.

### Honl Speed Strap

Award-winning photojournalist David Honl created a versatile line of light modifiers for Speedlites. The Speed Strap is the core of the system. It is a rubber-backed strap with Velcro-like fuzz on the other side. When needed, you attach the Speed Strap around the head of your Speedlite and then attach the various modifiers to the strap. If the modifier is heavy, you can add a second Speed Strap after you have affixed your modifier to provide a bit more grip.

### LumiQuest Cinch Strap

LumiQuest, the company that championed the concept of folding Speedlite modifiers, has heard the drumbeat and now offers its own Cinch Strap. It's similar to the Honl design, but it's a bit narrower and longer.

### DIY Strap

You can make your own straps with a bit of wide Velcro sewn to a bike inner tube (a thorn-proof tube works best; it's thicker). You want the fuzzy side facing out from your Speedlite. Also, you will need a short piece of the hook side at the end.

*Figure 13.6* Honl Speed Strap.

*Figure 13.7* LumiQuest Cinch Strap.

*Figure 13.8* For heavy mods, I use a second strap around the modifier.

## DOME DIFFUSERS

A slip-on dome diffuser is an essential modifier in my basic lighting kit. Its job is to interrupt the outward blast of photons and send them in numerous directions. Larger dome diffusers chase after the idea of spreading light around in the same way that a bare light bulb does.

### Sto-Fen Omni-Bounce

This is an inexpensive, versatile modifier that every Speedliter should own. The Sto-Fen Omni-Bounce is a translucent plastic box that fits over the head of your Speedlite. It transfers the light in many different directions. Rather than fly straight forward, the light also goes out the side of the box. Sto-Fens are molded for specific models, so be sure to get the right one for your Speedlite.

Photojournalists often use a Sto-Fen with their Speedlite head angled up at a 45° angle. The idea is that the diffuser will throw the light up to the ceiling and off of walls for a softer look. Of course, if you are outdoors or in a very large room, the benefit of angling the Sto-Fen is minimal.

*Figure 13.9* The Sto-Fen Omni-Bounce slips onto the head of a Speedlite.

*Figure 13.10* When the Sto-Fen is fired directly at the subject from an on-camera Speedlite, the light has a bit of shape, but not much.

*Figure 13.11* When indoors, angling the Sto-Fen up will bounce a bit more light off the ceiling and soften the shadows a bit more.

*Figure 13.12* The egg-shaped Flashpoint Q Diffuser Dome straps onto the head of a Speedlite.

### Flashpoint Q Series Diffuser Dome

If you think about it, a household light bulb throws off light in all directions. It bounces off the ceiling and the walls. In contrast, a Speedlite mainly throws out light in one direction—straight forward.

Studio strobes typically have bulbs that extend out front. When there's no reflector or modifier on a studio head, it's called "bare bulb." The effect can be dramatic if the light is in close—giving a strong amount of falloff. A bare bulb can also be used to replace the effect of a household fixture that appears in the frame.

The Flashpoint Q Series Diffuser Dome is a unique Speedlite modifier in that it comes close to achieving the look of a bare bulb studio head. Strap it on and the light will fly in every direction. They come in two sizes: the A size fits the 580-series, and the B size fits the 430-series.

Although the Flashpoint Q Diffuser Dome is light enough to be used on-camera, I have never found a good reason to do so. My preferred method is to use it off-camera as described below.

### Use A Dome Diffuser In Close

My favorite way to use a diffuser dome is to drop it in close to my subject. The effect is similar to that of a bare bulb—meaning that the light falls off dramatically.

Comparing Figure 13.13 to Figure 13.14, you'll see that the larger Flashpoint Q Diffuser Dome creates a different look than the Sto-Fen.

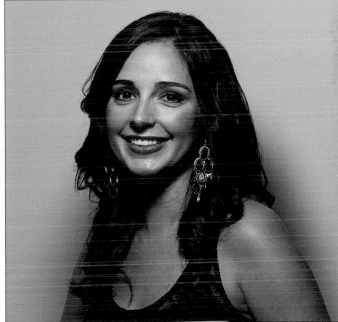

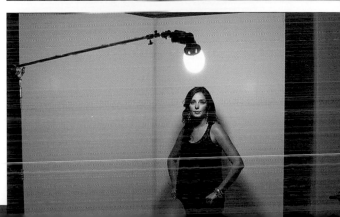

*Figure 13.13* Dropping the Sto-Fen in close on a pole creates dramatic light from a single Speedlite.

*Figure 13.14* The longer length of the Flashpoint Q Dome Diffuser creates a softer look than the Sto-Fen when used in close.

*Figure 13.15* The set shot for Figure 13.14.

## BOUNCE REFLECTORS

A bounce reflector has a simple purpose: make the Speedlite seem bigger by spreading the light around. You'll find it handy when you want to bounce the light but don't have a suitable wall nearby, such as in large spaces or outdoors.

### Honl Snoot

As you will read shortly, the main purpose of the Honl snoot is to create a long tube through which the Speedlite fires. Since the Honl snoot is made of flexible nylon cloth, it can also be fashioned around three sides of the Speedlite to form an impromptu bounce reflector. My favorite for this is the 8″ gold snoot as it provides a bit of warmth to the light.

### Honl Speed Gobo

Another part of the Honl system that can be used as a bounce reflector is the 4″ x 7.5″ Speed Gobo. Two styles are available—white and gold. Both are black on the opposite side. See pages 180–181 for other uses for Honl's Speed Gobos.

### Your Hand...Seriously

When I'm shooting on the run and need a quick bounce reflector, I'll use my hand behind the Speedlite. Sure, it's not as efficient as as true bounce reflector, but in a pinch it works. An added benefit is that it warms up the color of the flash a bit.

*Figure 13.16* *The Honl snoot can be used as a bounce reflector. I appreciate this versatility. This is the gold/silver zebra pattern which warms the light sightly.*

*Figure 13.17* *The large Rogue FlashBender can be used flat, as shown, or curved into any number of shapes.*

*Figure 13.18* *The LumiQuest ProMax has an open web top and several reflective inserts—including the silver insert shown here.*

## Rogue FlashBender

The Rogue FlashBender is simlilar in size and shape to the Honl snoot—but offers a few distinct advantages. The first is that it contains flexible metal rods that enable you to shape the FlashBender to fit your needs—from a wide, flat panel to a narrow snoot. The second advantage is that its strap attaches directly to the head of your Speedlite—so you don't need to fumble for a speed strap. There are three sizes: large and small reflectors that can bend into snoots, plus a narrower version that works as a bounce card and gobo.

## LumiQuest ProMax Bounce System

The LumiQuest ProMax Bounce System is a multifunction rig. The frame has a unique webbed top. Use it open and it will throw 80% of the light to the ceiling and bounce 20% forward to create a small catchlight in the eyes of your subject(s). If the ceiling is too high or you just want more punch, as shown in Figure 13.21, you can drop in one of the white, gold metallic, or silver metallic reflector panels—although, to my eye, the metallic inserts punch too much light forward and make the photo look like it was shot with on-camera flash.

*Figure 13.19* The Honl snoot works well as a bounce reflector. This shot used the gold/zebra snoot on-camera—which adds a bit of warmth to the skin tones.

*Figure 13.20* The Rogue FlashBender is the largest of all the bounce reflectors discussed in this section. Its white surface provides a nice, soft bounce for the Speedlite. As you can see here, the color is neutral.

*Figure 13.21* I find that the metallic inserts in the Lumiquest ProMax throw too much light forward for my taste. This shot was made with the silver insert from the same camera position as the photos above.

## SOFTBOXES THAT ATTACH TO SPEEDLITES

A softbox provides a space for the light from the flash or strobe to bounce around before it heads out through a single or double layer of diffusion panel on the front. It is a great way to make the apparent size of your Speedlite seem much bigger. The advantage of a larger light source is that the shadows soften when the light comes from multiple angles—the same way that clouds soften sunlight.

### Lastolite Ezybox Speed-Lite

This is my favorite of the Speedlite-mounted softboxes. It has inner and outer diffusion panels so that the light softens nicely. The 9″ square face is the largest among the group. The face is recessed so that there is a definite edge to the light—very helpful for feathering the light. It mounts quickly and securely to the Speedlite without any additional straps. It folds up quickly.

### LumiQuest Softbox III

The LumiQuest Softbox III is an ingenious configuration of plastic and cardstock. It measures 8″ x 9″ across the face, yet folds flat for easy transport. While it's not the same as shooting with a larger softbox (like the Lastolite Ezybox), the size is big enough to create soft light on a close-up. It attaches directly to your Speedlite by the Velcro tabs (included) or onto either the LumiQuest Cinch Strap or Honl Speed Strap.

*Figure 13.22* *The Lastolite Ezybox Speed-Lite straps on to a Speedlite via a secure, double-strap system. It is the only softbox in this size range that has a recessed front panel—a feature that I appreciate.*

*Figure 13.23* *The Lumiquest Softbox III has a translucent plastic panel with an extra-thick patch to minimize the center hotspot.*

*Figure 13.24* *The Honl Traveler 8 is a cone of heavy-duty nylon that lays flat for transport. The removeable front panel attaches quickly.*

## Honl Traveler 8

The most unique feature of the Honl Traveler 8 is that its face is circular rather than square. This becomes apparent in the catchlights (the reflection of the softbox) in the eyes. As the removeable front panel is thick, white nylon, the Traveler 8 has a hotspot at the center. You can use this to your advantage and create dramatic falloff by using it in close. If you want more even light, then slip a Sto-Fen on your Speedlite before you connect the softbox to a Honl Speed Strap. Like all Honl modifiers, the Traveler 8 is lightweight, easy to pack, and quick to set up.

**Figure 13.25** *The Lastolite Ezybox Speed-Lite creates an even spread of light. It's my favorite of the Speedlite-mounted softboxes.*

**Figure 13.26** *The Lumiquest Softbox III throws light that is slightly hot at the center. The flush front occasionally flares into the lens.*

**Figure 13.27** *The Honl Traveler 8 softbox has a distinctively warm center. Its best attributes are that it folds flat for travel and weighs almost nothing.*

## RING LIGHT ADAPTERS

A ring light is a special light through which you insert your camera lens. They are often used for fashion photography. The look of a ring light is distinctive because it provides a soft light with highlights on the surfaces that directly face the camera and, if the subject is close to a wall, a shadow that literally edges the subject.

The two competing ring light designs for use with Speedlites are the Orbis and the Ray Flash. Although their look is similar, they are not exactly the same. Further, there are significant differences in how each attaches to a Speedlite.

### Ray Flash

The Ray Flash by ExpoImaging is designed to work with your Speedlite mounted to your camera. The advantage is that you can operate your camera with both hands, as you do normally. The downside is that, because different Speedlites and different cameras have slightly different heights, you have to get the model that is specific for your Speedlite model. Of course, if you don't have several models of Speedlites, then this is not an issue.

In my trials, I've found that the Ray Flash is about ½ stop brighter than the Orbis. To my eye, I also see a bit more snap to the highlights and a bit more light at the bottom of the frame.

*Figure 13.28* The Ray Flash attaches directly to a Speedlite in the camera's hotshoe.

*Figure 13.29* The Orbis Arm attaches to the bottom of the camera and enables the Speedlite to be positioned below the lens so that the camera can be operated with both hands.

*Figure 13.30* A unique feature of the Orbis is that it can be held in one hand to provide off-axis fill-flash. While this eliminates the distinctive look of the ring light (which occurs because the light surrounds the lens), it does provide a nice soft fill.

### Orbis

The Orbis takes a generic approach that enables it to connect to "most" Speedlites by slipping over the extended head. The Orbis design also means that the Speedlite cannot be mounted in the camera's hotshoe. Instead, you have to connect the camera and Speedlite via an off-camera cord, preferably an E-TTL cord so that you can maintain full E-TTL control.

Another distinguishing point of the Orbis is that it must be held—either by the photographer (which takes one hand off the camera), with the Speedlite mounted on a light stand (which means that the light is fixed in position), or by a special Orbis bracket (which adds portability and a bit of weight).

I've also used the Orbis as an off-camera fill light by attaching the Speedlite to a long E-TTL cord. The resulting light is softer than direct flash, but not as soft as light coming from a medium to large softbox.

### Deciding Between the Ray Flash and the Orbis

As you can see in Figures 13.31 and 13.32, the look of the light is similar but not identical. If you prefer one over the other, then that may help you make your choice.

If you have several Speedlite models, then the Orbis is the more versatile choice. In my case, since all of my Speedlites are the same model, it's not an issue that the Ray Flash is model-specific.

Personally, I'm more fond of the Ray Flash because I appreciate that I do not need other gear, such as an off-camera cord or bracket, to continue holding my camera as I normally do.

Still undecided? Toss a coin—you'll be well serviced by either ring flash adapter.

*Figure 13.31* A quick headshot with the Ray Flash.

*Figure 13.32* A headshot with the Orbis.

## SNOOTS

A snoot is a tube—either flexible or rigid—that you attach to the front of a flash to limit the spread of light. The length of the snoot is the main controlling factor: the longer the snoot, the tighter the pattern.

Another factor is the reflectiveness of the snoot. A shiny metallic fabric, like the Honl 8″ gold zebra, will reflect light diagonaly—which minimizes the effect of the snoot. If you find that this is an issue, then roll the snoot inside out so that the back nylon is to the center.

### Honl Snoots

HonlPhoto makes snoots out of durable black nylon backed with soft silver or a shiny gold/silver zebra fabric. The silver version comes in 5″ and 8″ lengths; the zebra in 8″ only.

I always have a couple of Honl snoots in my Speedlite kit—specifically an 8″ silver and 8″ zebra. I prefer the 8″ length as it creates a tighter pattern. As you can see in Figure 13.36, the 5″ snoot allows the light to spread farther. This is not bad. In fact, you may like the gentler touch.

The assembly and attachment of the Honl snoot takes literally seconds. Velcro runs down two edges so that the snoot can be rolled into a tube and sealed along the entire length. Short strips of Velcro on one end enable the snoot to be attached to a Honl Speedstrap that is stretched around the Speedlite.

*Figure 13.33* The Honl 8″ snoot in gold zebra fabric and the Honl 5″ snoot in silver. Inset: rolling the Honl 8″ gold zebra snoot inside out minimizes the spread of the light. Compare Figure 13.37 to the sidebar opposite.

*Figure 13.34* The FlashBenders rolled as snoots. As you can see in Figure 13.38 opposite, the effect of the white interior is less reflective than a shiny metallic interior and more reflective than a black interior.

*Figure 13.35* The conical snoot by Flashpoint limits the flash to a narrow beam. The addition of a grid to the snoot further columnates the light, as shown in Figure 13.39 opposite.

## Rogue FlashBender

The Rogue FlashBenders are similar in size and shape to the Honl snoots. The large Flash-Bender is 10" long and the small is 6" long. They attach directly to the Speedlite via a built-in strap. As shown in Figure 13.17 on page 170, the FlashBenders have a soft white interior.

## Flashpoint Q Snoot

The Flashpoint Q snoot is a lightweight metal cone that attaches to a Speedlite via a built-in bracket and strap. This is essentially the same design used for snoots on studio strobes. A nice feature of this snoot is that the honeycomb grid at the end tightens up the column of light just a bit more. This is a great modifier if you want a tight spot of light to accent hair texture or as a dramatic touch on a face or the scene.

---

### SPEEDLITER'S TIP

**—Roll Your Metallic Snoot Inside Out—**

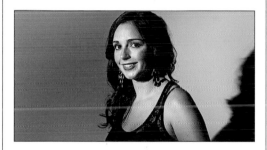

If your subject is close to a background that you are trying to keep dark, you might find that the reflective interior of the snoot actually throws light onto the background. The quick fix is to roll the snoot the other way so that the black side is to the interior. Compare the shot above (Honl 8" gold rolled normally) to Figure 13.37 at right.

---

*Figure 13.36* Honl 5" snoot. The short length throws light in a wide arc—on the subject and background.

*Figure 13.37* Honl 8" gold snoot rolled inside out.

*Figure 13.38* Rogue FlashBender rolled as snoot. The white interior throws a bit of flash on the background.

*Figure 13.39* Flashpoint Q Snoot with grid provides the tightest cone of light.

## GRIDS

The purpose of a grid is to constrain the spread of light coming from the flash. The size of the grid determines the amount of control: the tighter the grid, the tighter the column of light. In case you are wondering about the difference between a grid and a snoot, check out the Geek Speak sidebar at right.

### Honl Grids

Honl grids are pro grade and easy to carry. Honl offers two models: ¼″ grid and ⅛″ grid. I carry both but find most times that the ⅛″ grid is the one for the job.

Here's a trick I learned from Joe McNally: when you need just a bit more light in a subject's eye, strap on a ⅛″ grid and turn the power way down on a Speedlite. Then move it in as close to the eyes as you can get. If the power is low enough, the grid will lift in the brightness of the eyes and the effect will be subtle—it won't broadcast that a special eye light was used.

**Figure 13.40** *Honl grids feature a durable plastic frame that surrounds and protects the grid.*

**Figure 13.41** *The Honl ¼″ and ⅛″ grids shown at life-size.*

**Figure 13.42** *The Flashpoint Q 6″ beauty dish makes a great holder for grids.*

**Figure 13.43** *Three grids, sizes ¼″, ⅛″, and ¹⁄₁₆″, are available—shown lifesize.*

## Flashpoint Q Beauty Dish And Grids

Flashpoint makes a 6″ beauty dish that is intended to strap on to a Speedlite. While I have not found the 6″ beauty dish itself to be of much use (generally the bigger the beauty dish the better, see pages 198–199), I have found this mini dish to be a great holder for the 6″ grids that Flashpoint sells as part of the expanded kit for the beauty light.

When I'm shooting on a dim set and want to create a slash of light, I reach for the Flashpoint Q Beauty Dish set. I really appreciate how quickly I can change grids without disturbing the position of the Speedlite. The more I use them, the more I like them.

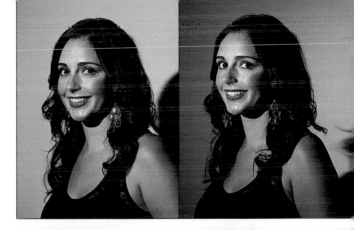

---

### GEEK SPEAK

#### —Grids vs. Snoots—

So what's the difference between a grid and a snoot when it comes to light? That's a good question. Think of a grid as being an artist's paintbrush and a snoot as being a housepainter's brush.

Grids have a degree of precision that snoots lack. Grids, particularly those ⅛″ and smaller, have rather defined edges. Flexible snoots, like the Honl or one rolled from a sheet of Cinefoil, can be shaped by hand and have a soft, irregular edge to the light.

To be fair, the cone-shaped snoot by Flashpoint Q has a defined edge (and it comes with a removable grid). So, you could call it a grid-like snoot.

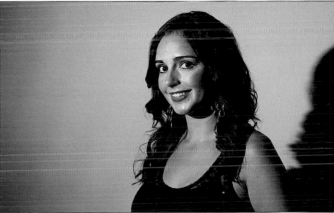

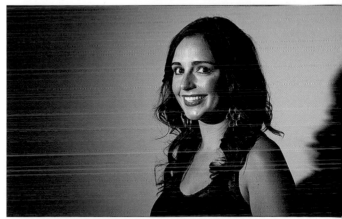

---

*Figure 13.44* Left: a headshot with the Honl ¼″ grid. Right: a headshot with the Honl ⅛″ grid.

*Figure 13.45* Headshot with the Flashpoint Q ¼″ grid.

*Figure 13.46* Headshot with the Flashpoint Q ⅛″ grid.

*Figure 13.47* Headshot with the Flashpoint Q 1/16″ grid.

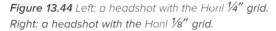

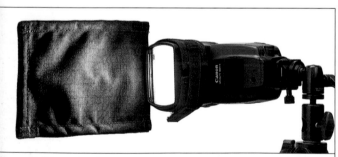

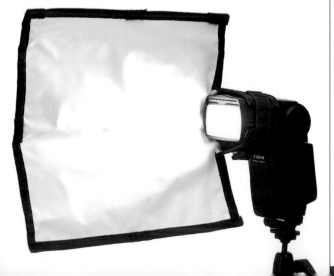

A gobo is Hollywood-talk for "go between." Anything that can be put between a light source and the subject could be a gobo: your hand, a piece of Cinefoil, a card, some gaffer's tape....

A flag is an opaque gobo with a rectangular shape. As a Speedliter, you will frequently want to control the spread of your light with a flag. You use a flag on the top, bottom, or either side of your Speedlite.

A flag can be helpful when lighting from the side or front—especially if you want to keep the light on your subject and off the background.

Another important use of a flag is to prevent flash from flaring into the lens when you have a Speedlite that is angled at your subject from behind. This is easily fixed by attaching a flag on the camera-side of the flash so that it does not spill into the lens. Compare Figures 13.50 and 13.51 at right to see the difference.

If you use flags on both sides of the Speedlite, you have a set of "barn doors" that can be used to direct the light at your subject without letting it spill onto the background or into the camera lens. Also, as shown in Figure 13.52, you can push a Speedlite with barn doors in close to create a dramatic slash of light.

*Figure 13.48* Top: A Honl Speed Gobo positioned to keep the Speedlite from lighting the background. Middle: A Honl Speed Gobo positioned to keep the Speedlite from flaring into the lens. Bottom: A pair of Honl Speed Gobos positioned as barndoors.

*Figure 13.49* Top: The Rogue FlashBender Bounce Card can be used for the same purposes as the Honl Speed Gobo. The black panel is removable so that it can also be used as a bounce reflector. Bottom: The FlashBender large reflector makes a great flag, especially when the Speedlite is zoomed wide.

### Honl Speed Gobos

HonlPhoto makes a handy gobo that can also be used as a simple bounce card. Measuring 4″ x 7½″, it is black nylon backed with stiff plastic. The other side is either white or gold. As there are hooked patches on both sides, you can attach it to the Speed Strap either way.

Use the black side toward the flash if you are trying to flag (limit) the spread of the light. Use the white or gold side toward the flash, with the head tilted up, and you have a nice bounce card (that pushes a bit of light forward into the eyes while most of it bounces off the ceiling to fill the room).

They are sold individually. If you buy a pair—one white and one gold—you can use them together as a set of barn doors and have two options for bounce cards. I carry two in my kit all the time.

### Rogue FlashBender Bounce Card

Rogue makes a FlashBender that is similar in use to the Honl gobo. Conveniently, Rogue has a strap built in, so you can attach it directly to the Speedlite. One of the black nylon panels is removable so this FlashBender can also be used as a bounce reflector as discussed on pages 170–171.

If I happen to be using the Speedlite with the head zoomed wide, I strap on Rogue's large FlashBender reflector (as shown in Figure 13.49 opposite). This extra width guarantees that the flash is blocked completely.

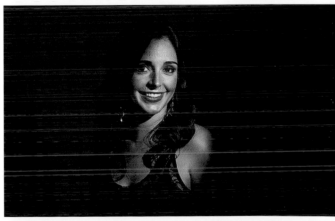

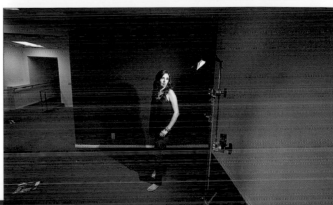

**Figure 13.50** *The flare from the rimlight in the upper right corner is a creative touch for some and a bane for others.*

**Figure 13.51** *Adding a Honl Speed Gobo to the camera-side of the Speedlite blocks the flash from the lens without affecting the quality of the rim light.*

**Figure 13.52** *This dramatic slice of light is created by using a pair of Honl Speed Gobos as barn doors.*

**Figure 13.53** *The set shot for Figure 13.52 as lit by the ambient light. For the view of the final exposure, refer to Figure 13.1 at the opening of the chapter.*

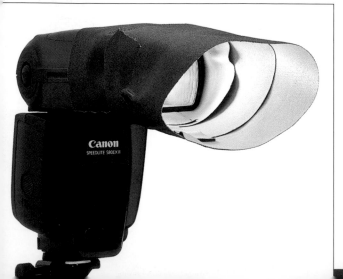

### Gels

I consider the use of gels to be an essential part of Speedliting. Their use, for both color correction and for dramatic effect, is the topic of Chapter 20, *Gelling For Effect*. So, if you need the details right now, head to page 280.

### Rosco Cinefoil

Cinefoil is basically industrial-weight aluminum foil that has been coated with heat-proof black paint. It was invented in Hollywood as a quick way to modify hot lights on movie sets.

Cinefoil is great for forming a quick snoot or flag. The matte finish just eats up light. You can literally wrap it around a flashhead and press tightly. Then shape it as needed.

When done, unwrap the foil and fold it up for another day. I always have a few crumpled sheets folded up in my lighting kit.

### Gaffer's Tape

Gaffer's tape is the duct tape of the photo universe. While it comes in a rainbow of colors (which is helpful for marking your gear), the main color is black. Uniquely, it has the ability to provide a strong grip and then be removed without leaving a residue. The sky is the limit when it comes to ways to put it to use. Call it "gaff" and you'll sound like a veteran.

*Figure 13.54* *The precut gels by HonlPhoto have hooked strips that enable them to be attached and removed quickly from a Honl Speed Strap.*

*Figure 13.55* *This is one of my ancient pieces of Cinefoil being used as an impromptu flag. Buy a roll and split it with several friends.*

*Figure 13.56* *Gaffer's tape, or simply "gaff," will save the day when you've left a piece of gear at home. As a light modifier, gaff is perfect for attaching gels to a Speedlite and for crafting snoots and flags on the fly. To see how gaff can be used as grip gear, turn to page 215 and check out Figure 15.28.*

## DECIDING WHICH MODS ARE RIGHT FOR YOU

### Novice Essentials

- E-TTL Off-Camera Cord
- Sto-Fen Omni-Bounce
- Honl color correction gel kit
- Honl Speed Strap for each Speedlite

### Gear For The Enthusiast

- E-TTL Off-Camera Cord
- Sto-Fen Omni-Bounce
- Honl color correction gel kit
- Honl Speed Strap for each Speedlite
- Honl 8″ snoot in silver or large Rogue FlashBender Reflector
- Honl Speed Gobos, one white / one gold
- Honl ⅛″ grid

### Syl's Always-In-The-Bag Essentials

- Two E-TTL Off-Camera Cords
- Sto-Fen Omni-Bounce: one per Speedlite, up to a total of three
- Honl Speed Straps: one per Speedlite, plus an extra one or two
- Honl 8″ snoots: in both gold zebra and silver or Honl 8″ snoot in gold zebra and large Rogue FlashBender reflector
- Honl grids: two ⅛″ and one ¼″
- Lastolite Mini Ezybox softbox
- Honl Speed Gobos: white and gold
- Cinefoil: a couple of well-traveled pieces, about 12″ x 12″ each
- Color correction gels: a minimum of two each of full, half, and quarter cuts of CTO and CTB, and Plus Green
- Color effect gels: an assortment of saturated colors that I've picked up along the way (see Chapter 20 for details).
- Black gaff: 2″ is the most versatile width.

*Figure 13.57* Essentials that every novice needs.

*Figure 13.58* The Enthusiast's kit.

*Figure 13.59* My essentials laid out for packing.

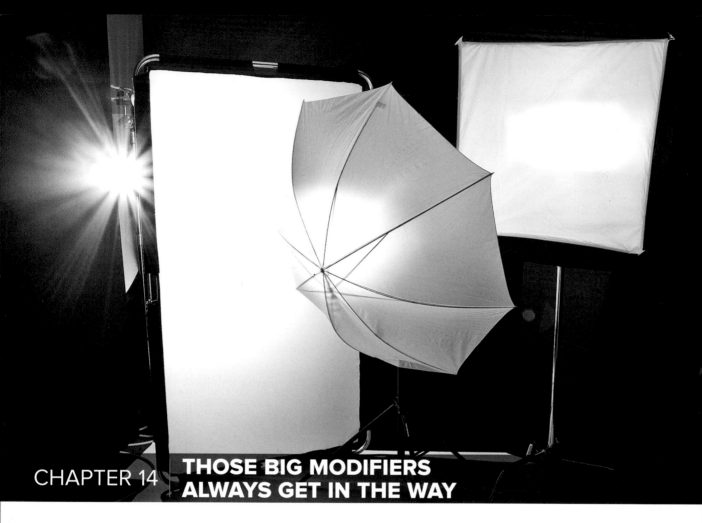

# CHAPTER 14 — THOSE BIG MODIFIERS ALWAYS GET IN THE WAY

**Figure 14.1**
*A Speedlite may be small relative to most subjects that it will light. However, with the right modifiers, you can craft any style of light that you desire.*

## The Short Version

When thinking about Speedlite modifiers, "big" is relative. It can be a small softbox that uses a separate bracket because it's just a bit too heavy to be supported by direct attachment to the Speedlite. It can also be a 20′ x 20′ metal frame that is holding a silk diffusion panel over an elephant in a dry, desert lake bed (true story).

The common link between the small softbox and the giant silk is that they both stand between the light source and the subject. They both change the apparent size of the light source and the character of the light falling on the subject.

As a Speedliter, I frequently put a variety of big mods between my subject and the light coming from my Speedlite.

## WHY MOD IN A BIG WAY

Let's face it, the front of a Speedlite is pretty small compared to the size of most things we point it at. Like the sun, which seems relatively small because of Earth's distance from it, when a light source is small relative to the size of the subject, the light will be directional and the shadows will be hard.

You know that clouds are nature's light mod. When they drift in, sunlight becomes softer because the parallel rays bounce off the water vapor and then come at you from many angles rather than from a single direction.

It's the same with Speedlites. If you put a big modifier between your flash and the subject, the light will appear to come from a larger source and, hence, the shadows will be softer.

### Three Types Of Big Modifiers

You can divide big light modifiers up into three groups:

- Those that increase the apparent size of the Speedlite—i.e. make the source seem bigger—as the light passes through them (shoot-through umbrellas, soft boxes, diffusion panels)
- Those that increase the apparent size of the Speedlite—i.e. make the source seem bigger—as the light bounces off of them (reflective umbrellas, reflectors, white boards, shiny boards)
- Those that stop or limit light (flags, blackboards, and solids)

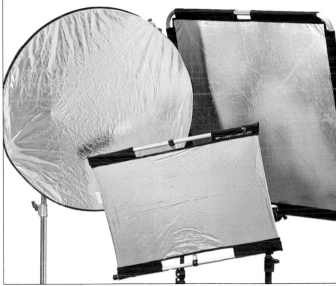

*Figure 14.2* Umbrella, softbox, and diffusion panel are mods that make the light source seem bigger.

*Figure 14.3* Disk reflector, California Sunbounce, and Scrim Jim are mods that bounce light.

*Figure 14.4* Flags, solid, and black foam core are mods that stop light.

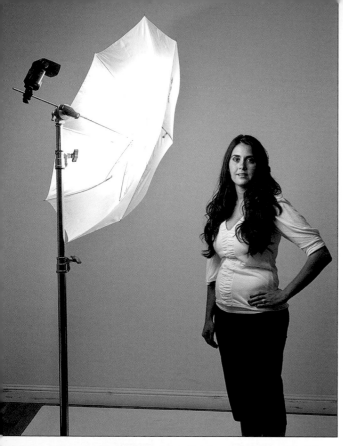

## UMBRELLAS

An umbrella is an easy-to-understand modifier. The framework is the same as the rain-repelling kind. The covering is either translucent (a.k.a. shoot-through) or reflective.

The greatest advantage of umbrellas is that they are widely available and relatively inexpensive. The basic idea is that firing your Speedlite through or into an umbrella makes the light come at the subject from many angles—meaning that umbrellas create soft light.

The downside to umbrellas is that, because of their curved shape, they throw light everywhere: on your subject, on the background, into the lens.... An umbrella can be tough to control with any precision.

If you are starting your journey as a Speedliter, then an umbrella is the perfect modifier to get you started. Know also, though, that if you stick with Speedliting, eventually you will grow beyond using an umbrella—you will want a modifier with more control, like a softbox. But, for now, an umbrella is a great place to start.

### Umbrella Fabrics

Umbrellas can be divided into two categories: shoot-through and reflective.

A *shoot-through umbrella* is made of thin white satin. To use one, you point the shaft of the umbrella away from your subject and position your Speedlite(s) to fire through the fabric.

A *reflective umbrella* typically has a flat white or shiny metallic lining. The most common metallic color is silver. You will also see gold and zebra (a zigzag combination of two colors). To use a reflective umbrella, you point the shaft of the umbrella at your subject and position the Speedlite(s) so that the light flies into and bounces off the fabric.

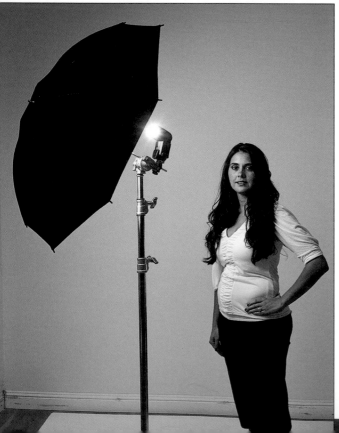

**Figure 14.5** *Shoot-through umbrella—the Speedlite fires towards the subject and through the umbrella.*

**Figure 14.6** *Reflective umbrella—the Speedlite fires away from the subject and into the umbrella.*

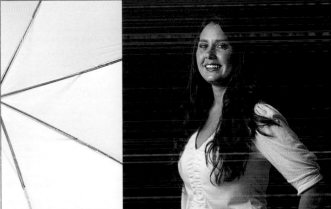

## AT A GLANCE: UMBRELLAS

**Advantages:**
- Affordable
- Easy to store and carry
- Many sizes and fabrics available
- Easy to use with multiple Speedlites

**Not So Good:**
- Throws light everywhere
- Hard to feather and define edge of light
- Often breaks easily

**Best For:**
- Beginning with off-camera flash
- Lighting groups and broad areas
- Fill flash (especially white- or silver-lined)

When it comes to reflective umbrellas, there is a visible difference to the look of the fabrics.

- White, not to be confused with shoot-through, provides the softest light.

- Silver, if used up close, adds snap and contrast. You will see it in the highlights. Silver is also helpful if you are going to throw the light a long way, as when you are lighting a large group or a big interior.

- Gold adds warmth to the light.

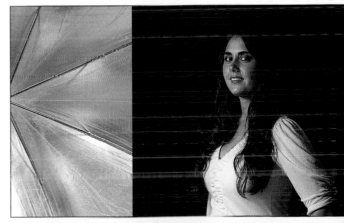

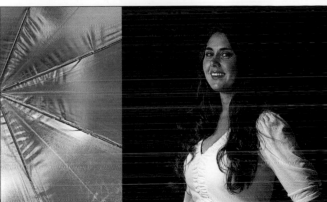

*Figure 14.7* Shoot-through umbrella.

*Figure 14.8* White reflective umbrella.

*Figure 14.9* Silver reflective umbrella.

*Figure 14.10* Gold reflective umbrella.

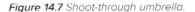

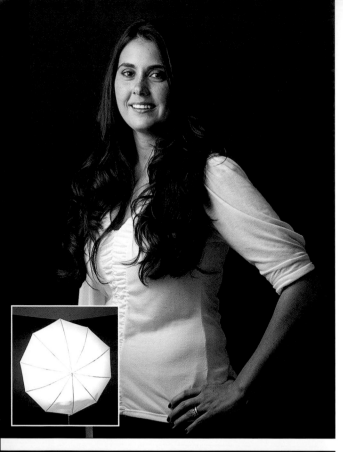

## Convertible Umbrellas

A convertible umbrella is typically a white shoot-through with a removable black cover. I think that convertible shoot-through umbrellas are great—but not for the idea behind their creation. The designer's idea is that you can have both a shoot-through and a reflective umbrella combined into one umbrella. I have a different approach.

My view is that I can use the removable cover as a built-in flag. Keeping a portion of the umbrella covered gives me a bit of control that I otherwise would not have. For instance, by leaving the cover in place on the back half of the umbrella as shown in Figure 14.12, I can light Sandra while preventing the umbrella from throwing much light onto the background. Or, by using the cover horizontally on one half of the umbrella I could have lit Sandra's face while creating a natural vignette below.

I say that if you need a reflective umbrella, then carry a reflective umbrella. The light traveling through the satin twice—once out to the outer cover and then once back through toward the subject—takes the snap out of the light. So I carry both a convertible shoot-through and a shiny silver umbrella—using each type for their intended purposes. Sure, if you are in a pinch and need a reflective umbrella, go ahead and use your convertible umbrella that way.

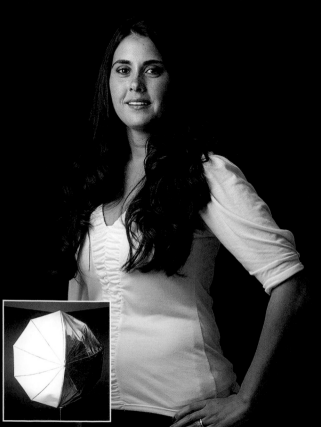

*Figure 14.11* In this shot, a whole shoot-through umbrella was used. This allowed a good bit of the light to hit the wall behind the subject.

*Figure 14.12* Here I used the cover of the convertible umbrella to flag the half of the umbrella that faced the wall. The light on Sandra is essentially the same. The wall appears darker because of the flag.

## Collapsible (Double-Folding) Umbrellas

Thanks to some umbrella genius, a collapsible umbrella is one that double folds down from full size into a portable package. My favorite, the Westcott #2001, opens from a 2" x 14½" package into a 43" umbrella—large enough to shoot headshots of one person or two people who like each other a lot. (Be sure to read the sidebar at right so that you understand that 43" is not always 43".)

The Westcott #2001 is a perfect partner to the Manfrotto #5001B stand—which is only slightly larger that the umbrella when folded up. They make a great pair of travelling companions that will fit into a daypack or a carry-on suitcase.

## Umbrella Sizes

The umbrella's size is a significant factor in determining how many people or how large an area it will cover. Also, keep in mind that the position of the Speedlite(s) on the umbrella shaft and the position of the umbrella relative to the subject also greatly affect the coverage.

Here are general guidelines for the most common sizes (as measured across the face of the umbrella):

- 30"–32": 1 person head and shoulders, 2' x 3' tabletop/product (1 Speedlite)
- 40"–45": 2–3 person head and shoulders, 1–2 person ½-length, 4' x 6' tabletop/product (1 or 2 Speedlites)
- 56"–60": 3 person full-length, 5' x 8' tabletop/product (2 to 4 Speedlites)
- 72"–80": large groups (3 to 6 Speedlites)

One thing to consider is that you can use a large umbrella on a single person—often for full-length shots. The opposite is not true—a small umbrella on a group is not so successful.

## —Sizing Up Your Umbrella—

So, just how big is your umbrella? As you can see below, there really is no standard across the industry. Some manufacturers state the diameter as measured across the front. Others seem to approximate the long way round—meaning that they measure along the outside of the fabric.

In the interest of being fair, here are the details of how I conducted my impromptu survey. I measured just one umbrella of each model and took just one set of measurements from each umbrella. I did not measure across the front and around the ribs in several directions. So if the measurement is off by an inch or two, I can chalk that up to field wear on my gear. Umbrellas are fragile creatures that can lose their perfectly curved shape with just one over-zealous gust.

In looking at the numbers, it is obvious that some manufacturers, such as Westcott, state the longer number—the measurement around the ribs rather than across the face. Does this bother me? Not at all. Some of my favorite gear is made by Westcott. It's just helpful to know that a Westcott 43" umbrella will be closer to a 36" umbrella from Calumet, Flashpoint, or Lastolite.

| | Stated Diameter | Measured Diameter | Measured Along Ribs |
|---|---|---|---|
| Calumet AU3045 | 45" | 45" | 54" |
| eBay Generic | 60" | 58" | 69" |
| Flashpoint LTU40S | 40" | 42" | 46" |
| Lastolite 8-in-1 | 40" | 42" | 50" |
| Photoflex RUT60 | 60" | 56" | 68" |
| Photek Softlighter II | 60" | 59" | 68" |
| Photek Sunbuster | 72" | 72" | 82" |
| Westcott #2001 | 43" | 38" | 44" |
| Westcott #2021 | 60" | 51" | 60" |
| Westcott #4630 | 86" | 83" | 96" |

## Umbrella Adapters

The *umbrella adapter* is a hinged bracket that provides the means to connect an umbrella to a light stand. It has a large opening at either end: one for the light stand and the other for a *spigot* (threaded insert) for connecting a cold shoe.

One side will also have a small hole running perpendicular to the hinge. The side with the small hole goes above the hinge, as shown in Figure 14.13, so that the umbrella can tilt.

Umbrella adapters are made both in plastic and metal. For lightweight work, the plastic adapters are fine. For larger umbrellas and multi-Speedlite rigs, I always use a metal umbrella adapter. My favorite is the Manfrotto #2905, shown in Figure 14.14.

## Positioning Umbrellas On The Set

Umbrellas follow the same principles of physics as all other modifiers. If the umbrella is relatively close to the subject, its apparent size will be larger, so:

- The light will come at the subject from many angles
- The shadows will be softer
- The falloff will be greater

If the umbrella is relatively far from the subject, its apparent size will be smaller, so:

- The light will come at the subject from a narrow set of angles
- The shadows will be harder
- The light will appear more even across the face of the subject

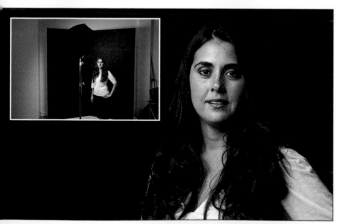

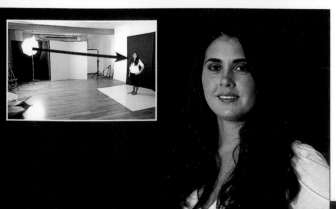

*Figure 14.13* The hole for the shaft of the umbrella should go above the hinge (as shown at left). If the shaft is below the hinge, then the umbrella will not tilt.

*Figure 14.14* A plastic umbrella adapter (left) is fine when starting as a Speedliter. If you use large modifiers, pay a bit more for the durability of a metal umbrella adapter (right).

*Figure 14.15* In this shot, the umbrella was 4' from the subject, creating dramatic fall-off.

*Figure 14.16* Moving the umbrella out to 16' creates flat light that lights the subject more evenly.

## Mounting Multiple Speedlites

One advantage of an umbrella, when compared to a softbox, is that it is relatively easy to shoot with several Speedlites. Essentially, it is just a matter of having a special adapter.

Lastolite's TriFlash combines three cold shoes and an umbrella adapter. The shoes are positioned at 90° angles. It has a swivel bracket that attaches to the light stand and a hole for the umbrella shaft.

IDC's Triple Threat is a block of machined aluminum that is intended to hold three Speedlites at 120° angles around the shaft of an umbrella. There is a ¼-20 thread so that it can be threaded onto a spigot in the top of an umbrella adapter.

Lightware's FourSquare is also machined from a block of aluminum. It comes as part of a unique softbox system (discussed in the next section). As its name suggests, the FourSquare will hold four Speedlites. It has threads for both ¼-20 and ⅜-X. It's unique in that it can also hold two umbrellas (facing in opposite directions).

## Double Umbrella Setups

Studio photographers often use large, dome-shaped softboxes, like Elinchrom's Octa, when they need a broad field of soft light. The unique design of these softboxes is that the strobe head is mounted inside and faces the back of the softbox. Thus, the light has a chance to fly around before it moves out through the front.

You can use a reflective and shoot-through umbrella to achieve a similar light. The main difference is that a big Octa has a flat front and the umbrella is curved. The FourSquare bracket is especially well-suited for a double umbrella set-up as it has two holes for umbrella shafts.

**Figure 14.17** Lastolite's TriFlash lighting pattern.

**Figure 14.18** IDC's Triple Threat lighting pattern.

**Figure 14.19** Lightware's FourSquare lighting pattern.

## SOFTBOXES MADE FOR SPEEDLITES

You can think of a softbox as the much better behaved cousin of a shoot-through umbrella. Because of their shape, umbrellas tend to spray light out over a wide swath. Softboxes provide much better control because they have opaque sides and a flat front. This limits the options for the light's flight path.

### Anatomy Of A Softbox

A softbox typically consists of a black nylon box that is lined with either a reflective white or silver fabric. As with umbrellas, silver gives a snappier quality to the highlights. White provides a more gentle wrap. Frankly, for Speedlite work I prefer the silver because it's more effective at pushing light out the front.

Most softboxes have four sides, but some have six or eight (the latter are called "octas"). The box is held open by metal rods that run through sleeves along the corners. The rods come together into a plastic or metal speed ring. The light source attaches to or is inserted through the speed ring.

The front of the softbox is a diffusion panel made of white nylon fabric. Some models have a removable inner diffusion panel (a.k.a. inner baffle) that softens the light a bit more. I prefer softboxes that have two diffusion panels—both removable. This gives me the most options and makes it easy to modify the Speedlite (by adding a gel or Stofen).

*Figure 14.20* *The 28" Apollo softbox by Westcott. Mounts one to four Speedlites inside. Silver interior.*

*Figure 14.21* *The 24" Ezybox by Lastolite. Holds one Speedlite facing forward as shown. Silver interior and interior diffusion panel.*

*Figure 14.22* *The 30" Ezybox by Lastolite. Holds one Speedlite facing forward as shown. Silver interior and interior diffusion panel.*

*Figure 14.23* *The FourSquare softbox by Lightware. Mounts one to four Speedlites inside. White interior.*

The front will be either flush or recessed a couple of inches. The advantage of the recessed front is that it limits the spread of the light. I prefer softboxes with recessed fronts because they give me just a bit more control as to where the light does and does not go.

## Survey Of Speedlite Softboxes

**Westcott Apollo**—If you are just stepping up to a softbox from an umbrella, I encourage you to consider the Westcott Apollo as your first softbox. It produces beautiful light, sets up quickly, can accommodate one to three Speedlites—all for about half the cost of the Ezybox.

Measuring 28″ x 28″, the Apollo features a highly reflective silver interior. In contrast to the Lastolite Ezybox design, which pushes the light from the back straight to the front, the Apollo design places the Speedlite inside the softbox. The advantage is that by facing the Speedlite toward the back of the softbox the light bounces around and emerges as a very even field. The disadvantage is that you cannot fire the Speedlite via Canon's built-in wireless system because the line-of-sight path is blocked by the softbox. This issue is easily overcome by using an extra-long E-TTL cord or by using radio triggers.

If you have a multi-Speedlite bracket, like the Lastolite TriFlash, you can mount several Speedlites in the larger Apollo. With an extra-long E-TTL cord, you can fire the master and slaves together inside the Apollo.
*Typical price: $120.*

*Figure 14.24 The Westcott Apollo can be used with one or several Speedlites. This headshot of Sandra was made with one Speedlite firing at ½ power.*

*Figure 14.25 The look of three Speedlites firing inside an Apollo is very similar to the look of one flash. For this shot, the trio was fired at ⅛ power—which enables a shorter recycle time.*

*Figure 14.26 The pattern of one Speedlite firing in the Apollo (left) and the pattern of three Speedlites firing. For the trio, I used the Lastolite TriFlash as a bracket.*

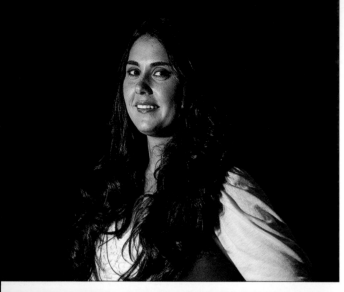

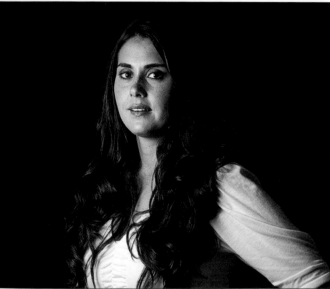

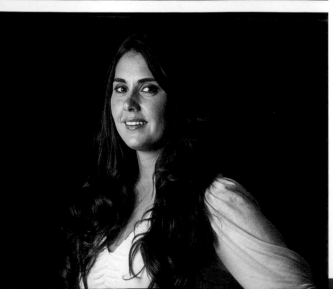

**Lastolite Ezybox Hotshoe**—This is my favorite softbox to use when Speedliting—for three reasons. First, it sets up in a matter of seconds. The built-in steel bands literally pop it into shape. The included Speedlite bracket snaps right into the back. It could not be simpler. Second, the Ezybox Hotshoe creates beautiful light. In addition to the recessed front panel, there is an inner diffusion panel to soften the light even more. Third, it folds up into a nice compact kit—about 8″ in diameter and 4″ thick. The only way to make it better would be to have a two-head adapter so that I could double the light I push through it.

When it comes to firing a Speedlite, the Ezybox works perfectly with my favorite extra-long E-TTL cord or with radio triggers. Canon's line-of-sight wireless also works—but you will want to rotate the body of the Speedlite sideways so that the wireless sensor on the front faces the master.

The 24″ x 24″ size is a good size for head-shots and ½-length portraits. If you have a bit of power to spare, you can get more diffusion by putting a Sto-Fen Omni-Bounce on your Speedlite before mounting it on the Ezybox. *Typical price: $225.*

*Figure 14.27* A bare Speedlite creates hard light.

*Figure 14.28* Using the outer diffuser only on the 24″ Ezybox softens the light significantly.

*Figure 14.29* Here both the inner and outer diffusers have been installed in the Ezybox—creating slightly softer light.

**FourSquare Softbox**—True confession: I bought a FourSquare within five minutes of seeing it online for the first time. This is a softbox designed specifically for shooting multiple Speedlites (up to four). Now, to fire multiple Speedlites simultaneously while they are hiding inside a softbox you need to either use radio triggers or run a cord into the box. Since Canon Speedlites do not have optical slave eyes built in, if you go with a radio trigger you'll either have to have one for each Speedlite or use splitters. My preference is to run an extra-long E-TTL cable into one unit and have it control the other Speedlites via Canon's built in circuitry. (Remember, there's a difference between an optical slave eye, which fires the flash when it sees a burst of light, and Canon's wireless E-TTL technology, where a master unit communicates instructions from the camera to slave units.)

At the hub of the FourSquare is a highly engineered block of anodized aluminum. In addition to spots for four Speedlites, it is drilled to accommodate two umbrellas. For instance, you could forego the softbox and fire the Speedlites into a silver umbrella that's clam-shelled with a shoot-through umbrella. Cool! The FourSquare is beautifully built and packs down into an easy-to-stow 18"-long stuff sack. It's the most expensive softbox I own for Speedliting, but worth every penny.
*Typical price: $270.*

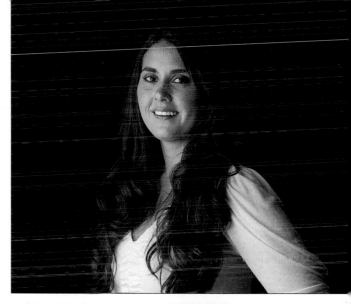

*Figure 14.30 The FourSquare is the largest of the softboxes made specifically for Speedliting (although the Apollo is a close second). This large size and the equal spread of the Speedlites means that the light wraps around the subject beautifully.*

*Figure 14.31 The FourSquare will hold four Speedlites. Note that I have twisted the heads 90° so that the light bounces off the sides of the FourSquare before it flies forward through the diffusion panel.*

### SPEEDLITER'S TIP

### —Deciding Which Softbox Is Right For You—

For many Speedliters, the purchase of a softbox is the second most expensive piece of gear in the kit (Speedlites will generally be the most expensive items). How do you decide which is right for you? Here are some thoughts:

- *Price*: softboxes range from $100 to $300+
- *Size for Speedliting*: a softbox in the 20" to 24" range is good for headshots, bigger for taller or wider shots.
- *Number of Speedlites*: Many softboxes can only handle a single Speedlite. If you want a softbox that will handle two or more, your choices are limited.

*My Recommendations*

*Novice*: Westcott Apollo

*Committed Enthusiast*: Westcott Apollo or Lastolite Ezybox

*Pro Speedliter*: Apollo, Ezybox or FourSquare

## CONVERTING A STUDIO SOFTBOX FOR SPEEDLITE USE

If you have a softbox for use with monolights or studio strobes already, you can think about converting it for use with a Speedlite.

Keep in mind that the distribution of light from a Speedlite is different from a monolight or studio strobe. With a Speedlite, the bulb fires forward through a flat panel. The tubes in monolights and studio strobes are tubular and send light in many directions simultaneously. See Figure 14.32 for a comparison of the two.

### Softbox Adapters For Speedliting

**Cheetah Speed Pro Bracket**—This simple bracket mounts the Speedlite horizontally above a lightstand and connects to Bowens / Calumet speedrings. Most softbox makers sell Bowens compatible speedrings, so you are not limited to Bowens softboxes. Remember to spin the Speedlite so that the slave sensor faces the master. It also holds the Cheetah Beauty Dish described on page 198.

**Chimera Speedlite Speed Ring**—I've used Chimera softboxes with my studio strobes for over 15 years. They are the industry standard for design and quality. So naturally, I went looking for a way to use the smaller Chimera softboxes, like the 12″ x 16″ Mini Bank (flush front, no inner baffle) and the 16″ x 22″ Super Pro Plus (recessed and removable front, inner baffle) with my Speedlites. The 2795 Speed Ring, with the included drop-bracket and cold shoe, work just fine with 580-series Speedlites. The 2790 Speed Ring is the one to use with the 430-series.

*Figure 14.32* The shapes of flash tubes on mono-lights and studio heads causes them to throw light in many directions rather than just forward.

*Figure 14.33* The Cheetah Speed Pro Bracket enables a Speedlite to be used with larger softboxes

*Figure 14.34* The Chimera 2795 holds the 580EX.

*Figure 14.35* The iDC Slipper is a robust aluminum rig that is model specific to RadioPoppers or PocketWizard's Mini/Flex.

Advantages:

- Easy to store and carry
- Tighter control of light

Not So Good:

- Can be expensive
- Multi-Speedlite options limited

Best For:

- Soft light

**iDC Slipper / Double Header**—Bruce Dorn, an internationally renowned editorial and advertising photographer—who is also a Canon Explorer of Light—has been designing and distributing high-grade photo gear for a number of years. His iDC Slipper is an innovative speed ring/bracket that will connect a Speedlite to a full-sized softbox. The iDC Double Header holds two Speedlites horizontally

**Kacey Speedlight Brackets**—The first thing to know about the Kacey Speedlight Brackets—and virtually everything else made by Kacey Enterprises—is that they are well designed and overbuilt. Don't confuse these brackets with the lightweight brackets sold by others for a fraction of the price. It's not that the Kacey brackets are heavy—they're not—but the aluminum is thicker than any other bracket I've seen. There's no doubt that they are engineered to securely hold the Kacey Beauty Reflector (see page 198) and one or two Speedlites in a breeze. The brackets are available in both single and double Speedlite models. I'd suggest the double just so you can keep your options open. In addition to fitting the Beauty Reflector, Kacey offers several adapters that will enable you to mount virtually any softbox.

*Figure 14.36* The iDC Double Header enables the use of two Speedlites with a large softbox.

*Figure 14.37* The Kacey Speedlight Bracket is a robust choice that can hold one or two Speedlites. Here one head is configured for a standard softbox

*Figure 14.38* The Kacey Speedlite Bracket configured for two Speedlites with an Elinchrom adapter.

## SPEEDLITER'S TIP

### —No Studio-Sized Softbox?—

Don't fret if you don't have a studio-sized softbox. The only reason that you would have one is because you're already shooting a monolight or studio strobe (and you're likely reading the *Handbook* because you're tired of hauling all that heavy gear around). If you've not ventured into the realm of large flash and don't have studio-sized gear, feel free to stick with Speedlite-sized gear.

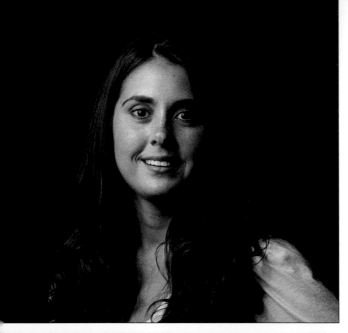

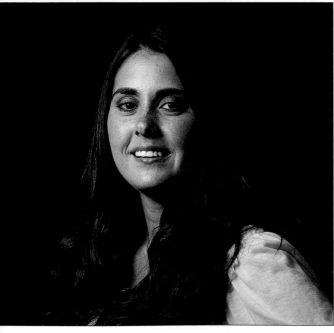

## BEAUTY DISHES

A beauty dish is essentially a broad, shallow pan with a hole cut in the center for a strobe. There is a reflector a short distance in front of the tube that scatters the light out to the sides of the beauty dish before it can move forward. The effect is a relatively small field of soft light.

### Beauty Dishes For Speedliting

**Kacey Beauty Reflector**—Beauty reflector, beauty dish: po-TAY-toe. po-TAH-toe. Kudos to Jerry Kacey for bringing the first full-sized (22") beauty dish to market that is designed with Speedlites in mind. Unlike studio dishes that are typically made of metal, the Kacey dish is made of plastic—which means that it's lightweight and durable, a perfect combination for Speedliters who often travel.

This is a professional-grade modifier that produces beautiful light. As you can see in Figure 14.39, the size of the Kacey enables it to throw a broad field of light that is even from edge to edge.

**Cheetah Beauty Dish**—The Cheetah Beauty Dish is a 16" metal bowl that attaches to the Cheetah Speedlight Pro bracket (and any other Bowens mount). A metal disk at the center bounces the light back to the bowl. Designed to work with Cheetah Speed Pro Bracket—see page 196. It has the highlight snap that is typical of silver dishes—yet does not blow out the highlights.

**Lumodi Beauty Dish**—The Lumodi Beauty Dish is lightweight plastic that has been thermomolded into a bowl. Unlike the Kacey and Cheetah, which require a bracket to hold the Speedlite, the Lumodi connects to the head of the Speedlite via a Velcro strap. As you can see in Fig. 14.43, the center is a bit hot.

*Figure 14.39* *Headshot with a Kacey Beauty Reflector.*

*Figure 14.40* *Headshot with a Cheetah Beauty Dish.*

*Figure 14.41* *The Kacey Beauty Reflector.*

*Figure 14.42* *The Cheetah Beauty Dish.*

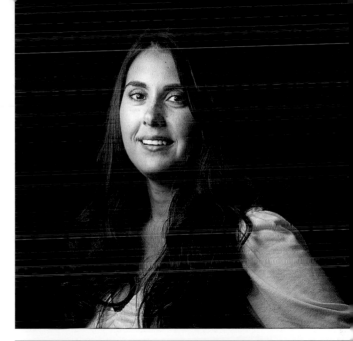

### Beauty Dish Compared To Other Mods

In terms of control, a beauty dish is similar to a softbox, meaning that it has a defined edge that you can use to feather the light. If you add a grid to a beauty dish, you have a light that is soft yet highly directional. In terms of softness, a beauty dish sits between an umbrella and a softbox.

### Apollo Softbox – Beauty Dish Style

If you flip the diffuser on a 28″ Apollo over the top and move it in close to your subject, you'll find that it can create light that is very similar to a beauty dish. As you can see in Figure 14.44, the Apollo lit Sandra's hair a bit more than the true beauty dishes. This is a function of size. The front of the Apollo is 6″ wider than the Kacey (and square), so it reaches around the subject a bit more.

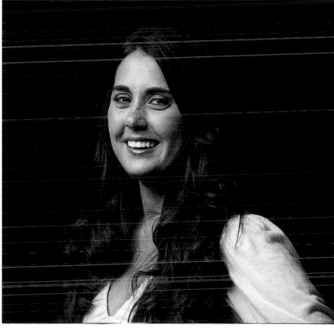

*Figure 14.43* Headshot with Lumodi Beauty Dish.

*Figure 14.44* Headshot with Apollo Softbox with diffusion panel flipped up.

*Figure 14.45* The Lumodi Beauty Dish.

*Figure 14.46* Apollo Softbox in beauty dish mode.

## SCRIMS AND DIFFUSION PANELS

A scrim is a semitransparent sheet of fabric. When stretched across a frame and used as a light modifier, a scrim becomes a diffusion panel. Diffusion panels can be used to soften any direct light source.

### Scrim And Diffuser Fabrics

**Silk**—Traditionally a silk was exactly that—white silk. Today it broadly refers to any lightweight, white fabric used as a scrim. Thin white nylon is the most common material for a silk. In a pro catalog, you will find silks listed by the amount of light they block—¼, ½, ¾, and full stop.

> *Silks are often used over the top of a subject to cut the harsh contrast created by direct sunlight.*

**Black Net**—Black net essentially is a neutral density filter for a light source. If you stretch a large black net tight across a frame and place it behind your subject, it will become invisible to the camera. This can be helpful if you need to reduce, but not entirely eliminate, the intensity of a bright background scene. Single net reduces about ¾ stop of light. A double net will provide about 1½ stops of reduction.

### Styles

**Collapsible Disk**—A 5-in-1 collapsible disk reflector kit is part of my novice Speedliter's kit. It consists of a diffuser disk and a cover made of four fabrics: black, white, silver, and gold. You can fire your Speedlite through the diffuser disk to make soft light. You can hold the diffuser disk over your subject to kill the intensity of direct sun. A 32″ disk is the easiest to carry. A 42″ disk will be more versatile.

*Figure 14.47* A 5-in-1 kit is built around a collapsible diffuser disk and removable cover.

*Figure 14.48* Lastolite's Skylite panels are robust and hold a standard range of fabric panels.

*Figure 14.49* Westcott's Scrim Jim panel system offers the widest selection of fabrics.

*Figure 14.50* Westcott Fast Flags fold for transport.

**Square/Rectangular Frame**—When you go beyond 32″ to 36″, it can be difficult to keep a diffuser disk taut. A better alternative is to use a frame system. Two of my favorites are the Lastolite Skylite and the Westcott Scrim Jim. Both come in a variety of sizes and offer several diffusion and reflective fabrics.

**Open-Sided Frame**—An open-sided frame holds the fabric on all but one of the long sides. The advantage is that the lack of a rod or tube on the fourth side allows for a shadowless transition from the diffuse light to direct light. Both F.J. Westcott's Fast Flags (Figure 14.50) and Matthews' Road Rags fold up into easy-to-transport kits.

### How Diffuser Position Affects Light Quality

The closer that your subject is to the diffusion panel, the softer the light will be. Also keep in mind that as you push the panel in closer, the contrast in the shadows will become deeper (meaning that the chiaroscuro increases).

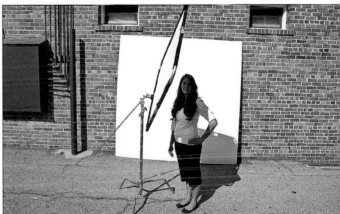

Conversely, the farther out you pull the diffusion panel, the flatter the light will become across your subject. In both cases, the diffusion panel creates soft light. The difference is the range of contrast on your subject.

*Figure 14.51* Headshot made in direct sunlight.

*Figure 14.52* Headshot with diffuser disk at 16″.

*Figure 14.53* Headshot with diffuser disk at 4′.

*Figure 14.54* Headshot with diffuser disk at 12′.

*Figure 14.55* Set shot of diffuser at 16″.

*Figure 14.56* Set shot of diffuser at 12′.

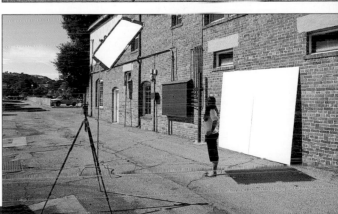

## REFLECTORS

Reflectors can be used with both ambient light and flash. With ambient, a reflector is mainly used to bounce light into the shadows to reduce contrast in the scene. With flash, a reflector can be used to increase the apparent size of the light and thereby soften the shadows.

### Foam Core Reflectors

Foam core is a styrofoam sheet covered on both sides with heavy paper. A sheet of foam core makes an inexpensive fill card for reflecting light into shadows. You can buy 3′ x 4′ sheets at office supply stores and larger sheets at pro photo or theater supply stores.

### Fabric Reflectors

Reflectors come in all the styles that were discussed in the previous section on scrims. The difference, of course, is that the fabric panel is reflective rather than semitransparent. Most reflectors will have a different fabric on each side of the disk or panel. The four main colors are: white, silver, gold, and zebra (a zigzag mix of two colors). When starting, a 5-in-1 collapsible reflector will do fine.

---

**AT A GLANCE: REFLECTORS**

Advantages:
- ■ Inexpensive (basic units)
- ■ Easy to store and transport

Not So Good:
- ■ Need light source to reflect
- ■ Difficult to fine-tune the amount of light

Best For:
- ■ Filling shadows
- ■ Quick bounce flash

---

*Figure 14.57* Headshot with white fabric reflector.

*Figure 14.58* Headshot with silver fabric reflector.

*Figure 14.59* Headshot with gold fabric reflector.

*Figure 14.60* Set shot of gold reflector in use.

## FLAGS AND SOLIDS

Photography is not always about lighting—sometimes it's about shadowing. So remember, another way to shape light is to block it from the subject, from the background, or from the lens. Flags and solids are as valuable as any other light modifier.

### Flags

A *flag* is an opaque object used to block light coming from a source—such as a Speedlite. In the preceding chapter, on pages 180–181, we saw a number of ways that a flag can be used to increase the drama of light. Sometimes a card, a bit of Cinefoil, or that piece of cardboard is all that's needed to turn average light into something special.

### Solids

A *solid* is similar to a flag in that it also is opaque and used to block light. The distinction is that a light source is flagged, whereas ambient fill is blocked by a solid. The photos at right demonstrate the concept of *negative fill,* which—I agree—sounds like an oxymoron. The idea, simply, is to absorb light that would otherwise fly by the subject and bounce back as fill.

> ### AT A GLANCE: FLAGS & SOLIDS
>
> Advantages:
> - Can be made impromptu during shoot
>
> Not So Good:
> - Nothing in particular
>
> Best For:
> - Controlling spill from Speedlite (flag)
> - Controlling fill (solid)

*Figure 14.61* The bare brick tints the fill light red.

*Figure 14.62* White foamcore provides bright fill.

*Figure 14.63* A black solid maintains the original look while removing the red cast from the brick.

*Figure 14.64* The Scrim Jim black solid in use.

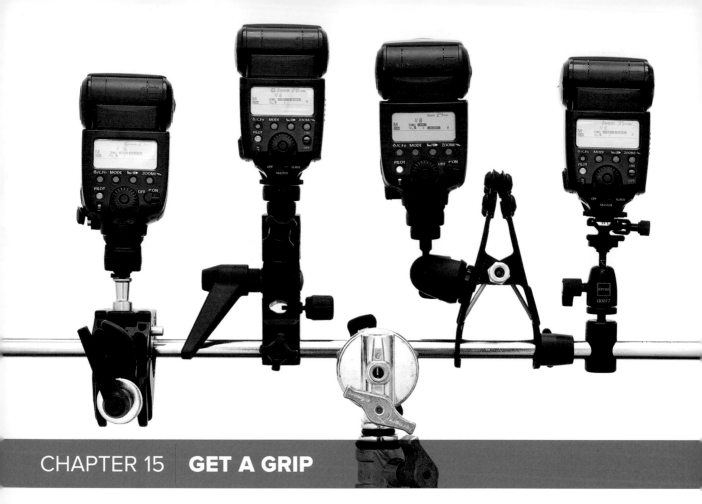

# CHAPTER 15 | GET A GRIP

## The Short Version

By now, you know that to create interesting light, you have to create interesting shadows. To create interesting shadows, you have to get your Speedlite off the axis of the lens. To accomplish that, you'll want to be able to put it virtually anywhere.

Grip is the gear used to hold a light on a set. For our purposes, it's anything other than your camera's hot shoe that helps hold a Speedlite in place.

**Figure 15.1**
*Creating great light starts with putting your Speed-lites in the right spot. From left: Super Clamp, Umbrella Adapter, Justin Clamp, and Lovegrove Bracket.*

## MOUNTING A SPEEDLITE ANYWHERE

Creating just the light you want begins with placing the Speedlite precisely where you need it. For off-camera work, most shooters think of starting with a lightstand, which is the topic of the next section. For me, Speed lite placement begins right at the foot of the flash—because you have to start by mounting the Speedlite on *something*.

### Speedliting Begins With A Shoe

There are hot shoes and there are cold shoes. Both will hold the foot of a Speedlite. The difference is that a hot shoe will trigger a flash and a cold shoe merely holds the flash.

In the case of hot shoes, the simpler versions have a single terminal at the center. More deluxe hot shoes have contacts that match the look of the E-TTL hot shoe. However, if the connection is PC-sync or miniphone, then you can only shoot in Manual mode and not in E-TTL.

Cold shoes are simple assemblies of plastic and/or metal. Among my favorite plastic cold shoes are the Manfrotto #143S Flash Shoe and the recently-launched Frio (described below).

Some metal cold shoes are just solid blocks of metal machined to receive the Speedlite foot. Others are little metal clamps that tighten onto the foot of the Speedlite.

One thing to watch out for on a metal cold shoe is that the five pins on the bottom of the Speedlite do not contact the metal shoe. Many designs have a recessed center that creates a gap. For those that don't, I use a strip of gaffer's tape as a bit of insulation to prevent the pins from shorting out against the metal.

The new Frio has become a personal favorite. This ingeniously-designed cold shoe has no moving parts. The plastic deck provides complete protection against the pins shorting. The threaded metal socket on the bottom is very robust—providing a secure connection to the swivel bracket or lightstand.

*Figure 15.2* Both of these hot shoes are manual mode-only. You can tell because the cords are removable.

*Figure 15.3* I prefer metal cold shoes that have a recessed center. If the cold shoe does not have a recessed center, then I will use a strip of gaffer's tape as insulation.

*Figure 15.4* The plastic body of the Frio protects the Speedlite from shorting. The metal socket on the bottom provides a secure means of connection.

### SPEEDLITER'S TIP

#### —Your Speedlite Came With A Cold Shoe—

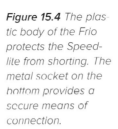

New Speedlites come with a plastic cold shoe. It's that U-shaped mini-stand that's hidden in the inside pocket of the Speedlite case. If you look closely at the bottom, you'll see that it has a ¼-20 thread that will allow you to connect it to a spigot. Be careful that you don't overtighten it. If you do, the threads will strip. Because of this risk, I prefer to use a cold shoe with a metal thread.

## Swivel Adapters

A swivel adapter provides a hinged connection between a Speedlite and a light stand. If it has a hole through one half, it can also be called an umbrella adapter, as the hole can be used for the shaft of the umbrella. (See page 190 for more information on using an umbrella adapter.)

For economy, a plastic swivel adapter will suffice. These are quite common and are available from a wide range of manufacturers. For durability and heavy loads, I use an all-metal swivel adapter. My favorite is the Manfrotto 026 Swivel Adapter. It is strong enough that I trust it to hold my camera if I'm shooting time-lapse photography from a remote angle.

Also, I prefer swivel adapters that have a female socket on both sides. Some adapters have a cold shoe permanently attached to one side. The disadvantage of the permanent cold shoe is that I cannot simultaneously tilt the

adapter and spin the body of the Speedlite in the adapter. This is a real issue when shooting wireless as I often spin the slave so that the sensor (on the front) faces the master.

**Lovegrove Flash Bracket**—Damien Lovegrove, a Bristol-based photographer/blogger/teacher, has come up with a ballhead adapter that I've become quite fond of. The advantage is that it is compact, fast to use, and enables me to swivel my Speedlite in virtually any direction after turning a single knob. I think the base that Damien chose was especially ingenious because you can mount it vertically or horizontally on the top stud of a lightstand. You can buy the Lovegrove Flash Bracket at LovegroveConsulting.com or assemble a similar version by connecting a Manfrotto 014-38 Rapid Adapter to a mini ballhead—such as the Gitzo G0077, Manfrotto 492 or the Giottos MH-1304.

*Figure 15.5 Here is one of my DIY "Lovegroves" mounted: (top) horizontally on a light stand, (left) vertically on a Super Clamp, and (right) on the boom of a C-Stand. As long as I do not need to mount an umbrella, this is the flash bracket that I reach for.*

---

That little threaded insert that came with your swivel adapter is called a spigot. Some spigots have a ¼-20 thread at one end and a ⅜-16 thread at the other. Others combine a threaded end with a tapered hexagon at the other. They are designed to fit in the Super Clamp.

Spigots that are made of soft, lightweight metal should be discarded and replaced with more durable brass or steel spigots. I carry my assortment of spigots (which includes a few spares as they get lost easily) in a plastic screw caddy.

## Clamps

If you find yourself frequently shooting in a variety of locations on tight schedules, you should drop a couple of clamps in the bottom of your grip bag. You might not find the need for them for a long while, but when you do, you'll be grateful that you have them on hand.

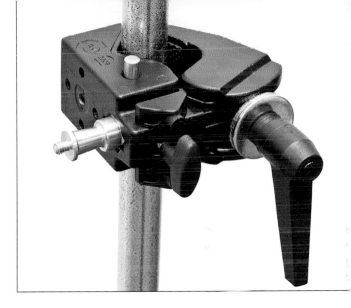

A clamp will give you the opportunity turn a chair, a ladder, a window, or a door into a light stand. Here is a rundown of my favorites.

**Super Clamp**—The Manfrotto 036 Super Clamp is a wide-jawed clamp that has a hexagonal socket and locking pin. It is the base for a modular system that has a wide number of accessories. If you thread a spigot into a cold shoe, the Super Clamp can hold a Speedlite directly. Or with a Magic Arm (described in the next section), it can be used to place a Speedlite in a precise location. If you have just one clamp, I suggest that it be a Super Clamp.

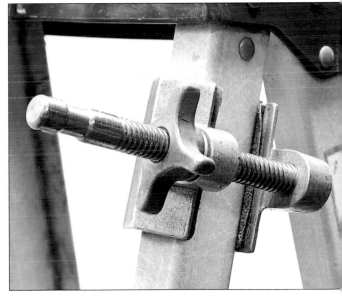

**Cardellini**—Outside of the movie industry, this versatile clamp is virtually unknown. I'm on a personal crusade to change that. Created by Steve Cardellini, a Hollywood grip master, the Cardellini is essentially a set of wide, V-shaped jaws on a long bolt with a $\frac{5}{8}''$ tip. The star nut enables the Cardellini to be attached with great force, yet removed quickly. It comes in a variety of lengths. My favorite is the 6" model, which will hold onto anything from a car window to a 4"-thick piece of wood. When sold by Matthews Studio Equipment, it's a Matthellini.

**Justin Clamp**—The Justin Clamp is the Swiss Army knife of grip. It consists of a spring-loaded clamp with a $\frac{5}{8}''$ spigot, a $\frac{5}{8}''$ socket with thumbscrew, and a miniature ballhead with a cold shoe. The clamp was created from an assembly of stock Manfrotto parts by Joe McNally and Justin Stailey (then a Bogen tech rep). You'll find it listed in the Mantrotto catalog as the 175F Spring Clamp with Flash Shoe.

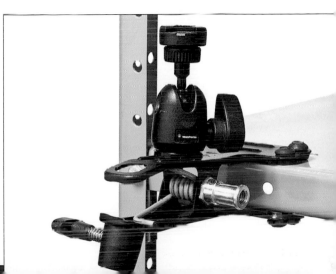

*Figure 15.6* The multi purpose Super Clamp.

*Figure 15.7* My well-worn 6" Cardelini Clamp.

*Figure 15.8* The versatile Justin Clamp.

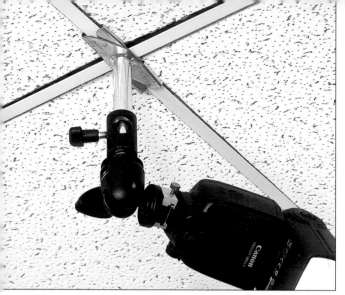

## Making A Special Connection

Try to never let your gear limit your vision. If the perfect place for a Speedlite is right above an executive's desk or tucked into the corner of a panoramic window, there is a way to keep your light there.

**Drop-Ceiling Scissor Clamp**—The Avenger C1000 has a single purpose: to hang an industry-standard $\frac{5}{8}''$ pin from the T-bars used to hang acoustic ceilings in commercial and office spaces. If you have a wide-angle shot that prevents the use of a light stand, with the Scissor Pin you can hang a Speedlite from the ceiling. The simple design makes the post the nut for the bolt that tightens the scissor arms. To use, you loosen the post, slip the arms on the T-bar, and then lock everything down by turning the post.

**Suction Grip**—This is a clamp that I seldom have occasion to need. Yet, in some circumstances, there is no substitute. The Manfrotto 241 Suction Grip will enable you to literally attach a Speedlite to a window. If you are shooting in a space with great glass windows and need to hide a Speedlite just out of frame, this would be the clamp to have. When several 241s are used together with connector rods, they have enough strength to hold cameras and large lights to cars driving on movie sets.

**Sparrow Plate**—Here's another specialty connection that will save your hiney when there's no place for a light stand. The Avenger C1100 Sparrow Plate can literally be slipped into a doorjamb. A hole in the plate also enables it to be nailed or screwed into many surfaces.

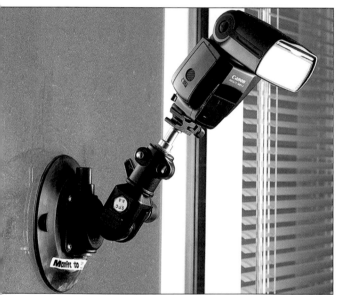

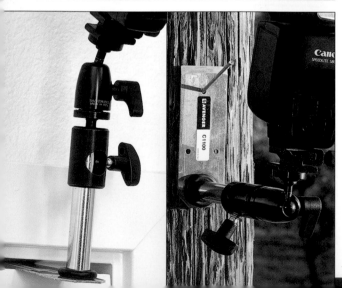

*Figure 15.9* *The Avenger C1000 Scissor Clamp enables a Speedlite to be mounted to the frame of a drop ceiling—commonly found in offices.*

*Figure 15.10* *Sometimes there is no better place to put a Speedlite than just beyond the camera's view of a panoramic window. The Manfrotto 241 Suction Grip will adhere firmly to any smooth surface.*

*Figure 15.11* *An Avenger C1100 Sparrow Plate can hold a Speedlite in a doorjamb (left). It can also be nailed to a telephone pole (right).*

## Flexible Arms And Their Cousins

There will be times when the spot where you can mount the clamp is not the spot where you want to put your Speedlite. Putting an arm in between can give you the control you need.

**Flex Arm**—The Manfrotto 237 Flex Arm is 18″ of wrapped steel that bends when you apply a bit of force. Although its intended use is to hold lightweight modifiers and flags, the Flex Arm is strong enough to support a Speedlite. Conveniently, one end has the hex fitting that locks into the socket on a Super Clamp. For more precise control and more strength, take a look at the Magic Arm.

**Magic Arm**—The Manfrotto 143N Magic Arm is a heavy-duty arm capable of supporting seven pounds of gear. The unique ball joints at the ends release when you swing the lever at the center hinge. This makes precise placement of a Speedlite on a Magic Arm extremely quick.

**Gorillapod**—Of course, this isn't an arm—it's three arms that resemble a tripod. Handier than an octopus (because you don't need to keep it wet), the arms of a Gorillapod can be wrapped around tree branches, lamp posts, pipes, etc. I use the GP2 (a.k.a. Gorillapod SLR). It weighs about as much as half a can of soda—yet holds 1.75 pounds (the weight of two 580EX IIs).

**Nasty Clamp**—Rather than be the elephant in the room, photographer Matt Monroe dubbed his invention the Nasty Clamp. Essentially it is a #2 spring clamp (a.k.a. pony clamp) connected to a length of Loc-Line—a flexible series of plastic segments. Thanks to a ¼-20 thread at the end, the Nasty Clamp will connect directly to a cold shoe—which means that you can park a Speedlite almost anywhere.

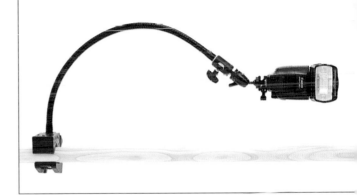

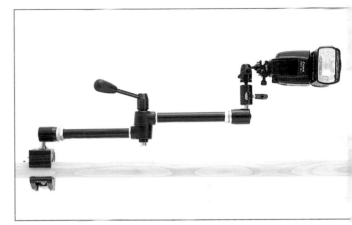

*Figure 15.12* The Manfrotto 237 Flex Arm is virtually indestructible and, well, very flexible.

*Figure 15.13* The Manfrotto 143N Magic Arm will enable you to put a Speedlite exactly where you want it to be.

*Figure 15.14* The Gorillapod GP2 on a grapevine.

*Figure 15.15* The Nasty Clamp on a picket fence.

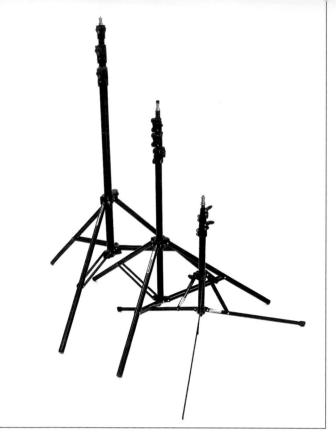

*Figure 15.16 Three lightweight Manfrotto stands that are perfect for Speedliting: (from left) the 5001B Nano, the triple-riser 367B, and the 1005BAC Aluminum Ranker stand.*

*When travelling, I typically take three to five of the 5001B Nanos and three of the 1005BAC, which conveniently lock together to save space.*

## SOMETIMES YOU HAVE TO TAKE A STAND

One of the great benefits of Speedlites is that they are light and easy to move. When it comes to light stands for Speedliting, sometimes a lightweight stand is all that's needed; other times a heavy-duty studio stand is the better choice.

### Lightweight Stands

**Nano Stand**—When light weight and compactness are the main criteria, I always reach for a Manfrotto 5001B Nano Stand. This unique design hinges the legs backwards; when folded, the whole stand is just 19" long. Yet the five sections extend to about 6' in height. If you put the legs flat on the floor, the Speedlite will be about 20" from the ground. When you extend the legs out at a 45° angle and extend all the rises, the Speedlite will be about 6' from the ground. This is a great working range.

**Basic 9' Stand**—If you typically shoot outdoors with an umbrella or softbox or if you want a stand to use with monolights or studio strobes, the Nano Stand will not provide the stability that you need. For these situations, I carry the more traditional stand, like the Manfrotto 367B. The tubular legs have twice the spread of the Nano, which provides much more stability. The risers also extend to 9'. If you need more height, the Manfrotto 368B extends to 12'.

**Air-Cushioned 9' Stand**—An air-cushioned stand is one that has gaskets between the center columns that prevent the load from dropping suddenly when a knob is released. This is helpful when you are hoisting several lights and a large modifier (like the FourSquare softbox loaded with Speedlites, or the Kacey Beauty Reflector). For extended trips, when I need the stability of a large stand and have to minimize the weight and bulk of my grip bag, I carry the Manfrotto 1005BAC. Their unique design enables them to fold flat and lock together. Three stands take up only 6" x 6" x 39". Yet they are big enough to hold any of my favorite large modifiers.

## C-Stands—When Stability Matters

A C-stand is a unique and versatile stand capable of hoisting heavy loads to tall heights. For instance, a 40″ C-stand will reach up to 10′. Even though a Speedliter's loads are seldom heavy, when you're shooting in windy conditions the advantage of a C-stand's weight and stability becomes obvious. I consider C-stands to be part of my essential gear for large location shoots. If you travel, the good news is that they are available at virtually any rental house for just a few dollars a day.

**Load to the right of the knob**—The industry standard is that the load is always placed to the right of the knob on a grip head. This way, gravity will help tighten the head rather than loosen it.

**Color**—I don't mind if my aluminum stands are black. They do not have much metal to absorb heat. For a C-stand (which is made of heat-retaining steel), I always prefer chrome as it stays cooler in the sun.

**Arm / Grip Head**—You'll want to get an arm and a grip head with your C-stand. The standard arm is 40″ long and will come with a grip head permanently attached to one end. You'll also need a grip head to attach the arm to the C-stand. A C-stand complete consists of all three parts.

**Nail Pin**—I carry Manfrotto E650 6″ pins with me, even when I am renting stands. I find the use of the pin in the extension arm grip head gives me an added bit of control. Surprisingly, I have frequently rented stands and learned that the rental house does not stock a nail pin. So now, I carry my own.

**Risers**—This is a double-riser C-Stand, which means that it has two center columns that can be extended. When loosening the knob, always keep a hand on the column to keep it from crashing down.

**Legs**—As you can see, the C-stand has three legs, each at a different height. This enables several C-stands to be used very close together. For storage, they fold flat. When opening the base, hold the long leg with your left hand and pull the next leg to the right until it locks into place. Some stands are made so that the center column detaches from the legs. I prefer this style as it is easier to pack. When placing the stand, point the longest leg in the direction of the load so that it supports the load overhead.

**Sandbag(s)**—For safety, always add one or more sandbags to the base. If you're wondering whether you need to add another sandbag, the answer is always yes.

**Figure 15.17** *Avenger A2030D 40″ C-Stand with Detachable Base, Avenger D200 2″ Half-Grip Head, Avenger D520 40″ Extension Grip Arm, and Avenger E650 ⅝″ Male Adapter (aka. Nail Pin).*

Most of the light that we encounter comes from above. Yet Speedliters often don't make the effort to re-create this effect because they either don't think about it or they don't have the right gear. Now that you're thinking about it, what do you need to do it?

In a pinch you can extend a lightweight stand and hold it overhead with a Speedlite attached. For longer reaches, you'll appreciate the length of an extendable pole. For longer spans of time and for hoisting large mods, you'll appreciate the support of a boom.

### Poles—Because Light Comes From Above

The advantage of a pole is that an overhead light modifier can be moved into position quickly and then transported through a crowd. Assuming that you are working with an assistant, this is a perfect solution for event and location photography.

**Lastolite Extra-Long Extension Handle**—This telescoping aluminum pole (model #LS2435) has four flip tabs that make quick work of adjusting the length from 29″ to 83″. The end features a standard ⅝″ fitting that also has a removable ¼″-20 thread. Because it's easier to pack than the Shur-Line pole, this is now my official "road pole" that I take anytime I travel.

**Shur-Line Easy Reach Pole**—I discovered this pole when my youngest son was goofing off in the paint department at Home Depot one day. He was gleefully zipping it in and out just by pushing a button and sliding the handles apart. This is the reason to seek out the Easy Reach— you push a button and slide the handles apart to extend the pole in an instant. It's a standard painter's pole. So, you'll need to add the Kacey Pole Adapter. There are two lengths—I prefer the longer 4′-9′ pole (model #06572L).

**Figure 15.18** *Lastolite Extension Pole #LS2435.*

**Figure 15.19** *Shur-Line Easy Reach Pole.*

**Figure 15.20** *The Kacey Pole Adapter.*

**Kacey Pole Adapter**—Painter's poles hold great potential because they are light and long. The problem is that you can't attach any lighting gear to them directly because the threads are so large. Enter the Kacey Pole Adapter. This ingeniously milled bit of aluminum enables you to convert any painter's pole into a light pole with an industry-standard ⅝" fitting. I suggest that you use a bit of Loctite adhesive to affix the adapter permanently in place on the painter's pole. Otherwise, it has a habit of loosening a bit as you twist the pole under the weight of the softbox.

### Booms and Boom Stands

The only difference between a boom and a boom stand is that you need to add a stand for the first and it comes attached to the second. Here are a couple of rigs sized for Speedliting.

**Manfrotto 024B Light Boom**—If you have a medium to large stand (one rated to hold 18 pounds or more) consider adding the Manfrotto 024B Light Boom to your kit. Weighing in at 3½ pounds, the 78" pole will support any typical Speedliting setup. It disassembles into three 28" sections, so it's easy to pack for location shoots. It comes with a counterweight and grip head for connecting the boom to your stand.

**Manfrotto 420B Combi-Boom Stand**—This uniquely designed stand hides a boom in the center column that extends to 6'. When the boom is used vertically as an extension to the center column, the stand stretches to nearly 15'. In either case, at maximum extension, the load should be limited to 4½ pounds. This capacity works well for most of Speedliter setups. When folded up, the 420B is about 45" long so it will fit into most grip bags.

*Figure 15.21* Manfrotto 024B Light Boom attaches quickly to one of my C-stands. Shown here holding the Kacey Beauty Reflector.

*Figure 15.22* Manfrotto 420B Combi-Boom Stand stores the boom in the center column for easy transport and quick setup. Shown here holding the Four-Square softbox.

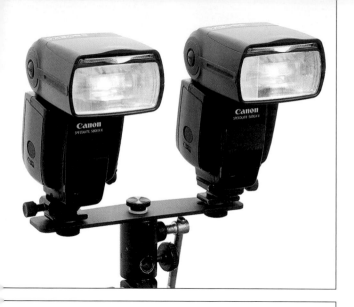

## RAILS AND OTHER MULTI-LITE MOUNTS

Once you become an avid Speedliter, I guarantee that you will start to think of reasons to shoot multiple Speedlites. Here are a number of ways to fire off two or more from the same stand.

### Mounts For Multiple Speedlites

**Wizard Dual-Flash Bracket**—This simple plate will hold two Speedlites side by side on top of a swivel adapter. It's an effective way to start with multiple Speedlites (*wizardbrackets.com*).

**Lastolite TriFlash**—see page 191.

**iDC Triple Threat**—see page 191.

**FourSquare**—see page 191.

### DIY Light Rails

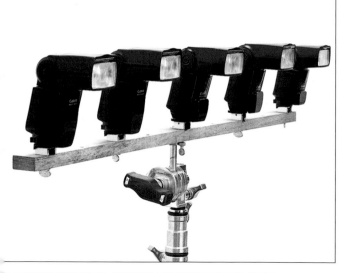

As we will discuss at length in Chapter 23, *Smashing Pumpkins With Gang Light*, I am fond of using many Speedlites arrayed on a long rail. When setting up any number of Speedlites on 3′, 6′, or 8′ rails, I always have had to construct my own. Red oak is a great material for this. A 1″ x 2″ piece cut to length and then drilled with ¼″ holes every 6″ or so is the basic design. I epoxy in a ⅝″ bolt as the post and then grind off the hex head.

### Turn Your C-Stand Into A Light Rail

If you lock the arm of a C-stand horizontally, you can turn it into a rail of light. No one ever said that your gear has to match. If you are looking to fire several Speedlites through a large diffusion panel, then use every adapter and clamp that you have in your bag.

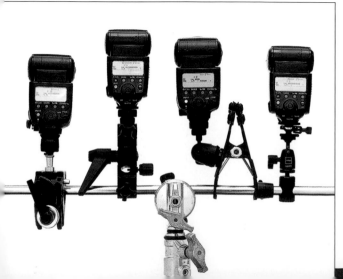

*Figure 15.23 The Wizard Dual Flash bracket will hold a pair of Speedlites (and radio triggers, if needed).*

*Figure 15.24 My DIY light rails are made of 1″ x 2″ red oak with holes drilled every 6″. This rail is 3′ long.*

*Figure 15.25 Turn the arm of your C-stand into the UN of lighting by attaching every adapter in your kit so that you can gang up a bunch of Speedlites.*

## STAYING FLEXIBLE: BUNGIES, STRAPS, AND GAFF

I believe in redundancy. So, I'll say it again—I believe in redundancy. Having several ways to do the same job helps assure that I can continue to work if a piece of gear breaks or is left behind. Here are three items that I tuck into my lighting bag for those just-in-case moments.

### Bungies

Elastic cord was invented for those times when nature parks a tree exactly where you want to put your light stand. When I come upon these situations, one option is to strap the Speedlite in place rather than try to wrestle with Mother Nature. I find that elastic bungies with a plastic ball are just the solution.

### Velcro Straps

An alternative to elastic cords is to carry a few 12" lengths of Velcro straps. Conveniently, they now come in precut lengths with the hooks and loops on opposite sides of the same strap. The half-inch variety is perfect for positioning a Speedlite on a fence or rail. For travel, they roll into compact, well-behaved coils.

### Gaffer's Tape

Gaffer's tape is the photographer's version of duct tape. It sticks to just about any surface—without leaving a residue when removed. Generally, "gaff" is black, although it comes in a range of colors. New rolls are quite long, 150' or so. When they are almost finished, I tuck them into the dark corners of my gear bags. Then, on those occasions when a piece of essential grip gear is left behind, I'll dig for a remnant roll of gaff and jury-rig a solution. It's seldom pretty or professional-looking, but it's better than not having a Speedlite at all.

*Figure 15.26* Bungies are a quick way to attach a Speedlite just where you want it to be.

*Figure 15.27* A few Velcro strips are an easy way to turn a fence post into a light stand.

*Figure 15.28* Once again, gaffer's tape to the rescue.

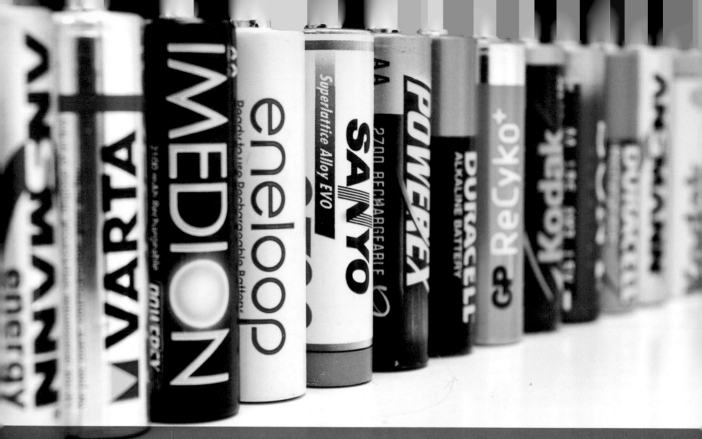

# CHAPTER 16 | KEEPING THE ENERGY UP

### Figure 16.1
*There are many choices when buying AA batteries for your Speedlites. The best type for you depends upon your shooting style, your battery charger, and your budget.*

## The Short Version

Speedlites are power-hungry creatures. As a Speedliter, if you become well acquainted with the many types of batteries and chargers out there, you'll end up minimizing how much it costs to feed your Speedlites.

Of course, there is no perfect battery. The many trade-offs include cost, shelf life, capacity, and power delivery. Knowing the range of options you have will help you choose the best type for your style of shooting.

If you go with rechargeable batteries, knowing how and when to charge them is as important as buying the right type of battery.

## BATTERIES BASICALLY

A battery is a bank account for electricity. Your Speedlite carries four AA batteries. Their job is to provide a load of electrons to the capacitor—which, in turn, can instantly unload those electrons through the flash tube. The batteries are relatively slow to charge and discharge. The capacitor works at hyper-speed.

How well your batteries perform on a specific shoot often depends on the type of batteries that you use. There is no battery that is the best for every Speedliter. Here are several criteria that go into making the right choice:

**Cost**—Rechargeable batteries are more expensive than single-use batteries at the time of purchase. Yet, when measured over their lifespan, they are much cheaper than single-use batteries.

**Availability**—If you're on the way to a shoot and realize that you've left your batteries at home, availability may be an important factor.

**Shelf life**—Some batteries will stay charged for a long time; others will discharge even when they are unused. Sure, we'd all like batteries that hold a charge forever. Slow-discharge batteries give up performance somewhere else.

**Capacity**—Long-life batteries (a.k.a. slow-discharge) generally have less capacity. High-capacity batteries often will not hold their charge for an extended period.

**Rechargeability**—Not all batteries can be recharged; those that can sometimes require a special charger. Not all chargers work the same. There are so many options!

**Delivery**—The ability of a battery to deliver power will determine whether a Speedlite recycles between flashes quickly or slowly.

**Heat**—Batteries will heat up as they discharge, especially when discharged rapidly. Too much heat can ruin the electronics in a Speedlite.

**Environmental Impact**—Every battery has an impact on the environment. I feel a tinge of guilt every time I throw out a battery.

As a bit of research for this chapter, over the course of two months, I fired a 580EX II more than 24,000 times. I fired it in manual mode at full power so that I could see which AA batteries performed the best. No, I didn't get a callous on my index finger—I used Canon's TC-80N3 Timer Remote Controller to fire the shutter every 20 seconds.

The idea behind the torture test was to see how many full power pops a set of batteries would produce at the 20-second interval. I concede that both the full power pop and the 20-second interval do not represent how most of us shoot. But I needed a baseline for the test.

I tested 32 different sets of batteries, including the leading brands from all the major battery types—alkaline, lithium, nickel-metal hydride, low-discharge nickel-metal hydride, and nickel zinc. The rechargeable batteries were tested three times (plus out-of-the-box for the pre-charged rechargeables).

The testing chamber was a large cardboard box. When the Speedlite fired, the frame was white. When the Speedlite did not fire, the frame was black. The Speedlite was fired until there were at least three misfires in a row. The image above is a screengrab from Lightroom that shows the data for a set of Kodak alkaline batteries. After 142 full power pops, the batteries started to die. After the last pop at frame 166, they were completely finished.

Normally, I would never run a Speedlite until the batteries failed. In fact, I change batteries any time I see the Pilot button linger in green for 1″ before switching to red. E-TTL seems most happy when the batteries are strong, so I change them often...except when running a torture test.

My conclusions are presented throughout this chapter. For all of the details on the tests, head to *Speedliting.com*.

## SINGLE-USE BATTERIES

Nonrechargeable AA batteries have the benefit of being available everywhere. That's great if you're in a pinch and need fresh batteries right away. The downside is that on a per-flash basis, there is no battery that is more expensive.

### Alkaline

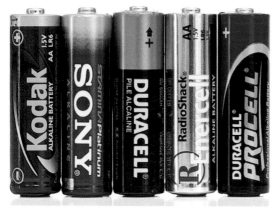

*Figure 16.2 Alkaline batteries averaged 165 pops.*

> Pros: *Relatively inexpensive, widely available, long shelf life*
>
> Cons: *Single use, slow recycling time, excessive heat*

Alkaline batteries are the standard, can-find-them-anywhere battery. They are fine for casual use. Once you become a power Speedliter, you'll want to move on.

I was surprised in the torture test how well the alkalines performed. On the average, they provided 165 full-power pops. So if you remember on your way to a shoot that you forgot to recharge your batteries, don't hesitate to stop at a convenience store and buy a few four-packs of alkalines to get you through.

A warning: in the test, the Duracell ProCells (the red and black battery in the photo above) became so hot that the plastic wrap around the cells shrunk and cracked. That's way too hot for safe use in Speedlites.

### Lithium

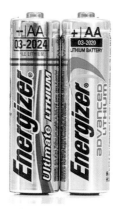

*Figure 16.3 Lithium batteries averaged 52 pops.*

> Pros: *Extremely long shelf life, light-weight, operate in a wide range of temperatures (–40°F to 140°F).*
>
> Cons: *Relatively expensive (2–3x cost of alkaline), poor performance under heavy load, excessive heat.*

I am surprised at the number of Speedliters I've met who use lithium batteries in their Speedlites. Based on the torture test, lithiums are very hesitant to give up their electrons—which is why lithium are touted for their 5–10 year shelf life (which I admit is a plus).

In the torture test, the lithiums averaged a mere 52 pops before a misfire. However, when I tested a set of lithiums at a three-minute interval, instead of the 20-second interval, they gave up 218 pops before failure. So, it's not that they don't have the capacity. It's just that they don't want to deliver the juice at the rate the Speedlite wants it.

Interestingly, they are much lighter in weight than other types of batteries—an advantage perhaps if you are outfitting for a long journey and must take only precharged batteries.

My thought is that lithiums should not be used for day-to-day Speedliting. However, I think that there is a place in every Speedliter's bag for a set or two as an emergency backup. Throw them in and forget about them for several years. Then, when you are desperate, dig them out and start your Speedlite up again.

## RECHARGEABLE BATTERIES

Most Speedliters end up using rechargeable batteries—the question is how much money they pour down the drain before making the switch. Sure, rechargeables are more expensive on the front end and you have to buy a charger as well. In the long run, though, there is no cheaper power source on a per-flash basis.

### Nickel-Metal Hydride (NiMH)

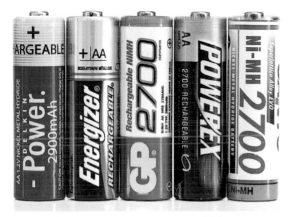

*Figure 16.4* NiMH batteries averaged 296 pops.

*Pros: Highest capacity, fast recycling*

*Cons: Self-discharge reduces output*

Nickel-metal hydride is the standard for rechargeable AA batteries these days. They have the highest capacity among rechargeables and provide a rapid recycling of the Speedlite.

In the torture test, the NiMH batteries averaged 296 full-power pops before a missed frame. The outright winner of the test, across all the batteries, was the Sanyo 2700, with an average of 296 pops.

The weak spot of NiMH, and it's definitely a point to consider, is that they self-discharge: 5–10% during the first 24 hours and then .5–1% per day thereafter. So, with NiMH it's best to give your batteries a full charge within 24 hours of a shoot. If you can't (or won't) do this religiously, then you should get the low-discharge nickel-metal hydride instead.

### Low-Discharge Nickel-Metal Hydride (LD-NiMH)

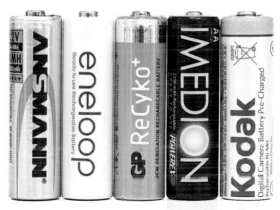

*Figure 16.5* LD-NiMh averaged 235 pops.

*Pros: Good shelf life, fast recycling*

*Cons: Lower capacity than NiMh*

A few years ago, "precharged, rechargeable" batteries became widely available. If you look at the really small print on the battery, you will see that they are NiMH.

The great benefit of these batteries is that they will hold 75–80% of their charge for up to a year. This is great news for Speedliters who are not diligent about recharging their batteries before every shoot—which is essentially all of us. So consider LD-NiMh to be the best battery choice for Speedliting.

In the torture test, all the brands provided 150–200 pops right out of the package, which puts them on par with alkalines. Then, in the recharge tests, they averaged 235 pops. That's about 20% less than regular NiMH—but for the long-term stability, this is a good trade-off.

Sanyo Eneloop, Powerex Imedion, and Kodak Digital Camera Battery are the three leading LD-NiMH. Eneloops are available at many Costcos. The Kodak version is stocked at Walmart and many other big-box stores.

## —My Bad Experience With Nickel-Zinc—

Nickel and zinc are common and inexpensive metals. A century ago, Thomas Edison combined them into experimental batteries—but gave up in favor of other chemistries.

Today the pairing of nickel and zinc has been revitalized as the newest form of rechargeable battery. PowerGenix, the company behind the patented technology, states that NiZn offers the capacity of traditional alkaline batteries and the economy of rechargeable batteries.

So, being the adventurous guy that I am, I rounded up three sets of the PowerGenix batteries for the AA Battery Torture Test. As I did with all the batteries (when I could) I acquired the sets from different sources in the hopes that I would get batteries from different manufacturing lots. I also acquired two of the PowerGenix chargers that are required for these batteries.

There's no doubt that NiZn can unload a lot of electrons in a hurry. In fact, when I tested the recycling time for all the batteries in the torture test (by measuring the time required to fire ten full power pops while waiting for the Pilot button to return to red between each pop), the NiZn were among the fastest. This was the last of the good news for NiZn.

In the torture trials, the NiZn actually provided fewer pops (155 average) than did regular alkaline batteries (165 average). Also, one cell in set #2 failed after the second round. It would not take a charge in any of the slots in either of the special chargers.

The final straw came after the first test for set #3 (169 pops). The batteries were actually too hot to hold. My infrared thermometer showed that their temps ranged between 175° and 185°! The temperature of the battery compartment was 165°. There is a thermal-cut-out circuit in the 580EX II—but it links to the flash head, not the battery compartment.

As for the Speedlite, I left it to cool overnight with the battery compartment door open. At first all seemed normal. The flash would fire and the power would go up and down. Then I noticed that it would not control slaves as a master.

So I sent it off to Canon for evaluation and repair. Canon Pro Services advised that the circuit board was damaged. It cost $125 to have it replaced.

It goes without saying that I'm no longer putting NiZn batteries in my Speedlites. Perhaps Thomas Edison was right all along.

I know. I know. You are really just looking for that sage advice as to which batteries are best for you. Looking into my crystal ball...I see the answer forming. It says, "It depends."

**Figure 16.6** *There is no one best battery.*

### Best AA: When Life Gets In The Way

*Eneloops* or *Imedions*: If you are going to be like most people and not think about your batteries until you want to use them, then go with a low-discharge nickel-metal hydride (LD-NiMh) battery. They combine the long-term economy of being rechargeable with the convenience of not self-discharging between shoots. Eneloop (made by Sanyo) and Imedion (made by Powerex) performed well in the torture test.

### Best AA: When Maximum Power Matters

*Sanyo 2700* or *Powerex*: If being diligent about recharging just before a shoot is the price you are willing to pay in order to get the maximum amount of power out of your batteries, then go with regular nickel-metal hydride batteries (NiMh). They will provide about 25% more pops than LD-NiMh.

### Best AA: When Finding Them Matters

*Any Alkaline*: If being able to buy fresh batteries on your way to a shoot is all that matters, then buy alkalines. Check the expiration date— the farther out the date, the fresher the battery.

### Buying Batteries

- For the best selection and great prices online, visit *ThomasDistributing.com*.
- For a local supply of precharged recharge-ables (a.k.a. LD–NiMh), head to the photo counter at a big-box store.
- If you are in a jam, you can buy alkaline batteries at a gas station.

### Avoid Mixing Batteries

- Think of your batteries as quadruplets. Buy your batteries in sets of four. Label them as a set of four, shoot them as a set of four, and charge them together.
- If you are not using a battery caddy, a thick rubber band can keep them together.
- Never mix battery types in a flash. Their voltages and discharge rates will vary.

### How I Manage Batteries

- I write the date of purchase on each battery and replace them after a year. The old ones go to household uses (flashlights, wireless keyboards, etc.).

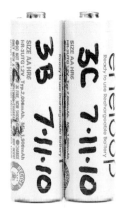

**Figure 16.7** *I write the date and set number on every new battery.*

- I carry at least two sets of batteries for every Speedlite in my bag. Generally half are regular NiMH and half are LD–NiMH.
- If I did not get around to charging my NiMH before the shoot, I will throw a brick of alka-line batteries in my bag as a backup.
- Somewhere down in the bottom of one of my bags are two sets of lithium batteries—waiting for their chance to shine years from now. If I use them slowly, they have the ability to deliver a couple hundred full-power pops. This is the only reason I've come up with to carry lithium batteries.

Canon's CP-E4 Compact Battery Pack is a vital accessory for power shooters that provides several valuable benefits. First, it dramatically reduces the recycling time—by as much as 70%. Second, it allows you to shoot longer without having to stop to change batteries. Third, it helps maintain a higher voltage—which helps the reliability of your E-TTL exposures.

The CP-E4 holds eight AA batteries in a remov-able tray. If you are a power shooter, you can buy a second tray and have another set of bat-teries ready to load.

The CP-E4 works with the 580EX II, 580EX, 550EX, 540EZ, MR-14EX, and MT-24EX. It will not work with 400- or 200-series Speedlites.

*A word of warning*: A number of third-party bat-tery packs are available—some for as little as a third of the cost of the CP-E4. As tempting as the price may be, know that you run the risk of damaging your Speedlite if the external pack sends too much voltage.

---

**SPEEDLITER'S TIP**

#### —How To Cut Your Recycle Time In Half—

I was once asked by a sports photographer to come up with a Speedlite solution that would allow her to photograph 10k runners as they crossed the finish line. She needed a bit of fill flash to light up their faces and she needed almost instantaneous recycling. I suggested she do two things: use multiple Speedlites and to connect each to an external battery pack.

There are two factors that determine how fast your Speedlite recycles (a.k.a. recharges): the power level of the flash and how fast the electricity can get out of the batteries and into the capacitor.

When time really matters, then using two Speedlites at half-power or, better still, four Speedlites at quarter-power will be much faster than shooting a single Speedlite at full-power. Add to this strategy the significant reduction in recycling time that comes from an external battery pack and you have a great synergy. (*Important tip*: when using multiple Speedlites in this manner, put their heads as close together as possible so that they do not create multiple shadows.)

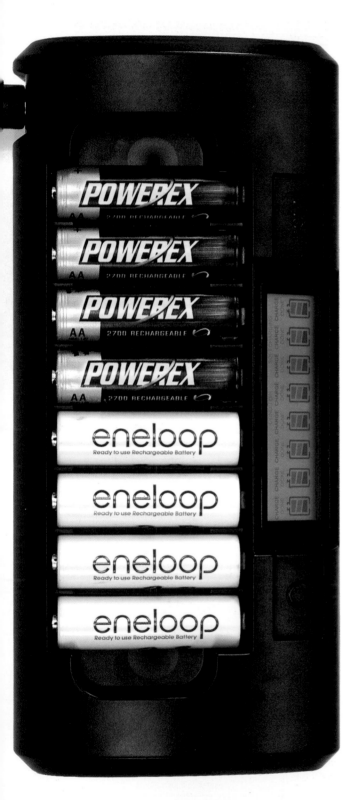

## CHARGING BATTERIES

Most Speedliters use rechargeable batteries. Having a good charger is as important as having an adequate supply of batteries. Having a bad charger can ruin good batteries quickly.

In use, each battery will discharge at a slightly different rate. It's best if your charger handles batteries individually or, at most, in pairs. Charging an almost full battery on the same circuit as an almost empty battery will shorten the life of both.

### The Risk Of Inexpensive Chargers

I know. It's tempting to buy an inexpensive charger. However, if you are willing to pay good money for batteries, you should get a good-quality charger to match. The risk of a cheap charger is that it will overcharge your batteries and significantly reduce their lifespan.

Many inexpensive chargers use a timer to control the length of the charge. If you insert a battery that is not fully discharged, the charger will keep pumping in power until the timer runs out. Timer-based chargers will also restart the clock if the cycle is interrupted (for instance, you pull the charger out to use the plug for another purpose and then reinsert the charger).

### What Makes A Charger Smart

A smart charger has the ability to sense the amount of charge left in a battery. Generally, this is indicated by some sort of LED light or LCD panel.

The smartest of the smart chargers will have an individual circuit for each battery. This means that each battery is charged individually.

Some smart chargers charge the batteries in pairs—stopping the charge to both when the first battery is finished. To minimize the impact, you should be careful about keeping your batteries grouped in sets.

*Figure 16.8* *My favorite charger is the Maha C801D. It has eight charging circuits so that each battery is monitored individually.*

## Maha C801D—My Favorite Charger

I rely on the Maha C801D (shown opposite) to keep my batteries in top shape. It's an eight-cell charger that can handle both AA and AAA batteries at the same time.

I chose the C801D because each battery is on an individual circuit. After making hundreds of voltage measurements on batteries coming out of the torture test, I can attest to the fact that individual batteries do not discharge at the same rate—even when coming out of the same device. So, for optimal performance, it's very important to have a charger that treats the batteries as individuals.

I am also fond of the C801D because it is a multi-voltage power pack. Essentially, with a plug adapter, I can plug this charger into any outlet around the globe.

The charger offers three charging modes.

- The *default mode* is a rapid charge that will charge eight batteries in about an hour.
- The *soft charge* (activated by pushing the right button) extends the charging time to about two hours. The slower cycle maximizes both battery life and performance. This is the mode you should use if you have the time.
- In *condition mode* (activated by hitting the left button), the charger tops up each battery, then discharges, and finally recharges to full capacity. The whole reconditioning cycle takes 12–14 hours. I do this when the performance of a battery set has declined significantly (and then return to using the soft charge).

## Maha C204W—A Great 4-Cell Charger

If you are looking for a more compact charger, then consider the Maha C204W. The major difference between it and the C801D (besides capacity) is that it charges batteries in pairs rather than individually. Two AAs will charge in about an hour. Four AAs will charge in about two hours. As with the C801D, there is also a conditioning mode that will revitalize overused and neglected batteries.

## CARRYING BATTERIES

As discussed earlier, the best practice for optimizing the performance and lifespan of your batteries is to buy, use, and store your batteries in sets of four. This will keep you from loading batteries with different power levels into a Speedlite.

Also, if you travel by air, you'll be required to carry your batteries in a way that prevents short circuits. So, dropping your entire inventory into a plastic bag is not recommended.

### PowerPax Battery Caddy

I carry all my AA batteries in the plastic Power-Pax Battery Caddy. You can buy the slim version that holds four batteries, or you can buy the 12-pack version.

Aside from the organization, what I like most about the PowerPax caddies is that they come in a range of colors. Unlike most of my photo gear, which only comes in black, it's easy to see a yellow PowerPax in my gear bag.

I store my freshly charged batteries with the tip down and the discharged batteries with the tip up. This way, I can quickly tell which is which.

*Figure. 16.9* I think PowerPax battery caddies are great. At a glance I can tell my fresh batteries from the spent batteries—tips down for fresh and tips up for discharged

PART 4 | **SPEEDLITING IN ACTION**

# CHAPTER 17 | LIGHTING PORTRAITS CLASSICALLY

**Figure 17.1**
*Eight lighting styles created
with a single Speedlite. Top
row: Broad, DMV, On The Nose,
and Short. Bottom row: Loop,
Rembrandt, Split, and Horror.*

## The Short Version

I'm an impulsive photographer. I craft light to fit my vision—a vision that is often fine-tuned during the shoot. I don't always think in terms of the classic styles of portrait lighting, yet I know that all of the lighting styles in this chapter roll around in my subconscious and whisper to me as I'm moving lights and mods into place.

Don't feel that you have to memorize each and every one of these styles. However, if you can come to understand the mechanics behind them, you will have a strong foundation on which to build your own lighting styles.

## ONE MORE TIME AROUND THE LIGHTING COMPASS

To create interesting light, you have to create interesting shadows. To create classic light, you have to create classic shadows. To create classic shadows, watch old black and white movies or spend an afternoon or two shooting all of the lighting styles covered in this chapter.

Of the eleven lighting styles discussed, I'd say that only seven are truly classic: *Broad, Butterfly, Short, Loop, Rembrandt, Split,* and *Horror.* The other four—*Copy, DMV, On The Nose,* and *Hatchet*—are more akin to slang. Yet it is as important to understand how they are created as it is to understand how the true classics are created.

From the camera's perspective, the placement of the shadows is determined by where the light is (or lights are) in relation to the camera. If you move the camera's position, you can go from one lighting style to another. For instance, if you are shooting *On The Nose* and move the camera so that it lines up under the flash, you've effectively switched to *DMV.*

As you will see throughout this chapter, most of these lighting styles can be created with one Speedlite. A few styles require two Speedlites: *Copy, Butterfly,* and *Hatchet.*

*Horror* lighting, by the way, is not created at a specific point on the Lighting Compass. Rather, it can be created from virtually any point by moving the light below the subject and firing it upwards.

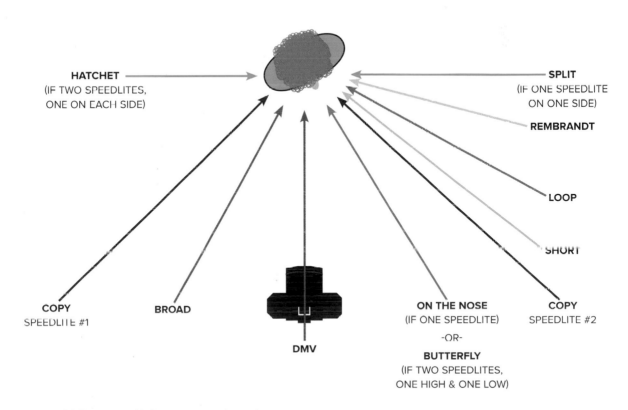

*Figure 17.2 The style of light you create depends largely upon the position of the Speedlite(s) relative to the camera.*

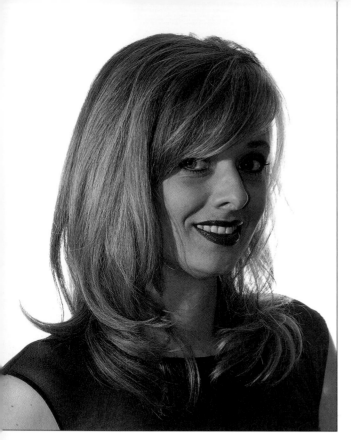

## BROAD LIGHTING

When your subject is not staring straight into the lens—that is to say, when your subject's nose is not pointed straight at the lens—then one side of the face will appear longer to the lens than the other.

If the main light hits the longer side of the face—the side of the face that is closest to the camera—then you've created Broad lighting.

Broad lighting minimizes the shadows that the camera sees. Facial features, such as bony cheeks, become more subtle. Broad lighting also makes thin faces appear wider.

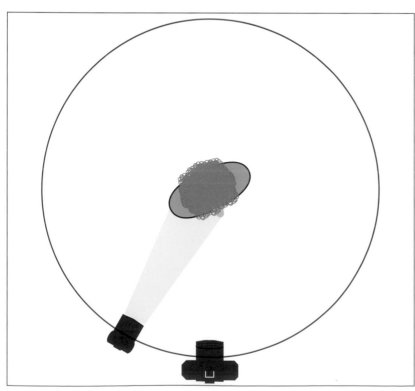

## DMV LIGHTING

"Welcome to the Department of Motor Vehicles" is no way to start a portrait session. Have you ever seen a driver's license that has a good mug shot on it?

I hope by this point in the *Handbook* that you've already figured out from the photo at right that DMV lighting is on-axis flash—meaning that the main light is centered above the lens. Even if the Speedlite is not attached to the camera, you can still create on-axis flash.

DMV lighting, on-axis lighting, and on-camera lighting all yield flat photos because both sides of the face are lit equally. There are no shadows to create a sense of shape and texture. "Next please!"

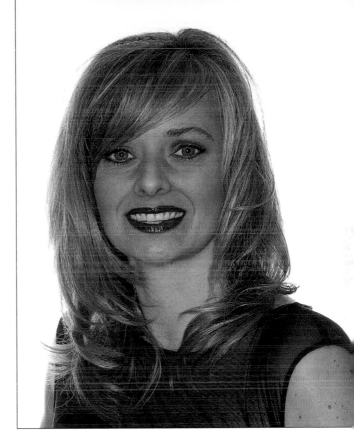

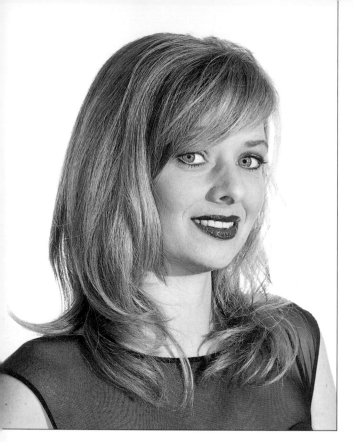

## ON THE NOSE LIGHTING

My friend Don Giannatti (*Lighting-Essentials. com*) taught me this trick. Essentially he said, "If you want to have a woman love your lighting, then have an assistant follow her nose with the light and be sure to keep it pointed straight at her nose." So, if you have only a single Speedlite, keeping it pointed at your subject's nose will create flattering light—just be sure that your subject is not facing the camera straight on. If she is, then push the Speedlite straight up so that it creates a small shadow under the nose and chin. As you can see here, when aimed properly, even straight flash can yield pleasing results.

## BUTTERFLY/PARAMOUNT LIGHTING

Butterfly lighting, made popular during the golden era of Hollywood at Paramount Studios, is the foundation of glamour lighting. Essentially it is On The Nose lighting done with two lights—one above and one below. Women with pronounced cheekbones love butterfly lighting because it smoothes out the facial structure by eliminating shadows. On the other hand, men's faces are best lit otherwise.

To set up Butterfly lighting, line up your key light so that it points directly at your subject's nose. Then, raise the light so that it casts a shadow below the nose, but do not raise it so high that the shadow reaches the lip. For the best effect, fire your Speedlite through a diffuser disk or a softbox. Use a reflector disk or second Speedlite below your subject's face as fill.

The curious name, Butterfly, is said to come from the shape of the nose shadow, but I think you have to squint to see it that way.

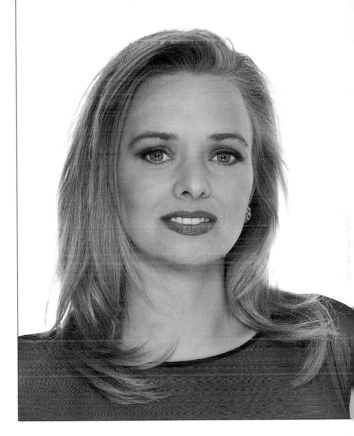

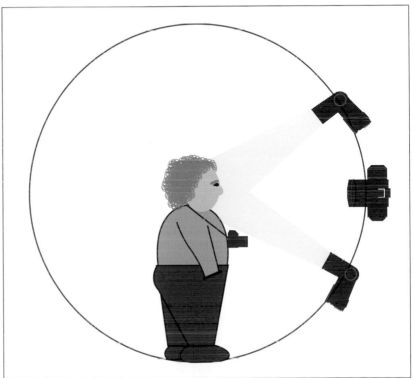

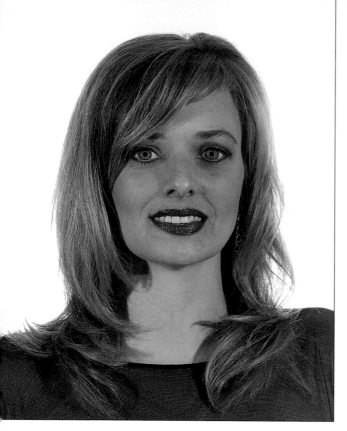

## COPY LIGHTING

Think of copy lighting as an advanced form of DMV lighting. Instead of one on-axis light source, Copy lighting uses two identical sources positioned on the right and left sides of the lens at a 45° angle from the subject. It lights the subject equally from each side. The shadows created by one light are filled by the other. So, like DMV, the light flattens the subject's face.

If you turn the power down on one of the lights, then you are creating shadows and have moved beyond the realm of copy lighting and into the realm of creating interesting light.

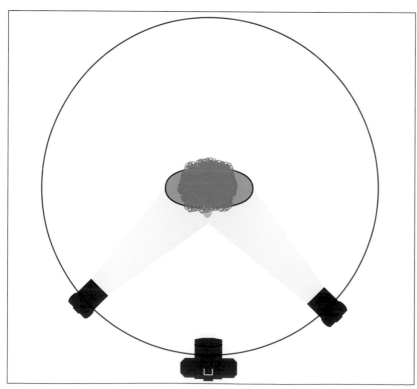

## SHORT LIGHTING

By moving the key light around to the other side of the lens so that it illuminates the side of the face that is farther from the camera, I've created Short lighting.

Short lighting puts more of the face into shadow. This is helpful when you want to slim down a round face a bit.

Keep an eye on the camera-side ear. If the key light lights the ear, then you need to swing the key a bit farther back on the lighting compass. With short lighting, the camera side ear should be in the same amount of shadow as the cheek.

I've already chanted, "If you want to create interesting light, you have to create interesting shadows" a number of times. So it should not be a surprise that I use Short light far more often than I use Broad light.

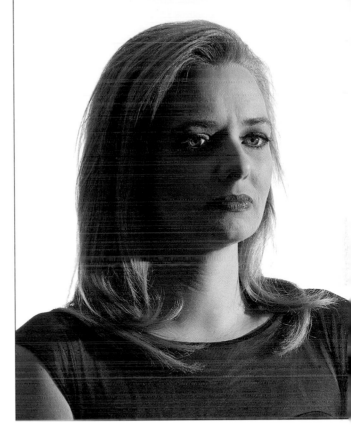

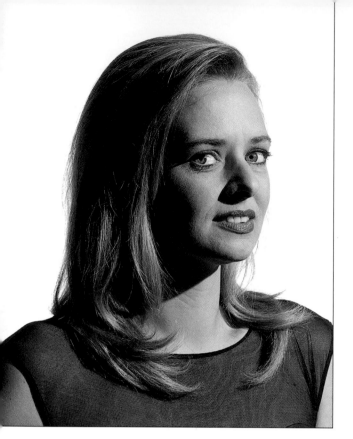

## LOOP LIGHTING

There are many types of Short lighting—the main difference among them being how far around the lighting compass you place the key light. The way to tell them apart is to look at the details of the nose shadow.

As you saw on page 231, if the key light points straight at the nose, then you are on your way to creating Butterfly lighting. If you continue to swing the key light around the arc of the lighting compass, you will see that the nose shadow changes. When the shadow becomes a distinct shape that angles away from the nose, then you have Loop lighting.

With Loop lighting, the nose shadow angles towards the corner of the mouth—but does not touch the cheek shadow. If it does, as you'll see on the next page, you've missed Loop lighting and gone straight to Rembrandt lighting. Think of Loop lighting as being that narrow zone between Butterfly and Rembrandt.

## REMBRANDT LIGHTING

Rembrandt, the 17th-century Dutch painter, continues to teach the world to see light. His signature portrait style emphasized the merging of light and shadow.

As far as Speedliting is concerned, Rembrandt lighting is similar to Loop lighting—except that the key light is swung farther back on the lighting compass so that the nose shadow connects with the cheek shadow. The signature look for a Rembrandt painting and Rembrandt lighting is a triangle of light beneath the eye that is farthest from the key light.

If you increase the apparent size of your Speedlite with a modifier and push it in close to your subject—so close that it's almost in the frame—then you'll find that the shadows become very rich, as in a Rembrandt masterpiece.

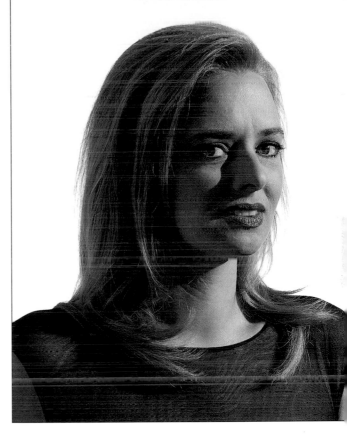

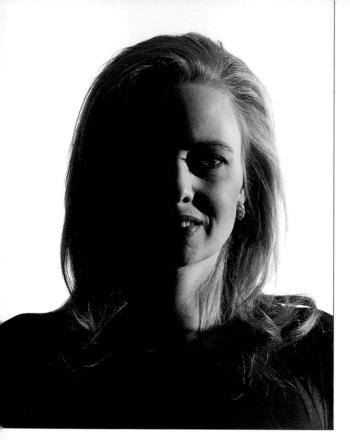

## SPLIT & HATCHET LIGHTING

Split lighting creates a psychological or emotional depth in a portrait. If half the head is lit and the other half is obscured in deep shadow, then a sense of mystery is created. By using a fill reflector on the opposite side of the Speedlite, I can throw light into the shadow and remove a bit of the mystery. If I use a second Speedlite rather than a fill reflector, I can precisely control the amount of light that fills the shadow and, thereby, precisely control the mood that the photograph portrays.

To move from Rembrandt to Split lighting, you move the key light to 90° on the lighting compass and lower it so that it is at the same height as the subject's head.

Hatchet lighting, although not shown here, is created by adding a second Speedlite to the Split lighting setup on the opposite side. The effect is that both sides of the head are lit and there's a dark divide between the two running down the center of the face.

## HORROR LIGHTING

We know intuitively that light falls. The sun is above. Shadows are below. When shadows rise, something is wrong. Cue the scary music. Horror lighting isn't wrong—assuming that you want to make frightening photos.

Horror light happens when the main light is lower than your subject's head. Remember that slumber party where you stuck a flashlight to your chin? Same thing. The lower the light, the scarier the shadows.

Don't confuse horror lighting with a low fill light that you're using to fill shadows. It's the main light that we're talking about. When most of the light comes from below, then the shadows rise and the shoot gets scary. If you're doing this when you shouldn't, then it's really scary.

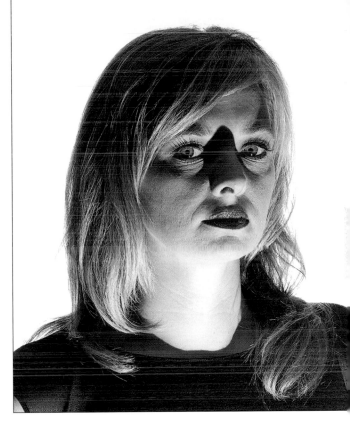

# CHAPTER 18 | PORTRAITS WITH ONE SPEEDLITE

## The Short Version

When it comes to photographs, there is nothing in the world that we like to look at more than pictures of other people. So, if you jumped straight here without reading the previous 237 pages, I understand completely. The quick answer is, "Yes, you can make great photographs of people with a single Speedlite."

This chapter will take you through many of—but certainly not all—the types of light you can create with a single Speedlite. Ultimately, it is your imagination and willingness to experiment that will be your guide.

**Figure 18.1**
*Both of these images were lit with a single Speedlite. The difference is the amount of ambient light. There's a good bit in the left frame. At right, the shutter has eliminated virtually all of the ambient light.*

There are 400 pages in the *Handbook* because there are so many ways you can shoot with Speedlites. Here is a quick summary as it relates to one-light portraits.

### One Speedlite, So Many Jobs

A single Speedlite can serve one of four main purposes:

- *Key light*—Provides the main light on your subject
- *Fill light*—Adds light to the shadows so that the viewer can see details that would otherwise be hidden
- *Separation light*—Lights your subject from behind so that the hair and shoulders will stand out from the background
- *Background light*—Lights the background either to reveal details about the environment or, when very bright, to put your subject into silhouette

### Location, Location, Location

The quality of light you get from your Speedlite is largely determined by its location. As I've said many times in the *Handbook*, "If you want to create interesting light, you have to create interesting shadows." If you don't know what this means, take a close look at the information in Part 1, "Before Speedlites, There Was Light."

The bottom line is that you need to get your Speedlite off the top of the camera. Seriously, pretend as if your Speedlite cannot connect to the hotshoe on top of your camera. Check out Chapter 10, *Move Your Speedlite Off-Camera,* if you need ideas on how to do this.

*Figure 18.2* The difference between these two photos is the position of the flash and the setting of the zoom. This shot was made with the Speedlite bolted into the camera's hotshoe. The zoom was set to Auto—resulting in a zoom of 35mm.

*Figure 18.3* For this shot the Speedlite was manually zoomed to 105mm and held about 14" straight above the camera. I had my assistant aim it directly at Kaitlin's face. The vignette is created by the zoom of the Speedlite.

I've said it before: The range of bright and dark tones that can be recorded by our cameras is much narrower than the range of light we can see. With a single Speedlite, there is the great possibility that when you balance your exposure for the light on the bright side of your subject's face, the other side will fall into dark shadow. An easy fix, when using one Speedlite, is to fill the shadows with a reflector.

### Fly A Bit Of Light Past Your Subject For Fill

The idea in using a reflector to fill shadows is that you capture the light that flies past your subject and bounce it back. It helps if you angle your Speedlite so that a bit of its light flies in front of your subject. This is the light that you will catch in the reflector and bounce back. When you angle a light away from your subject, you are feathering the light.

### Get Your Fill Reflector In Close

I push my fill reflector in as tight to my subject as possible—meaning that the reflector comes in until I see it in the frame and then I back it out just enough so that I don't have to head into Photoshop later.

*Figure 18.5 (opposite) My friend Zack Arias (zarias.com, OneLightWorkshop.com), lit with a single Speedlite at camera right. The two keys to making this shot were to flag the flash from hitting the steel door directly behind Zack and to fill the shadowy side of his face. To flag the background, I strapped a large Rogue FlashBender to the side of the Speedlite and aimed it right behind Zack's shoulder. To fill the shadows, I angled a 42" gold/silver reflector disk so that the flash flying past Zack's nose would bounce back into the shadows.*

*Figure 18.6 (inset) The shot without the reflector.*

### Lighting Details

**Environment:** indoors

**Time of Day:** late night

**Ambient:** very dim tungsten

**Speedlite:** one 580EX II

**Metering Mode:** Manual

**Power Level:** ¼

**Zoom / Pan:** 70mm

**Gel:** none

**Modifier:** Sto-Fen Omni-Bounce on head, large Rogue FlashBender strapped to off-camera side of head

**Distance to Subject:** 3′

**Height:** level with Zack's head

**Trigger:** extra-long E-TTL cord

### Camera Details

**Camera:** 5D Mark II

**Lens:** 24–70mm f/2.8L

**Distance to Subject:** 8′

**Exposure Mode:** Manual

**Exposure:** 1/60″, f/8, ISO 400

**White Balance:** Flash

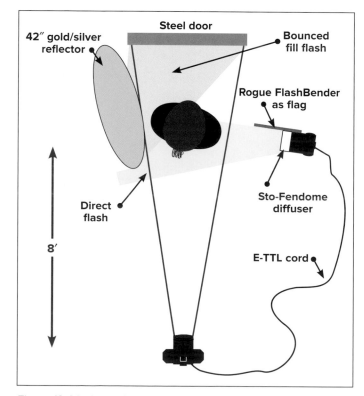

Figure 18.4 Lighting diagram.

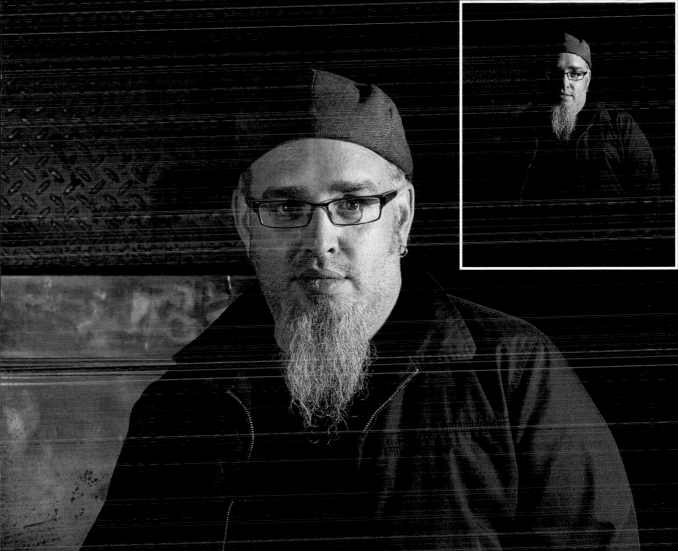

An umbrella is an easy and relatively afford-able way to significantly increase the apparent size of your Speedlite—which means that the edges of the shadows will soften as the light reaches around your subject.

## Umbrella 101: A Quick Review

For this shoot, I rounded up the four main types of umbrellas and Westcott's 28" Apollo softbox—which is the next logical step beyond an umbrella. As you read in Chapter 14, *Those Big Modifiers Always Get In The Way*, there are two main classes of umbrellas—shoot-through and reflective.

You can think of a shoot-through, used for Fig-ure 18.9, as a white satin diffuser that opens as an umbrella. When unflagged, it will throw light in a wide arc—including the background.

For reflective umbrellas, the main fabrics are white, silver, and gold. You can also find gold/silver zebra—which is a zigzag pattern of both.

## Lighting Details

**Environment:** indoors, photo studio
**Time of Day:** not a factor
**Ambient:** industrial fluorescent
**Speedlite:** one 580EX II
**Metering Mode:** E-TTL
**FEC:** 0 FEC
**Zoom / Pan:** zoomed to 28mm
**Modifier:** as listed
**Distance to Subject:** about 6'
**Height:** angled 6' above head
**Trigger:** extra-long E-TTL cord

## Camera Details

**Camera:** 5D Mark II
**Lens:** 100mm f/2.8L Macro IS
**Distance to Subject:** 10'
**Exposure Mode:** Manual
**Exposure:** 1/30", f/5.6, ISO 800
**White Balance:** Daylight

## Similarities And Subtleties

At first glance, the five headshots opposite appear very similar. Then the gold-tinted im-age, Figure 18.12, jumps out. A gold reflective umbrella, if used sparingly, can help you blend soft light into a sunset shot. When used with a cool white balance, its light can resemble a spray-on tan. So consider it a specialty item.

The difference between white and silver is largely in the highlights. Figure 18.10, the silver umbrella, is teetering on blowing out the high-light detail in Natalie's hair. The white umbrella provides a broad field of soft light.

*Figure 18.8 (opposite, top left) This set shot of the shoot-through umbrella is typical of all the shots in this series.*

*Figure 18.9 (opposite, center left) The shoot-through umbrella throws light everywhere—includ-ing the background.*

*Figure 18.10 (opposite, bottom left) The silver umbrella borders on blowing out the highlights.*

*Figure 18.11 (opposite, upper right) The white umbrella balances highlight and shadow.*

*Figure 18.12 (opposite, bottom center) The gold umbrella can resemble a spray-on tan.*

*Figure 18.13 (opposite, bottom right) Westcott's 28" Apollo softbox also creates beautiful light.*

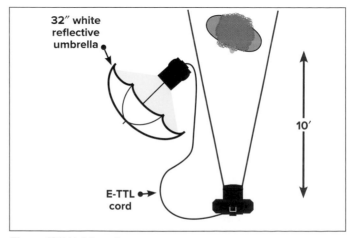

*Figure 18.7 Lighting diagram.*

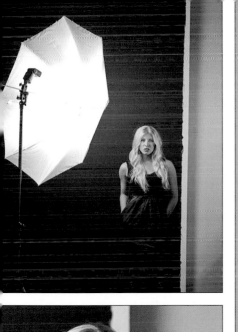

Look at the two photos opposite. The only difference between them is the shutter speed of the camera. So, feel free to think of the shutter as a light modifier.

### Separate The Two Types Of Light

There are two types of light in your flash photographs—the light that's already there and the light you create with your Speedlite. It helps to think of them separately.

The light that's already there (the *ambient* light) can be dimmed with a faster shutter speed or brightened with a longer shutter speed. If you are shooting the camera in Av (Aperture Priority) mode, then you can dial the ambient up or down with Exposure Compensation. If you are shooting the camera in Manual mode, then you change the shutter directly.

### Lighting Details

**Environment:** corporate conference room

**Time of Day:** not a factor

**Ambient:** dim incandescent

**Speedlite:** one 580EX II

**Metering Mode:** E-TTL

**FEC:** 0 FEC

**Zoom / Pan:** zoomed to 105mm

**Gel:** none

**Modifier:** none

**Distance:** about 6′ to subject

**Height:** level with subject's head

**Trigger:** extra-long E-TTL cord

### Camera Details

**Camera:** 5D Mark II

**Lens:** 24–70mm f/2.8L

**Distance to Subject:** 6′

**Exposure Mode:** Av, then Manual

**Exposure Comp:** 0, then −6 stops

**Exposure:** as listed

**White Balance:** Daylight

### The Camera's Vision Vs. Your Vision

Your camera's meter wants to see the world as a medium shade of grey. When you are in a dim environment, the camera will typically overexpose the scene (relative to how you are viewing what's in front of you).

The upper shot on the opposite page was made in a corporate conference room that was rather dim. Thanks to Alex, a model who can stand like a statue, and my Gitzo tripod, I was able to get the shot at the camera's desired shutter speed of ⅓″. The background appears brighter than it actually was. Notice that the flash, fired in E-TTL, created a nose shadow that blends with the ambient shadows.

For the lower shot, I moved my shutter from ⅓″ to ¹⁄₂₀₀″—a change of six stops. E-TTL set the power on the Speedlite at a similar level as the top shot.

*Figure 18.15 (opposite, top)* ⅓″, f/8, ISO 400. *Speedlite fired in E-TTL with 0 FEC.*

*Figure 18.16 (opposite, bottom)* ¹⁄₂₀₀″, f/8, ISO 400. Speedlite fired in E-TTL with 0 FEC.

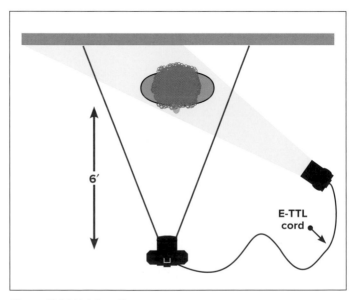

*Figure 18.14 Lighting diagram.*

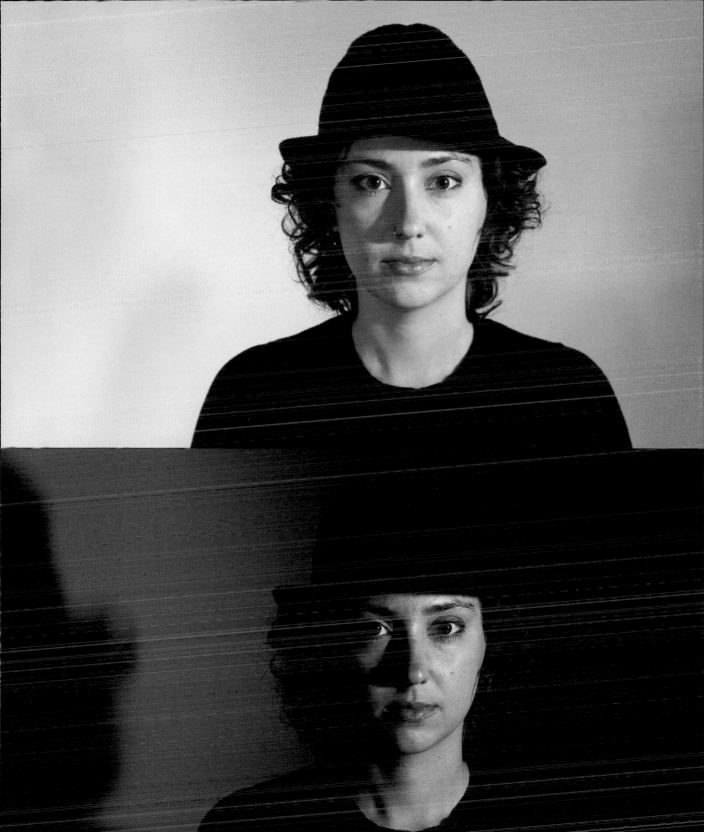

Sometimes turning your Speedlite at the background can create more dramatic light than when you aim it at your subject. For this shoot, I actually underexposed Arian to such an extent that he turned into a silhouette.

### Use Zoom To Create The Background Pattern

Even before Arian stepped into the frame, I experimented with different zoom settings on my Speedlite to see how they could illuminate the background. If you want a broad, even field of color, zoom your Speedlite out wide (to 24mm). If you want a spot of light that dramatically fades to black, zoom it in tight (to 105mm). The hero shot at right was made with the 580EX II zoomed to 70mm. The hotspot of color is the result of the Rosco medium red gel firing onto the deep yellow wall.

### Hide The Flash

Pay attention to the details when shooting silhouettes. I had to hide the Speedlite behind Arian's leg and instruct him on exactly where to stand.

### Sometimes Less Is More

When it comes to the intensity of the color from a gel, the more light you push through it, the lighter the color appears. So, if you are looking for a deep saturated color, remember to turn the power of your flash down rather than up. I know this sounds backwards.

*Figure 18.18 (opposite) My hero shot was made with the Speedlite power dialed manually to ⅛.*

*Figure 18.19 (inset) The set was two sheets of tile board pushed up to a yellow wall.*

### Lighting Details

**Environment:** empty store
**Time of Day:** not a factor
**Ambient:** very dim, overhead fluorescents turned off during shoot
**Speedlites:** one 580EX
**Metering Mode:** Manual
**Power Level:** ⅛
**Zoom / Pan:** zoomed to 70mm, panned straight up
**Gel:** Rosco Medium Red
**Modifier:** none
**Distance:** pushed up to wall
**Height:** sitting on floor
**Trigger:** Elinchrom Skyports

### Camera Details

**Camera:** 5D Mark II
**Lens:** EF 17–40mm f/4L
**Distance to Subject:** 12′
**Exposure Mode:** Manual
**Exposure:** 1/160″, f/8, ISO 400
**White Balance:** Flash

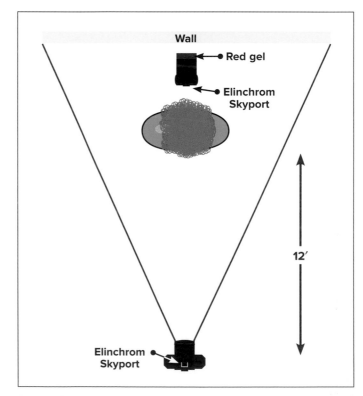

*Figure 18.17 Lighting diagram.*

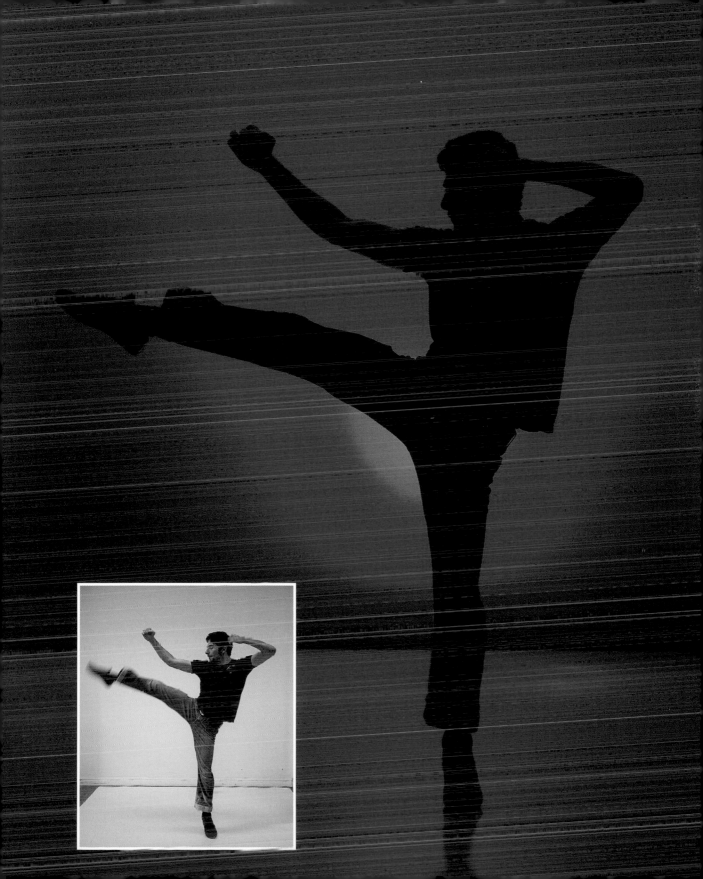

I like shooting in the direction of the sun. This is particularly effective with location portraits as it creates a bright outline across the subject's hair and shoulders. The problem is that our cameras cannot capture this bright light and the details in the shadows at the same time. Your Speedlite will be happy to come to the rescue.

### It's Not Whether To Fill, It's How To Fill

Unless you are looking to turn your subject into a silhouette, you will need to use your Speedlite to add fill light that will open up the shadow details when you point your camera toward the sun. There are a couple of considerations for fill light: where the Speedlite should be placed and if, and how, to modify it.

While you certainly can use your Speedlite on-camera for fill flash (as the Canon engineers designed it), I prefer to move my Speedlite off-camera. Usually, I will place it opposite the sun. I imagine a line that runs from the sun's direction through the subject and I place my Speedlite along that line.

As for whether to modify the Speedlite or not, this depends on two things: how much light I need to get out of the Speedlite and the quality of light that I'm looking for. I encourage you to try both straight flash and bouncing the Speedlite into a large reflector.

### Use A Bit Of CTO Gel To Warm The Fill

In this shoot, I used a ½-cut of CTO gel to warm the fill. As shown in the top photo, I think there is a natural blending of the fill on Misha's face with the warmth of the sunlight on the background. If ungelled, the fill flash would have been very cool and unnatural.

### Lighting Details

**Environment:** vineyard
**Time of Day:** late afternoon
**Ambient:** direct sun
**Speedlite:** one 580EX II
**Metering Mode:** E-TTL
**FEC:** 0 FEC
**Zoom / Pan:** 105mm
**Gel:** ½-cut CTO
**Modifier:** none
**Distance:** about 12′ to subject
**Height:** about 1′ above subject's head
**Trigger:** extra-long E-TTL cord

### Camera Details

**Camera:** 5D Mark II
**Lens:** 100mm f/2.8L Macro IS
**Distance to Subject:** 15′
**Exposure Mode:** Aperture Priority
**Exposure Compensation:** −⅔ stop
**Exposure:** 1/1600″, f/2.8, ISO 100
**White Balance:** Daylight

*Figure 18.21 (opposite, top)* My hero shot with fill created by direct Speedlite.

*Figure 18.22 (opposite, bottom)* Without the fill flash, Misha becomes a poorly done silhouette.

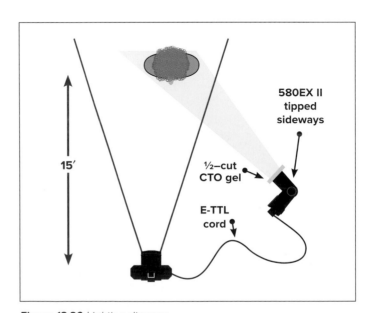

*Figure 18.20* Lighting diagram.

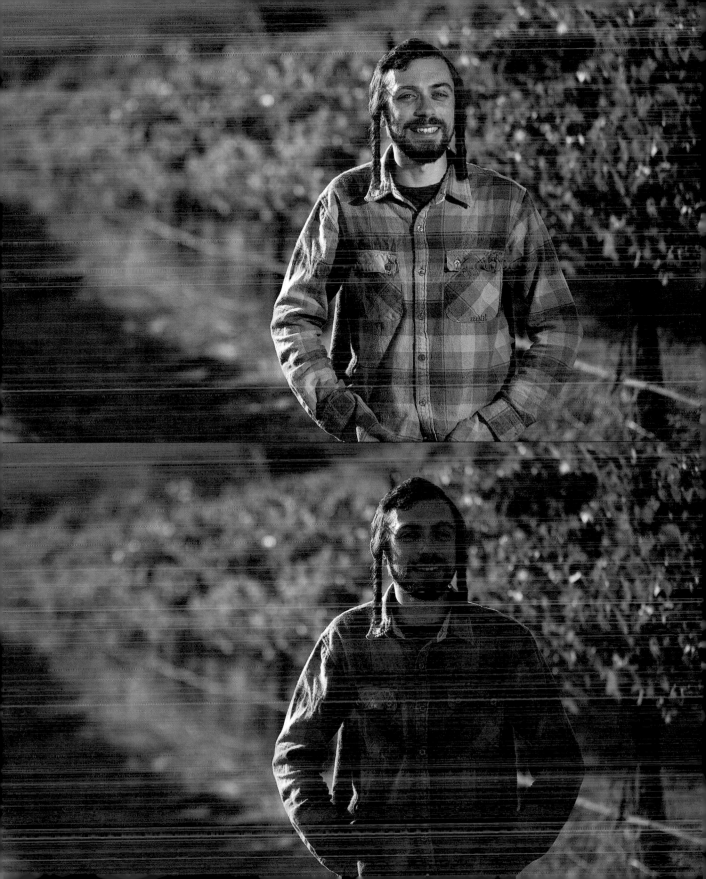

Is there a difference between light created by the various sizes of Lastolite's Ezyboxes—Speed-lite (about 10"), Hotshoe 24", and Hotshoe 30"? As these portais of my friend Annete show, the answer is "no and yes."

### All Three Ezyboxes Create Soft Light

The upper left image is the ambient light as the camera wanted to record it in Av with 0 EC. Just below is my manual exposure (ambient minus 3 stops). At bottom left, I fired a bare Speedlite at Annette. You can tell it is bare because the shadows are hard and the light does not reach around her face.

Now look on the right side at the three images created by the three sizes of Ezyboxes. You can see in each that the light reaches around Annette's face and that the shadows are soft. To make a fair comparison, I moved the stand so that the diffuser of each softbox was the same distance from her face.

### Lighting Details

**Environment:** outdoors under eave
**Time of Day:** mid-afternoon
**Ambient:** indirect sunlight
**Speedlite:** one 580EX II
**Metering Mode:** E-TTL
**FEC:** 0 FEC
**Zoom / Pan:** 24mm
**Gel:** none
**Modifier:** Lastolite Ezyboxes
**Distance to Subject:** about 2'
**Height:** centered on subject's nose
**Trigger:** extra-long E-TTL cord

### Camera Details

**Camera:** 5D Mark II
**Lens:** 100mm f/2.8L Macro IS
**Distance to Subject:** 8'
**Exposure Mode:** Manual
**Exposure:** $\frac{1}{125}$", f/8, ISO 100
**White Balance:** Daylight

### The Difference Is The Reach Of The Light

I also centered the height of each softbox on Annette's nose. As you can see in Figure 18.27 (the largest frame), the small Speed-lite Ezybox did a fine job of creating soft light. The difference between the three, and you have to look close to see it, is that the larger softboxes also carried the soft light farther down on Annette's arms. If I had lowered the 30" so that the top was even with Annette's hat, the soft light at the bottom would be even more apparent.

*Figure 18.24 (opposite, top left)* My 5D Mark II metered the ambient at $\frac{1}{30}$", f/5.6, ISO 100.

*Figure 18.25 (opposite, center left)* I dimmed the ambient by manually dialing the exposure to $\frac{1}{125}$", f/8, ISO 100—a change of −3 stops.

*Figure 18.26 (opposite, bottom left)* Without a softbox, the bare flash creates hard shadows.

*Figure 18.27 (opposite, upper right)* Even the smallest of the softboxes, the Lastolite Speed-lite, created beautiful light.

*Figure 18.28 (opposite, bottom center)* The Ezybox 24" provides soft light with a slightly smaller vignette at the bottom.

*Figure 18.29 (opposite, bottom right)* The Ezybox 30" provides beautiful light from Annette's hat down to her hands.

*Figure 18.23 Lighting diagram.*

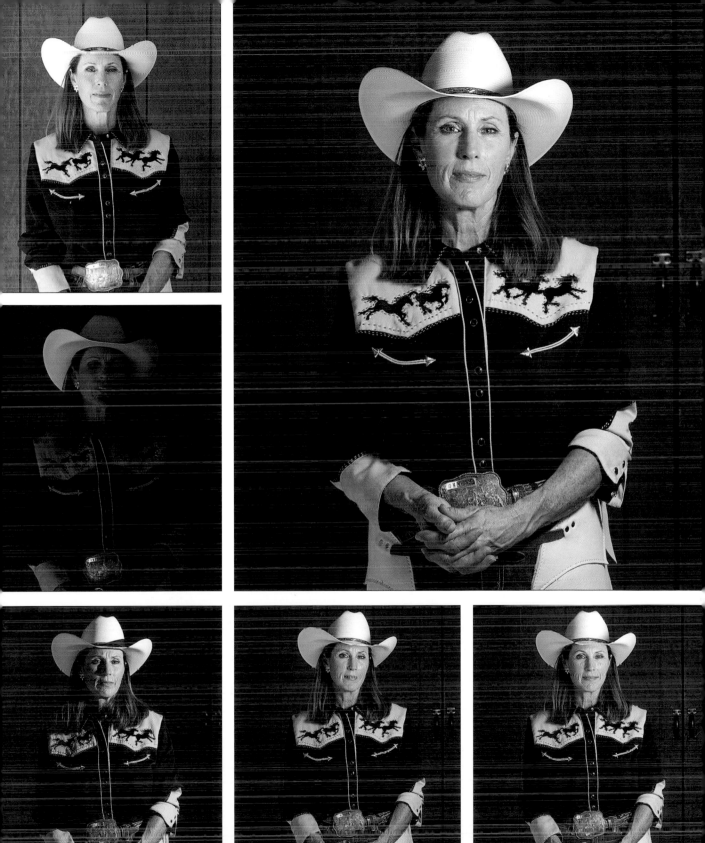

One of the keys to success as a photographer is to know how to listen to that little voice that says, "Your idea is not working out. It's time to run with the opportunity that's unfolding right in front of you." This is exactly the situation I found myself in while making a portrait of my friend Matt in his music store as a demo for a group of workshop students.

## Overthinking And Overlighting

Matt's store is long, narrow, and has a high ceiling covered with customer's guitars. So, as you can see in the inset, my original idea was to light the guitars on the wall at the back of the store, light the guitars on the ceiling, and eventually light Matt with a shoot-through umbrella. I think Matt's gesture says it all. "You want to do what?"

## Simplicity Wins Again

The only part of my original lighting plan that survived was the use of a 42″ shoot-through umbrella just to camera right. I lit Matt and let the ambient—a blend of sunlight through a huge window behind me and quartz halogen—light the rest of the frame. To warm the flash, I gelled the Speedlite with a ½-cut of CTO and set the white balance to Daylight.

*Figure 18.31 (opposite)* Capturing personality is as important as capturing great light.

*Figure 18.32 (inset)* I originally placed three Speedlites to highlight background elements.

## Lighting Details

**Environment:** store interior

**Time of Day:** late morning

**Ambient:** mix of window light and quartz halogen

**Speedlite:** one 580EX II

**Metering Mode:** E-TTL

**FEC:** +1

**Zoom / Pan:** zoomed to 24mm

**Gel:** ½-cut of CTO

**Modifier:** 42″ shoot-through umbrella

**Distance:** 6′ to subject

**Height:** centered 1′ above Matt's head

**Trigger:** extra-long E-TTL cord

## Camera Details

**Camera:** 5D Mark II

**Lens:** 17–40mm f/4L

**Distance to Subject:** 5′

**Exposure Mode:** Aperture Priority

**Exposure Compensation:** 0

**Exposure:** 1/30″, f/4, ISO 200

**White Balance:** Daylight

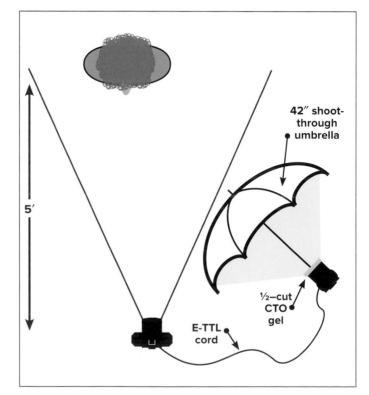

*Figure 18.30* Lighting diagram.

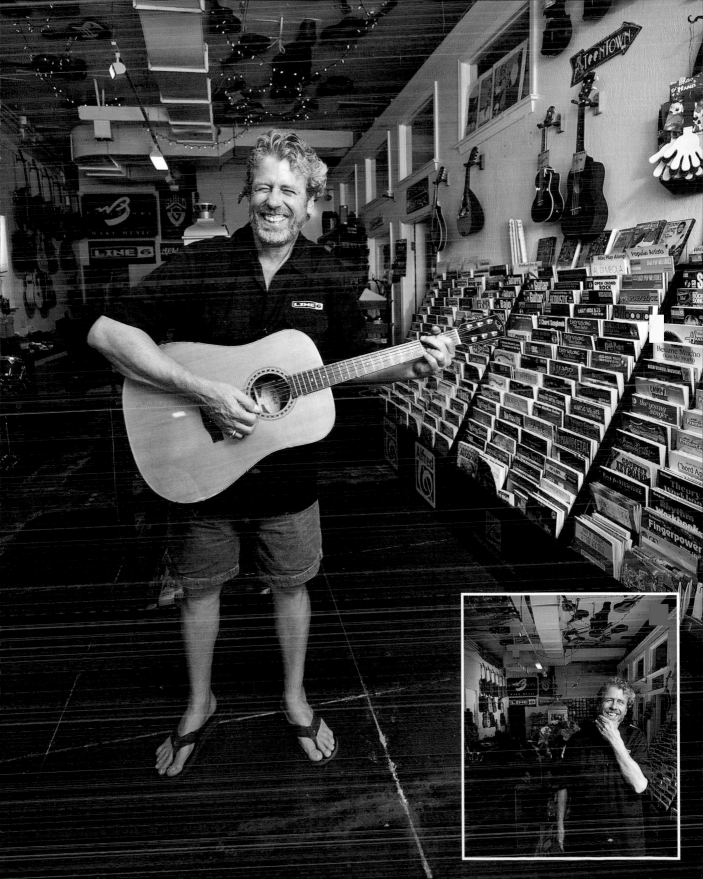

I've long had it in my head to shoot a portrait of my friend Alan in the *El Tiradito* shrine at the gateway to Tucson's barrio. The shrine is perpetually lit with candles—except right after a big rain shower—which is when fate finally scheduled my three-hour dash to Tucson for the shoot. So rather than find the shrine aglow by candlelight, I found it bathed in the industrial glow of a nearby sodium-vapor streetlight.

### Driving The Ambient Towards Candlelight

We found a precious few candles that could be relit and collected those into the niche. The second task was to find an exposure that would convey the presence of those candles. My camera, in Aperture Priority, suggested that an 8″ exposure would work. Remember, the camera thinks the whole world should be a shade of medium grey. I switched to Manual and underexposed the ambient by three stops. You can see the difference in Figures 18.34 and 18.35.

### Lighting Details

**Environment:** Tucson barrio
**Time of Day:** evening after sunset
**Ambient:** sodium-vapor street light
**Speedlite:** one 580EX II
**Metering Mode:** E-TTL
**FEC:** 0
**Zoom / Pan:** zoomed to 35mm
**Gel:** full-cut CTO
**Modifier:** 36″ disk diffuser
**Distance:** about 4′
**Height:** centered on Alan's face
**Trigger:** extra-long E-TTL card

### Camera Details

**Camera:** 5D Mark II
**Lens:** 24–70mm f/2.8L
**Distance to Subject:** 10′
**Exposure Mode:** Manual
**Exposure:** 1″, f/8, ISO 800 (3 stops under ambient)
**White Balance:** custom at 3450K

### Conveying Candlelight With A Speedlite

There were two steps to create flash that blended visually with the lit candles—change the color and soften the light. To warm up the Speedlite, I strapped on a full-cut of CTO gel. To soften the light, I activated the self-timer on my camera and then hustled over each time to hold a 36″ diffuser disk about a foot in front of the flash. As you can see in Figures 18.36 and 18.38, both steps were necessary to blend the flash with the ambient light and candles.

*Figure 18.34 (opposite, top left) My 5D Mark II metered the ambient at 8″, f/8, ISO 800.*

*Figure 18.35 (opposite, center left) I dimmed the ambient by manually dialing the exposure to 1″, f/8, ISO 800—a change of –3 stops.*

*Figure 18.36 (opposite, bottom left) A bare Speedlite is both harsh and out of balance with the feel of the scene.*

*Figure 18.37 (opposite, upper right) My hero shot conveys the sense of the candlelit shrine.*

*Figure 18.38 (opposite, bottom center) The Speedlite gelled with a full-cut CTO balances with the candles, but is still too hard.*

*Figure 18.39 (opposite, bottom right) Using the self-timer on the camera, I was able to walk over and hold the diffuser disk in front of the Speedlite.*

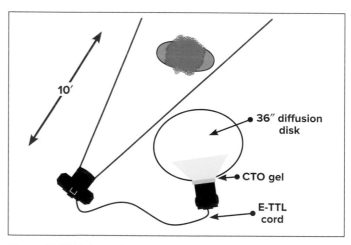

*Figure 18.33 Lighting diagram.*

You know my mantra by now—*to create interesting light, you have to create interesting shadows.* Adding a grid to the front of a Speedlite is an easy way to create interesting shadows.

### Gridology

Speedlite grids are typically made in a honeycomb pattern. (The details are discussed on pages 178–179.) The interesting thing about the honeycomb pattern is that it creates a circular pattern of light regardless of the actual shape of the grid frame. So the rectangular Honl grids will have a similar pattern to the round Flashpoint Q grids.

The two reasons that I prefer the Flashpoint Q grid system is that it comes with a finer grid (about 1⁄16″) and the grids are held out in front of the Speedlite—which creates a more delicate vignette.

### Lighting Details

**Environment:** indoors, studio
**Time of Day:** not a factor
**Ambient:** industrial fluorescent
**Speedlites:** one 580EX II
**Metering Mode:** E-TTL
**FEC:** +1 FEC
**Zoom / Pan:** zoomed to 28mm
**Gel:** none
**Modifier:** Flashpoint Q 1⁄8″ Grid
**Distance:** about 12′
**Height:** 9′
**Trigger:** E-TTL cord

### Camera Details

**Camera:** 5D Mark II
**Lens:** 70–200mm f/2.8L IS II
**Distance to Subject:** about 20′
**Exposure Mode:** Shutter Priority
**Exposure Compensation:** +1⁄3
**Exposure:** 1⁄1000″, f/2.8, ISO 800
**White Balance:** Daylight

### High Speed Sync To Kill The Ambient

The studio at Seattle Photo Associates where I did this shoot is lit with industrial fluorescents. You can see a bit of their tint in the left photo on page 238. To ensure that I would eliminate the ambient, I activated high-speed sync and set the camera to 1⁄1000″ in Shutter Priority (Tv). The rest was simple. The camera opened the aperture wide and E-TTL adjusted the flash as needed.

*Figure 18.41 (opposite)* *The lack of shadows on McKenzie's face is due to the alignment of the off-camera Speedlite. It is literally pointing at her nose. It's the other shadows that make this shot—the lace pattern on her legs, the crisp outline on the back wall, and the staccato of light/shadow along the side wall.*

*Figure 18.42 (inset)* *The set shot lit with the industrial fluorescents in the SPA studio.*

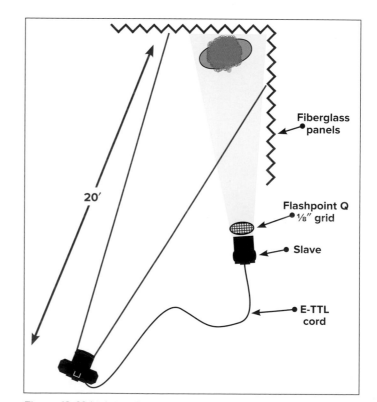

*Figure 18.40 Lighting diagram.*

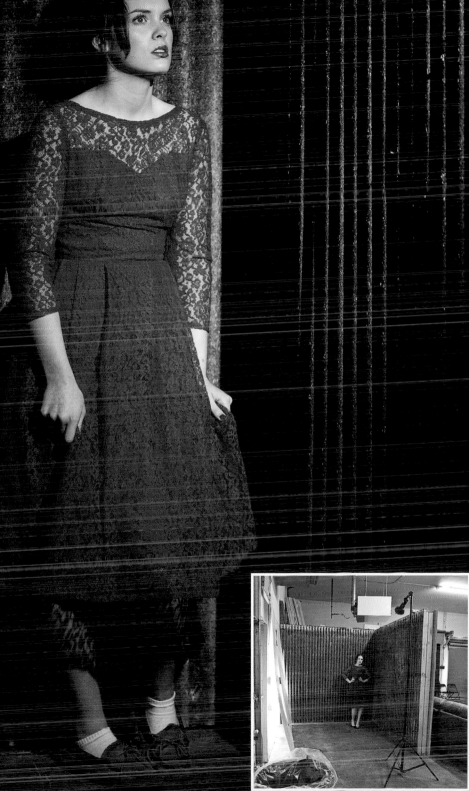

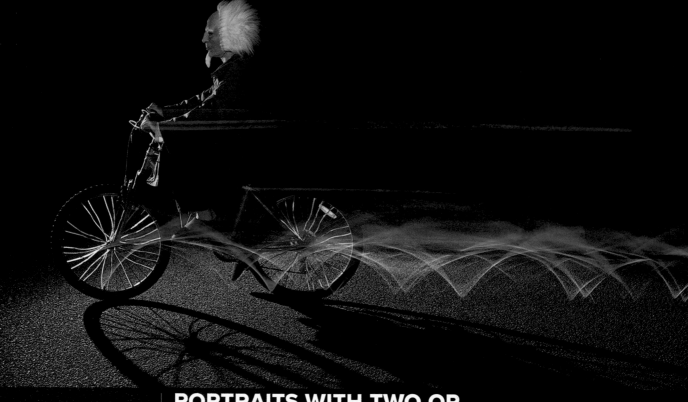

## The Short Version

Speedliting is about controlling the ambient light and crafting flash to fulfill your vision. The addition of a second and third Speedlite to your kit enables you to create many additional types of lighting that are not possible with a single Speedlite.

Sometimes you will use your Speedlites as individuals—with each one filling a specific job. Other times you will team your Speedlites together so that their power works together. Either way, your photographs will have more dimension and power.

**Figure 19.1**
*Combine a couple of off-camera flashes with a rambunctious teen and 36 glow sticks on a dark country road...you're bound to come up with an interesting photo or two.*

## OPENING HORIZONS WITH MULTIPLE SPEEDLITES

Once you get the hang of creating great light with a single Speedlite, I hope that you will begin exploring the vast horizons that open up when you start to use additional Speedlites. Truly, once you've sorted out how to use one Speedlite, the hardest part is already done.

### Advantages Of Multiple Speedlites

There are four main reasons why shooting with multiple Speedlites makes sense:

- *Light shaping*—The ability to send light from two or more angles gives you the ability to shape the light and the shadows according to your vision.
- *More power*—If you have a single Speedlite firing at full power, then adding a second Speedlite provides an additional stop of light.
- *Faster recycle*—For shoots where a faster recycle is critical, firing multiple Speedlites at lower power will be faster than firing a single Speedlite at higher power.
- *Redundancy*—Inevitably, gear fails. Having an additional Speedlite or two will ensure that you can keep shooting when the inevitable happens.

### How To Fire Two and Three Speedlites

Hopefully you did not jump straight to the people-shooting chapters. If you did, here's a quick rundown of the ways to fire off-camera Speedlites. For all the details, please read Chapter 10, *Move Your Speedlite Off-Camera*, and Chapter 11, *Wireless Speedliting The Canon Way*.

- *Built-in wireless*—Canon's 400- and 500-series EX Speedlites have the ability to receive instructions from a compatible master Speedlite. E-TTL, Manual, and Multi modes are available.
- *Extra-long E-TTL cord*—You can move your master Speedlite off-camera with an E-TTL compatible cord. Then you have the advantage of off-camera lighting and the functionality of Canon's built-in wireless communication with slaved Speedlites.

- *Long PC-sync cord*—This is the cheapest way to move a Speedlite off-camera. However, as the cord can only say, "Fire now," you have to adjust the power of your Speedlites manually. Also, the other Speedlite(s) have to be fired via an optical slave.
- *Manual radio triggers*—Manual radio triggers are a convenient way to fire off-camera Speedlites. Like a PC-sync cord, the only signal a manual radio trigger can carry is "Fire now." So you have to adjust the power on all the Speedlites by hand (a.k.a. manually).
- *E-TTL radio triggers*—For an event or wedding photographer who needs the convenience of E-TTL without the hassle of maintaining the line-of-sight connection needed by Canon's built-in system, E-TTL radio triggers are a great (but expensive) solution. If you don't shoot for pay in crowded environments, an extra-long E-TTL cord will likely get the job done just as well.

### Deciding Which Speedlite Is Best As #2 or #3

If you currently have a 400-series Speedlite and are looking to add a second Speedlite, I strongly encourage you to get a 500-series Speedlite. You'll need a 500-series Speedlite as a master. If you can afford it and have a compatible camera body, get a 580EX II as the ability to control the Speedlite from the camera LCD is a huge benefit. If you are on a budget, look for a lightly used 580EX or 550EX on eBay or Craigslist.

Now, if you already have a 500-series Speedlite and you're looking to add a second Speedlite, the options are a bit more broad. If you ever expect to shoot an event wirelessly for a paycheck, then get another 500-series Speedlite so that you have a backup master. If you're not worried about having the ability to continue shooting wirelessly after gear failure, then the economy of a 400-series Speedlite might be attractive. However, keep in mind that the 430EX II only has whole-stop power increments in Manual and the head only rotates 270°.

As much as I enjoy thinking up new ways to light, there are times when shooting a traditional lighting plan keeps me from getting into trouble. If a client just wants a well-lit business headshot, then I should not dig into my bag of dramatic lighting techniques. This is when I fall back on the classic three-light portrait setup.

## Three Lights United By One Cause

The classic three-light setup has a *key light* that provides the greatest amount of light on the subject, a *fill light* that keeps the details in the shadows, and a *hair* or *rim light* that provides a bright line of separation from the background.

Using our lighting compass as a reference (see page 61), the key and fill are at opposite sides of the lens axis and at about 60°.

The rim/hair light is always behind the subject in the vicinity of 120°–170°. Additionally, the rim/hair light is placed high and angled down. If it has a narrow throw and hits only the hair, then it's a hair light. If it spreads more widely and falls across one or both shoulders then it's a rim light.

## A Great Time To Use
## Wireless Manual Flash

A classic headshot is a perfect situation for running your Speedlites in Manual mode as the distance between each of the lights and the subject is not changing. Further, if you have a number of different headshots to do, then you won't have to fiddle much with the lighting when the next person steps in for his session.

Remember, Canon's built-in wireless system handles Manual as well as it handles E-TTL. For this shoot, where the hair light was almost touching the ceiling, it's very handy to be able to change the power level from the LCD on the back of the camera.

I've trained myself to assign the light(s) on the left side of the camera into group A and those on the right side into group B. (While not a big

deal in Manual, this habit is very helpful when using A:B ratio control in E-TTL.) So for this shoot the fill light was group A, the key light was group B, and the hair light was group C.

All three lights were controlled from the master Speedlite bolted into the hotshoe on my camera. To keep the master from spraying on-camera flash on the shot, I disabled it—meaning that it sent instructions to the slaves and then remained dark during the actual exposure. If I had three Speedlites rather than four, I would have moved the master to the key light position and controlled it via an extra-long E-TTL cord.

## Lighting Details

**Environment:** corporate office space
**Time of Day:** not a factor
**Ambient:** office fluorescents
**Speedlites:** one 580EX II as master, three as slaves
**Metering Mode:** Manual
**Zoom / Pan:** key: 70mm, fill: 35mm, hair: 35mm
**Gel:** none
**Modifier:** none
**Distance:** key and fill 6' from subject, hair 2' above
**Height:** key and fill slightly above subject's head
**Trigger:** Canon built-in wireless system

## Camera Details

**Camera:** 5D Mark II
**Lens:** 70–200mm f/2.8L IS II
**Distance to Subject:** 8'
**Exposure Mode:** Manual
**Exposure:** $\frac{1}{160}$", f/9, ISO 200 (4 stops under ambient)
**White Balance:** Cloudy (to provide a bit of warmth)

*Figure 19.2 (opposite, top left)* Key light only.

*Figure 19.3 (opposite, center left)* Fill light only.

*Figure 19.4 (opposite, bottom left)* Hair light only.

*Figure 19.5 (opposite, top right)* Key, fill, and hair lights working together.

*Figure 19.6 (opposite, bottom right)* The lighting diagram.

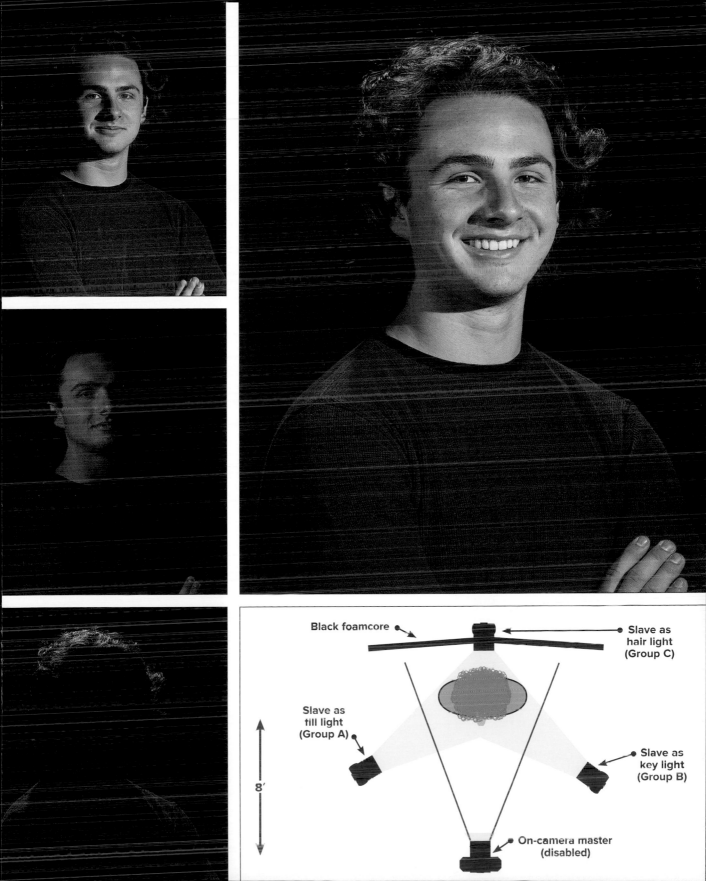

Black foamcore ●

Slave as
hair light
(Group C)

Slave as
fill light
(Group A)

Slave as
key light
(Group B)

8'

On-camera master
(disabled)

To say that a face is lit with fashion or glamor lighting means that it is virtually shadowless. There is no doubt that commercial fashion shoots can cost a lot of money. The good news for us Speedliters is that you can create face-sized fashion lighting with a couple of softboxes or shoot-through umbrellas.

## Meet The Clamshell—A Two-Speedlite Glamor Setup

The clamshell gets its name because two large modifiers are brought close together on one side with barely enough room for the photographer to poke his camera through. The other side is opened wide, like a clamshell, for the subject's head or torso. If this sounds confusing, take a look at Figure 19.7, and you'll get the concept.

The clamshell takes two soft light sources and brings them together so that they fill each other's shadows. We know that light falls, so generally the upper light is slightly brighter—say, by a stop—than the bottom light.

## Control The Top-Bottom Ratio Through E-TTL

For this clamshell shoot, I decided to shoot in E-TTL so that I could use the wireless ratio control to adjust the amount of light top to bottom. I connected the Speedlite inside of the Apollo softbox to a 16′ E-TTL cord and made it the master (which, by default, puts it in group A). The Speedlite tucked into the back of the Lastolite Ezybox was set as a group B slave. Yes, I had to jockey the boxes a bit so that the slave could see the signal coming out of the Apollo.

Deciding on the ratio between the top and bottom is like adding salt to soup—you do it to fit your taste. The hero shot on the opposite page, Figure 19.10, was shot at 2:1. This is not a precise ratio as the Apollo pushes out the light a bit differently than the Ezybox.

## Clamshell With One Speedlite

If you do not have two Speedlites, then use a reflector disk on the bottom. If you have both a silver and a white reflector, try each to see which you prefer. Remember to tuck it in as close as you can—just out of the frame—and to angle it up slightly.

## Lighting Details

**Environment:** outdoors under eave of patio
**Time of Day:** mid-afternoon
**Ambient:** open shade
**Speedlites:** two 580EX IIs
**Metering Mode:** E-TTL
**FEC:** 0
**Zoom / Pan:** 24mm on each light
**Gel:** none
**Modifier:** Westcott Apollo (28″) on top, Lastolite Ezybox (24″) on bottom
**Distance:** Kaitlin stood at edge of softboxes
**Height:** immediately above and below at 45°
**Trigger:** extra-long E-TTL cord

## Camera Details

**Camera:** 5D Mark II
**Lens:** 24–70mm f/2.8L
**Distance to Subject:** 2′
**Exposure Mode:** Manual
**Exposure:** $\frac{1}{200}$″, f/8, ISO 400 (2⅔ stops under ambient)
**White Balance:** Auto (AWB) = 4900K

*Figure 19.7 (opposite, top left)* In a clamshell, the camera is stuffed between the two modifiers.

*Figure 19.8 (opposite, center left)* The ambient light on the patio—as the camera wanted to expose for it.

*Figure 19.9 (opposite, bottom left)* The ambient light after I underexposed it by 2⅔ stops.

*Figure 19.10 (opposite, top right)* The clamshell setup produced soft light that wrapped around Kaitlin's face.

*Figure 19.11 (opposite, bottom right)* The lighting diagram.

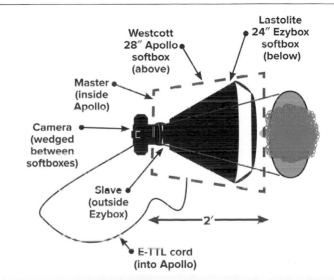

Westcott
28″ Apollo
softbox
(above)

Lastolite
24″ Ezybox
softbox
(below)

Master
(inside
Apollo)

Camera
(wedged
between
softboxes)

Slave
(outside
Ezybox)

2′

E-TTL cord
(into Apollo)

The unique design of a ring light, which puts the lens in the center of the light, creates a distinctive shadow that outlines the subject. Ring light is a lighting style that cycles in and out of favor with art directors and consumers. Generally, it is used for a youthful, fashion-oriented look. What I like most about this shoot is that I broke out of that stereotype and merged two lighting styles—ring light and hatchet light—to give a sculptural look to a young lacrosse player.

### The Synergy Between Ring Light And Hatchet Light

A ring light is recognized for the nearly shadowless quality of light that it gives to a face. Rather than create facial shadows, a ring light creates facial highlights along the eyebrows, down the nose, and across the cheeks. Yet, when used by itself, ringlight appears flat.

The hatchet lighting in this shot was created with two 580EX IIs on stands out wide to each side—just behind Ben's shoulders. As you can see in Figure 19.13, the danger of hatchet lighting is that it hides facial details in the frontal shadow.

I love the synergy of ring light and hatchet light. The ring light creates a gentle foundation (and some crazy highlights on the shiny jersey). The hatchet lighting creates highlights on the side of Ben's jersey, helmet, and face. As you can see, the combination is far better than either alone.

### Flag The Hatchets / Pan Their Heads

The hatchet lights are behind Ben and angled slightly forward. So there's a real risk that they will flare into the lens. I flagged each with a Rogue FlashBender Bounce Card. As you can see in Figure 19.14, I kept the removable black panels in place so that the flash would not bounce onto the background. Also note how I panned the Speedlite so that the slave eye on the front faced the camera.

### Lighting Details

**Environment:** outdoors in deep shade
**Time of Day:** late afternoon
**Ambient:** open shade
**Speedlites:** one 580EX II as master, two as slaves
**Metering Mode:** E-TTL
**FEC:** +1
**Ratio:** 4:1 (ring light : hatchets)
**Zoom / Pan:** hatchets panned to side, zoomed to 70mm
**Gel:** none
**Modifier:** Ray Flash ring light adapter on master
**Distance:** master 12′, hatchets 5′
**Height:** all about 6″ above Ben's helmet
**Trigger:** Canon built-in wireless system

### Camera Details

**Camera:** 5D Mark II
**Lens:** 24–70mm f/2.8L
**Distance to Subject:** 12′
**Exposure Mode:** Manual
**Exposure:** ¹⁄₄₀″, f/4, ISO 400 (2⅓ stops under ambient)
**White Balance:** Daylight

*Figure 19.12 (opposite, top left) A ringlight has a distinctive shadow that runs around the edges of the subject.*

*Figure 19.13 (opposite, center left) Here is the hatchet lighting without the ringlight. Note that my shutter speed has eliminated all of the ambient light.*

*Figure 19.14 (opposite, bottom left) To keep the hatchet lights from flaring into the lens, I flagged each with a Rogue FlashBender. Note how I panned the head so that the slave eye on the front of the Speedlite is facing directly at the camera.*

*Figure 19.15 (opposite, top right) The synergy of ring light and hatchet lights creates the sculptural depth that gives this photo its punch.*

*Figure 19.16 (opposite, bottom right) The lighting diagram.*

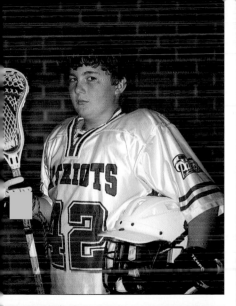

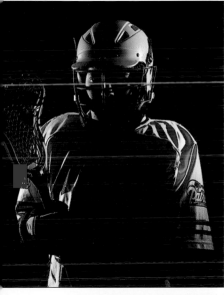

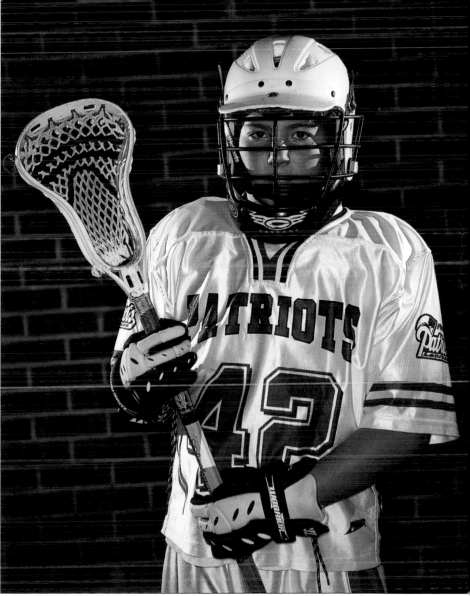

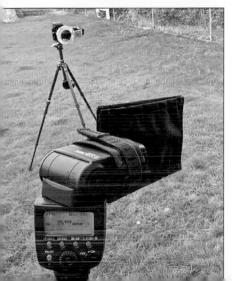

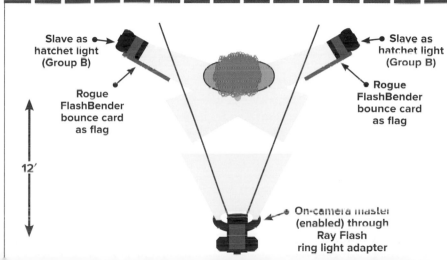

Slave as hatchet light (Group B)

Slave as hatchet light (Group B)

Rogue FlashBender bounce card as flag

Rogue FlashBender bounce card as flag

12′

On-camera master (enabled) through Ray Flash ring light adapter

If you want your images to convey a mood, then the color of your flash is as important as its position and how you modify it. Take a look at Figure 19.17 (upper left). This available light image has no emotion. The north window light is cold and flat. Fortunately, as Speedliters we have options.

### Making Light Do What It Does... Come In Through A Window

The most powerful McNallyism I ever learned was "Light comes in through windows. Remember that." Joe's right. Light does come in through windows. So often we use our Speedlites inside when we should actually be placing them outside. Fortunately, Canon's wireless system makes easy work of controlling lights outside a window.

For this shoot I mounted a pair of Speedlites shoulder-to-shoulder and raised them slightly above the middle of the windows on a C-stand. Each was gelled with a full-cut of CTO. They were about 10′ from the building. I set them to slave mode and controlled them by running my master to the window on a long E-TTL cord. The master's instructions flew out the window and beautiful light flew back in.

### Gesture And Framing Change The Mood

Compare Figures 19.18 and 19.20. In the larger image, Kaili's face is open and bathed in beautiful light. In the smaller image, her face has angled away from the window. One eye is obscured by a lock of hair and the other hides in shadow. It's not that one photo is better than the other—each has power. The deciding factor is the emotion that you want to convey.

Now look at how I zoomed wide in Figure 19.19. Kaili has moved away from the window, yet she is surrounded by golden light. Same model in the same room with the same light—yet the feeling of this image is different than the other frames.

### Lighting Details

**Environment:** indoors
**Time of Day:** late afternoon
**Ambient:** north light coming through tall windows
**Speedlites:** one 580EXII as master, two as slaves
**Metering Mode:** E-TTL
**FEC:** 0
**Zoom / Pan:** slaves zoomed to 70mm
**Gel:** full-cut of CTO on each slave
**Modifier:** none
**Distance:** slaves to window 10′, window to Kaili 2′ to 6′
**Height:** slightly above center of window
**Trigger:** Canon built-in wireless system

### Camera Details

**Camera:** 5D Mark II
**Lens:** 17–40mm f/4L
**Distance to Subject:** 2′ to 6′
**Exposure Mode:** Manual
**Exposure:** ⅛0″, f/4, ISO 200 (2⅓ stops under ambient)
**White Balance:** Daylight

*Figure 19.17 (opposite, top left)* The ambient light through the north-facing windows was flat and slightly blue—meaning that it was really dull.

*Figure 19.18 (opposite, center left)* Small details can change the mood. Here Kaili's eyes are obscured by a lock of hair and the shadow of her nose.

*Figure 19.19 (opposite, bottom left)* Zooming wide to show more of the environment changes the feel of the image.

*Figure 19.20 (opposite, top right)* The mood of this portrait is created by Kaili's subtle gesture and the color of the flash.

*Figure 19.21 (opposite, bottom right)* The lighting diagram.

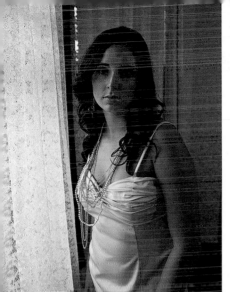

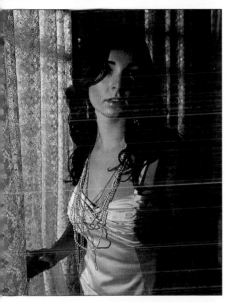

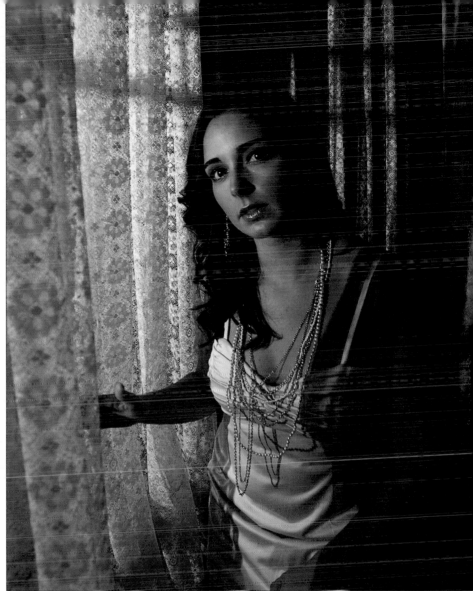

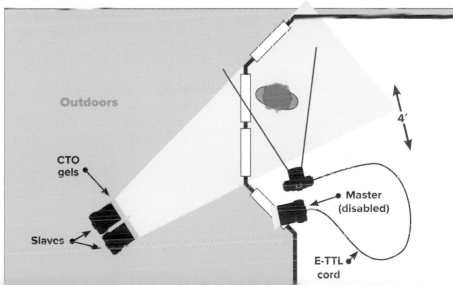

Outdoors

CTO
gels

Slaves

Master
(disabled)

E-TTL
cord

4'

When Speedliting portraits of three or more people, I typically reach for a 60″ silver umbrella. For this business portrait in a transmission shop, I needed to create a large field of relatively soft light and I needed to do it quickly.

### Sometimes Dramatic Is Good, Sometimes Usable Is Better

My sole objective in lighting this portrait was to deliver an image that the business owners could use on their website and in the local newspaper. I wanted to create light that would add depth to the image without harsh shadows. I had just a few minutes between the opening of the shop and the arrival of the first customers. So the ease of rigging a big umbrella made it the perfect modifier.

### Lighting Details

**Environment:** automotive shop

**Time of Day:** morning

**Ambient:** mix of cloudy daylight and fluorescent

**Speedlites:** three 580EX IIs

**Metering Mode:** E-TTL

**FEC:** +1

**Zoom / Pan:** zoomed to 24mm

**Gel:** none

**Modifier:** 60″ silver umbrella

**Distance:** about 12′ to subjects

**Height:** about 2′ above subjects' heads

**Trigger:** extra-long E-TTL cord

### Camera Details

**Camera:** 5D Mark II

**Lens:** 17–40mm f/4L

**Distance to Subject:** 10′

**Exposure Mode:** Manual

**Exposure:** 1/30″, f/8, ISO 400 (⅔ stop under ambient)

**White Balance:** Daylight

### Corded Master And Wireless Slaves

To fill a large umbrella with light, I mounted three Speedlites on the IDC Triple Threat (see page 191 for details). One of the Speedlites was connected to an extra-long E-TTL cord and configured as the master. The other two were set as slaves. This gave me the ability to control the entire system from my camera's LCD monitor.

### Push The Stand Back For Even Light

To keep the light even across a group, push the light back at least twice the width of the group. In this case, the guys were about 6′ across, so I pushed my C-stand back to about 12′. When the light gets to within 1.5x the width of the group, you will find the light falls off dramatically across their faces.

*Figure 19.23 (top) The hero shot.*

*Figure 19.24 (bottom left) Without the flash there is not enough light to craft an interesting portrait.*

*Figure 19.25 (bottom center) You can see the umbrella on the right edge of the frame.*

*Figure 19.26 (bottom right) The iDC Triple Threat holds three Speedlites on the umbrella shaft.*

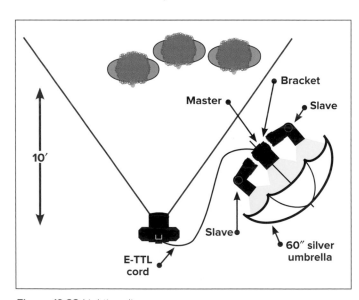

10′

Bracket

Master

Slave

Slave

E-TTL cord

60″ silver umbrella

*Figure 19.22 Lighting diagram.*

When it comes to making a mood-filled portrait, there is no easier way to light than to push a big softbox in close. By pushing the light in close, the inverse square law takes over and creates deep shadows. Pull the softbox out a ways and you'll find that the mood changes as the light becomes more even.

## Why I Prefer A Softbox To An Umbrella

The quality I like most about softboxes is that, unlike an umbrella, they push soft light out in a very controllable manner through the flat front. This is especially true for softboxes that have a recessed front. I use the lip of the softbox to control where the edge of the light falls and—where it does not fall—like on the background.

## Westcott's Apollo—A Great Way To Start

I own a lot of softboxes. You will, too, if you stick with photography long enough. The one that I recommend when stepping up from umbrellas is Westcott's 28″ Apollo. It is large enough to create beautiful light on one or two people. Yet it is affordable, easy to carry, and quick to set up. Uniquely, the stand rises through the bottom of the box and you mount the light(s) inside—which is what I like the most.

The Apollo can accommodate one to four Speedlites. The additional Speedlites don't change the light. Rather, they shorten the re-cycle time. Which is so helpful when you have a model who likes to dance with the softbox.

## Master And Slaves Together Inside The Box

There are two ways to fire a Speedlite that is tucked inside a softbox: use a radio trigger or run a long cord in from the camera. If you want to remotely control the power level of multiple Speedlites inside a softbox, then you have to connect a radio trigger to each Speedlite or, with an E-TTL cord, make one a master and set the rest as slaves.

## Front Diffused Or Front Open

The Apollo's silver interior does a fine job of bouncing the light around, especially since the Speedlites are mounted to face the back. If you want a large source that has a bit more snap, then flip the diffuser panel over the top and shoot the flash bouncing directly off of the silver interior.

## Lighting Details

**Environment:** large studio

**Time of Day:** not a factor

**Ambient:** industrial fluroescents

**Speedlites:** three 580EX IIs, one as master, two as slaves, all were inside the softbox

**Metering Mode:** E-TTL

**FEC:** −1

**Zoom:** heads zoomed to 24mm

**Gel:** none

**Modifier:** Westcott 28″ Apollo softbox

**Distance:** just out of frame

**Height:** centered on model's face

**Trigger:** extra-long E-TTL cord

## Camera Details

**Camera:** 5D Mark II

**Lens:** 100mm f/2.8L Macro IS

**Distance to Subject:** 10′

**Exposure Mode:** Manual

**Exposure:** $1/200″$, f/2.8, ISO 400 (5 stops under ambient)

**White Balance:** Daylight

*Figure 19.27 (opposite, top left) Here Nyema plays directly into the Apollo—just out of frame.*

*Figure 19.28 (opposite, center left) A twist of the torso away from the light changes the mood a bit.*

*Figure 19.29 (opposite, bottom left) There is no mystery when the camera sets the exposure.*

*Figure 19.30 (opposite, top right) Turning away from the softbox creates a subtle mystery.*

*Figure 19.31 (opposite, bottom right) The lighting diagram.*

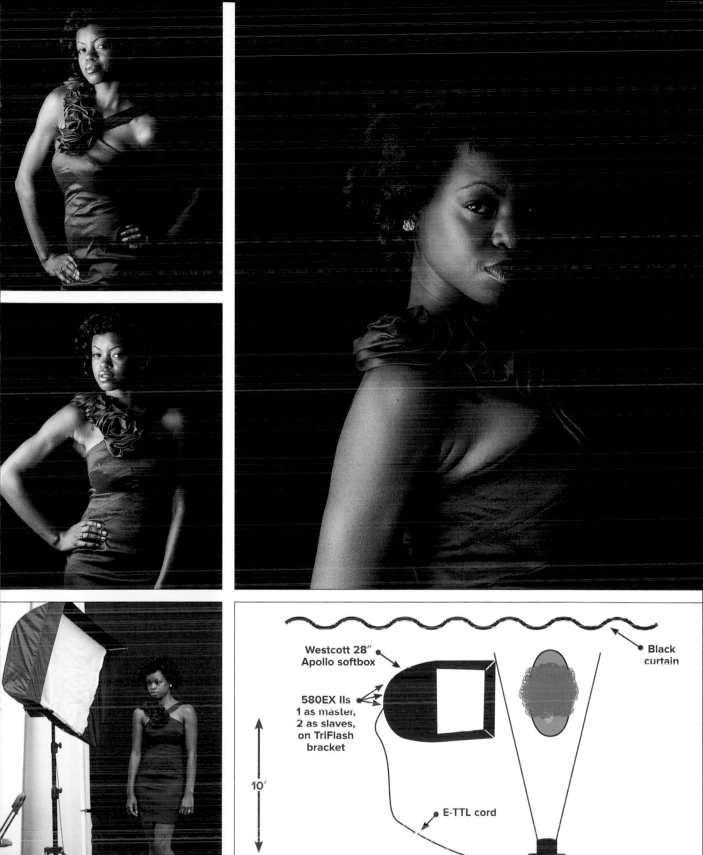

Westcott 28″
Apollo softbox

580EX IIs
1 as master,
2 as slaves,
on TriFlash
bracket

Black
curtain

10′

E-TTL cord

Some shoots are planned and planned again. Others happen before you realize what you're doing. This shoot is the latter. During one of my Speedliting workshops in Paso Robles, my buddy Arian was waiting for the students to set up their lights. So, we seized both the opportunity and a nearby lampshade to see what we could do in a handful of minutes.

## Lighting A Lampshade

My initial approach was to park a slaved 580EX on Arian's head and balance the lampshade on top of it. To give it a barebulb look, I slipped a Sto-Fen on for good measure. To enable the slave eye to see, I spun the head of the Speedlite around 180° so that it was angled down while the sensor faced up. You can see the result in Figure 19.32. Most of the light literally blew out the top. Oops.

## Improvise, Improvise, Improvise

Arian's a great guy and a talented model—especially when it comes to the dramatic and unusual. So he did not flinch when I said, "I need to have you balance the Speedlite on your head with this towel on top of it and the lampshade on top of the towel. Oh, and we have to stuff the towel so that the slave eye is not blocked." The balance thing worked (mostly).

Now, all the light that had blown upward now turned direction and headed downward. My first reaction in seeing the image in Figure 19.33 was that Arian's face was blown out. Then I took creative license and accepted it as a fair representation of what a lightbulb looks like under a lamp shade. We were, after all, shooting for fun—free of a specific visual end that we had to achieve. Time to move on again.

The next couple of minutes proceeded with Arian trying to keep the Speedlite balanced on his head as he moved through a series of hand gestures to suggest different messages. In the just a few minutes we had several fun images.

## Lighting Details

**Environment:** indoors

**Time of Day:** not a factor

**Ambient:** dim incandescent

**Speedlites:** two 580EX IIs, one as on-camera master, one as slave

**Metering Mode:** Manual, used camera LCD and histogram as guide

**Power Level:** not recorded, but varied a lot

**Zoom / Pan:** slave head rotated 180° and angled down so that slave sensor faced ceiling

**Gel:** none

**Modifier:** Sto-Fen dome diffuser on slave

**Distance:** the width of a few hairs

**Height:** balanced on Arian's head, seriously

**Trigger:** Canon built-in wireless system with master disabled

## Camera Details

**Camera:** 5D Mark II

**Lens:** 17–40mm f/4L

**Distance to Subject:** 2′ to 4′

**Exposure Mode:** Manual

**Exposure:** ¹⁄₄₀″, f/4, ISO 400 (3 stops under ambient)

**White Balance:** Daylight

*Figure 19.32 (opposite, top left) My first effort demonstrated that I'd have to flag the Speedlite to keep it from blowing out the top of the lampshade.*

*Figure 19.33 (opposite, center left) Blocking the light from flying upward, sent it downward. Arian may be blown out, but have you ever stared at a lightbulb? It looks about the same.*

*Figure 19.34 (opposite, bottom left) One of Arian's spontaneous gestures. I had him tilt his head slightly so that his eyes would show.*

*Figure 19.35 (opposite, top right) When Arian made this gesture, which I think is brilliant, I asked him to tip his head down so that the lampshade barely hid his eyes.*

*Figure 19.36 (opposite, bottom right) The lighting diagram.*

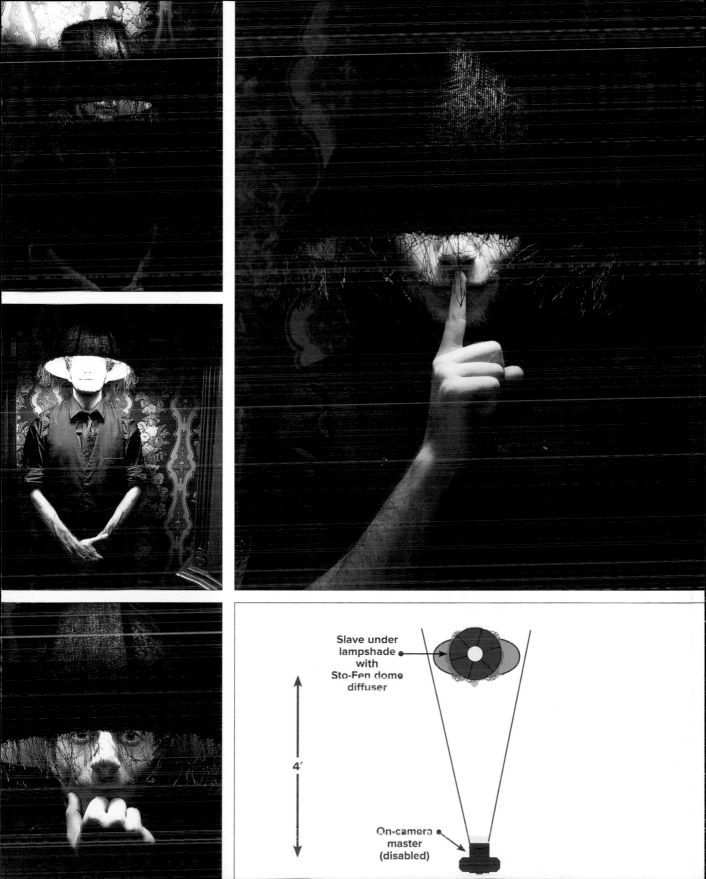

Slave under
lampshade
with
Sto-Fen dome
diffuser

4'

On-camera
master
(disabled)

To make captivating photographs you need to go to the edge of the light—meaning point your camera towards the sun—and you need to shoot from interesting angles. Although we were deep in the canyon of the Truckee River about the time the sun was going down, I think this shoot meets the second criteria nicely. Literally everyone and everything was in the river.

### I'm A Fan Of The C-Stand

Using a C-Stand to hold a single Speedlite may seem like overkill. Yet, when that light needs to be held aloft in a flowing river, the C-Stand is the perfect choice. Its weight means that a sandbag is not necessary. If you need a bit more stability, then stand on the base until it suctions down into the mud a bit. The arm with the grip head meant that we could position the light precisely where we wanted without moving the stand.

### Two Lights In E-TTL

Even though the distance between Dawn and the two Speedlites was not changing—believe me, we moved across that slippery bottom as little as possible—I ran the flash system in E-TTL. This gave me two helpful tools: ratio control to quickly move the balance of light between the two Speedlites, and FEC to raise or lower the overall power of both lights together.

### The Value Of Rimlight

Moving a Speedlite behind your subject and firing it towards the camera can provide huge results. If you compare Figure 19.38 to 19.40 you'll see what I mean. Moving a Speedlite behind Dawn created the all-important line of light on her arm and added sheen to her hair.

The other Speedlite was tucked into a Lumiquest Softbox II. From a distance of 10′, I was not looking for it to provide soft light—which it won't at that distance. Rather, I wanted to make the Speedlite seem slightly larger so that the fill light would not appear so edgy.

## Lighting Details

**Environment:** Truckee River Canyon

**Time of Day:** late afternoon, sun below horizon

**Ambient:** pink skylight reflecting off of clouds

**Speedlites:** one 580EX II, two 580EXs

**Metering Mode:** E-TTL

**FEC:** +1

**Zoom / Pan:** slaves panned so sensors faced master, Speedlite in softbox zoomed to 24mm, Speedlite with grid zoomed to 50mm

**Gel:** none

**Modifier:** Lumiquest Softbox III just left of Dawn, Honl ¼″ grid behind Dawn on left

**Distance:** each about 10′

**Height:** softbox 1′ above Dawn's head, grid level with her head

**Trigger:** Canon built-in wireless system

## Camera Details

**Camera:** 5D Mark II

**Lens:** 70–200mm f/2.8L IS

**Distance to Subject:** 20′

**Exposure Mode:** Manual

**Exposure:** $1/125$″, f/2.8, ISO 800 (1 stop under ambient)

**White Balance:** Custom 4200K

*Figure 19.37 (opposite, top left) The advantage of using C-stands in the river was that they did not need sandbags.*

*Figure 19.38 (opposite, center left) Here the gridded Speedlite is to camera right—adding a trace of light to the top edge of the kayak. Compare this shot to the rimlight in Figure 19.40 that was created when I move the gridded flash behind Dawn.*

*Figure 19.39 (opposite, bottom left) File corruption happens. Get used to it. This frame was totally random. All the other frames from the shoot were fine.*

*Figure 19.40 (opposite, top right) Although we had already shot this pose, when the sun dropped below the clouds for a minute and filled the canyon with pink light, we shot it again.*

*Figure 19.41 (opposite, bottom right) The lighting diagram.*

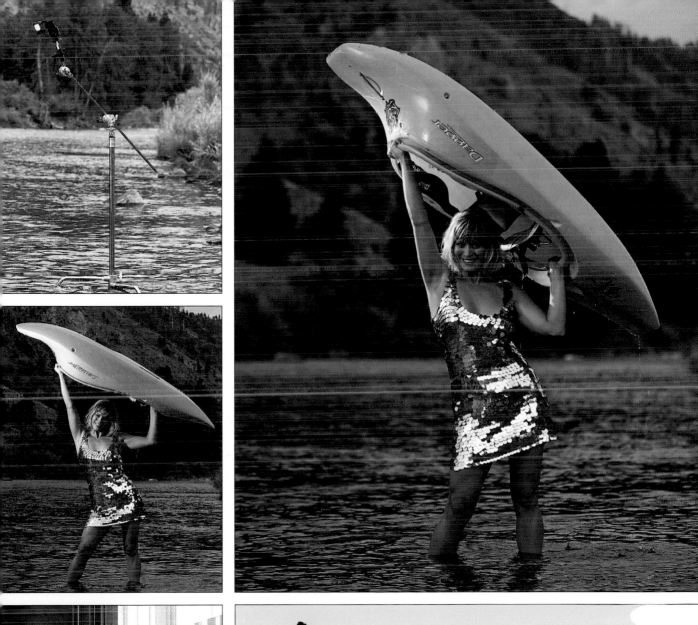

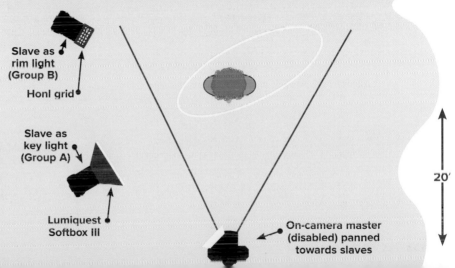

Slave as rim light (Group B)

Honl grid

Slave as key light (Group A)

Lumiquest Softbox III

On-camera master (disabled) panned towards slaves

20'

For reasons that I've never understood, second-curtain sync is disabled when the Canon wireless system is activated. Many have said that multi-Speedlite, second-curtain sync is not possible with the Canon system. I respectfully disagree—as long as you're willing to think creatively.

### Sync—It's Always A Matter Of Timing

In first-curtain sync, the flash fires as soon as the shutter opens. In second-curtain sync, the flash fires just before the shutter closes. In both cases on this shoot, the rider and bike were frozen when the flash fired.

Given that we were shooting literally under starlight, the only ambient light was the 36 glow-tubes attached to the bike. To emphasize the motion, I used a 2″ shutter speed. My aperture and ISO were selected so that the glow tubes would be captured by the camera.

### Lighting Details

**Environment:** country road

**Time of Day:** night

**Ambient:** glow-tubes on bike

**Speedlites:** one 580EX II, one Lumopro LP160

**Metering Mode:** Manual

**Power:** $\frac{1}{128}$ on 580EX II, $\frac{1}{64}$ on LP160

**Zoom / Pan:** zoomed to 50mm

**Gel:** Canary Yellow on corded master, $\frac{1}{2}$-cut of CTO on slave opposite camera

**Modifier:** none

**Distance:** both about 6′ to subject

**Height:** about 1′ above subject's head

**Trigger:** extra-long E-TTL cord

### Camera Details

**Camera:** 5D Mark II

**Lens:** 24–70mm f/2.8L

**Distance to Subject:** 6′

**Exposure Mode:** Manual

**Exposure:** 2″, f/4, ISO 800

**White Balance:** Daylight

### I Say The Camera Does Not Need To Know That The Speedlite Is Off-Camera

I love using an extra-long E-TTL cord because the camera does not know that the Speedlite is not in the hotshoe. This means that a Speedlite can be moved off-camera and fired in second-curtain sync. If you have just a single Speedlite, you can make amazing photos this way—with the flash firing in E-TTL or Manual.

If you have multiple Speedlites, it's important to not turn on the wireless system. Rather, you have to switch the corded Speedlite into Manual mode and trigger your other flashes via optical slaves. Why Manual? It eliminates the pre-flash so that the optical slaves will fire at the right moment. (See pages 122–123 for more details on using optical slaves.)

To prove it works, I used a LumoPro LP160 as the slave (firing towards the camera).

*Figure 19.43 (top)* In second-curtain sync, the light trails naturally behind the rider.

*Figure 19.44 (bottom)* In first-curtain sync, the light strangely flies ahead of the rider—creating the appearance that he is moving backwards.

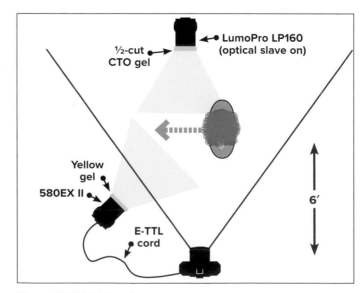

*Figure 19.42 Lighting diagram.*

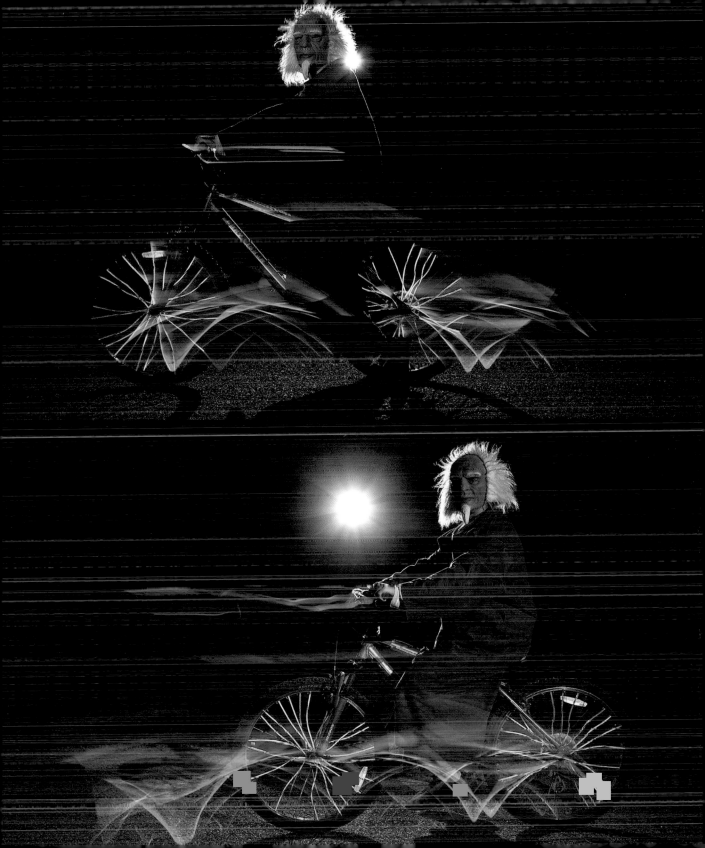

Sometimes my best ideas come as the result of an "accident" and sometimes they come because I asked, "What if...?" The idea of twin-light—the firing of two bare Speedlites separated by a foot or so—is one of those what-if moments. It started when I decided to use a TriFlash as a bi-flash.

### The Lastolite TriFlash—A Personal Favorite

Lastolite's TriFlash is a versatile bracket that is always in my grip kit. It holds up to three Speedlites at 90° angles. I use it frequently to mount several Speedlites inside of the Apollo softbox and also when firing a 60″ umbrella—as you saw on pages 268–269. Just because the TriFlash is made to hold a modifier does not mean that it has to be used with one.

### Together Or Apart, That Is The Question

There are many times when I fire two Speedlites together because I need the extra power. Earlier in this chapter, in the Color Creates Mood shoot (pages 266–267), you read that I flew the light of two Speedlites in through a window. To avoid having a double shadow, I mounted them so that their heads were touching—using two Lovegroves on a C-stand arm.

For this shoot, I wanted two heads separated slightly so that one would provide fill for the other—you know, modify without a modifier. When a pair of Speedlites are mounted on the sides of the TriFlash, the heads are about 12″ apart. The downside, as you can see in Figure 19.45, is that you get a distinct double shadow. So a bit of cropping might be in order—which is the only difference between Figures 19.45 and 19.48. It's the same shot in each frame.

Now compare the lighting in Figure 19.46 to 19.48. The first was lit with a single Speedlite and the second with twin-light. Notice that the facial shadows are darker and larger in 19.46. Right there is the subtle advantage of twin-light. It creates a broad swath of direct light.

### Lighting Details

**Environment:** large studio

**Time of Day:** not a factor

**Ambient:** industrial fluorescent

**Speedlites:** three 580EX IIs, one on-camera as master (disabled), two as off-camera slaves

**Metering Mode:** E-TTL

**FEC:** +1

**Zoom / Pan:** slaves zoomed to 105mm

**Gel:** none

**Modifier:** none

**Distance to Subject:** 12′

**Height:** about 8′

**Trigger:** Canon built-in wireless system

### Camera Details

**Camera:** 5D Mark II

**Lens:** 100mm f/2.8L Macro IS

**Distance to Subject:** 15′

**Exposure Mode:** Manual

**Exposure:** $\frac{1}{160}$″, f/5.6, ISO 400 (1⅓ stops under ambient)

**White Balance:** Daylight

*Figure 19.45 (opposite, top left) The telltale sign of twin-light is the double shadow.*

*Figure 19.46 (opposite, center left) In this one-light shot only the right Speedlite fired. Notice that the nose and chin shadows are more pronounced.*

*Figure 19.47 (opposite, bottom left) Our set was a piece of red fabric on a wall.*

*Figure 19.48 (opposite, top right) The distance between the heads gives twin-light its snap. Here I've cropped the frame to minimize the double shadow.*

*Figure 19.49 (opposite, bottom right) The lighting diagram.*

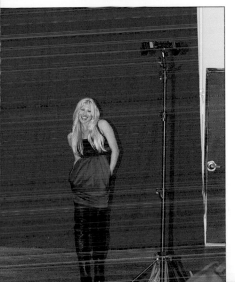

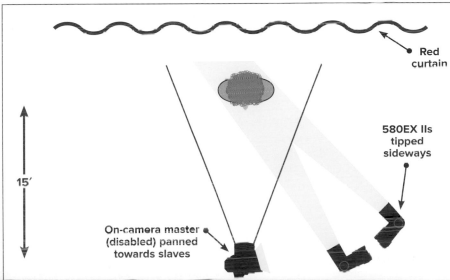

Red
curtain

580EX IIs
tipped
sideways

15′

On-camera master
(disabled) panned
towards slaves

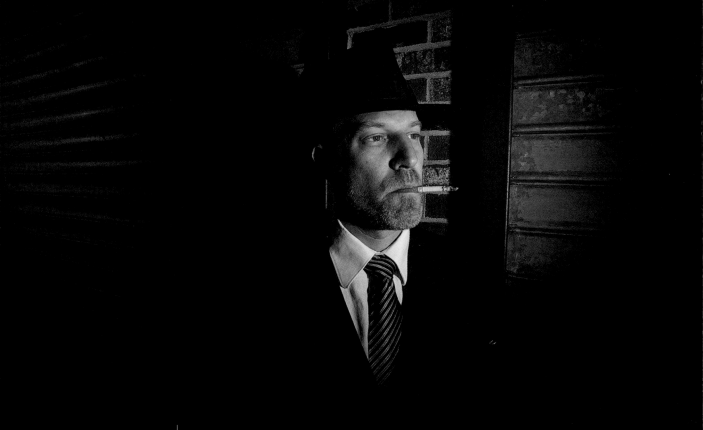

# CHAPTER 20 | GELLING FOR EFFECT

**Figure 20.1**
*Two Speedlites, two gels, a flag, and a grid created the dramatic light in this noir portrait. For the details, see pages 292–293.*

## The Short Version

There are two major groups of gels: those that shift the color of one light to another (e.g., daylight to tungsten) and those that create a color effect (e.g., change the color of a background to bright red). Using both types of gels, along with changes in the white balance of your camera, can create dramatic effects.

There are also two minor groups of gels—neutral density and polarizing—that limit the light without changing its color. Think of these as technical rather than creative gels.

*Note*: Each of the gel samples featured in this chapter was photographed individually. They do not look like photos of gels because I captured the light of a 580EX flying through the gel rather than ambient light reflecting off of the gel. This gives a more accurate portrayal of the color that each gel will produce when used with a Speedlite.

Gels are an important part of a Speedliter's kit. These thin sheets of colored plastic change the color of your Speedlite for technical and creative purposes.

### The Main Uses Of Gels

For now, know that gels can be used for four main tasks:

- *Color correction*: CTO (color temperature orange) gels make your Speedlite appear to the camera as if it was a tungsten light bulb. CTB (color temperature blue) gels can be used on tungsten sources to balance them with the daylight color of your Speedlites. Plus Green gels will help move your Speedlite into the funky color balance of fluorescents.

- *Theatrical color*: There is literally an entire rainbow of colored gels that can be used on a Speedlite. Strap one on when you want to add a spot of color on your subject or background.

- *Neutral density*: Sometimes setting your Speedlite to minimum power just is not low enough. To get even less light out of your flash, you can darken it with a neutral density gel.

- *Polarizing*: If you have to photograph an antique oil painting that has shiny varnish over a cracked surface, the easiest way to eliminate the glare is to polarize your light sources and then shoot with a polarizing filter on your lens.

---

### SPEEDLITER'S TIP

#### —Speedlite Color Balance—

For all practical purposes, a Speedlite is balanced to the color of daylight at midday, about 5500K. When color-correcting a Speedlite to match the look of another light source, you can follow the guidelines for matching daylight to that source.

---

*Figure 20.2* The Rosco Strobist Gel Collection provides a wide assortment of gels. At 1.5" x 3.25", they barely fit a 580EX. On the smaller 430EX, they're fine.

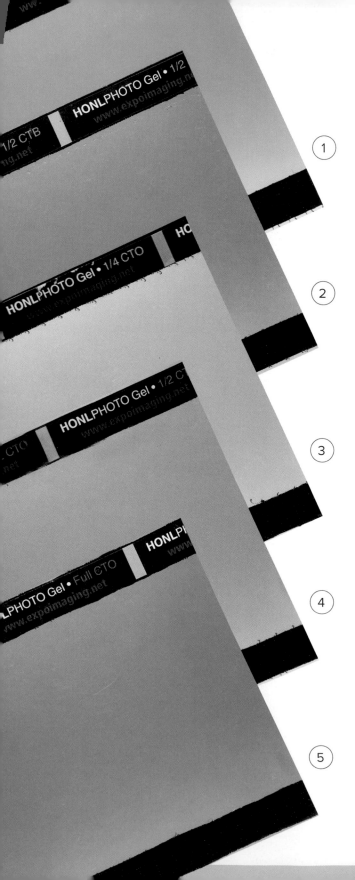

## IF COLOR CORRECTION IS NEEDED, DID SOMETHING GO WRONG?

So you hear some guy going on about how he used a color correction gel. Then you wonder what went wrong with his colors that made it necessary to correct them. Here's an insider's tip: if they were called "color shift" gels, then you would not be so confused.

The issue is not that one color is right and another is wrong. The issue is that there is either a difference in the color temperature of two light sources or a difference between the color temperature of a light source and the color balance of the medium used to record that light.

### Why Hollywood Invented Color Correction Gels

Hollywood has long dealt with differences in the color temperature of light sources. For instance, big tungsten lights will often be used outdoors to provide a broad swath of fill light on sunlit sets. Tungsten has a lower color temperature than daylight, meaning that it will appear orange on daylight film. To make the orange-tinted tungsten light appear like daylight, the grip will frame up a big sheet of CTB (color temperature blue) in front of each hot light. The additional blue shifts the color of the tungsten light so that it appears to the camera the same way that natural daylight appears.

Conversely, there are daylight-balanced incandescent lights, such as the HMI (short for Hydrargyrum medium-arc iodide, which is why everyone calls these lights HMI). For daylight

*Figure 20.3 My well-used color correction gel set from HonlPhoto. Each gel is edged with hooked velcro strips that attach directly to a Speed Strap.*

1. *Plusgreen*
2. *Half-cut CTB*
3. *Quarter-cut CTO*
4. *Half-cut CTO*
5. *Full-cut CTO*

till, an HMI can be used without a gel. However, if you want to use an HMI indoors and balance it with traditional tungsten lights, the grip will frame up a big sheet of CTO (color temperature orange) in front of the HMI to make it appear more orange, like the tungsten lights.

## Color...It's A Balancing Act

In the predigital era, film was balanced for either daylight or tungsten. If you shot tungsten film outdoors, the images looked very blue. If you shot daylight film indoors with tungsten illumination, the images looked too orange.

In the digital world, these differences are handled by the white balance setting (WB) in the camera. Canon's Auto White Balance (AWB) setting is so good that perhaps you've never found the need to explore the dedicated white balance settings on your camera.

As you know, every time you fire your Speedlite, your photo has two types of light in it—ambient and flash. If the color temperatures match, then they will blend naturally. If the color temperature of the flash is different than the ambient, then your photo will have a color cast in either the ambient or flash.

For instance, in Figure 20.4 (upper right), the ambient and flash blend naturally in this incandescent-lit studio because I used the Tungsten WB and gelled the Speedlite with full-cut CTO. Yet, in the frame below, I switched the white balance on the camera to Daylight and the color has shifted to amber.

Likewise, in Figure 20.6, I used the Tungsten WB, but pulled the gel from the Speedlite—so the flash appears blue. Finally, I switched back to Daylight WB with the Speedlites ungelled. The color is more neutral, but the shot appears over-lit with flash.

**Figure 20.4** *Tungsten WB with full-cut CTO.*

**Figure 20.5** *Daylight WB with full-cut CTO.*

**Figure 20.6** *Tungsten WB with ungelled Speedlite.*

**Figure 20.7** *Daylight WB with ungelled Speedlite.*

## GETTING DRAMATIC WITH COLOR

Once you move beyond the precision of matching one light source to another, the world of gels gets very colorful. Color effect (a.k.a. theatrical) gels literally come in a rainbow of colors.

So how and why would you want to use color in your photographs? Here are a few ideas.

- *Create ambience*—you can change the mood of a scene completely with a gel. Want scandal? Go with red. Want sadness? Go with deep blue.

- *Tint the shadows*—if the key light on your subject is warm, then tint the fill light with a cool gel. The next time you watch a movie, you will see that this is done all the time.

- *Spruce up a dull scene*—what do you do when you arrive on location and discover that the background is plain, boring white? You can dim the ambient with the shutter and then turn the background into any color you want with a gelled Speedlite.

---

### SPEEDLITER'S TIP

#### —Neutral Density Gels—

There will be times when your Speedlite produces too much light—even at its minimum power setting. This is particularly true for tabletop and macro work where the flash is in very close.

Rosco produces three neutral density filters that will reduce the flash by one, two, or three stops without shifting the color.

Rosco N.3 (3402) = 1 stop.
N.6 (3403) = 2 stops. N.9 (3404) = 3 stops.

---

**Figure 20.8** *My collection of Roscolux gels. Top to bottom: Fischer Fuchsia, Scarlet, Medium Red, Orange, Mayan Sun, Deep Straw, Primary Green, Leaf Green, Indigo, Bright Blue, Tahitian Blue, and Rose Indigo.*

## MY FAVORITE GELS

When you're starting out, you'll do fine with the HonlPhoto color correction and color effect gel sets. Then, as you become more experienced and more obsessed, you'll want to put together your own collection.

Here's a rundown of my favorite gels. The numbers listed are from the Rosco gel set. You can find similar gels from Lee Filters as well.

### Color Correction Gels

*CTO / Color Temperature Orange*—full (3407) and half (3408)—these are the standard gels for blending Speedlites with incandescent bulbs. Remember to set the camera's white balance to tungsten.

*Plusgreen*—full (3304) and half (3315)—helpful when you wish to shoot Speedlites with fluorescent lights. Try both Daylight and Fluorescent white balances.

*Vapor*—Industrial (3150)—sometimes helpful when shooting Speedlites under sodium-vapor lamps. Can also help with some fluorescents.

*CTB / Color Temperature Blue*—usually CTBs are used on tungsten lights to move them towards daylight. Speedlites are already daylight balanced, so CTBs are of little use this way. If you are really fanatical, you can use a ¼-cut of CTB with the open shade white balance. I don't.

### Color Effect Gels

*CalColor Primaries*—blend these calibrated colors together and you can create white light as I did on page 38—Blue (4290), Green (4490), and Red (4690).

*Roscolux Colors*—I've picked these twelve colors as a basic rainbow of gels. They are shown on the opposite page top to bottom as listed here—Fischer Fuchsia (349), Scarlet (24), Medium Red (27), Orange (23), Mayan Sun (318), Deep Straw (15), Primary Green (91), Leaf Green (386), Indigo (59), Bright Blue (79), Tahitian Blue (369), and Rose Indigo (358).

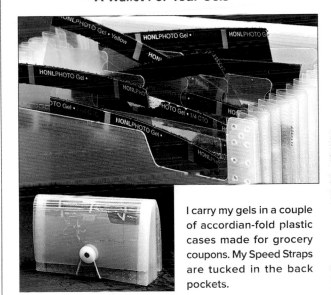

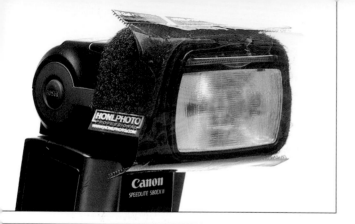

The key to mounting gels is to make sure that there are no light leaks around the gel. If there is a gap, white light will dilute the effect of the gel. Here are a handful of ways to attach a gel to a Speedlite—listed in order of my preference.

### Velcro To Speed Strap—My Favorite

When the sun is setting and I'm trying to gel a Speedlite for a bit of balanced fill flash, I need to be able to change my gels in a split second. The fastest way I've found is to use a Honl Speed Strap and large gels (3.75″ x 3.75″) that have hooked Velcro along two sides.

### Gaffer's Tape—Inexpensive and Versatile

One of the many uses for "gaff" is to affix gels to your Speedlites. I think that this is the best way to affix a Rosco-Strobist gel to a 580EX. A gaffed gel can be installed and removed quickly.

### Acrylic Gel Holder—Durable

The rigid, acrylic holder from *GelHolder.com* is sized for the Rosco Strobist set. It is very well crafted and quick to connect to a Speed Strap. Due to the size of the Rosco Strobist set, it is almost too small (in terms of height) for a 580EX. If you have a 430EX, it will do fine.

### Lumiquest Gel Holder—Not A Good Fit

Lumiquest makes a plastic pocket to hold the Rosco gels that I cannot recommend. As you can see at left, it's a poor fit on a 580EX and the gel pocket hangs in front of the slave sensor. For a DIY holder, use a vinyl name badge holder from a trade show.

*Figure 20.9* I prefer oversized gels that I can attach or remove to a Honl Speed Strap in a split-second.

*Figure 20.10* Strips of gaffer's tape can be used again and again to hold a gel in place.

*Figure 20.11* The rugged acrylic holder from GelHolder.com holds the Rosco Strobist gels.

*Figure 20.12* The Lumiquest gel holder is a tight fit on the 580EX. The gel pocket blocks the slave sensor.

## MIXING WHITE BALANCE AND GELS CREATIVELY

Beyond instant feedback, the two greatest advantages of digital photography over film are that both ISO and white balance ("WB") now can be changed from frame to frame. With film, I literally had to change film in order to change either of those "settings."

### Creativity Is Often A Matter Of Balance

Today, you can think of WB as another creative tool. By changing to a specific WB, your camera effectively adds the opposite of that light source to the file. Then, by adding a gel to your Speedlite, you can make it appear as something other than daylight to your camera.

> *If you gel your Speedlite to match the WB, then the flash will appear neutral white. If your WB and gel do not match, then your image will have a color cast—either in the portion lit by the ambient light or the portion lit by the Speedlite.*

For instance, the shoots on pages 288–289 and 290–291 both use a CTO gel on the Speedlite. The main difference between the images is that one was shot with a Daylight WB and the other in a Tungsten WB.

The two WBs used most commonly for creative effect are Tungsten and Fluorescent.

### Tungsten

As you have seen throughout the *Handbook*, shooting a Tungsten WB under tungsten light yields neutral whites. Conversely, shooting a Tungsten WB under daylight yields a strong blue cast. The reason for this is that, in broad strokes, blue is the opposite of amber. So, to increase the blueness of a blue sky, switch your camera into Tungsten and light your subject with Speedlites gelled with full cuts of CTO. Your subject will appear very neutral in color and the sky will appear very saturated. This is the technique used for The Blue World on pages 290–291. If you want to amp the sky and warm your subject, use a full-cut and a half-cut or two full-cuts of CTO on your flash.

### Fluorescent

Old-school fluorescent tubes had a definite green cast. The Fluorescent WB tries to neutralize the green by adding a magenta tint to the image. So, the next time you want to create more contrast between salmon clouds and an indigo sky at sunset, switch your camera to Fluorescent WB and light your subject with Speedlites gelled with Plusgreen.

**Figure 20.13** *The only difference between these two frames is the white balance. At left is Daylight, and at right is Fluorescent.*

### SPEEDLITER'S TIP

#### —Cut Your Own Gels—

For many years I have cut my own Speedlite-sized gels from the 20″ x 24″ sheets sold by major photo houses. One sheet will provide 30 4″ x 4″ gels—which is a good size if you want to attach Velcro strips like Honl. The downside is that you end up with 30 of the same gel rather than an assortment of different gels. So go in with a bunch of friends, buy a wide range of sheets, and hold a gel-fab meet-up. You can buy lengths of the Honl-sized ⅜″ hooked Velcro at *OCFGear.com*.

Golden hour is that period of the day right after sunrise or just before sunset. The blinding harshness of the midday sun is absent. The color of the light is very warm. The shadows rake horizontally at long angles. Like rush hour, golden hour is not limited to 60 minutes. Its start and stop times depend upon your location and the time of year.

To create the effect of golden hour when shooting with Speedlites, you have to do two things with the light:

- Make it come in at a low angle
- Make it look orange

The effect is created by using a Daylight white balance and gelling the Speedites with full-cuts of CTO to mimic a setting sun.

### We Expect That Sunlight Comes Indoors Through A Window

We know intuitively that sunlight comes inside through windows. We also know that when the sun is high overhead that the window light will be indirect and cool. When the sun is low we expect it to be warm-colored and have long shadows. For the lighting to be believable for this shoot, it was critical that I mimic the qualities of a late afternoon sun.

I parked a pair of 580EX IIs side by side on a Wizard Bracket and then gelled each with a full cut of CTO. To create the effect of long shadows, I zoomed the heads to 105mm and then hoisted the Speedlites to 7' on a C-stand. After several test shots, I determined that the stand should be about 15' from the window.

### Manage The Ambient By Making It Go Away

For a shot like this, where I am creating a lighting effect, it is often easier to create all the light than to try to blend it with the ambient. So, I took care of the ambient by choosing a shutter speed that would significantly underexpose the natural light, as shown in Figure 20.15.

### Lighting Details

**Environment:** indoors, intermittent rain outside

**Time of Day:** mid-afternoon

**Ambient:** daylight, very flat due to clouds

**Speedlites:** 580EX II on extra-long E-TTL as master facing out through window, two 580EX IIs on Wizard Bracket outdoors as slaves

**Metering Mode:** E-TTL

**FEC:** 0

**Zoom/Pan:** heads zoomed to 105mm

**Gel:** full-cut CTO on each slave

**Modifier:** none

**Speedlite Distance To Subject:** 15' to window, then subject 5' from window

**Height:** raised on C-stand to 9', angled slightly down

**Trigger:** master connected to the camera's hot shoe via 24' off-camera E-TTL cord, tucked up to window, triggering slaves

### Camera Details

**Camera:** 5D Mark II

**Lens:** Canon 35mm f/1.4L

**Distance to Subject:** 10'

**Exposure Mode:** Manual

**Exposure:** $\frac{1}{80}$", f/4, ISO 100 ($4\frac{1}{3}$ stops under ambient)

**White Balance:** Daylight

*Figure 20.14 (top) The CTO and shallow angle of the light create the effect of sunset even though a light rain was falling outside. Setting the camera to Daylight white balance assured that the CTO would be recorded as warm light. Had I set the white balance to Tungsten, the flash would appear as neutral light—very unlike the quality of late-afternoon sun.*

*Figure 20.15 (bottom left) Here's the shot without any flash. I chose a shutter speed that would significantly underexpose the ambient light. This enabled me to control all aspects of the light that was hitting the subject.*

*Figure 20.16 (bottom right) The lighting diagram.*

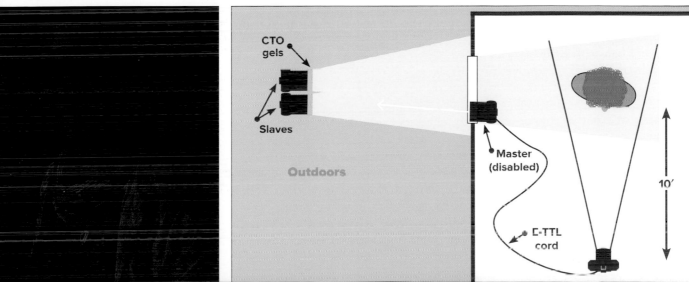

CTO gels

Slaves

Outdoors

Master (disabled)

E-TTL cord

10'

Trust me on this one—you can make the sky turn bluer by strapping an orange gel to your Speedlite. Like I said, trust me.

### The Tricky Tungsten Trick

The first step is to shift your camera to a Tungsten white balance. The Tungsten white balance counteracts the orange tint of incandescent lights by adding a blue tint to the entire frame. Under tungsten lights, this additional blue makes the whites appear white. This also means that, under daylight, the entire frame will seem slightly blue.

The second step is to shift the color of your Speedlites so that they appear like tungsten—which means that the light from your Speedlite will appear white to the camera. Generally it takes a full cut of CTO to make the Speedlite look neutral with a Tungsten white balance. If you want the subject to have a warmer look, add another ½-cut or full cut on top.

### Put Your Subject In Shade First

Make it easy on yourself by putting your subject in shade and pointing the camera towards the north sky. If there is no source of shade, then make your own. For this shoot, two of my sherpas, sons Vin and Tony, managed the 6′ x 6′ Lastolite Skylite panel—which you can see in Figure 20.22.

### Lighting Details

**Environment:** outdoors
**Time of Day:** late afternoon
**Ambient:** direct sun, blocked with panel
**Speedlites:** three 580EX IIs in softbox
**Metering Mode:** E-TTL
**FEC:** 0
**Pan:** zoomed to 24mm
**Gel:** full-cut CTO
**Modifier:** Westcott 28″ Apollo softbox
**Distance:** 4′
**Height:** softbox 2′ above Colin's head
**Trigger:** cord to master inside Apollo

### Camera Details

**Camera:** 5D Mark II
**Lens:** 24–70mm f/2.8L
**Distance to Subject:** 10′
**Exposure Mode:** Aperture Priority
**Exposure Compensation:** 0
**Exposure:** ⅟₃₂₀″, f/5.6, ISO 100
**White Balance:** Tungsten

*Figure 20.18 (top left)* Our ambient light was direct sun—which we promptly blocked with a panel.

*Figure 20.19 (center left)* Daylight WB with full-cut CTO on the Speedlites. Colin's skin is too warm and the sky is too dull.

*Figure 20.20 (bottom left)* Tungsten WB and bare flash. Everything has that tungsten blue tint.

*Figure 20.21 (top right)* Tungsten WB and full-cut CTO on the Speedlites. Colin's skin has returned to a more natural tone.

*Figure 20.22 (bottom right)* Our set was a spot on the side of the road. To left: the Lastolite Skylite panel that we used to put Colin in the shade. To right: the Westcott Apollo 28″ softbox with a Tri-Flash bracket holding three Speedlites inside.

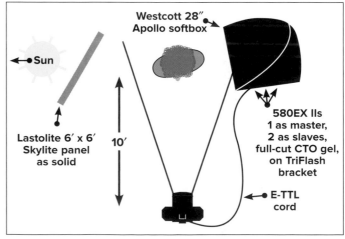

*Figure 20.17* Lighting diagram.

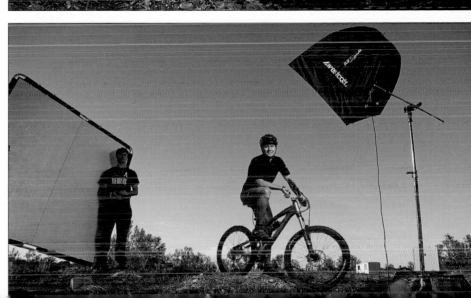

My friend Mark Krajnak is a fanatic about film noir and the many novelists who feed the genre. (To see what I mean, visit his blog *JerseyStylePhotography.com*.) When I decided that I must make his portrait, there was no question about what he would wear and how I would light it.

### Hide The Ambient Light

Our set was an abandoned storefront. We found it just after the sun had set. As you can see in Figure 20.22, in Av the camera is more than happy to stay open long enough (3.2″) to create a photo by the light of a single street lamp. Switching the camera into Manual at $\frac{1}{60}$″ sucked out every bit of the sodium-vapor light.

### Daylight, Two Gels, A Flag, and A Grid

For consistency when gelling, it's important to set the white balance of the camera to something other than auto (AWB). For this shot, I used Daylight WB.

At camera left, I gelled the flash with medium red and flagged the light from the camera with the large Rogue FlashBender. The role of this light was to light the steel door.

At camera right, I gelled the flash with a half-cut of CTO and gridded with the Flashpoint Q $\frac{1}{8}$″ grid. The half-CTO warms the light on Mark just a bit. The grid makes the light very directional. You can see the effect quite easily in the opening shot on page 280.

### Be Open To "Accidents"

I came to this shoot with a preconceived idea of the light that I wanted to create. About halfway through, I fired the camera before the second slave had recycled. I then realized from this "accident" that I had other options for the light. You can see two of them in Figures 20.23 and 20.3. If you learn from every shot, then new options will open up for you.

### Lighting Details

**Environment:** neglected urban street
**Time of Day:** 30–90 minutes after sunset
**Ambient:** sodium-vapor street light overhead
**Speedlites:** 580EX II on-camera as master, two more as wireless slaves
**Metering Mode:** Manual
**Power Levels:** left slave: $\frac{1}{8}$, right slave: $\frac{1}{4}$
**Zoom / Pan:** both slaves zoomed to 24mm
**Gel:** left slave: Medium Red, right slave: half-CTO
**Modifier:** right slave: Flashpoint Q $\frac{1}{8}$ grid
**Distance:** left slave: 6′, right slave: 4′
**Height:** left slave: 8′, right slave: 3–4′
**Trigger:** Canon's built-in wireless system

### Camera Details

**Camera:** 5D Mark II
**Lens:** 24–70mm f/2.8L
**Distance to Subject:** ranged from 2′ to 8′
**Exposure Mode:** Manual
**Exposure:** $\frac{1}{60}$″, f/11, ISO 400 (5+ stops under ambient)
**White Balance:** Daylight

---

### SPEEDLITER'S TIP

#### Color Intensity With Gels

If you're firing through a colored gel and need to get more color, you need to turn the power of the flash down. I know that seems like the opposite of what you should do. Turning the power up actually makes the color thinner rather than more saturated. To keep the power dialed up, you'll have to layer on additional gels until you get the intensity of color that you desire.

---

*Figure 20.22 (top left) Our set was a vacant storefront. We started about 20 minutes after sunset.*

*Figure 20.23 (center left) Be open to "accidents." Here the left (red) Speedlite fired without the right.*

*Figure 20.24 (bottom left) Later, I intentionally fired the right (half-CTO) Speedlite without the left.*

*Figure 20.25 (top right) Remember that there are no boundaries for what you can do with colored gels.*

*Figure 20.26 (bottom right) The lighting diagram.*

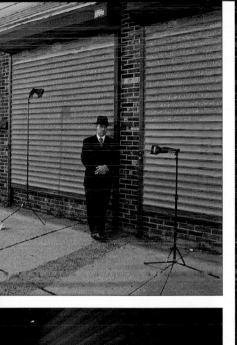

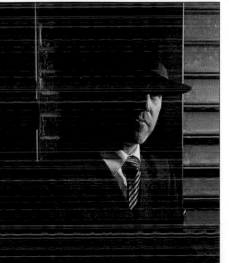

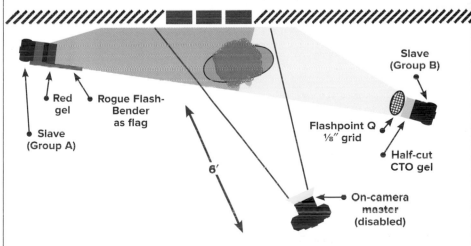

Slave
(Group A)

Red
gel

Rogue Flash-
Bender
as flag

Slave
(Group B)

Flashpoint Q
⅛″ grid

Half-cut
CTO gel

6′

On-camera
master
(disabled)

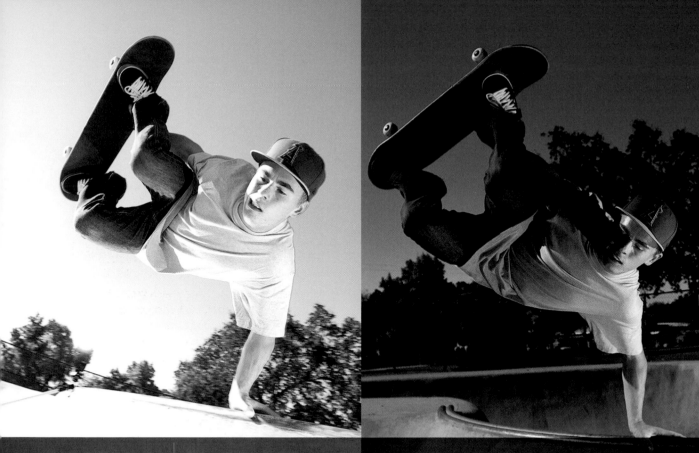

# CHAPTER 21 | SLICING TIME WITH HIGH-SPEED SYNC

## The Short Version

High-Speed Sync (HSS) changes the way your Speedlite fires. Rather than a single, strong pulse, your Speedlite sends out an ultra-fast burst of low-power, stroboscopic pulses. Because the strobe pulses are so close together, your Speedlite effectively turns into a continuous light source for an instant.

High-Speed Sync enables the use of virtually any shutter speed on your camera—up to $\frac{1}{8000}''$ on the fastest models. The trade-off is that the power of the flash is greatly reduced—typically by 2½ stops.

### Figure 21.1
*High-Speed Sync enables me to shoot at virtually any shutter speed. At left, the normal sync speed of my camera ($\frac{1}{200}''$) blows out at a wide aperture in full sun. At right, the shot at $\frac{1}{1250}''$ with the Speedlite switched into HSS.*

## HOW HIGH SPEED SYNC CHANGED MY CAREER

When comparing the weight of the medium format and view cameras that I used to shoot professionally and the clunky studio packs that I used with them, the bulk of my Canon DSLRs and Speedlites seems as sporty as a two-seat roadster. I've never had the occasion to think, "It's too bad that this 5D Mark II does not weigh 13 pounds." Further, there is nothing about the expense and environmental impact of shooting film that I miss.

Still, I must confess that, for a long while, there was one element about the old days that I missed greatly—the ability to sync flash at any shutter speed I desired. As you will read on the following pages, the mechanics of a DSLR's shutter imposes a limitation on the shutter speeds that can be used when shooting flash.

When I first moved from film to digital, I kept shooting with my old lights. There was too much to learn about melding the workflow between camera and computer to pay much attention to the pint-sized Canon Speedlites. So, for several years, I bumbled along thinking that the fastest shutter speed I could use with flash on my DSLRs was 1/200".

Eventually, I began carrying a couple of Speedlites instead of my mid-sized Quantum Qflash. I appreciated the weight savings—yet still thought that my sync speed was capped at the rather sluggish 1/200".

Then my friend MD Welch gave me a succinct introduction to High-Speed Sync by saying, "Just push the H-button, dummy." With that empowerment, the world of HSS was opened to me. Once again I was able to explore the use of flash at virtually any shutter speed

I have made many memorable shots with High-Speed Sync—including the cover shot for this book. I have changed the weather and the time of day with HSS. I have frozen fast-moving action with HSS. I have shot wide open at high noon and filled the shadows with HSS.

I've no doubt that the path of my career has changed, as none of these shots would have been possible without the magic of HSS.

## ACTIVATING HIGH-SPEED SYNC

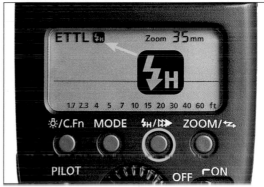

**Figure 21.2** *Activating HSS via the Speedlite LCD.*

The easiest way to activate High-Speed Sync is to push the "flashbolt-H" button on the back of a 430EX or 580EX (both original and Mark II). You will see that the "flashbolt-H" icon appears in the upper left corner of the screen. If you push the button a second time, you will go from HSS into Second-Curtain Sync. If you push it one more time, you will return to First-Curtain Sync. If you keep pushing the button, it will cycle around the three selections again.

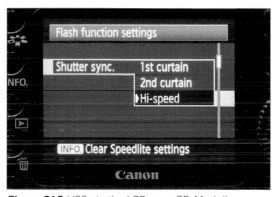

**Figure 21.3** *HSS via the LCD on a 5D Mark II.*

If you are shooting an EX II Speedlite on a compatible body (40D or later), you can also activate HSS via the camera LCD. It is found as an option under "Flash function settings." As HSS is so easy to activate via the Speedlite, I seldom activate it via the camera's LCD. That said, I use the camera's LCD frequently for the many functions (like wireless settings) that are harder to see on the Speedlite's LCD.

## SYNCING FLASH NORMALLY

The type of shutter in a camera determines how the flash synchronizes with the exposure. Canon DSLRs have focal plane shutters, which means the flash is coordinated with the movement of two curtains that fly across the sensor. Most point-and-shoot cameras have an electronic shutter, which means that the flash must fire when the sensor is energized to collect light. View cameras and some medium-format cameras escape the flash sync issue because they have leaf shutters inside their lenses, the blades of which open outward from the center.

### X-Sync Speed

The X-sync speed, commonly called *sync speed*, is the fastest shutter speed at which the normal flash pop will synchronize with the camera. It varies by camera model. On a 5D Mark II, it's $\frac{1}{200}''$. On a 7D it's $\frac{1}{250}''$. On a 1D Mark IV, the sync speed is $\frac{1}{300}''$.

The focal plane shutter in your DSLR is actually two curtains in front of the sensor. As shown in Fig. 21.4, when your camera is ready to fire, both curtains are fully closed across the sensor. The moment the shutter button is fully depressed, the 2nd-curtain opens fully and then the 1st-curtain opens. When the 1st-curtain is completely across the sensor, the entire sensor is exposed to light. The Speedlite will fire before the 2nd-curtain begins to close.

> *The sync speed is the fastest shutter speed at which the first curtain is completely across the sensor—meaning that the sensor is completely uncovered—before the second curtain has started to move.*

At slower shutter speeds, the sensor is completely uncovered between the opening of the first curtain and the closing of the second curtain. At speeds faster than the sync speed, as shown in Figures 21.11–21.16, there is no point where the entire sensor is uncovered.

*Note*: It's not a mistake that the image in these diagrams is upside down. This is the way that the lens projects the image onto the sensor.

**Figure 21.4** *When a DSLR is ready to fire, both the 1st curtain and 2nd curtain are closed across the sensor.*

**Figure 21.5** *When the shutter button is pushed, the 2nd curtain opens completely, then the 1st curtain begins to open.*

**Figure 21.6** *When the 1st curtain is fully open, the entire sensor is exposed to light.*

**Figure 21.7** *The Speedlite fires after the 1st curtain is completely across the sensor and before the 2nd curtain begins to close.*

**Figure 21.8** *The 2nd curtain begins to close across the sensor.*

**Figure 21.9** *When the 2nd curtain is completely across the sensor, the exposure is over. The 1st curtain then resets to the closed position.*

## Why Flash Won't Sync At Faster Shutter Speeds

At faster shutter speeds, the interval between the movement of the two curtains means that the second curtain starts to move before the first curtain has cleared the sensor. Essentially, as shown in Figures 21.11–21.16, the space between the curtains looks like a slit that travels across the sensor at a fast rate. The faster the shutter, the narrower the slit.

As you can see below in Figure 21.10, shooting faster than the sync speed results in an edge of the frame appearing dark because it was covered by the second curtain during the flash.

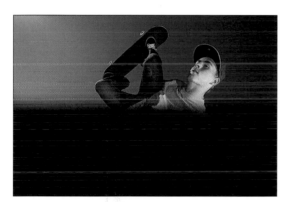

**Figure 21.10** *The telltale sign that the sync speed has been exceeded is a black band across the lower portion of the frame where the 2nd curtain blocked a portion of the sensor.*

### Your Camera Will Override Your Settings

To prevent this black band, your Canon DSLR will override your settings (when necessary) if there is a Canon Speedlite in the hotshoe. You may have set the shutter at ½₀₀₀″, but the camera will force it to the sync speed when there is a Speedlite in the hotshoe.

Likewise, if you are shooting in Av (Aperture Priority) at a wide aperture under bright ambient light, the shot will be overexposed when the camera fires at the sync speed rather than the much faster shutter speed needed to offset the wide aperture. This is the reason for the difference in the two frames shown in the chapter opener on page 294.

**Figure 21.11** *When a DSLR is ready to fire, both the 1st curtain and 2nd curtain are closed across the sensor.*

**Figure 21.12** *When the shutter button is pushed, the 2nd curtain opens completely then the 1st curtain begins to open.*

**Figure 21.13** *At speeds faster than the sync speed, the 2nd curtain begins to close before the 1st curtain is fully open.*

**Figure 21.14** *There is no point where the Speedlite can illuminate all of the sensor at once.*

**Figure 21.15** *The 2nd curtain continues its journey across the sensor.*

**Figure 21.16** *When the 2nd curtain is completely across the sensor, the exposure is over. The 1st curtain then resets to the closed position.*

## HIGH-SPEED SYNC CHANGES THE WAY YOUR SPEEDLITE FIRES

If there is a reason to become really good at Speedliting, it is High-Speed Sync. HSS is a Speedlite-only function. You cannot do HSS with monolights and studio strobes. Sure, there are some workarounds for these other types of flash—but I think they are as cumbersome to implement as these bigger lights are to lug around (and you still can't shoot at ⅛₀₀₀″).

### Changing The Way The Speedlite Fires

In normal flash mode, your Speedlite fires as a single pulse of light. In HSS, the Speedlite turns into an ultra-fast strobe light that turns on and off 35,000 times per second. Effectively the Speedlite becomes a continuous light source for the brief duration of the exposure.

| Closed | 1st curtain travelling | Fully open | 2nd curtain travelling | Closed |

**Speedlite Firing Normally**

**Figure 21.17** *In normal sync mode, the Speedlite fires one big burst of light when the shutter is fully open.*

| Closed | 1st curtain travelling | 1st & 2nd curtains travelling | 2nd curtain travelling | Closed |

**Speedlite Firing In High-Speed Sync**

**Figure 21.18** *In High-Speed Sync, the flash pulses rapidly as the two curtains travel across the sensor.*

As illustrated on page 296, you can see in Figure 21.7 that in normal sync mode, the sensor is fully uncovered at the time the Speedlite fires. In contrast, as shown in Figures 21.19–21.24, at faster shutter speeds, there is no single point where the sensor is completely uncovered. HSS handles this by pulsing the Speedlite for the entire time that the slit between the curtains travels across the sensor.

**Figure 21.19** *When a DSLR is ready to fire, both the 1st curtain and 2nd curtain are closed across the sensor.*

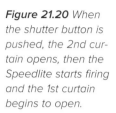 

Shutter speed faster than camera's sync speed. Speedlite firing in HSS.

**Figure 21.20** *When the shutter button is pushed, the 2nd curtain opens, then the Speedlite starts firing and the 1st curtain begins to open.*

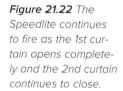 

**Figure 21.21** *The Speedlite continues to fire as the 2nd curtain begins to follow the 1st curtain across the sensor.*

**Figure 21.22** *The Speedlite continues to fire as the 1st curtain opens completely and the 2nd curtain continues to close.*

**Figure 21.23** *The Speedlite continues to fire as the 2nd curtain continues to close.*

**Figure 21.24** *When the 2nd curtain is completely across the sensor, the Speedlite stops firing.*

## The Power Hit In High-Speed Sync

High-Speed Sync enables the use of virtually any shutter speed on your camera—up to 1/8000″ on the fastest models. But don't think of High-Speed Sync as the solution for all your flash needs. The trade-off is that in order to get the ultra-fast stroboscopic pulse, the power of the flash is greatly reduced.

To quantify the power hit, I did a comparison between normal flash and HSS flash. I mounted my old Minolta Flashmeter IVF in the jaws of a Super Clamp on a light stand. Then I parked my camera with a 580EX II on top of a tripod and moved it so that the flashhead was exactly 36″ from the flashmeter. The Speedlite was connected to my camera via an E-TTL cord. I spent an afternoon firing off hundreds of pops at various power levels—controlling the Speedlite both manually and via E-TTL.

*Figure 21.25* My trusty old Minolta Flashmeter IV comes out of retirement to help me quantify the power hit in High-Speed Sync.

*Figure 21.26* I'm a firm believer that it's important to dress for the occasion—especially when I'm about to make 300 photos of a flashmeter.

Here is a summary of my observations:

- In E-TTL, when I did not exceed my sync speed, there was no difference in flash output between having HSS activated and not having it activated. Again, this was at or below the sync speed. Once I crossed over the sync speed, the light output fell.

- In E-TTL, once I crossed over the sync speed, the power dropped to about halfway between 1/4 and 1/8 power. Call it 1/6 power—which is a 2 1/2 stop drop from 1/1.

- By setting the camera to a small aperture when in normal sync, E-TTL drove the Speedlite to fire at full power. So the loss of power when crossing into HSS was significant and the shot was underexposed.

- By setting the camera to a wide aperture, when in normal sync, E-TTL fired the Speedlite at a lower power level. So, when I increased the shutter speed into HSS territory, then E-TTL actually increased the output from the Speedlite in an effort to compensate for the HSS power loss.

- With the Speedlite in Manual and with HSS activated, switching from 1/200″ (my sync speed) to 1/250″ cost me 2 1/2 stops of power just because the Speedlite fired in HSS mode. It did not matter what the Speedlite's power level was—1/1, 1/16, or 1/128. As soon as I moved across the sync speed, the light output dropped by an average of 2 1/2 stops.

- So, the takeaway is that E-TTL is better suited for HSS work than Manual because E-TTL will increase the power to compensate for the power hungry nature of HSS. However, if E-TTL is firing the Speedlite at 1/6 power or greater in normal sync, then E-TTL can only increase the power to 1/1—which might not be enough to compensate for the HSS power hit.

- If you need more power from your Speedlite when working in HSS, but can't get it because the flash is already firing at full power, then open your aperture and/or increase your ISO by one or more stops. Remember that, to keep the ambient exposure the same as before, you will also have to speed up your shutter by the same number of stops.

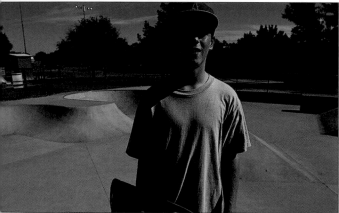

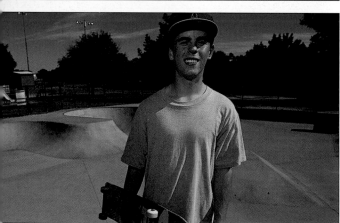

## WORKFLOW FOR CREATING DRAMATIC LIGHT WITH HSS

**Use HSS To Emphasize The Subject And De-Emphasize The Background:**

1. Put the camera in Aperture Priority (Av) mode and shoot a test shot at the aperture needed for the desired depth of field. You're looking to see what shutter speed the camera thinks is appropriate.

2. Put the camera in Manual at the same aperture as before.

3. Set the shutter speed one to three stops faster than the one determined by the camera in step 1. For instance, if the camera thinks the shutter should be at $\frac{1}{250}''$, switch it to $\frac{1}{2000}''$ for a three-stop change ($\frac{1}{250}'' > \frac{1}{500}'' > \frac{1}{1000}'' > \frac{1}{2000}''$).

4. Take a test shot.

5. Dial the shutter speed up or down and make more test shots until the ambient settles where you want it to be. You're not thinking about anything other than the ambient light here. The subject will be underexposed too. Fear not.

6. Modify your Speedlite to shape the light according to your vision: a grid, a snoot, a small softbox, or nothing at all.

7. Now turn your flash on in E-TTL mode with HSS activated.

8. With the Flash Exposure Compensation (FEC) dialed to 0, fire off a test shot.

9. Use the FEC to dial the amount of flash up or down until the lighting fits your vision.

10. Once you get the light looking how you want it, start firing away and giving your subject(s) suggestions and/or specific requests for movement.

Note: If you are more comfortable with your Speedlite when it's in Manual mode, go ahead and use it that way instead of in E-TTL with FEC.

**Figure 21.27** *The Aperture Priority test shot (step 1).*

**Figure 21.28** *The −2 stop test shot (step 3).*

**Figure 21.29** *The flash test shot at 0 FEC (step 8).*

**Figure 21.30** *Final ($\frac{1}{2000}''$, f/5.6, ISO 100, FEC +2).*

## ALTERNATIVES TO HIGH-SPEED SYNC

As a Speedliter, you should know that there are a couple of alternatives to HSS. Why should you know? So that you can impress your friends with newfound knowledge or so that you can get yourself out of a jam, whichever comes first.

### Faux-Speed Sync

HSS works because your Speedlite turns into a continuous light course, meaning that it appears to be on for the duration of the exposure. So what if the duration of your flash is longer than the shutter speed? You'll recall that at full power, a 580EX II fires for about 1⁄830″. So could you fire at 1⁄1000″ or faster?

The answer is yes, sometimes. The key is to disconnect the Speedlite from the camera and trigger it via a PC-sync cord or radio trigger. The camera cannot sense that the Speedlite is there—otherwise it will limit the shutter to the sync speed. Another option is just to use a non-Canon flash in the hot shoe.

You'll want to keep it in Manual at 1⁄1 as that gives you the longest flash duration. Then you'll have to experiment with the shutter speed and aperture until you find the combination that suits your vision. It's not elegant, like HSS, but it will usually work—especially with non-Canon gear—if you're really patient.

### Neutral Density Filters

Often the motivation to shoot HSS comes from wanting to use a fast shutter speed so that you can significantly underexpose the ambient light and still use a wide aperture. If you are working with flash units that are not compatible with HSS, you can literally dim the sun with a neutral density (ND) filter. An ND filter has a simple job—it blocks a specific amount of light without changing the color of the light that comes through.

For years I have carried the Singh-Ray Vari-ND in my camera bag. This unique filter gives me the ability to dial in two to eight stops of neutral density. Eight stops literally turns noon to midnight.

The downside—and it's a huge issue for me—is that an ND filter is difficult to focus through. Also, at the darker range, it is virtually impossible to see the nuances of expression on the subject's face.

Still, I carry it as a just-in-case solution. I believe in gear redundancy and in having options. So, I expect that someday the Vari-ND will enable me to shoot at a wide aperture under the noon sun with gear I borrowed because I managed to leave my Speedlite kit at home.

**Figure 21.31** *The Vari-ND filter ranges from 2 stops (top) to 8 stops (bottom) of neutral density.*

Two things about action sports portraits make them difficult to shoot:

- You have to use a fast shutter speed to freeze the action.
- You have to shoot under challenging lighting conditions.

Somehow a trip to our local skatepark seemed like a good way to put HSS to the test.

### Create A Zone Of Fill Light

Photographing Kyle flying through the air on his skateboard is like shooting a moving target. You know that something is going to happen, but you don't know exactly when or where. Sometimes he would fly high. Sometimes he would fly long.

To emphasize the height of his aerials, I used a wide lens in very close and shot upwards into the sun. I decided that my best bet for lighting was to create a wide zone of fill light with a couple of Speedlites parked underneath his take-off zone.

### Squeeze Every Photon Out By Switching To Manual

My goal with HSS for this shoot was not to overpower the sun. Rather I just needed a good dose of fill light. My shutter was set about a stop under the ambient to saturate the sky just a bit.

Since I was only using two Speedlites and they were spread apart, I needed every bit of light out of them I could get. So I switched from E-TTL into Manual and set the power to full (⅟₁). Jumping to Manual gives about a half-stop of additional brightness as the energy that would go to the E-TTL pre-flash is directed straight into the HSS pulse.

### Move The Master To A Spot That The Slaves Can See

I have heard many times from photographers that Canon's wireless system does not work outdoors in full sun. So, to these legions, I say,

"Turn your slaves away from the sun and move your master to a spot that they can see."

The real issue is that the slave eye, like all of us, has a hard time seeing when it's looking straight into the sun. In Figure 21.33 you'll see that I moved my master off-camera so that it was firing into the sun—meaning towards the slaves, which had been turned to look away from the sun.

### Lighting Details

**Environment:** outdoors, city skatepark

**Time of Day:** late morning

**Ambient:** full sun

**Speedlites:** three 580EX IIs, one as master, two as slaves

**Metering Mode:** Manual

**Power Level:** full

**Zoom / Pan:** slaves zoomed to 70mm

**Gel:** none

**Modifier:** none

**Distance:** 2′ to 4′

**Height:** below Kyle 1′ to 3′

**Trigger:** Canon built-in wireless system with master moved off-camera on E-TTL cord

### Camera Details

**Camera:** 5D Mark II

**Lens:** 17–40mm f/4L

**Distance to Subject:** 2′ to 4′

**Exposure Mode:** Manual

**Exposure:** ⅟₁₀₀₀″, f/5.6, ISO 100 (1 stop under ambient)

**White Balance:** Daylight

*Figure 21.32 (top) My favorite shot from the best HSS shoot I've done in a long while.*

*Figure 21.33 (bottom left) The master is on the stand at far right. One slave is on the left stand. The other is parked on the rail.*

*Figure 21.34 (bottom right) The lighting diagram.*

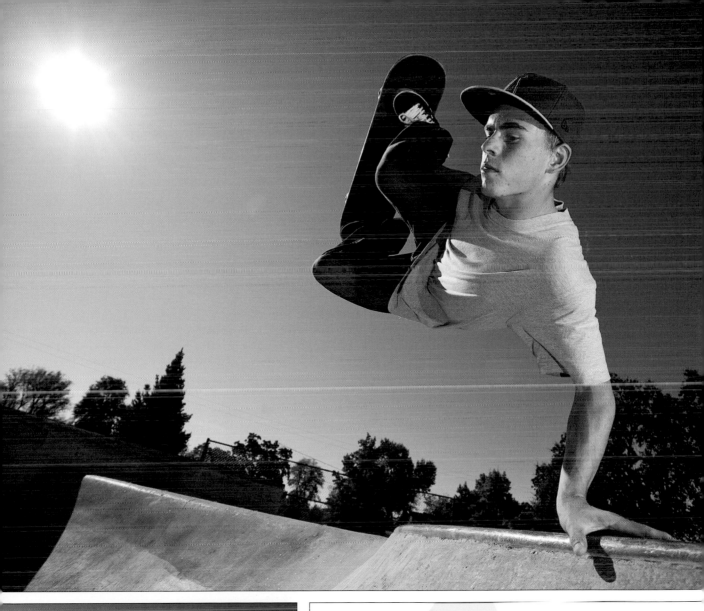

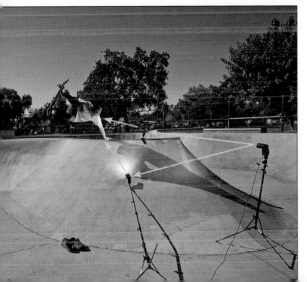

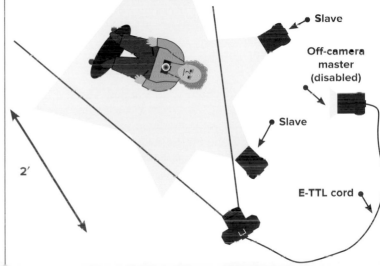

## SHOOT: FREEZING WATER ON A HOT DAY

There is something to be said for the spontaneity of brotherly love on an extremely hot summer day—especially when that affection morphs a garden hose from a delicate background spray of water into a direct headshot. The exact moment it happened is on page 50.

### Create And Create Again

My original idea was to shoot a high-speed sync demo using a curtain of water droplets to show the action-stopping power of HSS. Then, with Figure 21.35 in the can, everyone relaxed—as much as one can when it's 104° in the shade. And, as you can see, we definitely were not in the shade.

The camera proved that there was new magic to be had by streaming the hose directly onto Tony's head. So I once again, dare I say it, I changed creative horses in mid-stream. Rather than stop with a safe shot, I ran with the idea of capturing the surreal look of water frozen around Tony's expressive face.

At first he enjoyed the aquatic assault of his brother and the rest of us were envious. Eventually, though, the cool water became too much and the shoot ended with Tony shivering in the noon-time sun—proof that surrealism comes in many forms.

### You Can't Light This Shot Canon's Way

My intuition told me to run two slaved Speedlites up very high on stands winged out wide and slightly behind my shoulders. I tried to fire them with an on-camera master—but either the blazing sun blinded the slave sensors or the geometry was too wide for the master.

So I spun the slaves around so that their sensors were now facing away from the sun and panned their heads so that they again pointed at Tony. I then ran the master on a long E-TTL cord about 15′ behind me and literally set it on the ground with the head angled up to the slaves—which happened to be straight into the sun. Then the slaves fired without issue.

### Lighting Details

**Environment:** the Smashing Pumpkins set, a.k.a. right beside our house

**Time of Day:** mid-afternoon

**Ambient:** full sun

**Speedlite:** one 580EX II as master, two 580EXs as slaves

**Metering Mode:** Manual

**Power:** full

**Zoom:** slaves zoomed to 105mm

**Gel:** none

**Modifier:** none

**Distance:** about 5′

**Height:** about 4′ above Tony's head

**Trigger:** off-camera master on long E-TTL cord

### Camera Details

**Camera:** 5D Mark II

**Lens:** 17–40mm f/4L

**Distance to Subject:** 2′

**Exposure Mode:** Manual

**Exposure:** ½000″, f/8, ISO 400 (1 stop under ambient)

**White Balance:** Flash

*Figure 21.35 (top left) This is the portrait that I set out to make—nice, but very safe.*

*Figure 21.36 (center left) Without the Speedlites there is no magic to the water. The sun, however, is doing a great job as a rimlight on Tony's shoulders.*

*Figure 21.37 (bottom left) Here I've turned the set 180° so that the sun comes over my shoulder and straight at Tony as the key light. So boring.*

*Figure 21.38 (top right) This is just one of many hero shots that happened within a handful of minutes.*

*Figure 21.39 (bottom right) The lighting diagram.*

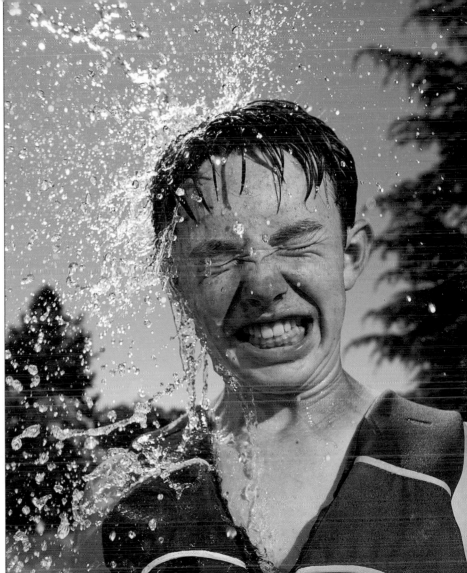

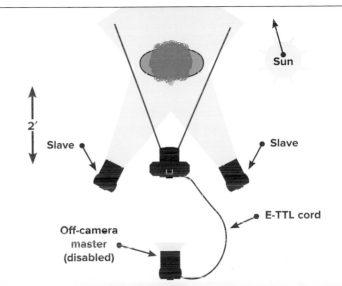

2′

Sun

Slave

Slave

E-TTL cord

Off-camera
master
(disabled)

There are two reasons to shoot at a wide aperture. The first is that you are shooting under dim light. The second is that you want to minimize the effect of a distracting background with shallow depth of field.

So what do you do if you want shallow depth of field when shooting under full sun? There is so much light that, in order to shoot at a wide aperture, you have to shoot at a fast shutter speed, right? This is exactly how I created the shot in Figure 21.40 on the opposite page—wide aperture (f/4) and a fast shutter ($\frac{1}{2000}$″).

### On-Camera Flash In Full Sun

The problem with shooting under full sun (at any shutter speed) is that the shadows will be harsh. Okay, so a bit of fill flash is needed to soften the shadows. Canon's E-TTL system does a fine job of calculating the power needed for a bit of fill flash when the ambient is bright. For this situation, where the Speedlite is providing fill rather than key light, on-camera flash works well.

So, I turned on the Speedlite and whammo! The camera overrides my settings and drives the shutter back down to its sync speed. I went from $\frac{1}{2000}$″ to $\frac{1}{200}$″—a change of 3⅓ stops.

So what happens to the aperture? In Shutter Priority, it automatically heads in the opposite direction, from wide to narrow—specifically 3⅓ stops from f/4 to f/13. You can see what this looks like in Figure 21.41 where I used the Speedlite for fill. Notice that at f/13 the backgrounds becomes more of a distraction.

It's important to note that in Aperture Priority the camera will switch the shutter up to the sync speed, but it will not change the aperture to offset the change. So the shot will be over-exposed, as it is in Figure 21.42.

Fortunately, with a quick push of a button, High-Speed Sync is activated. Now the Speedlite and camera work together to create just the right amount of fill at a wide aperture.

### Lighting Details

**Environment:** urban street
**Time of Day:** noon
**Ambient:** full sun
**Speedlite:** one 580EX II in the hot shoe
**Metering Mode:** E-TTL
**FEC:** 0
**Zoom:** Auto zoom
**Gel:** none
**Modifier:** none
**Distance:** about 10′
**Height:** level with Michaila's head
**Trigger:** hot shoe

### Camera Details

**Camera:** 5D Mark II
**Lens:** 100mm f/2.8L Macro IS
**Distance to Subject:** about 10′
**Exposure Mode:** Aperture Priority
**Exposure Compensation:** 0
**Exposure:** $\frac{1}{2000}$″, f/4, ISO 100
**White Balance:** Daylight

*Figure 21.40 (top left) A quick snapshot in full sun at noon. Made in Shutter Priority with the speed set at was $\frac{1}{2000}$″. The resulting aperture was f/4, which did a nice job of minimizing the background graffiti.*

*Figure 21.41 (center left) Firing the flash in normal sync does a nice job of filling the shadows. Notice how the background becomes more of a distraction. In Shutter Priority the camera automatically changed to the camera's sync speed ($\frac{1}{200}$″) and closed the the aperture down to f/13.*

*Figure 21.42 (bottom left) When working in Aperture Priority with the Speedlite turned on in normal sync, the camera will not exceed its sync speed. Since the aperture has been locked in Av, the resulting shot is significantly overexposed ($\frac{1}{200}$″, f/4).*

*Figure 21.43 (top right) On-camera flash in High-Speed Sync does a nice job of providing just the right amount of fill flash—enabling both a fast shutter and a wide aperture in full sun ($\frac{1}{2000}$″, f/4).*

*Figure 21.44 (bottom right) The lighting diagram.*

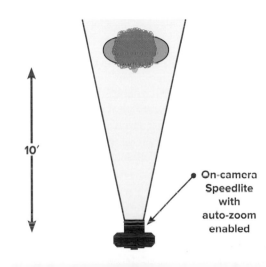

10'

On-camera
Speedlite
with
auto-zoom
enabled

## SHOOT: STRAY DOG AND STRAY LIGHT

Imagine the thoughts that ran through my mind when I heard, "We're doing a story on stray animals that adopt rural wineries and vice versa. We need you to make a photo of Buster. He's a pitbull." Honestly, the idea of coming away with a portfolio-quality image was not among my reactions.

### Previsualizing The Shoot

For several days I pondered two questions—how to craft an interesting pic of a pitbull and how to visually suggest that there's a relationship between an animal and a winery?

I settled on the idea of placing Buster in an iconic position—meaning the camera would be slightly below his nose—and shooting towards the front of the winery. This would cover the relationship aspect. The interesting photo of a pitbull part, I decided, would have to come through the lighting. I had it in my mind that I would hatchet light Buster in high-speed sync under a blazing, late-afternoon sun.

Then, within a minute of meeting Buster on location, two things became apparent: he was among the sweetest dogs that I'd ever met and he had his own ideas about photography.

### Revisualizing And Seizing The Moment

With diligent coaxing of Buster by his owner, Brian, I managed to get a handful of shots that fulfilled my original vision. You can see one of the outtakes in Figure 21.45. After almost every shot, Buster would walk over and sit with me in the driveway—where I was lying in the dust so that I could shoot up at him.

Then, after one shot, he walked past me a few feet and sat down by the road. As I swung around to find him, I saw the real shot—Buster sitting at the edge of the road where he likely decided that Cass Winery looked like a place that could offer food and shelter. Fortunately, he stayed there long enough for me to move my lights and fire off a few frames. He'd given me the shot I really had come to make.

### Hatchet Lighting At Its Best

Without the hatchet lighting, there is no magic to the shot. Compare Figures 21.45 and 21.46 to see the difference. Essentially the Speedlites—firing at each other—collide on Buster to fill the sun's shadows and sculpt his body.

### Lighting Details

**Environment:** rural country road
**Time of Day:** late afternoon
**Ambient:** blinding, full sun
**Speedlites:** two 580EX IIs
**Metering Mode:** Manual
**Power Level:** full
**Zoom / Pan:** both zoomed to 105mm and tilted
**Gel:** none
**Modifier:** none
**Distance:** about 6′
**Height:** 3′
**Trigger:** Canon built-in system, master corded

### Camera Details

**Camera:** 5D Mark II
**Lens:** 24–70mm f/2.8L
**Distance to Subject:** about 6′
**Exposure Mode:** Manual
**Exposure:** $\frac{1}{4000}$″, f/11, ISO 800 (1 stop under ambient)
**White Balance:** Daylight

*Figure 21.45 (top left) My original concept—show Buster and the winery. Notice how nice the hatchet light works here. Here the camera is looking 180° from the angle I used in Figure 21.48.*

*Figure 21.46 (center left) Without the flash there is nothing of interest in the frame. Foreground and background merge together.*

*Figure 21.47 (bottom left) The hatchet light arrangement with the corded master on the left and the slave by the gatepost on the right.*

*Figure 21.48 (top right) The hero shot was not one that I had intended to make. Yet it was the shot of the day and ran with the story as a full page.*

*Figure 21.49 (bottom right) The lighting diagram.*

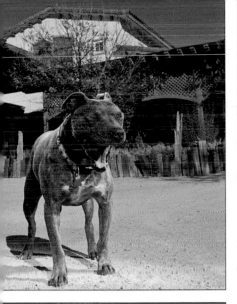

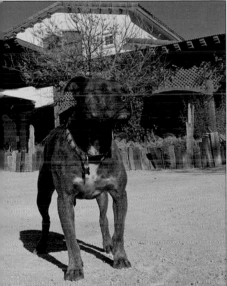

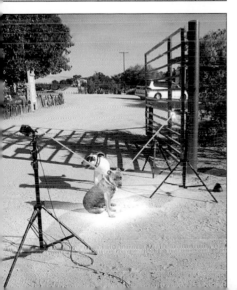

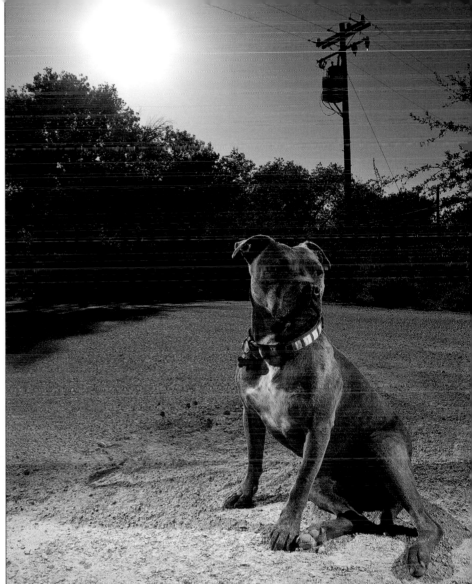

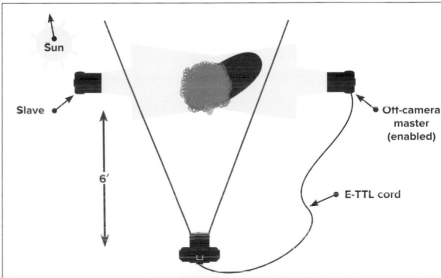

Sun

Slave

6′

Off-camera master (enabled)

E-TTL cord

# CHAPTER 22 | DIMMING THE SUN

## The Short Version

The shutter is the gateway to controlling the amount of ambient light in a photograph. If you want more, use a slower shutter speed. If you want less, use a faster shutter speed.

Novice Speedliters assume that to shoot a night shot, it has to be dark outside. To the contrary, you can literally dim the sun with a fast shutter speed. Then, by using High-Speed Sync, you can selectively light your subject so that the background drops away and the viewer's eye concentrates on the subject.

You might not have the need to turn noon to night. But knowing that you have the option of dimming the sun to some degree is a powerful and creative tool.

**Figure 22.1**
*There's no reason to wait for the sun to set in order to make the background disappear into darkness. You can dim the ambient light with the shutter and use Speedlites creatively.*

## OPTIONS FOR DIMMING THE SUN

The first step in dimming the sun is to underexpose the daylight to give it the quality that you want. Perhaps you want a slightly more saturated sky. Perhaps you need the effect of a full moon (which won't come again for two weeks). Perhaps you're after a pitch-black night. All are possible—even under a noon sun. Of course, there are many solutions for doing this.

### Why Not Just Use A Small Aperture And Sync Normally?

When teaching new Speedliters how to dim the sun with High-Speed Sync, the question is often, "Why not just shoot at the normal sync speed with a really small aperture so that you can use regular flash?" My response is, "You should go out and try." (This answer, by the way, also applies to all types of flash that won't work with your camera in High-Speed Sync: third-party speedlights, moonlights, and location/studio strobes.)

If you want to stay in normal flash mode, your shutter speed is limited to the sync speed. On my 5D Mark II, that's $\frac{1}{200}''$. If your shutter speed is capped by the sync speed, you can only dim the ambient light via the aperture. Okay, so how dark will it be if I shoot at $\frac{1}{200}''$ and f/22? Let's head outside at high noon and see what it looks like.

**Figure 22.2** *As dark as my 5D Mark II gets at noon: ISO 100, $\frac{1}{200}''$, f/22. No one is going to accept this as a good substitute for night*

### How About A Neutral Density Filter?

A neutral density filter is like a pair of sunglasses for your camera. It will reduce the light without creating a color shift. Using one or more neutral density filters is certainly another way to dim the ambient. The problem, as I see it (bad pun), is that I can't see through the neutral density filter to focus or compose.

### High-Speed Sync To The Rescue

In my opinion, High-Speed Sync is the perfect solution for dimming the sun. I can still focus and compose as I normally do, and I can use a shutter speed and aperture that give me the look I'm after.

For aesthetic reasons, as well as optical reasons, I typically try to stay under f/11. So, if I liked the look of the photo at left (which I already said that I didn't, but let's run with it for now), then an equivalent exposure to $\frac{1}{200}''$ at f/22 would be $\frac{1}{1600}''$ at f/8. So, to shoot at my desired aperture, my shutter is well into High-Speed Sync territory. I'd rather have the creative freedom to control the ambient with my shutter than to accept the limitations imposed by a sync speed of $\frac{1}{200}''$.

## —How Your Meter Wants To See The World—

Without minimizing the technological marvel that micro-circuits and computer code are, I often remind myself that the light meter's job is simple. It works to calculate an exposure setting for a world where everything is 18% grey.

Realizing that I don't live in a world that is always exactly 18% grey, I treat the light meter's work as a guideline rather than a rule. If the shot that results from the light meter's suggested exposure creates an image that fits my vision, then great—that is the right exposure.

However, the meter has no idea what is in front of the lens. So it will see a close-up of a tuxedo shirt (below, top row) as being very bright and underexpose it to make the whites into a medium grey. Likewise, the meter will see a frame filled with a tuxedo jacket as being very dark and overexpose the shot so that the black moves to medium grey as well.

Keep the difference between your vision and the light meter's vision in mind when a test shot gives you an exposure that is grossly under- or over-exposed.

Eventually you will begin to anticipate the difference. When shooting in Aperture Priority, if the subject is very bright, I will automatically dial in +2 stops of Exposure Compensation as I am raising the camera to my eye. Likewise, if the scene is very dark, I will roll the dial the other way so that I'm subtracting −2 stops of EC for my first test shot.

# HOW TO DIM THE SUN WITH A FAST SHUTTER

Let's set our exploration of Speedliting aside for the moment and just explore the shutter's role in dimming the sun. At right are eight frames that I shot with the sun straight overhead. It was not my intention to make an interesting image. Rather, I was focused on seeing how the bright whites and dark shadows would change.

I encourage you to shoot the same type of series. Lock your camera down on a tripod, set your camera to Manual exposure, dial the aperture to f/22 (or whatever the minimum is for your lens) and take a meter reading. For this series, I used the Evaluative metering mode so that the camera would consider all aspects of this contrasty scene.

At ISO 100, the meter reading was ⅟₅₀″ at f/22. It produced the shot shown in Figure 22.3. I then changed the shutter speed in whole-stop increments across a seven-stop range. Watch how the feel of the photo changes as the ambient sun is dimmed by the shutter.

*Figure 22.3 (1st row, left)* *As metered (⅟₅₀″, f/22). Good exposure overall, highlight details are preserved, shadow details under car are lost to black.*

*Figure 22.4 (1st row, right)* *Metered −1 EV (⅟₁₀₀″, f/22). Nice shade of blue in sky, rest lacks interest.*

*Figure 22.5 (2nd row, left)* *Metered −2 EV (⅟₂₀₀″, f/22). Obviously underexposed, but not enough to suggest night.*

*Figure 22.6 (2nd row, right)* *Metered −3 EV (⅟₄₀₀″, f/22). Looks like an overexposed shot taken under a full moon.*

*Figure 22.7 (3rd row, left)* *Metered −4 EV (⅟₈₀₀″, f/22). A great place to start when shooting night at noon.*

*Figure 22.8 (3rd row, right)* *Metered −5 EV (⅟₁₆₀₀″, f/22). Only the brightest whites show, too dark for printing.*

*Figure 22.9 (4th row, left)* *Metered −6 EV (⅟₃₂₀₀″, f/22). The place to head if you want pitch black.*

*Figure 22.10 (4th row, right)* *Metered −7 EV (⅟₆₄₀₀″, f/22). Black does not get any darker.*

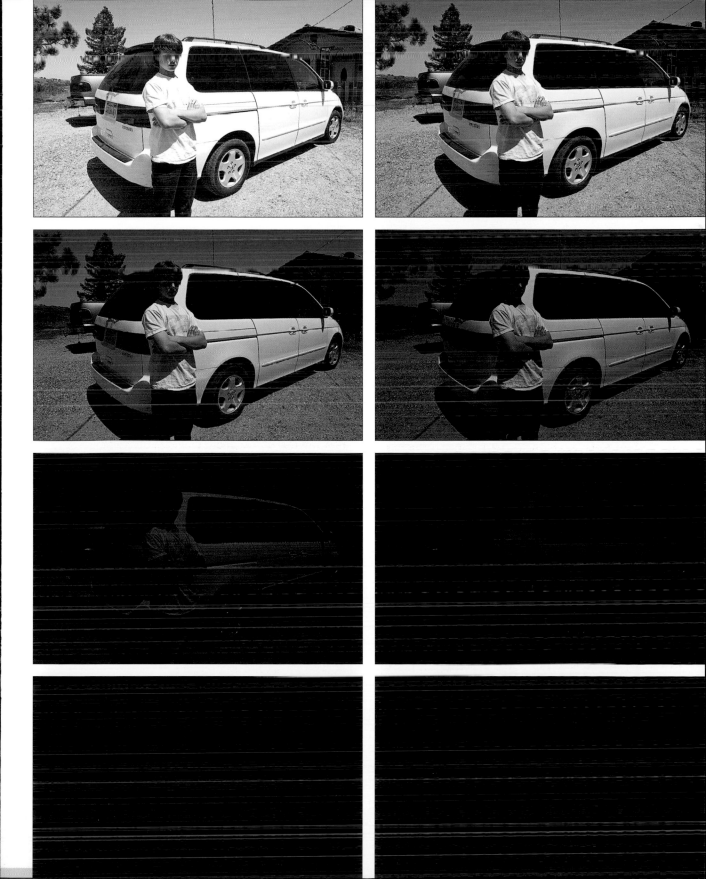

## —How Zoom Changes Apparent Brightness—

If you zoom your Speedlite aggressively, as I do, then you should know that the more you zoom, the brighter the center gets. Or, if you think about it in the opposite direction, remember that the wider you zoom the dimmer the light becomes—or so it appears.

It is not that the Speedlite actually becomes brighter as you zoom in or dimmer as you zoom out—it just appears that way. What is really happening is that, at a tight zoom, all of the Speedlite's output is being concentrated to a smaller area. Likewise, when zoomed out wide, all of the Speedlite's output is being spread over a much greater area.

Using a calibrated flash meter, I measured the light at each of the zoom positions on a 580EX. Just to be sure, I measured the light at distances of both 24″ and 48″. The results were almost identical.

As you can see in the following shots, there is a significant difference in the apparent brightness of a Speedlite across the zoom range. Using 105mm as the baseline for the test, I measured the difference in illumination at the center of the frame by firing the Speedlite in Manual at ⅛ power. The exposure setting on the camera remained the same through the test so that you can see the difference in brightness.

So, if you're shooting in HSS and struggling with the loss of power, check the Zoom setting on your Speedlite(s). If you can, zoom in tighter to concentrate the light on your subject.

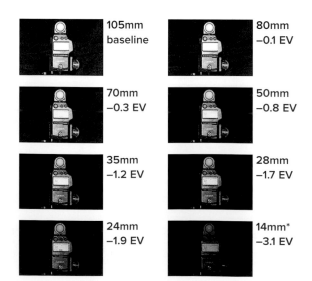

| | |
|---|---|
| 105mm baseline | 80mm −0.1 EV |
| 70mm −0.3 EV | 50mm −0.8 EV |
| 35mm −1.2 EV | 28mm −1.7 EV |
| 24mm −1.9 EV | 14mm* −3.1 EV |

*14mm is achieved by pulling out the Wide-Angle Diffuser*

## USING ZOOM AS A LIGHT MODIFIER

Creating the effect of a night scene may begin with your shutter speed, but the shot is made by where you light and don't light. To dim the sun and then add light back to everything because your Speedlite is set to Auto Zoom is to work against yourself.

Consider the control of where your light goes and does not go to be a critical Speedliting skill. When you are using your lighting to change the weather or to change the time, it is especially important to consider how to limit where your light falls.

By now, you know that the Zoom button is a built-in light modifier that I use frequently. During the Secret Agent Tony shoot, which follows on pages 316–317, I discovered that the spotlight effect was completely dependent on the narrow beam of light on his face. This was created by zooming the flashhead to 105mm.

In the series of pics opposite, which I shot with the Speedlite in E-TTL, pay attention to two things: where the light falls and how well E-TTL did at changing the flash power to keep the light on Tony's face relatively consistent as I zoomed. If you shoot the Speedlite in Manual, then you'll have to adjust the power level as you zoom.

Note: for this series, the Speedlite was about 2' from Tony's face and angled steeply down—from just outside the upper right corner of the frame. This is why the lighting pattern is angled.

*Figure 22.11 (1st row, left)* Zoom = 105mm.

*Figure 22.12 (1st row, right)* Zoom = 80mm.

*Figure 22.13 (2nd row, left)* Zoom = 70mm.

*Figure 22.14 (2nd row, right)* Zoom = 50mm.

*Figure 22.15 (3rd row, left)* Zoom = 35mm.

*Figure 22.16 (3rd row, right)* Zoom = 28mm.

*Figure 22.17 (4th row, left)* Zoom = 24mm.

*Figure 22.18 (4th row, right)* Zoom = 14mm.*

*14mm achieved by pulling out Wide-Angle Diffuser*

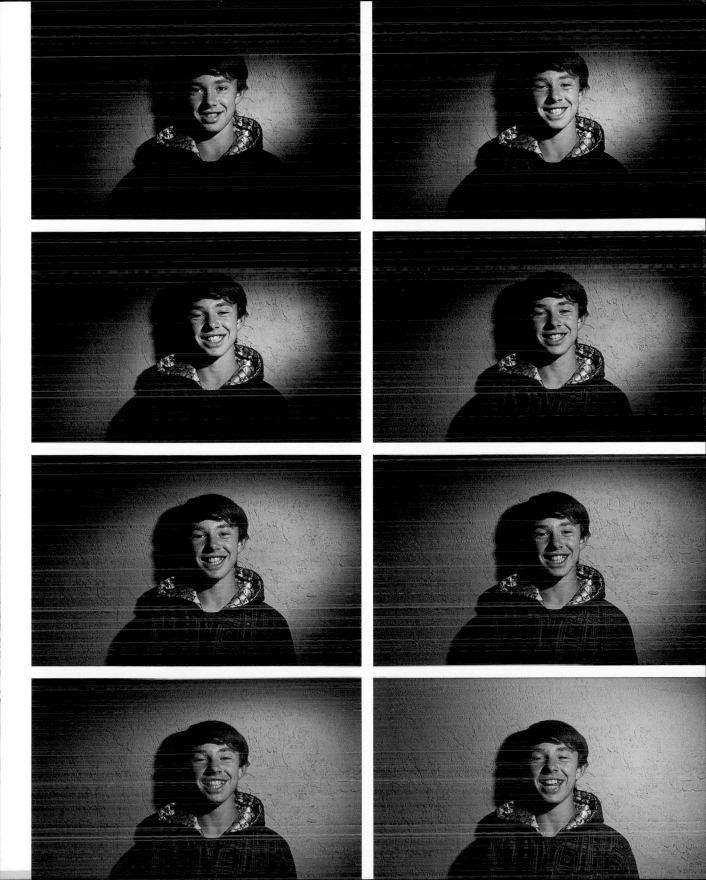

What happens to my 12-year old son Tony when I ask him to step outside for a quick lighting test? He becomes bored as I set up my gear and climbs up on the hood of his mother's minivan. Then he announces that he's a secret agent from the Secret Rampage Service and points to the logo on his school uniform.

### Turning Late Afternoon To Night

This shoot happened in the mid-afternoon on a very sunny day. As you can see in Figure 22.22 (opposite, bottom center), ¹⁄6400″ was more than enough to dim the sun.

The spotlight effect on Tony's face was created by moving a slave Speedlite in close—about 15″ from Tony's face. As you saw on page 315, the amount of zoom can greatly influence the feeling of the shot. In this case, I felt that 105mm was the best—which is very typical for me.

### Canon Wireless In Full Sun

When I have a single slave and an on-camera master that is disabled, I will angle it towards the slave for better communication—see Figure 22.23 (opposite, bottom right). I tried to use the ST-E2 Speedlite Transmitter, but it failed—which did not surprise me given the bright sun.

### Lighting Details

**Environment:** outdoors

**Time of Day:** mid-afternoon

**Ambient:** full sun coming straight at camera

**Speedlites:** one 580EX on camera as master, one 580EX II on stand as slave

**Metering Mode:** E-TTL

**FEC:** 0

**Zoom / Pan:** master panned to point to slave, slave zoomed to 105mm and tilted/panned so that flashhead matches angle of Tony's face

**Gel:** none

**Modifier:** none

**Speedlite Distance:** slave about 15″ from Tony's face

**Speedlite Height:** slave about 12″ above Tony's head

**Trigger:** built-in Canon wireless

### Camera Details

**Camera:** 5D Mark II

**Lens:** 24–70mm f/2.8L

**Distance to Subject:** about 4′

**Exposure Mode:** Manual

**Exposure:** ¹⁄6400″, f/7.1, ISO 100 (3⅓ stops under ambient)

**White Balance:** AWB (Auto)

*Figure 22.19 (below) The lighting diagram.*

*Figure 22.20 (opposite, top) The hero shot combines a sun-dimming shutter speed with a very tight zoom on the Speedlite.*

*Figure 22.21 (opposite, bottom left) Our impromptu set was bathed by the mid-afternoon sun. Notice how I aligned the head of the Speedlite along the axis of Tony's face.*

*Figure 22.22 (opposite, bottom center) At ¹⁄6400″ this is what the camera recorded from the ambient sunlight. Perhaps a bit of moonlight?*

*Figure 22.23 (opposite, bottom right) I angled the head of the master and zoomed the head to 105mm so that it would fire directly at the slave.*

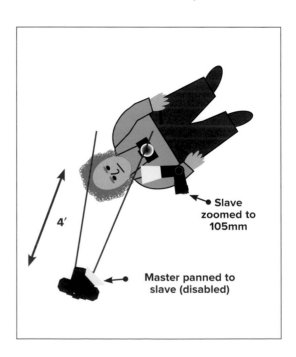

Slave zoomed to 105mm

4′

Master panned to slave (disabled)

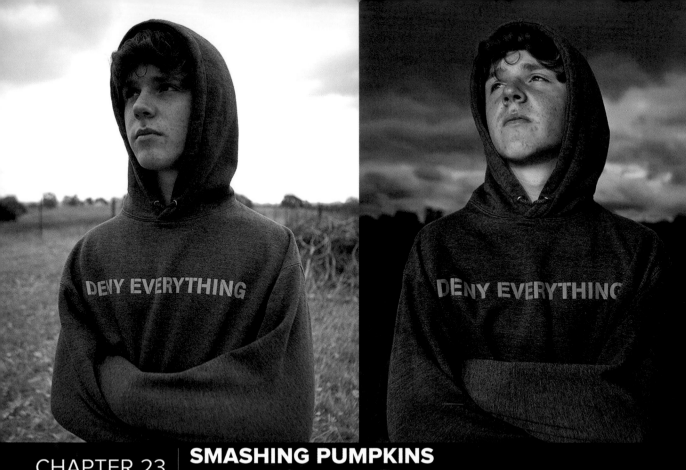

# CHAPTER 23 | SMASHING PUMPKINS WITH GANG LIGHT

## The Short Version

"Gang light" is a new way of thinking about how to use Speedlites. Rather than use them as individual units, you can position them close together so that they will create beautiful light—without the loss of light that comes when firing them through a modifier.

By combining the power of many Speedlites as one source, you also create a broad field of light through which your subjects can move. You also have the power to dim the ambient light and/or stop action with a fast shutter speed and High-Speed Sync (HSS).

### Figure 23.1
*As a Speedliter, you can use a bunch of Speedlites together to rescue a scene lit with dull ambient light and turn it into a beautifully lit scene that conveys shape and emotion. This was a quick setup as an afterthought to the Smashing Pumpkins shoot.*

# GANG LIGHTING—A NEW WAY TO LIGHT

Here's a true confession: I happened into the idea of gang lighting—assembling a large number of Speedlites onto a rail—by accident. I wasn't trying to create a new way to light. Actually, my motivation was to create an interesting article for my blog, *PixSylated*.

I had borrowed ten Speedlites from Canon, which had barely heard of me at the time, and an army of gear from RadioPopper, which had started shipping the first-ever E-TTL radio triggers just a few months before.

My goal was to share some pictures and a few thoughts on the Web about whether or not it was possible to fire off a large number of Speedlites with those newfangled E-TTL radio triggers. Once again, I consider this experience as proof that sometimes it's better to be creative than smart.

## Smashing Pumpkins: Lessons Learned

It became obvious within a few minutes on the Smashing Pumpkins shoot that the RadioPopper technology worked on a large number of Speedlites as well as it worked on one or two Speedlites. I was able to fire off a dozen Speedlites simultaneously and control their output from my camera without maintaining a line-of-sight connection. (Believe me, when a kid is swinging a baseball bat inches from your lens, it's great to not have to worry about maintaining a line-of-sight connection.)

What caught me by surprise was the beautiful quality of the light. It was gorgeous. Since I didn't know any better, I literally bolted the dozen Speedlites to an 8′ piece of oak that I attached to a C-stand with a large bolt. This is the secret of gang light—it looks like you are shooting with a giant softbox. But you don't have to buy a softbox. Nor do you take the loss of power that comes from firing through a modifier.

## Gang Light As A Light Modifier

When you have a bunch of Speedlites lined up on a rail, every one serves as both a key light and a fill light. Lights on the left side of the subject cast shadows on the right side. Those shadows are filled by the lights on the right side—which are throwing shadows to the left side.

By taking a bunch of small light sources and arraying them along or around your subject, you are effectively joining them together as a giant light source. Since you are a Speedliter, you know that the larger the light, the softer the shadows.

## Gang Light Overcomes HSS Power Loss

As I discussed in Chapter 21, *Slicing Time With High-Speed Sync*, the trade-off when using HSS is a loss of about 2½ stops of light. Using multiple Speedlites together overcomes the power loss and enables HSS to be used from greater—or, in my case, safer—distances.

Later in this chapter, you will see how I used gang light to create a broad field of soft light and super-fast shutter speeds for a soccer player (where I recreated the ambient sunlight from a different angle) and a motocross jumper (where I stopped the action midair). Neither shot would have been possible without the shutter speeds facilitated by HSS and the amount of light provided from multiple Speedlites.

## How To Be A Gang Lighter

Of course, there is no rule book for gang lighting. Heck, I don't even know where the boundary is between gang lighting and regular lighting. So if you have three Speedlites and you want to be a gang lighter, then great, you're in the club.

To be a gang lighter, the key thing is that you have to line up your Speedlites so that they work synergistically. Rather than think of your three Speedlites as individual sources, think of them as one source.

The second key to being a gang lighter is that you have to use the lights naked. Not you—I'm talking about the Speedlites. You have to fire them directly at your subject without a modifier. Lining up a bunch of lights behind a big diffusion panel (or a bed sheet) creates beautiful light, but it's not gang lighting. Why? When you fire the Speedlites at the diffusion panel, it becomes the light source. Take out the intermediary and you're back to gang lighting.

Finally, as a gang lighter you have to be an experimenter. You have to be willing to try different zoom settings on the Speedlites. You have to tilt and pan their heads toward the subject. You have to vary the position of the rail—anywhere from horizontal to vertical, and all points in between.

## The Math Of Gang Lighting

At first, the idea of needing a dozen Speedlites seems ludicrous. (If you're a guy, then you know that "need" is always relative, but I digress.) If you look at the math of gang lighting in terms of additional stops of light, the craziness begins to evaporate.

Let's say that you have a single Speedlite (any model will do) that is firing at full power and you need an additional stop of light. How many more Speedlites (of the same model) do you need to double the amount of light that you have? Since you have one Speedlite, adding another gives you the next stop of light (because it doubles the amount of light you have).

*Figure 23.2*

Now, let's say you want another stop of light; how many more Speedlites do you need? (Please don't say, "One.") Since you have two Speedlites, adding a stop of light requires two more Speedlites. Now you are shooting with four Speedlites.

*Figure 23.3*

To get the next stop of light, you need to have eight Speedlites. So, by adding seven Speedlites to the one you started with, you gained three stops of light.

*Figure 23.4*

## The Perfect Excuse For A Meetup

I only know one photographer who literally has a suitcase full of Speedlights—Joe Mc-Nally. Last time I checked, I think I counted 17 Speedlights in his bag. With one Speedlight as a master, then 16 Speedlights gives Joe...four additional stops of light.

As for me, I own six Speedlites, which makes me...less than half as bright as ol' Joe. No argument there.

Gang light is a great excuse to gather with your friends for a shoot. If you have one Speedlite, and a couple of friends have two each, and one person has four—then, together, you have nine Speedlites.

So don't think that you have to be rich or famous to shoot gang light. What you need to be is social.

## Building Rails For Gang Light

For my original gang light shoots, I created four rails out of oak, specifically 1" x 2" red oak purchased at Home Depot. Two of the rails are 40" long—sized to fit in my grip bag. The other two are 8' long—sized to not hit our ceiling when I stand them up indoors. The rails have a ⅝" post that mounts into the grip head on a C stand.

**Figure 23.5** *My homemade oak rails use a ⅝" hex bolt at the post. I drill a 9⁄16" pilot hole, add a few drops of Gorilla Glue, thread in the bolt, and, when the glue is dry, I cut off the hex head and then round the end with an electric grinder.*

The Speedlites are attached to the rail by coldshoes. I drilled ¼" holes every 6" along one side on side of the rail. These are the holes through which the bolt for the coldshoe passes. If you have a drill press (or a friend with one), use it. You need the holes to be perpendicular to the rail—otherwise, your Speedlite will tilt.

For the mounting post, I purchased ⅝" x 6" hex bolts. I drilled a snug 9⁄16" hole at the center of the rail. After applying a liberal quantity of Gorilla Glue (an expanding glue) to the hole, I threaded the bolt on as far as I could. After the glue had dried, with a large pair of bolt cutters I cut off the hex heads.

Finally, and this is the best part (in terms of sparks), I used a grinder to round off the end of the bolt and to grind down the bit of the threads that extended through to the other side of the rail.

## Other Options For Mounting Gang Lights

The 40" arm on a C-stand is more than capable of holding an army of Speedlites. The trick is that you have to have a way of attaching the lights to the arm. Many umbrella/swivel adapters have a hole that goes from one side to the other that will accommodate the C-stand arm. Likewise, Justin Clamps and Lovegrove Brackets will attach directly to the arm.

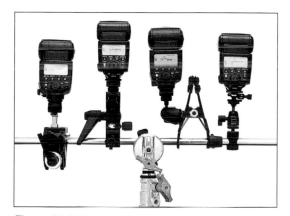

**Figure 23.6** *The arm of a C-Stand is a great place to mount Speedlites, from left: Super Clamp, generic plastic umbrella adapter, Justin Clamp, and my DIY version of the Lovegrove bracket.*

## Comparing A Bunch Of Speedlites To Other Options

After I published my original *Smashing Pumpkins* article, I received a lot of criticism from shooters who essentially said, "Instead of using $5,000 worth of Speedlites, I'd use XYZ big flash because it's easier and I'd look more professional."

So, let's compare using six 580EX IIs to a couple of popular options for portable strobes:

- Paul C. Buff's Einstein (as successor to the AlienBees), an A/C-powered monolight, and, to make it portable, we'll also need Buff's Vagabond battery pack
- Elinchrom's Ranger RX AS, a battery-powered studio pack (meaning that the controls are on the power pack rather than on the flashhead)

| | Six 580EX II | Einstein + Vagabond | Ranger RX AS |
|---|---|---|---|
| Cost | $450 x 6 = $2,700 | $450 + $300 = $750 | $2,350 |
| Minimum Purchase | $450 | $750 | $2,350 |
| Weight | 5 lbs. | 23 lbs. | 18 lbs. |
| Heads | 6 | 1 | 1 |
| Max, Sync Speed | $1/8000''$ | $1/250''$ | $1/250''$ |
| Built-In Modifiers | Zoom | No | No |
| Key and Fill Capable | Yes | No | No |
| Wireless Control Through Camera | Yes | No | No |
| Power Set By | E-TTL or Manual | Manual | Manual |
| Recycle Time | Medium to Slow | Fast | Fast |

*Figure 23.7* *A comparison of using several Speedlites against two popular portable strobe kits.*

What's all this info tell us about gang lighting? Well, here are my thoughts:

- The combination of HSS and a DSLR provides a wide range of creative options that are not available on a monolight/studio strobe. If HSS is important to you, gang lighting with Speedlites can provide a competitive advantage.
- Speedlites are an incremental system. You can buy one and then others as your skills grow. So, Speedlites are easier on your wallet than other types of flash.
- The weight and size of Speedlites is smaller than the other systems. It's also nice that you can leave any number of Speedlites at home if you don't need the whole rig. With a monolight or studio strobe, it's the whole kit or nothing.
- Having a master and five slaves gives you a wide range of lighting options. You can create many different lighting styles—even without modifiers. With a monolight/studio strobe you have a single head and will likely need to add a modifier.
- Speedlites will not recycle as fast as a monolight/studio pack. If this is important to you, as it is to fashion photographers, you should not shoot with Speedlites.

## Options For Firing Gang Lights

Triggering a gang light rig is a master/slave situation. I prefer to use the wireless system built into my Speedlites. This gives me the capability of controlling the power level of the lights from my camera—either in E-TTL or Manual mode.

The simplest option, both in terms of expense and setup, is to move the master off-camera with an extra-long E-TTL cord and position it where the slaves on the gang light rail can see it. This is how I prefer to shoot gang light.

The E-TTL radio triggers by RadioPopper and PocketWizard are also an option for gang lighting—though they are an expensive option.

Lastly, with mixed brands of flash, you can shoot in Manual mode with either optical slaves or simple radio triggers.

## SHOOT: SMASHING PUMPKINS

Just how fast a shutter speed do you need to freeze the seeds flying from a pumpkin that your teenage son is trying to drive over the left field fence? As you'll see in a moment, the answer to the shutter speed question is "really, really fast."

### Freezing Supersonic Seeds

Back in the days when I had my first SLR (hint: Nixon had just resigned), the top shutter speed on most cameras was $\frac{1}{500}$". In comparison, some 35+ years later, the shutter speeds on DSLRs seem supersonic. You'd think that anything north of $\frac{1}{2000}$" would be fast enough to freeze pumpkin shrapnel. Turns out that pumpkin seeds are supersonic, too.

I shot at a variety of speeds—all in full-stop increments—from $\frac{1}{400}$" on ($\frac{1}{800}$", $\frac{1}{1600}$",...). When I hit $\frac{1}{3200}$", and based on a close look at the camera's LCD, I was sure we had stopped space and time. Back in the studio, with the benefit of Lightroom and a large monitor, I discovered otherwise. Turns out that the magic didn't happen until $\frac{1}{6400}$".

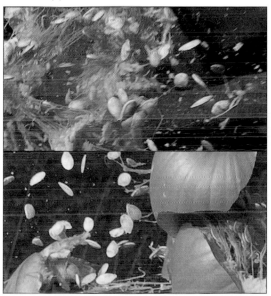

**Figure 23.8** At $\frac{1}{3200}$" (top), the seeds still show a bit of motion blur. At $\frac{1}{6400}$" (bottom) the seeds finally look sharp.

### Why Line-Of-Sight Wireless Would Have Failed

For the pumpkin smash-a-thon, I bolted a dozen Canon Speedlites onto a 8' piece of red oak. My gang light rail was held aloft by a couple of C-stands. I stood under the rail with the master atop my camera.

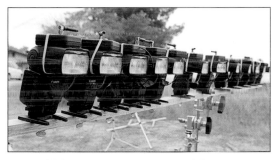

**Figure 23.9** My DIY rail loaded with 12 Speedlites.

Given that I was close enough to get splattered with pumpkin guts every time, there was no way that I was going to pay attention to where my master was pointing. Forget line-of-sight—it was my son, Vin, and his bat that had my full attention as I looked through the lens.

Further, the geometry between the master and the slaves was wrong. From the camera's position, the slaves were spread across 160° and the master's spread maxes out at about 80°. There was no way that all 12 slaves could see the master, even if I was standing perfectly still. So, Canon's traditional master-on-the-camera approach was out.

### Alternatives For Firing Gang Light

Since on-camera, line-of-sight would not work, I could move the master off-camera with an extra-long E-TTL cord or use E-TTL radio triggers. As I wrote at the opening of this chapter, the whole point of the shoot was to see if the newfangled RadioPoppers would work in this challenging situation—which they did flawlessly.

If I was doing this shoot today, I'd just move the master to its own stand and position it out of harm's way in a spot where all the slaves could see it. I'd connect it to my camera via a really long E-TTL cord and fire away.

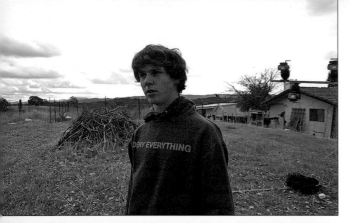

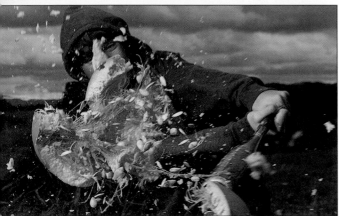

## Changing The Weather With High-Speed Sync

You can change the weather with High-Speed Sync. Figure 23.10 shows how the camera wanted to record the ambient light. I thought that the amount of sunlight coming through the clouds was too distracting. So I dialed the ambient exposure down via Exposure Compensation—eventually settling at −2 EV for the hero shot. As you can see, this underexposure helped add drama to the storm-filled sky.

### Lighting Details

**Environment:** outdoors
**Time of Day:** early afternoon
**Ambient:** scattered clouds, overcast
**Speedlites:** 12 580EX II slaves on rail and 580EX on-camera as master
**Metering Mode:** E-TTL
**FEC:** +2
**Zoom/Pan:** slaves zoomed to 80mm
**Gel:** none
**Modifier:** none
**Distance:** about 6′–8′
**Height:** rail about 6′ above ground
**Trigger:** RadioPopper P1s

### Camera Details

**Camera:** 5D
**Lens:** 24–70 f/2.8L
**Distance to Subject:** 5′
**Exposure Mode:** Aperture Priority
**Exposure Compensation:** −2 EV
**Exposure:** 1/4000″, f/5.6, ISO 400
**White Balance:** AWB (Auto)

*Figure 23.10* The ambient light as the camera wanted to see it—Aperture Priority, f/8, 1/100″.

*Figure 23.11* Another great shot—there were loads of almost-got-it shots. This type of shoot requires many "takes" to assure that you get a hero or two.

*Figure 23.12* The lighting diagram.

*Figure 23.13 (opposite)* You never know which shot will become iconic. I started out doing a shoot to test RadioPoppers. I came away with gang lighting as a new approach to Speedliting.

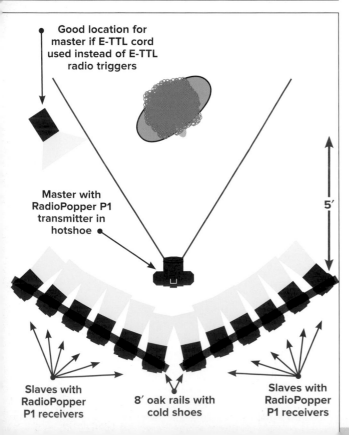

Good location for master if E-TTL cord used instead of E-TTL radio triggers

Master with RadioPopper P1 transmitter in hotshoe

5′

Slaves with RadioPopper P1 receivers

8′ oak rails with cold shoes

Slaves with RadioPopper P1 receivers

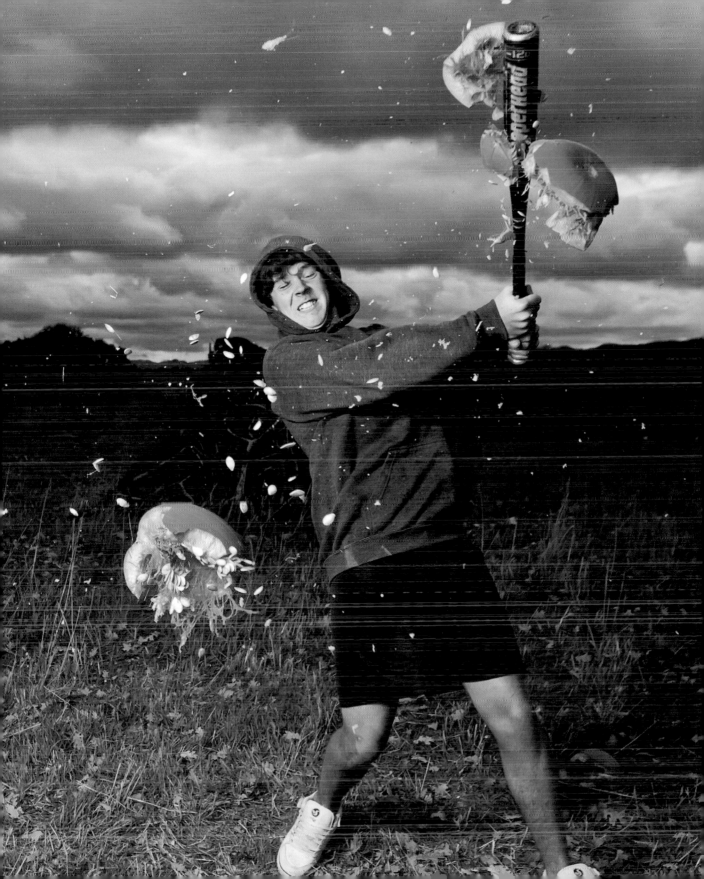

Take a quick look at the hero shot at right. Does it scream, "Hey, this was made on an old stage cluttered with theater gear"? Of course it doesn't. To the contrary, the lighting hides all of the clutter and focuses your eye on the subject. There is nothing else in the world.

### The Falloff Is The Key

The viewer sees the photograph, not the environment in which it was made—unless the photographer allows that environment to appear. For this shot, I created a new reality through the lighting—one other than the location in which I had to shoot, an old couch surrounded by chairs on the state of Piper's Opera House in Virginia Clty, Nevada. This new reality existed only for the duration of the flash and was frozen by the camera.

What you see is lit entirely by Speedlites—specifically, five 580EX IIs parked at 6" intervals on a homemade oak rail. The rail was held about 3' above Chelsea by a C-stand. The Speedlites were zoomed to 80mm. The rail was aligned with the couch. My goal with all of this was to precisely control where the flash went and, as importantly, where the flash did not go.

The other factor that created the falloff is the exposure setting. If you look at the set shot below left, you'll get a sense that the stage was lit with incandescent lights. For my hero shot, I increased my shutter speed to 1/200" and stopped down the aperture to underexpose the ambient by four stops.

### Speedlites Mimicking A Long Softbox

This is straight flash—there are no modifiers. The soft light is created because every Speedlite serves as both key and fill. Their arrangement creates a long, thin strip of light.

A studio photographer would create this look by using a special softbox called a strip bank on a single head in the same spot that I placed the rail. That gear would likely weight 25–30 pounds.

Once again, I'm happy to be a Speedliter. I can create the same look as the studio gear with a handful of Speedlites and, a few minutes later, rearrange the Speedlites to create a completely different type of lighting. My back is not complaining either, as my Speedlite kit weighs a fraction of what the studio gear weighs.

### Lighting Details

**Location:** Piper's Opera House, Virginia City, Nevada

**Time of Day:** not a factor

**Ambient:** tungsten stage lighting

**Speedlites:** five 580EX IIs on homemade rail, plus 580EX II on camera as master

**Metering Mode:** E-TTL

**FEC:** 0

**Zoom/Pan:** slaves zoomed to 80mm

**Gel:** none

**Modifier:** none

**Distance to Subject:** about 3'

**Height:** 3' straight above subject

**Trigger:** Canon built-in wireless

### Camera Details

**Camera:** 5D Mark II

**Lens:** 50mm f/1.2L

**Distance to Subject:** about 5'

**Exposure Mode:** Manual

**Exposure:** 1/200", f/4.5, ISO 100 (4 stops under ambient)

**White Balance:** Flash

*Figure 23.14 (top) The strip of soft light was created by five Speedlites. Each is acting as a key light and also as a fill light for the others.*

*Figure 23.15 (bottom left) This snapshot of the set shows it for what it was—lit with incandescent lights and cluttered with stage gear.*

*Figure 23.16 (bottom right) The lighting diagram.*

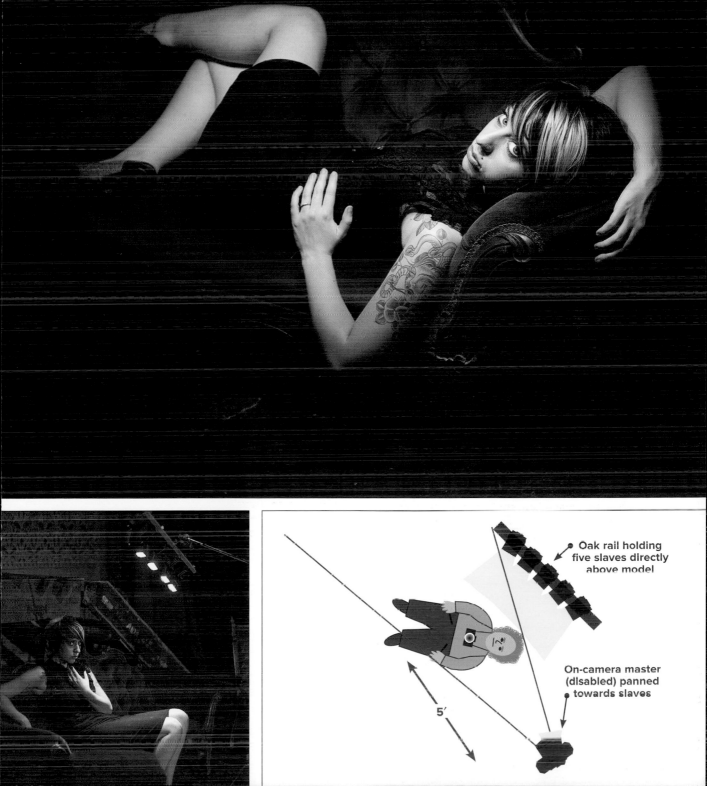

Oak rail holding
five slaves directly
above model

On-camera master
(disabled) panned
towards slaves

5'

## SHOOT: BACKYARD SOCCER CHAMPION

As the father of three sons, I've coached a lot of soccer teams. That's very handy when it comes to developing concepts for self-assignments. For Backyard Soccer Champion, I was looking to create the image for a full-page ad on soccer balls.

### Camera Angle And Lighting Create A Unique View

To create the perspective, I was lying on my stomach with my wide-angle lens literally 4″ from the ball. I had two goals for my exposure: to throw Tony out of focus to emphasize the ball, and to dim the ambient so that the Speedlites would create the look of direct sunlight.

Do you know the old axiom—the wider the lens, the deeper the depth-of-field? So, at 17mm, I had no coice but to shoot the lens wide open. That was the easy part.

To achieve my second goal—the dimming of the ambient so that I could create my own daylight—I dialed in −2 stops of Exposure Compensation and shot at ¼₀₀₀″. So consider this—if I had been limited to my sync speed of ½₀₀″—I would have had to shoot at f/19. At that aperture, everything would have appeared sharp.

To create a pool of light, I angled an 8′ rail with a dozen Speedlites parked at 6″ intervals. The idea behind the angle was that it would reach slightly around Tony and the ball. The Speedlites were triggered with RadioPoppers (only because I was testing them).

Unlike the Smashing Pumpkins shoot, were I was literally standing under the light rail, there was enough separation between me and the lights on this shoot that geometry would not have been an issue. Had I not been testing the RadioPoppers—which worked brilliantly—I could have pointed my on-camera master at the rail and triggered the slaves directly.

### Lighting Details

**Environment:** outdoors
**Time of Day:** late afternoon, sun behind subject
**Ambient:** open shade
**Speedlites:** 12 580EX/EX IIs slaves on rails and 580EX on-camera as master
**Metering Mode:** E-TTL
**FEC:** +2
**Zoom / Pan:** zoomed to 80mm
**Gel:** none
**Modifier:** none
**Distance:** 8′ to subject
**Height:** 2′ to 6′ above ground, rail angled
**Trigger:** RadioPopper P1 on each Speedlite

### Camera Details

**Camera:** 5D
**Lens:** 17–40mm f/4L
**Distance to Subject:** 4″ to ball
**Exposure Mode:** Shutter Priority
**Exposure Compensation:** −2 EV
**Exposure:** ¼₀₀₀″, f/4.5, ISO 400
**White Balance:** AWB (Auto)

*Figure 23.17 (top left)* The shoot happened in late afternoon. As you can tell from this ambient shot, Tony was in complete shadow.

*Figure 23.18 (center left)* I angled the rail to wrap the light around Tony and the ball.

*Figure 23.19 (bottom left)* You can get a sense of what my −2 EV underexposure did to the ambient and also a sense of the power of the flash by comparing these two shots.

*Figure 23.20 (top right)* Overall the effect of the gang light made the image look as if it was lit with sunlight. Now that you've read that and nodded, check out the shadows in the background—they're going the other way. Oh well, it's still great light.

*Figure 23.21 (bottom right)* The lighting diagram.

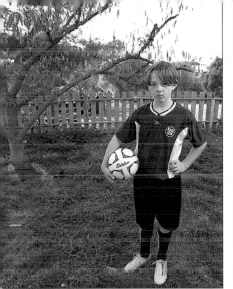

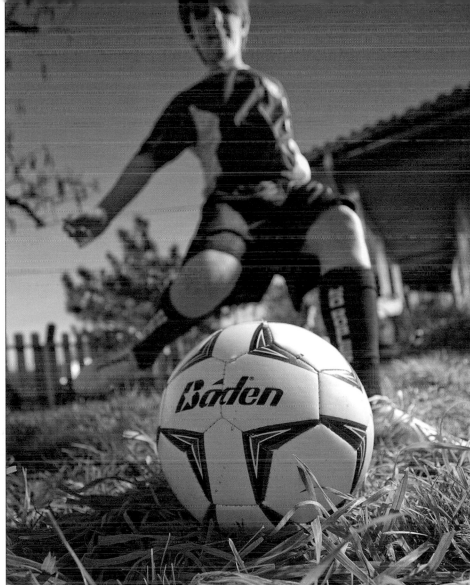

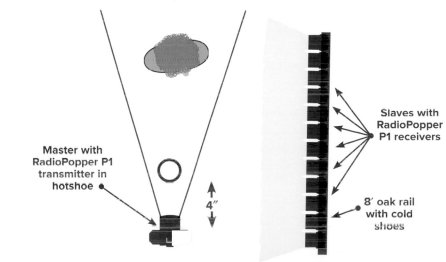

Master with
RadioPopper P1
transmitter in
hotshoe

Slaves with
RadioPopper
P1 receivers

4"

8' oak rail
with cold
shoes

Believe me—if you combine the desire to photograph a motocross rider flying through the air just after sunset with the instinct for self-preservation—you have a perfect situation to use gang light.

## High-Speed Sync And Soft Light!

The great challenge in photographing my friend Cy Quinn was that each pass over the jump was unique—I never had a sense of how high he would be or where he would land.

So I created a wide zone of light by lining up a dozen 580EX IIs on a pair of 8′ rails. With the Speelites at 12″ intervals, I had a lighting zone about 16′ wide.

The part that surprised me was the softness of this wide field of light. As is typical of gang light, each Speedlite worked as both key and fill. Check out the detail of light in Figure 23.23 (center left).

As I stood right in front of the rails and panned my camera as Cy flew by on each jump, there was no way that the on-camera master could hit all 12 slaves. Fortunately, I still had the arsenal of RadioPoppers on hand. They gave me the freedom to forget about line-of-sight.

A simpler way to fire the slaves would be to connect the master to an extra-long E-TTL cord and then park it on a stand far enough behind the rails so that it could cover the entire span of slaves. The last step in this setup would be to spin all of the slaves 180° so that their sensors faced the master and then spin the head of each slave 180° back so that they would flash the track. Honestly, this sounds like a lot more work than it really is.

## Lightroom Comes To The Rescue

You know my mantra that "I'm a photographer and not a retoucher." Well, as it happened, the hero shot was one in which Cy went a bit wide and flew just beyond the range of the Speedlites.

Fortunately, Lightroom was able to restore the brightness. Compare FIgure 23.24 (bottom left) with the hero shot, Figure 23.25. The difference is a +1.65 move on the Exposure slider in the Develop module, along with +30 on both Clarity and Vibrance.

## Lighting Details

**Environment:** outdoors

**Time of Day:** just after sun dropped below horizon

**Ambient:** dim, reflected off of sky

**Speedlites:** 12 580EX/EX IIs slaves on rails and 580EX on-camera as master

**Metering Mode:** E-TTL

**FEC:** +1 EV

**Zoom / Pan:** zoomed to 50mm

**Gel:** none

**Modifier:** none

**Distance:** 10′–20′ to subject

**Height:** about 7′ in air

**Trigger:** RadioPopper P1 on each Speedlite

## Camera Details

**Camera:** 5D

**Lens:** 24–70mm f/2.8L

**Distance to Subject:** 5′–15′

**Exposure Mode:** Manual

**Exposure:** $\frac{1}{1000}$″, f/8, ISO 400 (2 stops under ambient)

**White Balance:** Cloudy (adds a bit of warmth)

*Figure 23.22 (top left)* One of the challenges of shooting a motocross jumper is that you never know exactly where he'll fly. In this frame, Cy went so high that he flew out of the frame.

*Figure 23.23 (center left)* Gang light creates nearly shadowless light as you can see in this detail.

*Figure 23.24 (bottom left)* My original capture was underexposed when the motorcycle flew wide.

*Figure 23.25 (top right)* The hero shot was brightened in Lightroom, but the lighting is 100% gang light. I marvel at its soft, wraparound quality.

*Figure 23.26 (bottom right)* The lighting diagram.

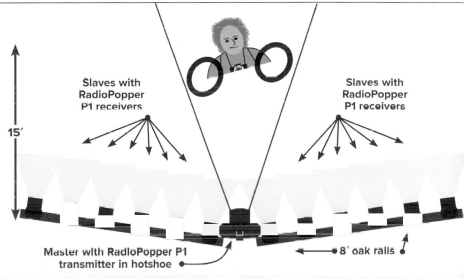

Slaves with
RadioPopper
P1 receivers

Slaves with
RadioPopper
P1 receivers

15'

Master with RadioPopper P1
transmitter in hotshoe

8' oak ralls

I've long wanted to create a portrait of a falconer the moment her charge returned to her glove. Thanks to the resourcefulness of my friend MD Welch, I was able to chase my vision one hot August day near Reno.

### Gang Lighting Fill Flash At High Noon

It is no surprise that the sunlight in Nevada's Great Basin Desert is brilliant—almost blinding—at midday. Given that I'd need a fast shutter to freeze the movement of the bird, the combination of the sunlight and the shutter meant that high-speed sync was a given.

To create a broad field of fill flash, I rigged my my pair of 3' DIY oak rails with five Speedlites on each. They were arranged as a wide V on either side of Marie and held aloft on C-stands. (It was at this shoot that I learned how much cooler chrome C-stands are than black in full sun.) The master was then run out on a long E-TTL cord to a stand placed just out of frame and a bit behind Marie. I controlled the entire setup from the back of my camera—using my Zacuto Z-finder locked onto the back of my camera so that I could see the display without the sun's glare.

### A Bit Of Photoshop

Often there's a gap between the photographer's vision and the resources at the shoot. The bird available for this shoot was a young hawk that had to remain tethered. So, even though I chant, "I'm a photographer, not a retoucher," you can see in Figure 23.28 that I removed the tether in Photoshop.

### Lighting Details

**Location:** desert outside Reno, Nevada
**Time of Day:** almost noon
**Ambient:** brilliant sun
**Speedlites:** 10 580EX IIs on homemade rails, plus 580EX II on cord as master

**Metering Mode:** E-TTL
**FEC:** 0
**Zoom / Pan:** slaves zoomed to 80mm
**Gel:** none
**Modifier:** none
**Distance to Subject:** about 8'
**Height:** level with subject
**Trigger:** Canon built-in wireless, master disabled

### Camera Details

**Camera:** 5D Mark II
**Lens:** 70–200mm f/2.8L IS
**Distance to Subject:** about 15'
**Exposure Mode:** Manual
**Exposure:** ¹⁄₁₂₅₀", f/5.6, ISO 100 (1⅓ stops under ambient)
**White Balance:** Daylight

*Figure 23.28 (top)* The hero shot met my previsualized image in every way.

*Figure 23.29 (bottom left)* At high noon, in the Great Basin Desert, the ambient sunlight is nearly enough to blind you. Even the shadows hide.

*Figure 23.30 (bottom center)* I underexposed the ambient by 1⅓ stops.

*Figure 23.31 (bottom right)* The gang light fills the shadows with natural-looking light.

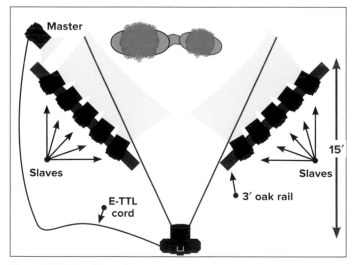

*Figure 23.27* Lighting diagram.

# CHAPTER 24 | SPEEDLITING EVENTS

**Figure 24.1**
*Of the many types of event photography, wedding photography focuses on creating lifelong memories for the people at the center of the event.*

## The Short Version

Most photographers I know shoot events at some point during the year. Some shoot events as a form of giveback or charitable donation. Others shoot events because it is their chosen profession—and many are paid handsomely for their work.

Event photography certainly gives you valuable experience at working under pressure while maintaining rapport with the people in front of your lens. Within reason, you can view event photography as a way to start developing a portfolio.

I see event photography as some of the most important work that I shoot. I accept the responsibility accordingly.

# THE DUAL ROLES OF EVENT PHOTOGRAPHY

When I'm shooting an event—a festival, a charity fundraiser, a gala dinner, or a wedding—I see my primary job as creating memories for the people who were there. If the event is one that repeats seasonally, my secondary job is creating images for the promotion of future events.

## Event Photography As A Memory Maker

There are two ways that my photography creates memories—one is near-term and the other is long-term.

- As the photographer, I continually move around the event, taking all kinds of photos. Those attending the event are far less likely to move around as much as I do. By moving around, I photograph moments that are happening almost simultaneously but in different locations. Essentially I'm showing people things that were happening around them.

- Time has a way of pushing older memories farther back into the recesses of our minds. For instance, my wife Amy and I have been married 19 years. Of course, I have memories of our wedding celebration—memories that have grown fuzzier over the years. Yet opening our wedding album brings those memories into sharp focus.

## Event Photography For Publicity

Many events serve a civic or charitable purpose. For these, even if not asked, I will shoot a range of compositions (vertical/horizontal, close in/out wide, subjects on the right/left, etc.). This is especially important when my camera is pointed at the event VIPs.

Images published in newspapers and magazines have a tremendous value to the event host. As is often said, "You can't buy that kind of publicity." Well, actually you can—but it is very expensive. By having a range of compositions centered on the VIPs, my chances of getting photos published are much greater.

## SPEEDLITER'S TIP

### —Shooting Events For Free—

I am often asked to photograph events for free. You will be solicited too. Here's how I make my decision as to whether I take a pro bono job.

If the group is not one that I'm already involved with or one whose cause I believe in, I will politely decline.

If the event passes the first test, I'll consider whether it is an event that has normal operating expenses. Many not-for-profit groups have paid staff (sometimes highly paid staff). If the event is a fundraiser for one of these groups, I expect to get paid.

If the event is truly an all-volunteer event, which is often the case with church, youth, and arts groups, I'll consider taking on the event as an in-kind donation. One condition I always request is that any photos used for publicity after the event have my name in a photo credit—which is usually very tiny.

*This photo credit (shown left at actual size) is typical for pro bono event coverage in magazines.*

## SPEEDLITER'S TIP

### —Quick Thoughts For Events—

- *Bring backups of all critical gear.* Gear always fails at an event—often through operator error caused by stress. If you plan on shooting wireless, you need to have at least two 500-series Speedlites that you can use as a master. Two camera bodies are a must as well. Rent or borrow backups if you need to.

- *Charge all your batteries* (camera and Speedlite) the night before. Bring twice as many as you think you'll need.

- *Pre-scout the venue.* Not only should you get acquainted with the layout of the space, you should also consider how the time of day will affect the lighting.

- *Ask your client for a short list* of all family members and VIPs. Do not hesitate to ask for someone to wrangle the family members and VIPs for you. You won't know who they are, nor should you spend time chasing them.

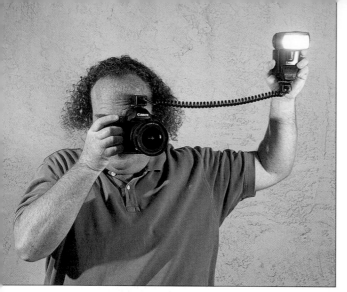

The type of event largely determines whether I have an assistant. My preference is always to have someone with me to help carry gear and, more importantly, to carry an off-camera light. The determining factor as to whether I have an assistant is the budget.

Based on whether or not I have an assistant, as well as the density of the group that I'm photographing, I will use one of three shooting strategies for events. The main difference between the three is who carries the off-camera flash.

### Shooting Solo In A Crowd

If I'm shooting solo and moving fast through a crowded event, I'll connect a 580EX to my camera with the OC-E3 cord and hold it at arm's length. By this point in the *Handbook*, you know why the flash has to be off-camera. Check out the Festival of the Arts shoot on pages 346–347 as an event where I hand-carried my off-camera Speedlite.

As to why I prefer to handhold a Speedlite rather than use a flash bracket—it is personal style more than anything. I know that many wedding and event shooters prefer to use a dedicated flash bracket, such as the Wedding-Pro Flash Bracket (WPF-1) by Really Right Stuff, shown in Figure 10.3 on page 116. The distinct advantage of a flash bracket is that you can control the camera with your right hand and the lens with your left hand—as you normally do. I own a WPF-1 and continue to marvel at how it keeps a Speedlite centered above my

*Figure 24.2* When I'm moving fast through a crowded event, I will often handhold my Speedlite in my left hand. I rest the Speedlite on my shoulder when I need to change a camera setting.

*Figure 24.3* When shooting solo at events that are not so crowded, I will fire a slaved Speedlite that is parked on top of a lightweight stand.

*Figure 24.4* If I have an assistant, then I shoot with the Lastolite Ezybox on an extendable pole.

camera as I switch the camera back and forth between vertical and horizontal orientation. Because the WPF-1 is lightweight and folds up compactly, I almost always have it in my kit.

Still, for me, my preference is to handhold my Speedlite high and to the left. When I need to zoom my lens, I'll park the Speedlite on my shoulder for a moment or two.

If you like the convenience of shooting with a flash bracket, I wholeheartedly recommend the WPF-1 by Really Right Stuff. If you prefer the look of flash when it's not lined up with your lens, forego the flash bracket and proudly hold your Speedlite in your left hand.

## Shooting Solo In An Open Area

Some events are casual affairs with people milling about in uncrowded areas. If I'm working alone at an event of this type, I'll switch to Canon's built-in wireless mode and park a slaved Speedlite on top of a Manfrotto 5001B (a.k.a. Nano) stand. This enables me to maximize the benefit of the off-camera flash—meaning that a Speedlite positioned 45° to 135° off the lens-subject axis is visually more interesting than a Speedlite that's barely off-camera in my left hand.

One example of a shoot where I'm fond of parking an off-camera Speedlite on a Nano stand is *Wheels of Wellness*—an annual showcase of vintage race cars that benefits The Wellness Community of Arizona.

As you can see on pages 344–345, to emphasize the shape of these great cars, I typically use the sun as a backlight so that I can catch the reflections of the paint and chrome. I'll position my off-camera Speedlite to my right or left and pan the head of the master so that it points right at it.

Because these are dynamic shoots, where I'm only spending a minute or two with each car and owner, I always shoot in E-TTL. If I think that I need more or less fill light, I will dial the power level up or down through flash exposure compensation (FEC).

## Shooting With An Assistant

If I have an assistant, I'll move the Speedlite to an extendable pole and shoot wireless. This gives me the ability to get the off-camera light right where I want it and not have to worry about someone tripping over a light stand.

In the past, I would have the assistant carry the Speedlite on an extended Nano stand. With the legs folded backward against the center column, it becomes an easy-to-carry pole. The limitation is that it is not strong enough to carry one of my favorite lighting modifiers for events—the Lastolite Ezybox.

With an Easy Reach and a Kacey Pole Adapter, discussed on pages 212–213, I have a rig that is strong enough to hold a Lastolite Ezybox. Make sure that you secure the adapter to the pole permanently with a bit of Loctite thread adhesive. Otherwise you will find that your gear can spin loose.

If you are looking to travel with a more compact kit, another pole option is the Lastolite Extra-Long Extension Handle, also discussed on pages 212–213.

---

### SPEEDLITER'S TIP

#### —Finding A Temporary Assistant—

If you are in need of an assistant for an event shoot, it's likely that there are several budding photographers in the area who would be happy to schlep gear in exchange for the opportunity to gain the experience. In all fairness, though, you have to be willing to provide a quality experience. This is not the gateway to finding an indentured servant. Also, be sure to check with your insurance agent to confirm that your policy will cover an assistant—both for injury and liability.

As for getting in touch with qualified candidates, here are several opportunities:

- *Photography instructors*—get in touch with the photo instructor at your local college.
- *American Society of Media Photographers*—the ASMP maintains an online list of assistants. It even allows you to search within a specific radius of your zip code. This free service is online at *ASMP.org/find-an-assistant/*.
- *Craigslist*—head to *Craigslist.com* and post a free listing. Be specific about the opportunity and your needs.

### E-TTL Is A Must For Events

You know from Chapter 9, *E Is For Evaluative,* that I shoot in E-TTL whenever the distance between the flash and the Speedlite(s) is dynamic. For events, I always shoot in E-TTL and use FEC to dial the flash power up and down.

I have two exceptions to the always-in-E-TTL rule. Both are used in situations where I have the time to set up before the event and determine the proper exposure:

- A set where attendees step into position— such as souvenir photos with a celebrity. Using Manual flash will avoid the problem of fast blinkers having their eyes closed by an E-TTL pre-flash.

- A shoot where people routinely pass through a predefined spot. If you're shooting an event like a race where lots of runners cross a finish line, Manual flash will provide a slight advantage over E-TTL in that the lack of a pre-flash means that your batteries will last longer.

---

**SPEEDLITER'S TIP**

**—Think Of The Speedlite As Supplemental Event Light—**

As I said at the outset of the chapter, I see my role as an event shooter to create memories for those at the event. This means that I'm not looking to create dramatic light. I want the look and feel of the ambient light to remain in the shots.

So, unless I am shooting an event that is in a dimly lit room, I use my Speedlite(s) as fill flash. I want my subject to be well lit, but not overlit.

---

### Jumping Between Wireless And Normal Flash At Events

When shooting wireless at an event, I often use a 580EX as my master because it has an external switch for the wireless system. So, under the pressure of a photo-worthy opportunity that's happening right in front of me, I can go from wireless (where I typically have the master disabled) to normal flash in a split second. With the 580EX II I have to go through the camera menus to make the change. By the time I've done that, the opportunity to catch the mother of the bride falling into the swimming pool will be long gone.

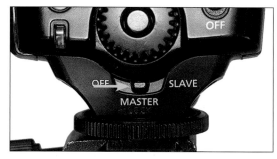

*Figure 24.5* *The external switch on the 580EX is a fast way to jump between normal and wireless flash.*

The downside to using the original 580EX as a master is that it cannot be controlled via the camera's LCD. So you have to be really good at navigating the wireless system via the Speedlite's LCD—which, if you do it often enough, you will be.

In the future, hopefully Canon will re-engineer the Camera User Settings (C1, C2... on the mode knob) so that I could do the following:

- C1 = Speedlite in E-TTL, wireless off
- C2 = Speedlite in E-TTL, wireless on, master disabled
- C3 = Speedlite in E-TTL, wireless on, master enabled

Actually, a better approach would be to give me these three options right on the power switch. Maybe, maybe. I'm sure we'll get an EX III someday.

## Triggering Off-Camera Speedlites At Events

As we explored in Chapter 11, *Wireless Speed-liting, The Canon Way*, there are several ways to trigger an off-camera Speedlite. And, as a reminder, I'd like to say again that my preference is to use the least amount of gear and the simplest technology that I can.

That said, here are the three ways that I trigger my off-camera Speedlite at an event:

- *Canon OC-E3 Off-Camera Cord*—This gives me full E-TTL control when I'm holding my Speedlite at arm's length. It is also the solution when you are shooting with a flash bracket.

- *Canon built-in wireless*—When I'm shooting an off-camera light that is parked on a stand, I will use Canon's built-in wireless system. To ensure that the master reaches the slave, I will pan the head on the master and zoom the flashtube to 105mm. A pleasant surprise when shooting indoor events is that you can often hide a Speedlite behind a post or a person and still fire it—because the communication from the master bounces off the walls.

- *RadioPopper PX radio triggers*—When I'm shooting an event with an assistant carrying the off-camera Speedlite on a pole, I reach for my RadioPopper PXs. Event photography is where these E-TTL radio triggers truly shine. During a fast-paced shoot, where the position of the slave is changing every few moments, RadioPoppers free me from having to worry about whether there is a line-of-sight connection with the master.

Elsewhere in the *Handbook*, I rave again and again about extra-long E-TTL cords. When it comes to shooting an event—where attendees could trip over a long cord—I leave the cord in my bag and avoid the liability.

### SPEEDLITER'S TIP

#### —Learning To Shoot Weddings—

Without a doubt, wedding photography is the most challenging type of event photography ever invented. Not only do you have the pressure of shooting on the fly, you're shooting a series of events that will not repeat themselves.

There's no way in just a few pages that I can provide comprehensive insights on how to shoot weddings and—more importantly—how to build a business as a wedding photographer. If you want to become a wedding photographer, I have three suggestions for you.

- *Learn from David Ziser*—Check out his blog, DigitalProTalk.com. Watch his tutorials online at KelbyTraining.com. Read his book *Captured by the Light* (New Riders, 2010).

- *Join the Digital Wedding Forum*—DWF is a discussion site for professional and aspiring wedding photographers (DigitalWeddingForum.com).

- *Attend the WPPI convention*—Held annually each winter in Las Vegas, the WPPI convention attracts thousands of wedding shooters from around the world. There are dozens of classes by top-name wedding shooters and an extensive tradeshow (WPPIOnline.com).

Paso Robles, my hometown, is the hub of central California's wine district—which means that there are a lot of weddings in the area. So, if you must know—yes, I've been bribed to shoot weddings in exchange for cases of great wine. Such was the arrangement for the vineyard wedding of Kristie Harvey and Lood Kotze—the talented winemaker at Cass Winery.

### Overruling The Camera

Pop quiz: what's the goal of the light meter? Hopefully you said to turn the world to medium grey. (If not, head to page 312 for a refresher.) So when the camera sees a predominantly dark scene, it will usually overexpose the shot because it is programmed to turn that abundant darkness into medium gray.

This is what happened in Figure 24.6 (top left). There is absolutely no magic to this shot because the camera grossly overexposed the scene. There is no hint of the rich color that we saw in the clouds.

My response—I dialed in –1⅔ stops of Exposure Compensation. As you see in Figure 24.7 (center left), this brought back the beautiful color in the clouds. Of course, without any fill flash, I still don't have a usable shot.

### Tom, Pole In That Gelled Sto-Fen

There are two secrets to the beautiful quality of the fill flash and they are connected—literally. I gelled the Speedlite with a ½-cut of CTO and then slipped a Sto-Fen dome diffuser right over the gel. You can see the assembly in Figure 24.8 (bottom left).

The ½-cut of CTO warms the light so that it blends into the sunset. Without it, the flash would have appeared noticeably cool.

I then had Tom, son number one who I had conscripted as an assistant, use the Manfrotto Nano stand (model 5001B) as an overhead boom to position the Speedlite just out of frame and right above the couple.

The beautiful falloff was created because the Sto-Fen was as close to their heads as it could be. If it had been farther back, the light would have been more even—think "less dramatic."

### Lighting Details

**Environment:** outdoors, vineyard
**Time of Day**: 15 minutes after sunset
**Ambient:** shooting into sunset
**Speedlites:** 580EX on-camera as master (disabled), 580EX as slave on nano stand held aloft by assistant
**Metering Mode:** E-TTL
**FEC:** +1
**Zoom / Pan:** master panned towards slave
**Gel:** ½-cut of CTO
**Modifier:** Sto-Fen Omni-Bounce
**Distance:** 6′
**Height:** 8′
**Trigger:** Canon built-in wireless

### Camera Details

**Camera:** 5D
**Lens:** 24–70mm f/2.8L
**Distance to Subject:** 8′
**Exposure Mode:** Aperture Priority
**Exposure Compensation:** –1⅔ EV
**Exposure:** 1/100″, f/6.3, ISO 200
**White Balance:** Daylight

*Figure 24.6 (top left) This is how the camera wanted to shoot the scene—the sunset is overexposed because the camera wanted to lift the dark tones to medium grey.*

*Figure 24.7 (center left) By dialing in –1⅔ stops of Exposure Compensation, I was able to capture the beautiful light in the clouds. Without the flash, it is obvious that this shot is useless.*

*Figure 24.8 (bottom left) A single Speedlite with a ½-cut of CTO tucked under a dome diffuser created the beautiful fill light. It was poled in high—just out of the frame at top center.*

*Figure 24.9 (top right) The combination of underexposing for the sunset and the soft, warm fill flash is what makes this shot so memorable.*

*Figure 24.10 (bottom right) The lighting diagram.*

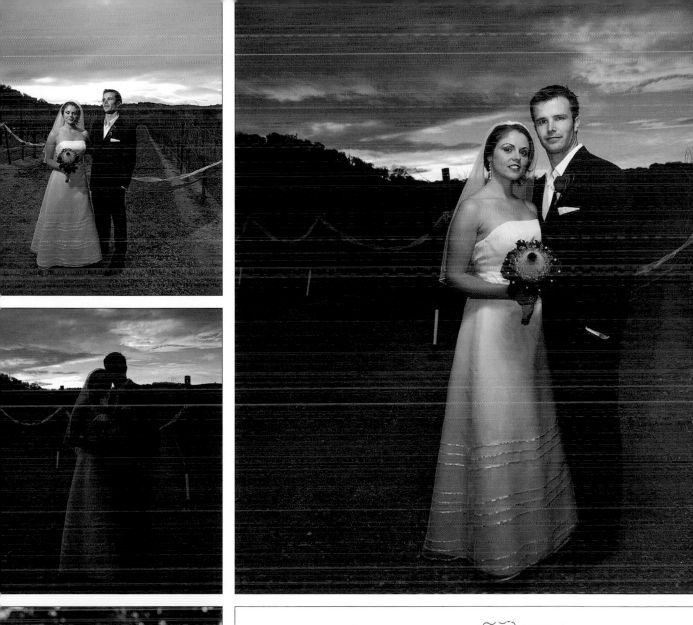

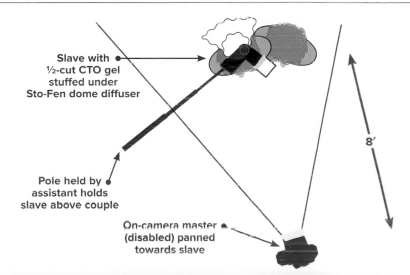

Slave with
½-cut CTO gel
stuffed under
Sto-Fen dome diffuser

Pole held by
assistant holds
slave above couple

On-camera master
(disabled) panned
towards slave

8'

My adopted hometown, Paso Robles, was also the adopted hometown of Ignacy Paderewski (1860–1941)—a Polish pianist whose diplomatic work in the US during and after World War I on behalf of Poland's independence earned him a state funeral at Arlington National Cemetery. Today, his musical legacy is celebrated each fall with a festival of performances held at local wineries (*paderewskifest.com*).

### A Pro Bono Shoot

This is a classic case of a shoot where I will shoot for free—because all of the event organizers are volunteers. Again, make your decision on whether you work for free based on your relationship with the cause and not on the promise of a photo credit.

My assignment was to shoot pictures for publicity (such as the magazine feature shown on page 335) and as souvenirs for VIPs.

### Running The Ezybox Around

In a shoot like this, I'm moving around and my subjects are moving around. So my preferred rig is to mount a Lastolite Ezybox on a pole and have an assistant (like one of my sons) carry it around for me. E-TTL is a must as the subject-to-flash distance is changing constantly. I used FEC to make fine adjustments to the flash power on the fly.

To fire the slave, I pointed the on-camera master to the left and twisted the body of the slave to the right (see Figure 24.13). If you do a lot of this kind of work, then a set of radio E-TTL triggers, likes RadioPopper P1s or PocketWizard's Mini/Flex, will be a huge help.

### Gelling For Warmth

The ambient light was all incandescent. So I gelled the slave with a full-cut of CTO. Rather than set the white balance to Tungsten, I shot in Auto (AWB), which gave a nice warmth to the skin tones...or maybe it was the wine and music that warmed everyone up.

## Lighting Details

**Environment:** winery

**Time of Day:** evening

**Ambient:** incandescent

**Speedlites:** two 580EXs, one as master (disabled), one as slave

**Metering Mode:** E-TTL

**FEC:** +1

**Zoom / Pan:** master zoomed to 105mm and panned towards slave

**Gel:** full-cut CTO on slave

**Modifier:** slave shot into Lastolite Ezybox hot shoe

**Distance:** 4′–15′

**Height:** held overhead, but varied

**Trigger:** Canon built-in wireless system

## Camera Details

**Camera:** 5D

**Lens:** 24–70 f/2.8L

**Distance to Subject:** 3′–12′

**Exposure Mode:** Aperture Priority

**Exposure Compensation:** +1 EV

**Exposure:** 1/160″, f/4, ISO 1000

**White Balance:** Auto

*Figure 24.11 (top left) One of the interesting aspects of concert photography is that the event lighting may be enough for your needs. This shot was made with only ambient light.*

*Figure 24.12 (center left) The Lastolite Ezybox rigged on a pole was carried by my son Tom.*

*Figure 24.13 (bottom left) The slave must be twisted on the back of the Ezybox so that its slave eye can see the master's signal. This means that the softbox must stay to my left. E-TTL radio triggers would have freed me of this restriction.*

*Figure 24.14 (top right) When held at a distance, the Ezybox becomes a hard light source (notice the edges of the nose and chin shadows). The light in this image works because the Ezybox was aligned with the Joel's nose—so there's no significant shadow across his face.*

*Figure 24.15 (bottom right) The lighting diagram.*

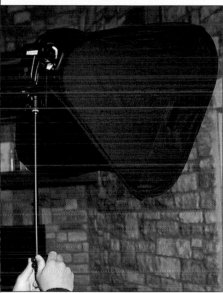

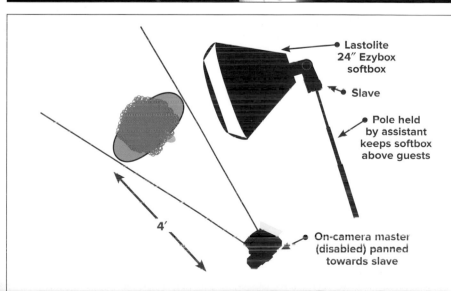

- Lastolite 24″ Ezybox softbox
- Slave
- Pole held by assistant keeps softbox above guests

4′

- On-camera master (disabled) panned towards slave

Here's proof that a single off-camera Speedlite can turn a snapshot into a cover shot. My assignment was to photograph the cars and their owners at the *Wheels of Wellness*—an annual showcase of historic race cars that benefits The Wellness Community of Arizona.

### A Paid Shoot

Wheels of Wellness is a major fundraiser for an organization that focuses on cancer prevention and support. Having lost my mother to breast cancer, I understand the importance of their work.

Yet, unlike the Paderewski Festival, Wheels of Wellness benefits an organization that has a full-time, professional staff. The event has other expenses—such as food from a caterer and the rental of a sound system. So, this is a shoot that I get paid to do—not at my commercial rates—but at a rate that is fair both for the organizers and my family.

### Some Subjects Almost Light Themselves

I love photographing auto events because the cars almost light themselves. The key is to skip the sunlight off of the paint. If you look at the shadows of the wheels in the hero shot, you will get a clue about the position of the sun—low and behind the car. That's where I always want the sun—behind the car.

### Some Subjects Never Light Themselves

The backlighting from the sun does a great job in bringing out the beautiful shape of this 1978 FA Indy car. Yet, as you can see in Figure 24.16 (top left), the car's owner is completely underlit. His brown jacket and pants just suck up the light when there is no flash.

By placing a single Speedlite on a stand about 10′ from the subject, I added the fill light that makes the hero shot what it is. This is straight flash—no modifier. The Speedlite was tilted so that the head was vertical to concentrate the light on the owner and nothing else.

### Lighting Details

**Environment:** outdoors, slightly overcast

**Time of Day:** winter, early afternoon

**Ambient:** backlit sunlight

**Speedlites:** 580EX II as master, 580EX as slave

**Metering Mode:** E-TTL

**FEC:** 0

**Zoom / Pan:** master panned towards slave and zoomed to 105mm, slave zoomed to 70mm

**Gel:** none

**Modifier:** none

**Distance:** 10′ from flash to subject

**Height:** about 6′

**Trigger:** Canon built-in wireless

### Camera Details

**Camera:** 5D Mark II

**Lens:** 24–70mm f/2.8L

**Distance to Subject:** 15′

**Exposure Mode:** Aperture Priority

**Exposure Compensation:** 0

**Exposure:** 1/80″, f/13, ISO 200

**White Balance:** Daylight

*Figure 24.16 (top left)* Compare this photo, shot without a flash, to the hero shot at right. You'll see the difference a single off-camera Speedlite can make.

*Figure 24.17 (center left)* By moving the camera so that the sun is behind the car, in the range of 135° to 170°, the metallic paint will appear as if it has been lit.

*Figure 24.18 (bottom left)* As you can see here, by swinging the camera around so that the sun is 90° to camera left, the paint flattens out.

*Figure 24.19 (top right)* For this shot, the sun is lighting the car and a bare Speedlite—tipped on its side so that the head is vertical—is lighting the owner.

*Figure 24.20 (bottom right)* The lighting diagram.

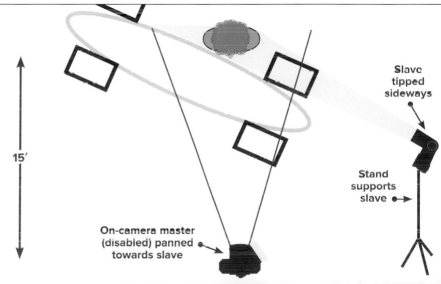

**Slave tipped sideways**

**Stand supports slave**

15'

**On-camera master (disabled) panned towards slave**

So what do you do when a 10′ tall stilt-walking dragonfly strolls past during a local arts festival? You start shooting. This is run-and-gun paparazzo shooting—camera and Speedlite held overhead at arm's length.

### Shooting Solo In A Crowd

As a favor to our local arts organization in Paso Robles, I photograph the annual Festival of the Arts each Memorial Day weekend. Here's a situation where I connected the Speedlite to my camera with a short, coiled off-camera E-TTL cord. For the hero shot at right, I literally held both the Speedlite and the camera over my head. This is a case when Live View on the 5D Mark II is a great help for composing the frame when the camera is overhead.

### Whoa...Syl Used Auto-Zoom?

Given the number of times throughout the *Handbook* I've said, "I zoomed the Speedlite to this or that," I know you'll find it surprising to learn that I did this shot with the Speedlite in Auto-Zoom. Why? At an event, I'm generally not trying to create dramatic light—especially when I'm running in and out of the shade at mid-day. All I wanted was a gentle fill flash.

Now, if you'll look closely at Figure 24.24, you will see that the flash indeed falls off in the lower half of the image. So what's going on—if the Speedlite is in Auto-Zoom, then it is supposed to match the view of the lens. Well...with the Speedlite held high overhead, sometimes my aim is a bit off. In this case, the vignette works to send your eye up to the face.

### This Was Straight Flash

The Speedlite is providing much-needed fill flash. If you look at the detail of my subject's face in Figure 24.23, you can see that the flash created nice catchlights and hard shadows. This photo would be useless without them.

### Lighting Details
**Environment:** outdoors, dappled shade
**Time of Day:** mid-afternoon
**Ambient:** backlit, deep shade
**Speedlites:** 580EX
**Metering Mode:** E-TTL
**FEC:** 0
**Zoom / Pan:** auto zoom
**Gel:** none
**Modifier:** none
**Distance:** 10′–12′
**Height:** held overhead, about 6.5′
**Trigger:** Speedlite connected to camera with OC-E2 cord

### Camera Details
**Camera:** 5D Mark II
**Lens:** 24–70 f/2.8L
**Distance to Subject:** 12′
**Exposure Mode:** Aperture Priority
**Exposure Compensation:** $+2/3$ EV
**Exposure:** $1/250$″, f/4, ISO 200
**White Balance:** Auto

*Figure 24.21 (top left)* This shot was made by the fill flash. Without it, the lighting on the subject would have been dappled shade.

*Figure 24.22 (center left)* The shadows above the eyebrow show that this was straight flash.

*Figure 24.23 (bottom left)* Getting the angle on a 10′ tall stilt-walker meant that I had to hold both the camera and Speedlite high over my head.

*Figure 24.24 (top right)* This shot is now used widely to promote the Paso Robles Festival of the Arts.

*Figure 24.25 (bottom right)* The lighting diagram.

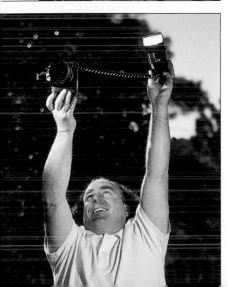

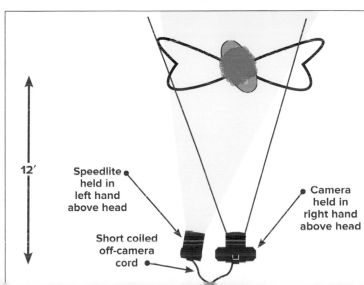

12′

Speedlite
held in
left hand
above head

Camera
held in
right hand
above head

Short coiled
off-camera
cord

# CHAPTER 25 | **STROBO, STROBO, STROBO**

## The Short Version

Stroboscopic flash is a way to fire one or more Speedlites for a specified number of flashes at a specific rate per second. Unlike a traditional disco strobe—which cannot be controlled in terms of either the exact number of flashes or the exact interval—a Canon Speedlite in Multi mode can provide precise and repeatable control.

When used scientifically, stroboscopic flash can be used to study motion. When used for fun, stroboscopic can create memorable photos of sports action and theatrical gesture.

**Figure 25.1**
*Even a simple act like walking can become visually dramatic. This stroboscopic image was made with a pair of 580EX IIs firing in Multi mode at 6Hz.*

## FLASHING AGAIN AND AGAIN

Multi mode turns your Speedlite into a disco strobe—meaning that the Speedlite will fire a specified number of times during one exposure. Think of Multi as a way to create time-lapse photos within a single frame.

### What You Need For Multi/Stroboscopic

- *Subject*: A subject that moves is best. The motion does not have to be smooth—like a golf swing—but it helps. Also, light-colored objects are easier to photograph stroboscopically than dark objects.

- *Black Set*: Having a dark place to shoot is a great help. Since the exposure will be relatively long, even a small amount of ambient light can add up.

- *Camera*: Any Canon EOS camera will do.

- *Speedlite(s)*: Must have at least one 500-series Speedlite. You can shoot several Speedlites in Multi via wireless mode (is this Multi Multi?).

- *Tripod*: The exposure in Multi mode is often several seconds. You will want to lock your camera down on a solid base.

- *Shutter Release*: Although it is possible to fire the shutter via the on-camera button, an electronic shutter release will allow you to focus on the action.

- *External Battery Pack*: Using an external battery pack will help with the reliability of your stroboscopic work. If you don't have an external pack, make sure you are using freshly charged batteries.

---

### SPEEDLITER'S TIP

#### —Yes, Your 430EX Will Do Multi—

Even though there is no Multi button on a 430EX, it will work as a slave in Multi. To see this for yourself, switch your 430EX into slave mode and switch a 500-series Speedlite into master mode. Then fire the master in Multi. Your slaved 430EX will follow along.

---

### Setting Your Speedlite For Stroboscopic Flash

After switching your 500-series Speedlite into Multi mode (by pressing the Mode button to cycle through E-TTL, Manual, and then into Multi), you will use the Set button and the Select dial to specify the following:

- *Number of flashes*: This is the total number of flashes that you want the Speedlite to emit (2, 10, 50, etc.).

- *Hertz (Hz)*: This is the frequency of the flashes, one Hz equals one flash per second, 10 Hz equals ten flashes per second.

- *Power level*: Multi mode fires the Speedlite at a fixed power level that you set. Doing stroboscopic flash in E-TTL is not an option. You may use any power level at or below ¼ power. The power level you select will determine the number of pops you get out of the Speedlite

Remember, when something on the Speedlite LCD blinks, it is asking if you want to change/set that value. You use the Set button to cycle through the options. You then specify the amount you want for the setting by turning the Select dial. A push of the Set button confirms your choice and starts blinking the next option.

### The Number Of Flashes

Shooting with stroboscopic flash is often a matter of best guesses. For instance, the number of flashes that you need is determined by the entire duration of the motion that you want to capture and how close you want the segments of that motion.

If you want to be a strobo geek, then use a stopwatch to time the golfer's swing or the ballerina's jump and divide that by the interval of time that you want between pops. If the swing or jump takes three seconds and you want three pops per second (3 Hz), then the number of flashes is nine.

Me? I just guess at the interval, dim the lights, and start a series of test shots.

## Maximum Number Of Flashes

When shooting stroboscopic, there is the risk that you can overheat your Speedlite and cause permanent damage. There are two mechanisms built into the Canon system to prevent overheating: a thermal circuit (580EX II only) and the programming of the Speedlite. In the latter case, the Speedlite will limit the number of flashes to the following quantities.

| | Power Level On Speedlite | | | | | |
|---|---|---|---|---|---|---|
| | ¼ | ⅛ | 1/16 | 1/32 | 1/64 | 1/128 |
| 1 | 7 | 14 | 30 | 60 | 90 | 100 |
| 2 | 6 | 14 | 30 | 60 | 90 | 100 |
| 3 | 5 | 12 | 30 | 60 | 90 | 100 |
| 4 | 4 | 10 | 20 | 50 | 80 | 100 |
| 5 | 4 | 8 | 20 | 50 | 80 | 100 |
| 6–7 | 3 | 6 | 20 | 40 | 70 | 90 |
| 8–9 | 3 | 5 | 10 | 30 | 60 | 80 |
| 10 | 2 | 4 | 8 | 20 | 50 | 70 |
| 11 | 2 | 4 | 8 | 20 | 50 | 70 |
| 12–14 | 2 | 4 | 8 | 20 | 40 | 60 |
| 15–19 | 2 | 4 | 8 | 18 | 35 | 50 |
| 20–50 | 2 | 4 | 8 | 16 | 30 | 40 |
| 60–199 | 2 | 4 | 8 | 12 | 20 | 40 |

*Flashes Per Second · Hertz (Hz)*

**Figure 25.2** *The maximum number of flashes that a Speedlite will allow in Mulit mode is based on the power level and the frequency of the flashes. This table shows the data for the 580EX II.*

## Setting The Hertz

I think it is best to have an experimenter's attitude when working in stroboscopic. The best advice I can give you on setting the Hertz is to guess and then do a test shot. That's exactly how I did the opening shot for this chapter—I just fiddled around until I got an image that I liked. Here's an alternate shot—the Hertz was set at 3Hz rather than the 6Hz used in the opener.

**Figure 25.3** *Compare this photo to Figure 25.1. For this shot the Hertz was lowered from 6Hz to 3Hz.*

## Power Level

There is no such thing as metering in Multi mode. You have to dial the power level in on the Speedlite. Like the Hz, it always starts with a guess and a test shot. As when working in Manual mode, if you don't know, then dial the power to ⅛ and see what happens.

## Shutter Speed

Your minimum shutter speed needs to be long enough to capture all your flashes. So, if you have set your Speedlite to fire 12 pops at 4 Hz, your exposure needs to be at least 3″ long—12 pops divided by 4 per second equals 3″.

If you are shooting on a black set (one with no ambient light), you can use extremely long exposures. Most Canon DSLRs have shutters speeds as long as 30″. If you need a longer exposure, switch your camera into Bulb mode—and be sure to use a shutter release cable.

## SINGLE SPEEDLITE STROBOSCOPIC

Stroboscopic flash is subject to the same physics that govern regular Speedliting— meaning that an on-camera Speedlite will flatten your subject in strobo as much as it does in the other flash modes. So, if you have a single Speedlite, my strong recommendation is that you move it off-camera with a cord. Even a short cord, like the OC-E3, can provide a bit of distance to held add some depth to your photo.

### Is A Single Speedlite Enough For Stroboscopic?

There is no doubt that a single Speedlite— even with its power limited to a maximum of ¼ in Multi mode—can produce enough light for stroboscopic shots. The real limitation of using a single Speedlite for stroboscopic work is the quality of the light that you will produce.

Keep in mind that the extended length of stroboscopic exposures necessitates that you shoot in very dark conditions. So, since your Speedlite(s) will be the sole source of light, the subject will have very dark, contrasty shadows. As you can see in the adjacent photos, a pair of Speedlites facing each other helps fill out the subject's form.

Still, if a single Speedlite is what you have, then it is far better to shoot with one flash than to just dream about shooting strobo.

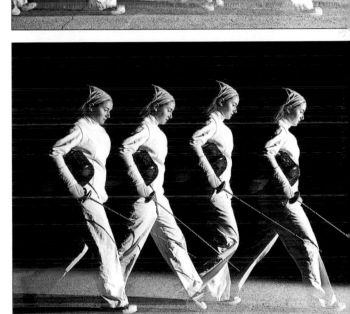

*Figure 25.4* Lit with two Speedlites—one on the right and one on the left.

*Figure 25.5* Lit with one Speedlite—on the right

*Figure 25.6* Lit with one Speedlite—on the left.

## MULTI SPEEDLITE STROBOSCOPIC

To coin a bad pun (as if there was ever a good pun), using multiple Speedlites is when stroboscopic really shines. And, at the risk of sounding redundant, I'm going to coin the phrase "multi-strobo" so that I can quickly refer to multiple-Speedlite-stroboscopic.

### Advantage #1: Better Light Quality

The first advantage of multi-strobo is that you have the ability to reduce the harshness of the shadows. Keep in mind that Multi has to be shot on a dark set. So, virtually all of the light hitting your subject will be coming from the Speedlite(s).

If you have a single Speedlite, then the side of the subject that is away from the Speedlite will be in complete darkness—as shown in Figures 25.5 and 25.6.

If you have multiple Speedlites, then you have options. By setting your Speedlites in front of and behind Helaina, as I did in Figures 25.1, 25.3, and 25.4, she is well lit. Notice how the brighter side transitions from the her back to her front as she moves farther from the left Speedlite and closer to the right Speedlite.

### Advantage #2: More Pops

If you take another look at the table in Figure 25.2, you will see that if you reduce the power from ¼ to ⅛ or from ⅛ to 1⁄16, you get more than twice the number of pops. So, by using two Speedlites side-by-side, say on a Wizard Bracket, then you can fire them at a lower power level and get more pops from the Speedlite.

### Advantage #3: Broader Field Of Light

If your subject is moving any distance, say you are photographing a runner sprinting 50′, then you will want to have many Speedlites so that you can create a wide area through which your subject can move.

### Advantage #4: More Even Light

If you have a subject that moves across the set, as in the case of Figure 25.1, then you have to think about the inverse square law (sorry). Specifically, if you want even light across a wide area, then you have to pull your lights back. When you pull your lights back, the light hitting the subject will become dimmer. So, the way to overcome that is to gang up a number of Speedlites and fire them off from a distance.

### Advantage #5: Faster Pops

A Speedlite lowers its power by shortening the length of the flash burst. So, the lower the power, the faster the burst.

Because strobo is shot on a dark set with the shutter open for a relatively long time, the duration of the flash is effectively the shutter speed for each individual pop of the flash. If you are shooting a subject that moves quite fast, having several Speedlites firing at low power will give you shorter bursts of flash—although as you can see in Figure 25.16 sometimes multiple Speedlites can be slightly out of sync.

### How To Configure A Slave For Stroboscopic Flash

1. Set the slaves up as slaves. Don't worry about them saying E-TTL on the LCD.
2. Set your master up as a master.
3. Switch the mode of the master to M (for Multi).
4. Push the Pilot button on the master to fire a confirmation flash or fire a test shot with your camera.

The slaves will instantaneously jump from E-TTL into Multi when they see the pre-flash from the master. If you have a 430EX as a slave, the LCD will still say E-TTL, but it will fire in Multi.

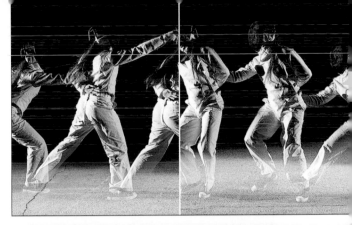

## OTHER CONSIDERATIONS FOR STROBOSCOPIC

I've wondered if Canon labeled stroboscopic as "Multi" mode because there are multiple things that can go "wrong." Don't fret. You'll sort them out as your go along. Here are a few discoveries that I've made along the way.

### Move In The Right Direction

If your subject does a sport that leads with one hand, like fencing or fly casting, then you'll find that one direction looks more natural than the other. In Figure 25.7, the left side is not as interesting to me as the right side.

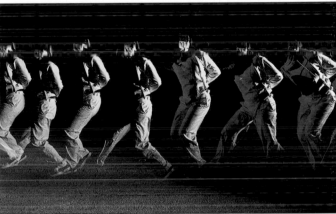

### Play With Gels

If you're shooting multiple Speedlites in strobo, then gel them with multiple colors. In Figure 25.8, you can see that the blue light stopped firing before the yellow. This happened because it was firing at $\frac{1}{8}$ power and the yellow light was firing at $\frac{1}{32}$ power.

### Spinning Vs. Linear Motion

If your subject is mostly spinning in front of the lens, then the series will pile up on itself. If your subject is moving across the frame, then you will capture a series that has more width.

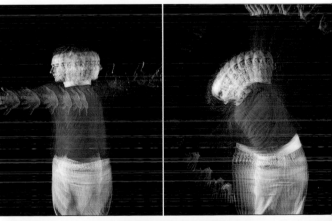

### Pitch Black Is Not Pitch Black

Thanks to the stroboscopic layering of light, you will find that your background is recorded differently than you see it. A black sheet of foam core will show up as grey. Bushes and rocks that you can't see will mix with your subject. The solution is to flag your lights.

*Figure 25.7* *The same action happening in opposite directions. The right appears more natural to me.*

*Figure 25.8* *Gels add to the strobo effect.*

*Figure 25.9* *Spinning motion (left) fills less of the frame than linear motion (right).*

*Figure 25.10* *If your Speedlites are not flagged, then you will likely find that background objects appear in the photo. Flag your lights and they will stay hidden.*

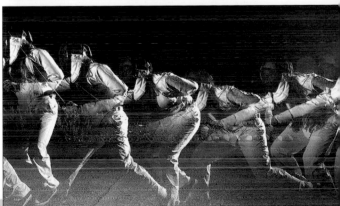

The Birdman shoot was a simple test out in our driveway one night. Fortunately we live out in the country, so we didn't have to contend with city lights. The backdrop was black foam core.

### Hold Still!

Back in the 1800s, when photography was mostly a type of alchemy practiced on paper, the sensitivity of photographic materials was so low that it would take minutes to make an exposure. For a portrait, this meant that the subjects would have the back of their heads stuck in brackets so that they would not wiggle.

This shoot made me wish that I had one of those contraptions in the garage. Try as he might, Tom could not hold his head perfectly still for 2″ *and* move his arms. So for next time...I'm thinking a light stand and a jumbo Cardellini right across the back of his ears might allow Tom to smile, or maybe not.

### Clothing Color

The three shots opposite were all made with the same flash settings. The difference, of course, is the color of Tom's shirt. It's interesting to see that if you want to hide a body part in a strobo shot then just drape it in black and it will disappear.

### Lighting Details

**Environment:** outdoors, driveway

**Time of Day:** night

**Ambient:** none

**Speedlites:** two 580EX IIs

**Metering Mode:** Multi

**Power Level:** 1⁄16

**Rate:** 8 Hz

**Number of Flashes:** 15*

**Zoom / Pan:** heads zoomed to 70mm, turned vertically

**Gel:** none

**Modifier:** none

**Distance:** 8′

**Height:** level with Tom's head

**Trigger:** corded master (enabled)

### Camera Details

**Camera:** 5D Mark II

**Lens:** 24–70mm f/2.8L

**Distance to Subject:** 10′

**Exposure Mode:** Manual

**Exposure:** 2″, f/9, ISO 400

**White Balance:** Auto

* **Note:** There is no need to set the number of flashes at the hertz times the shutter speed—as in 2″ x 8Hz = 16 flashes. For this shoot, I set the number of flashes at 15...just because I wanted to.

As long as your shutter speed is longer than the number of flashes times the hertz, then all of your pops will be captured.

*Figure 25.12 (top)* Tom's head is as stationary as it can be. Still there's a bit of motion blur.

*Figure 25.13 (bottom left)* If you can't be still, then try moving.

*Figure 25.14 (bottom right)* A black shirt in motion just disappears into the black background.

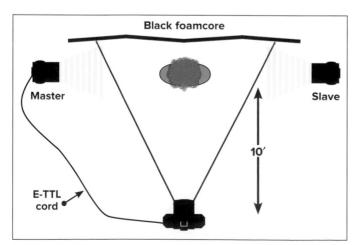

**Black foamcore**

Master

Slave

10′

E-TTL cord

*Figure 25.11* Lighting diagram.

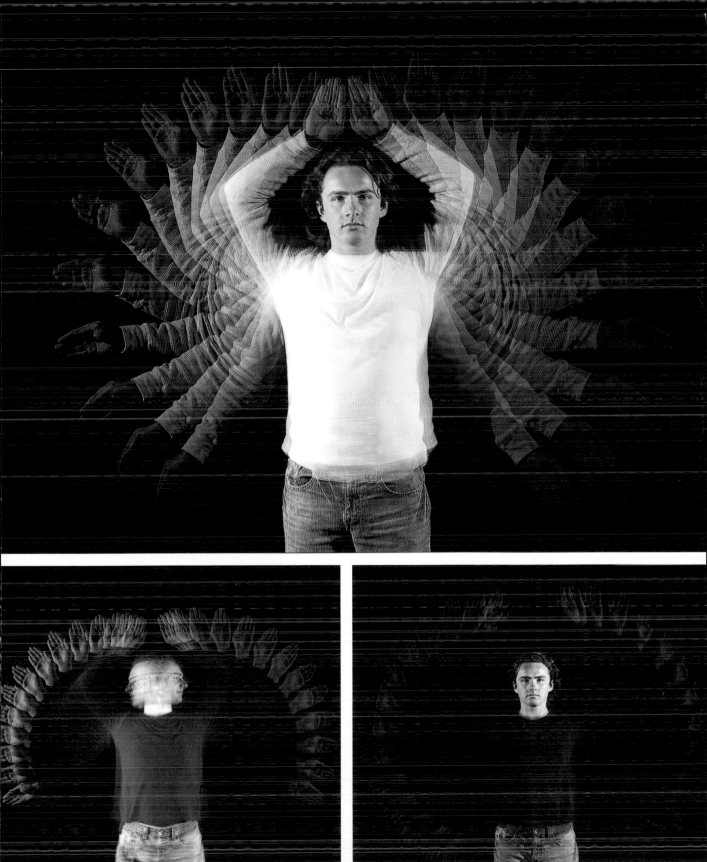

Which is more surreal—a stroboscopic image of a kid on a pogo stick or trying to watch a kid pogo stick under stroboscopic light? I can assure you that watching the real deal is the stranger of the two—definitely not an event for those prone to motion sickness.

### Sometimes You Just Have To Wonder

I had a simple idea—have Tony pogo across the set as a demo of linear motion. Well, it turns out for a kid whose personal best is something north of 652 hops that pogoing with lights blinking around you totally messes with your balance.

Tony gave it several valiant attempts—including one that ended with him basically flying sideways onto the ground. Fortunately, mom was elsewhere and the shoot could go on. Figure 25.18 is about as close as we could get to my original vision of a pogo-bunny hopping across the frame. I love these images nevertheless.

### Shifting Time

If you look in the upper left corner of Figure 25.16, you will see several instances where Tony's face appears to have split because the slaved Speedlite fell slightly out of sync with the master. The frames before and after were

fine. Apparently the blinking lights can make the slave dizzy too.

### Lighting Details

**Environment:** outdoors, driveway
**Time of Day:** night
**Ambient:** half-moon
**Speedlites:** two 580EX IIs
**Metering Mode:** Multi
**Power Level:** $1/32$
**Rate:** 1 Hz
**Number Of Flashes:** 14
**Zoom / Pan:** heads zoomed to 70mm, turned vertically
**Gel:** none
**Modifier:** none
**Distance:** 8′
**Height:** about 6′
**Trigger:** corded master (enabled)

### Camera Details

**Camera:** 5D Mark II
**Lens:** 24–70mm f/2.8L
**Distance to Subject:** 10′
**Exposure Mode:** Manual
**Exposure:** 16″, f/8, ISO 400
**White Balance:** Auto

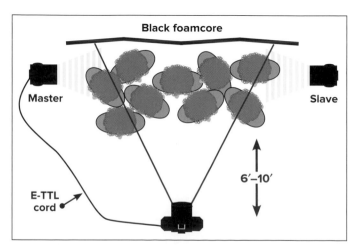

Figure 25.15 Lighting diagram.

*Figure 25.16 (top) The surreal effect of combining pogo and strobo—a truly unpredictable combination.*

*Figure 25.17 (bottom left) When Tony didn't jump around or across the set, the image just piled up on itself.*

*Figure 25.18 (bottom right) Our best result at getting a straight hop across the set.*

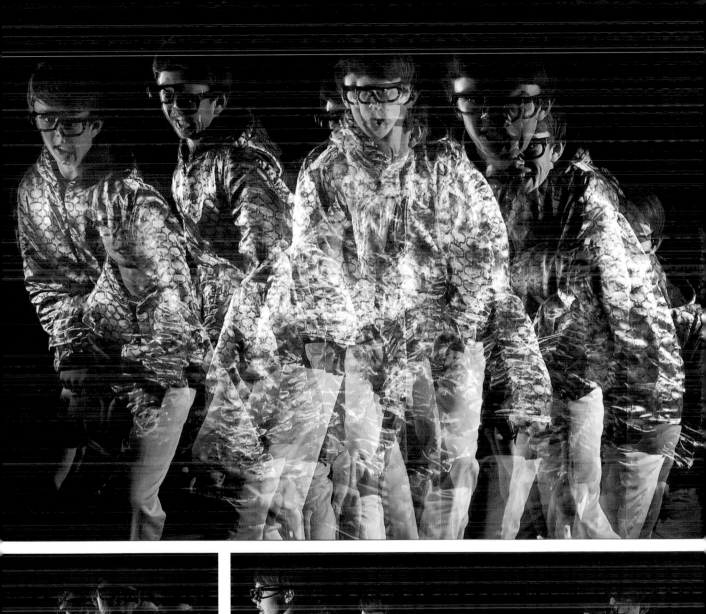

Should a portrait be of what a person looks like on the outside or of the person he is on the inside? From my view, we are the *who* of what we do. So, my answer is "both inside and outside, at once."

### Artistic License

As photographers, we often get hung up on making a photo that looks like something we experienced. Strobo gives us the ability to show a reality that we can't see. So, I don't get hung up on the fact that Ray's head shifted and that his arms are not delineated clearly. Rather, I enjoy the photo for what it is—a look at a world that I otherwise could not see.

### The Look Of In-Camera Strobo

With an in-camera strobo shot, such as Figure 25.20 opposite, it is virtually impossible to keep the subject from layering on top of himself if his motion is circular (a.k.a.: spinning). The transparency of the image, where one layer of brightness increases the brightness of an overlapping layer is the sign that a shot was done in-camera in a single frame.

If you're wondering how to create those *Sports Illustrated* shots where six sets of arms are spaced perfectly around the absolutely still body of the batter, you'd have to shoot six separate frames—each taken a fraction of a second from the next—and then layer selected elements from each in Photoshop.

### Lighting Details

**Environment:** outdoors, empty field
**Time of Day:** night
**Ambient:** twilight
**Speedlites:** four 580EX IIs
**Metering Mode:** Multi
**Power Level:** $\frac{1}{16}$
**Rate:** 3 Hz
**Number of Flashes:** 6
**Zoom / Pan:** heads zoomed to 80mm, turned vertically
**Gel:** none
**Modifier:** none
**Distance:** 10′
**Height:** level with Ray's head
**Trigger:** corded master (enabled)

### Camera Details

**Camera:** 5D Mark II
**Lens:** 24–70mm f/2.8L
**Distance to Subject:** 8′
**Exposure Mode:** Manual
**Exposure:** 2″, f/11, ISO 400
**White Balance:** Flash

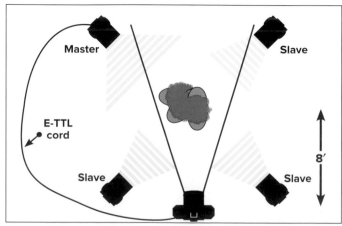

*Figure 25.19* Lighting diagram.

*Figure 25.20* Set your sights as a photographer on how you see the world and not on any particular set of rules about how to craft a "good" photograph.

# PART 5 | **APPENDICES**

## A

**A-Clamp:** metal spring clamp shaped like an "A"; always carry a few in different sizes

**Additive Primary:** the primary colors of light—red, green and blue—that can be added together to create white

**AE (Automatic Exposure):** any of several camera modes in which the camera selects certain exposure settings based on other settings specified by the photographer

**AE/AF Lock:** the ability to lock exposure and/or focus so that a frame may be recomposed

**AF-Assist Beam:** a pattern of red lines emitted from a Speedlite in low light so that the camera can focus

**Air-Cushioned Stand:** won't collapse immediately when the bracket is opened thanks to an air valve; my favorite type of stand

**Amateur:** a person who works at something for the love of it rather than to earn a living. Should not be used as a measure of skill. When it comes to photography, there are many amateurs who are far more skilled than working pros.

**Ambient:** the light that's already there, from the sun, room lights, etc.

**Angle of Incidence:** the principle that says light will bounce off of something at the same angle that it comes in, namely at the "angle of incidence"

**Aperture:** the "pupil" of the lens, controls the amount of light that is able to pass through, determines the depth of field

**Aperture Priority (Av):** automatic camera mode where you select the aperture and the camera selects the shutter speed based on the ISO that you've set

**Apple Box:** a standard studio fixture used to elevate subjects or gear. A standard apple box measures about 20″ x 12″ x 8″.

**Apparent Size:** the size of a light source as seen from the subject's position. The apparent size of a light gets bigger as it moves towards the subject.

## B

**Background Light:** a light pointed away from the subject and at the background

**Backlight:** a light coming straight over the subject's back that creates an even rim of light across the hair and shoulders

**Beauty Dish:** a wide, shallow dish with a center reflector that pushes the light back and out to the sides; creates a broad, soft light

**Blown Out:** highlights that have no detail

**Blue:** one of the three primary colors of visible light, the other two being red and green

**Boom:** used to hold a light over a subject

**Bokeh:** the shape of out-of-focus elements created by a wide aperture

**Bounce Flash:** firing a flash into a ceiling or a wall so that its apparent size will increase

**Bracketing:** the practice of shooting a range of exposure settings in the hopes that one will work

**Bulb:** camera setting where the shutter opens when you push the button and closes when you push the button again; used for long exposures

**Butterfly Frame:** a large frame for a scrim or solid that is uniquely hinged to fold up into a compact kit

**Butterfly Lighting:** a portrait lighting style in which the fill is placed directly under the key light, used on women mostly; gets its name from the small butterfly-shaped shadow it casts under the nose

## C

**C-stand:** a studio stand that has a broad base of legs at different heights and a double- or triple-riser column. Relatively heavy and very sturdy. When invented in Hollywood, they were 100″ tall and got the nickname "century stand."

**California Sunbounce:** a German-made reflector/scrim that stretches the fabric on a frame shaped like an "H". Disassembles into a very compact kit.

**Canonista:** a photographer who shoots with Canon equipment

**Capacitor:** an electronic circuit that stores energy (like a battery) but can release it immediately, used in strobes and Speedlites

**Cardellini:** clamp that has a long, threaded shaft and two wide-angle brackets; used to secure heavy items to beams, ladders, etc.

**Catchlight:** the reflections of a light source in the subject's eyes

**Catchlight Panel:** the small and nearly useless white plastic panel that pulls out of 500-series Speedlites

**Channel:** when shooting Speedlites in wireless mode, the channel is the frequency at which they communicate (1, 2, 3, or 4). Not to be confused with Group.

**Chiaroscuro:** the Italian way of saying that light dances with shadow

**Chimp (to):** the habit of looking at the LCD on a digital camera after every shot

**Cine Foil:** heavy aluminum foil covered in heat proof, black paint. Very handy to have in your kit when you need a quick snoot or flag.

**Clip (to):** when a photo is overexposed, the highlights clip to white, meaning that no color data is recorded. Likewise, when dark tones are underexposed they can clip to black, meaning that no tonal data is recorded. Clipping is indicated by a spike on the left or right edge of the histogram.

**Cloudy White Balance:** a digital white balance that adds warmth to an image

**Cold Shoe:** a clamp that holds the base of a Speedlite without providing any electrical contact

**Color Temperature:** the relative amount of yellow or blue in a light source. Like a candle flame, cooler temps are yellow and hotter temps are blue.

**Commander:** Nikon's way of saying "Master"; a wireless flash term

**Continuous Light Source:** a light source (sun, light bulb) that stays on; the opposite of a strobe or Speedlite

**Contrast:** the difference between black and white in a scene or image

**CTB:** "Color Temperature Blue," a color-correction gel invented for Hollywood that converts the yellow cast of a tungsten light into the more blue cast of daylight

**CTO:** "Color Temperature Orange," a color-correction gel invented for Hollywood that converts the blue cast of daylight into the warm tones given off by tungsten light bulbs

**Curtain:** part of the shutter mechanism in your SLR or DSLR. Two curtains are needed for an exposure—the first is closed and the second is open when your camera is waiting to fire; during an exposure the first one opens and the second one closes. The difference in the timing of their movement is your shutter speed.

**Cut:** used to describe the amount of correction produced by a CTO or CTB gel. The standard amounts are full-, half-, quarter- and eighth-cut.

**Cyan:** a color, one of the primaries in the Subtractive Color (pigment/ink) system. Think of it as aqua. In light, green and blue combine to make cyan.

## D

**Daylight Balance:** a color temperature setting that approximates the look of sunlight at noon

**Depth of Field (DOF):** the portion of a photograph, front to back, that appears to be sharp. Smaller apertures (those with higher numbers) yield more DOF than wide apertures.

**Diff:** short for "diffusion," any translucent fabric that spreads light around

**Diffuse Reflection:** the reflection off a surface that has a multi-faceted surface

**Diffuser:** a light modifier that causes the rays of light to change direction in an irregular pattern, as clouds do to sunlight

**Direct Reflection:** the reflection off a surface that has a mirror-like surface

**Dome Diffuser:** a plastic diffuser that snaps onto the front of your Speedlite

**Drag The Shutter:** a technique that uses a long shutter speed to collect ambient light from a background that the Speedlite cannot illuminate directly

**DSLR (Digital Single Lens Reflex)**: a camera in which the light travels through the lens and then hits a mirror and bounces up into the viewfinder. During an exposure, the mirror flips up before the shutter opens allowing the light to travel straight through to the film or sensor. When the shutter closes, the mirror resets.

**Dulling Spray:** provides a temporary dull finish to glossy surfaces like glass and metal

**Duvey:** short for "duvateen," a thick black canvas used on sets as a solid

**Dynamic Range:** describes the difference between the brightest bright and the darkest dark in a scene. Also used to describe the same range of a camera, monitor, or print.

E

**E-TTL:** Evaluative-Through-The-Lens, Canon's proprietary approach to metering flash exposure

**E-TTL II:** Canon's current generation of E-TTL technology; commonly referred to as E-TTL

**EC:** see Exposure Compensation

**Equivalent Exposures:** Combinations of ISO, shutter speed, and aperture that create the same exposure. If you don't change the ISO, then 1/125" at f/16 is an equivalent exposure to 1/250" at f/11.

**Exposure Compensation:** a setting used when shooting in Aperture Priority or Shutter Priority mode by which you tell the camera to over- or underexpose by a specific amount

**EV:** see Exposure Value

**Exposure Value:** a measure of light for which there are many Equivalent Exposures. At EV 0, the exposure would be ISO 100, 1", f/1.0 or its equivalent. At EV 1, there is twice the amount of light as EV 0.

**Ezybox:** a softbox made by Lastolite that comes in a variety of sizes—including two sizes for Speedlites. Ezyboxes have metal bands built in so that you can quickly snap them open or fold them closed.

F

**F-Stop:** an old-school way of describing the aperture setting on a lens

**Falloff:** used to describe light that goes from bright to dark quickly

**Feather:** the intentional aiming of a light source so that most of the light flies past rather than directly at the subject. Used either to send light into a reflector that will fill shadows or because the edge of the light has interesting qualities when it hits the subject.

**FEC:** see Flash Exposure Compensation

**Fill Light:** a light (ambient, continuous, or flash) used to fill shadows

**First-Curtain Sync:** a sync mode in which the flash fires at the beginning of the exposure

**Flag:** anything that can be used to keep light from hitting the subject or background

**Flash Bracket:** used by event and wedding photographers to hold their flash above the camera

**Flash Exposure Bracketing (FEB):** a curious legacy of the film era that is still a feature on Canon Speedlites. FEB alters the power of the Speedlite in three consecutive shots in the hopes that one will work. Digital cameras have made FEB obsolete.

**Flash Exposure Compensation:** a setting used when shooting in Aperture Priority or Shutter Priority mode by which you tell the camera to add or subtract the amount of flash by a specific amount. In Canon, this operates independently of Exposure Compensation. In Nikon, they are linked.

**Flash Exposure Lock (FEL):** a very useful feature that temporarily meters the ambient and flash reading from/near the center circle of the viewfinder.

**Flash White Balance:** a color temperature setting that approximates the color of light emitted by Speedlites

**Foam Core:** a styrofoam sheet covered with thick black or white paper on both sides. Available at office supply stores. Used to flag or reflect light.

**FourSquare:** a softbox by LightWare designed to hold up to four Speedlites

**Fresnel Lens:** originally used in lighthouses, a fresnel lens focuses light through rings of glass or plastic into a tight beam.

**Fuller's Earth:** a very fine clay dust that can be used to create a haze on a set

## G

**Gaffer:** on a movie or theater set, the gaffer sets the lights and configures the electricity to run them

**Gaffer's Tape:** "gaff" is a cloth tape, usually black, that removes without a mess after it is used. Can be used to make quick snoots or flags on a Speedlite. Always have a small roll in your kit.

**Gang Light:** my term for using multiple Speedlites simultaneously in wireless mode

**Gel:** a sheet of plastic tinted for a specific purpose. Color-correcting gels change the color temperature of one light source to another. Theatrical gels are used for the effect of their color alone.

**Gobo:** short for "go-between," anything that can be used between a light and the subject or background

**Green:** one of the primary colors of visible light, the other two being red and blue

**Grid:** a modifier that goes immediately in front of the light source. Limits the spread of the light.

**Grip (gear):** items used to hold lights and modifiers

**Grip (person):** the person on a set that places the light modifiers

**Group:** when shooting in wireless mode, a Group is one or more Speedlites that operate at the same power setting. The key light could be group

A and the fill light group B. Canon offers three groups (A, B, and C). Canon's Master is always assigned to Group A. Not to be confused with Channel.

**Guide Number:** an old-school way of expressing the power of a flash. The higher the guide number, the more powerful the flash. Technically, the GN can be divided by the distance to the subject to calculate the aperture

## H

**Hard Light:** a light that casts shadows with distinct edges. Put another way, it's a light that arrives on the subject with its rays nearly parallel. On a day without clouds, the sun is a hard light. A spotlight is a hard light. A Speedlite without a diffuser is a hard light.

**Hair Light:** a light positioned to create highlights on the hair, often as a way to provide visual separation between the subject and the background

**Hertz:** for events that repeat, one Hertz is one cycle per second

**High Key:** an image in which most of the elements are white or very bright

**High-Roller:** a type of studio stand used to hold large or heavy objects

**High-Speed Sync:** a flash mode in which the Speedlite fires an extremely fast series of bursts that effectively turns the Speedlite into a continuous light source. This enables the use of shutter speeds faster than the normal sync speed.

**Highlights:** the brightest portions of a photograph

**Histogram:** a graphic representation of the range of tones found in a photograph. Shadows are represented on the left side and highlights on the right. Most digital cameras can generate a histogram, which is a very good way to evaluate a digital exposure.

**Honl:** a line of modifiers developed by photojournalist David Honl expressly for use on Speedlites

**Hot Light:** typcially an incandescent (tungsten) light source used in a studio

**Hot Shoe:** a bracket on a camera that will accept the foot of a Speedlite and deliver electricity to trigger the flash

**Hot Shoe Adapter:** a bracket separate from a camera that will accept the foot of a Speedlite and deliver electricity to trigger the flash; usually has a threaded socket so that it can be attached to a stand or clamp

**Hue:** the character of a color as being red, orange, yellow, green, blue, etc.

## I

**I-TTL:** Intellegent-Through-The-Lens, Nikon's proprietary approach to metering flash exposure

**Incandescent:** a light bulb in which a hot metal filament burns bright in an atmosphere of insert gas

**Infrared:** the range of light just below that portion of the spectrum seen by humans. Hot objects give off infrared waves.

**Infrared Trigger:** a wireless device that emits infrared waves to trigger optical slaves on Speedlites

**Inverse Square Law:** that confusing bit of math that explains how light spreads out and, thereby, appears darker, as it moves farther from the source

**ISO:** a numeric measurement of a digital sensor's sensitivity. ISO 200 is twice as sensitive as ISO 100; ISO 400 is twice as sensitive as 200, etc.

### J

**Justin Clamp:** a combination of Manfrotto parts that creates a versatile clamp for Speedlites, nicknamed for its creator by Joe McNally

### K

**Kacey Pole Adapter:** a adapter that threads onto a painter's pole so that ⅝″ brackets can be attached to it

**Kelvin (K):** the unit used to describe color temperature

**Key Light:** the main light on a subject

**Kino:** a type of continuous light fixture, short for "Kino-Flo," the company that invented a line of flicker-free fluorescent lights that are balanced to daylight or tungsten. Originally invented for the movie trade, they are now popular with still photographers.

**Kicker Light:** a light coming from behind the subject that is to one side so that it lights one shoulder and the jaw

### L

**LED:** Light Emitting Diode, LED technology is advancing rapidly, giving photographers another type of continuous light source

**Lighting Ratio:** see Ratio

**Live View:** the live display of the image seen by the lens on the LCD monitor of the camera. When used with a loupe, Live View is a great way to achieve super-critical focus.

**Loop Lighting:** a lighting setup in which the key light is positioned so that the shadow of the subject's nose angles towards the corner of the mouth, but does not connect with the cheek shadow

**Low Key:** an image where the majority of tones are dark grey to black

### M

**Macro:** close-up photography

**Mafer:** jargon for a "Super Clamp," comes from Matthews Studio Equipment

**Magenta:** a color, one of the primaries in the Subtractive Color (pigment/ink) system. Think of it as ultra-pink. In light, red and blue combine to make magenta.

**Magic Arm:** a bit of grip gear by Manfrotto that can be used to place a Speedlite or a modifier, typically attached to a sturdy object by a Super Clamp

**Manual Exposure (M) (cameras):** an exposure mode in which the photographer sets the ISO, shutter speed, and aperture

**Manual (Speedlites):** a flash mode in which the photographer sets the power level of the Speedlite

**Master:** in multiple flash setups, the master communicates control messages to the slave or remote units

**Miniphone:** a type of cylindrical jack, measures ⅛″ (3.5mm) in diameter, commonly used to connect some sync cords and most radio triggers

**Mod:** short for modifier or modify

**Mode (camera):** the manner in which the exposure is set. Aperture Priority, Shutter Priority, and Manual are camera modes.

**Mode (Speedlite):** the manner in which the flash output is determined. E-TTL, Manual, and Multi are Speedlite modes.

**Modeling Light:** a continuous light in a strobe that shows what the flash will light; on Speedlites a quick burst of light pulses can be triggered as a modeling light

**Modifier:** anything used to change the character of the light coming from a flash (grid, snoot, softbox, gel, etc.)

**Monitor Pre-Flash:** see Pre-Flash

**Monolight:** a strobe in which the power supply, controls, and flash tube are a single unit

## N

**Noise:** a random pattern of color—typically found in the shadows—of images created in dim light with the ISO set to a high number

## O

**Off-Axis Flash:** a strobe head or Speedlite that is not in line with the direction of the lens. Off-axis flash creates shadows.

**Off-Camera Flash (OCF):** a Speedlite fired from any position other than the hot shoe atop the camera

**Off-Camera Flash Cord:** a cord that replicates the foot of the Speedlite and the camera's hot shoe and connects both

**On-Axis Flash:** a strobe head or Speedlite that is in line with the lens, whether mounted to the camera or not. Unless used sparingly, on axis flash will create a poorly lit photo.

**Optical Slave:** a circuit that senses a bright burst of light (from a strobe or Speedlite) that then tells another strobe or Speedlite to fire

**Overhead:** a large modifier (8' x 8' or bigger) that is suspended above the subjects, often in outdoor shoots

## P

**PC Cord:** a cord that attaches the camera and flash or an optical slave/radio trigger and flash

**Photon:** a particle of electromagnetic radiation, a.k.a. a particle of light

**Plusgreen:** a gel used over Speedlites to approximate the color of office fluorescents

**Pocket Wizard:** a line of radio triggers with many models, from simple triggers to units that communicate the E-TTL stream of instructions

**Practical:** a light fixture that normally exists on a location, a bedside lamp is a practical fixture

**Pre-Flash:** when shooting in E-TTL flash mode, the master and slaves (if any) fire a pulse at $\frac{1}{32}$-power so that the camera can take an exposure reading. The pre-flash causes some people to blink before the actual exposure is made.

**Program Auto (P):** an automatic mode in which the photographer sets the ISO and white balance and the camera sets the shutter speed and aperture

## Q

**Quick Flash:** a feature on 500-series Speedlites that enables the flash to fire at $\frac{1}{2}$- to $\frac{1}{16}$-power without fully recycling the flash

## R

**RadioPopper:** the first radio trigger that could carry the E-TTL communications between a master and slave Speedlites

**Radio Trigger:** a wireless device that tells an off-camera flash or strobe when to fire. Pocket Wizards and SkyPorts are radio triggers that only say, "Fire now." Other systems, like the RadioPopper, carry the E-TTL communication stream.

**Ranger:** short for Elinchrom Ranger, a popular studio flash that runs on a portable battery

**Ratio:** when shooting multiple Speedlites, the amount of light produced by one Group versus another Group. In Canon's system, 1:2 is a single stop difference, 1:4 is two stops' difference, 1:8 is three stops' difference.

**Rear-curtain Sync:** Nikon's phrase for second-curtain sync

**Red:** one of the three primary colors of visible light, the other two being green and blue

**Red Eye Reduction:** typically found on consumer cameras; fires a series of quick flashes so that the pupils of the subjects will constrict before the actual photo is made

**Reflector:** any modifier that can be used to shine light back into the shadows

**Remote:** see Slave

**Ring Light:** a modifier for Speedlites or a type of studio strobe head that fits directly around the camera lens, creates a soft light with shiny highlights and distinctive ring shadow

**Rembrandt Lighting:** a portrait lighting style in which the nose shadow meets the cheek shadow, thus creating a triangle of light under one eye

**Remote:** Nikon's word for a Speedlight controlled wirelessly by a master

**Rimlight:** light that comes from behind the subject and illuminates the hair/shoulders with a line of bright light; backlights and kicker lights both create rimlight

**Rocky Mountain Leg:** an adjustable leg on a light stand that can be extended to level the stand on uneven surfaces

## S

**Sandbag:** a pair of pouches sewn together and filled with sand or metal shot that are used to add weight to and stabilize a light stand

**Saturation:** a character of color that describes the purity of a color; e.g., red is saturated, white is desaturated, and pink is partially saturated

**Screwlock PC:** a sync cord connection that has a threaded collar that will screw into a socket, eliminating the tendency of PC cords to come loose

**Scrim:** a thin fabric used to diffuse light

**Scrim Jim:** a system of collapsible frames and fabric light modifiers made by Westcott

**Second-Curtain Sync:** a sync mode in which the flash fires just before the end of the exposure. With longer exposures, this creates a ghost trail from moving objects (like car lights) that trails behind the object.

**Separation Light:** a light behind the subject that creates a visual distinction from the background; rim and hair lights are separation lights

**Shiny Board:** a wood or foam panel that is covered in foil, typically used on large sets to reflect sunlight or incandescent light into the scene

**Shoot-Through Umbrella:** an umbrella of white satin or similar fabric used as a modifier by firing Speedlites or strobe heads through it

**Shutter:** the mechanism in the camera that hides the digital sensor or film plane from light until the moment of exposure

**Shutter Priority (Tv):** automatic camera mode where you select the shutter speed and the camera selects the aperture based on the ISO that you've set

**Shutter Speed:** the time that the digital sensor is exposed to light

**SkyPort:** short for "Elinchrom SkyPort," a wireless trigger

**Slave:** Canon's word for a remote flash

**Slave:** see Optical Slave

**Slave (to):** the triggering of one flash via a burst of light from another flash

**Slow-Speed Sync:** a sync mode in which the shutter stays open to allow for the collection of ambient light in the background

**SLR:** single lens reflex, see DSLR

**Snoot:** a modifier shaped like a tube that attaches to or around the head of a flash

**Softbox:** a collapsible modifier that has one or two diffusion panels

**Soft Light:** a light that casts shadows with very subtle (fuzzy) edges. This happens because the rays of light arrive at the subject from many different angles. The sun on a cloudy day becomes a soft light.

**Solid:** any opaque, black piece of fabric used on a set

**Sonia:** a company that makes optical slaves that are compatible with Canon Speedlites

**Specularity:** bits of light that reflect off the shiny parts of the subject

**Speedlight:** Nikon's name for its proprietary line of small flash. Also used generically by everyone other than Canon to mean small flash.

**Speedlite:** Canon's name for its proprietary line of small flash

**Speedring:** a bracket used to connect a softbox to a monolight or studio strobe

**Stofen:** short for "Sto-Fen Omni-Bounce," the white dome diffuser used by many

**Strobe:** a larger flash unit that runs off of A/C power or a large battery

**Strobist:** an enthusiast of David Hobby's widely read blog by the same name

**Stroboscopic:** a mode of flash in which the Speedlite emits a burst of repeated flashes

**Studio Strobe:** a powerful strobe that consists of one or more flashheads connected by cable to a power pack. Studio strobes are generally powered by A/C, although portable units generally run on a battery.

**Subtractive Primary:** the primary colors of pigment—cyan, magenta, and yellow—that must be removed from a sheet of paper to show white

**Super Clamp:** a wide clamp to which a variety of grip accessories can be attached

**Sync:** the timing of a flash so that it coincides with the opening of the shutter

**Sync Cord:** a cord that runs between the camera and flash. Most are manual, meaning that they only say, "Fire now!" An E-TTL sync cord carries the full communication between a Canon DSLR and Speedlite.

**Sync Mode:** the setting that tells the camera when to fire the Speedlite: at the start of the exposure, just before the end of the exposure, etc.

**Sync Speed:** the fastest shutter speed at which the entire film plane or sensor will be exposed before the 2nd-curtain starts to close

## T

**Third Party:** gear made by another company. Metz, Sunpak, and Vivitar are third-party manufacturers of small flash that will work with Canon cameras.

**Tri-Flash:** a bracket made by Lasolite that holds three Speedlites

**Tri-Grip:** a line of modifiers made by Lastolite that have a tear-drop shape that come as diffusers and reflectors

**TTL:** Through-The-Lens, an old mode of calculating flash exposure by measuring the amount of light reflecting off of the film while the shutter is open

**Tungsten:** a white balance setting that approximates the color temperature of an incandescent lamp. Also used as slang for any incandescent lamp.

**Twelve-By:** a 12' x 12' Silk or Solid. Six-By and Twenty-By are also common sizes.

## U

**Umbrella:** a popular light modifier that is either reflective, shoot-through, or combo; provides less control than a softbox

**Umbrella Swivel Adapter:** a hinged bracket that attaches between a light stand and a Speedlite that has a hole for the shaft of an umbrella. The most affordable are plastic. The most durable are metal. Own several.

**Underexposed:** an image made without enough light to properly illuminate the subject

## V

**Vignetting:** a dark pattern around the perimeter of an image; can be either intentional or unintentional

## W

**White Balance:** the setting that tells the camera what the color temperature of your main light source is

**Wide-Angle Diffuser:** the plastic shield that hides above your flash tube in your Speedlite. Pull it out and your head will now be at a zoom setting of 14mm.

**Wireless:** triggering Speedlites without a direct connection between the camera and flash

**Wizard Bracket:** a bracket designed to hold two Speedlites

## X

**Xenon:** the gas used to fill flash tubes in Speedlites

**X-Sync:** see Sync Speed

## Y

**Y-adapter:** a splitter used to connect two Speedlites to one radio trigger

**Yellow:** a color, one of the primaries in the Subtractive Color (pigment/ink) system. Think of it as, well, yellow. In light, red and green combine to make yellow.

## Z

**Z-finder:** a specialized loupe by Zacuto that snaps to a frame affixed to the camera's LCD monitor. The result is a light-tight seal that enables precise focusing via Live View in full sun.

**Zebra Stripe:** a zig-zag pattern on a reflector that alternates white with gold

**Zoom:** Speedlites have the ability to move the flash tube in and out to match the focal length of the lens (from 24mm to 105mm). The zoom can also be adjusted manually to tighten the throw of light.

There are loads of great resources for Speedliters on the web. Since I have the homefield advantage, I'll start with my own site on Canon flash and then share a wide range of my other favorite sites about photography.

### Speedliting
*Speedliting.com*
Syl Arena's site for Canon Speedliters. Also home to the Speedliting Forum—an international gathering place for Speedliters

### A Photo Editor
*APhotoEditor.com*
An insider's view on the world of editorial photography, from Rob Haggart

### Annenberg Space for Photography
*AnnenbergSpaceForPhotography.org*
An exciting new gallery and meeting place in the heart of Los Angeles

### American Society of Media Photographers
*ASMP.org*
Great tutorials and resources for learning about the business side of working as a professional photographer. Many local chapters across the country

### Cambridge In Colour
*CambridgeInColour.com*
A UK-based learning community for photographers—great tutorials

### Camera Dojo
*CameraDojo.com*
Kerry Garrison roams the digital imaging world both on his website and podcast

### Canon Camera Museum
*Canon.com/camera-museum/*
An online museum that presents the past, present, and future of Canon cameras

### Canon Professional Network
*CPN.Canon-Europe.com*
Professional-grade content on all aspects of Canon photography

### Canon Rumors
*CanonRumors.com*
A source of information and misinformation about what *might* be coming in the future

### Center for Creative Photography
*CreativePhotography.org*
Home to the archives of more than 50 great 20th-century photographers

### Chase Jarvis
*ChaseJarvis.com*
A voice on the leading edge of modern commercial photography

### Chris Orwig's Flipside
*ChrisOrwig.com/flipside*
Ideas, inspiration and images from the author of *Visual Poetry*

### DOUBLEtruck
*DTzine.com*
The most powerful photography magazine that you've *never* heard of

### EOS Magazine
*EOS-magazine.com*
A UK-based magazine and website on Canon photography with very high-quality content

### Illuminating Creativity
*JohnPaulCaponigro.com*
Valuable insights on creativity, vision, and technique from JP Caponigro

### International Center for Photography
*ICP.org*
Legendary museum and school in the heart of Manhattan

### Joe McNally's Blog
*JoeMcNally.com/blog*
Tips and tales from the Indiana Jones of editorial photography

### LensFlare35
*LensFlare35.com*
Home of Dave Warner's insightful podcast

**Light Stalkers**
*LightStalkers.org*
Professional / social resource for journalists, filmmakers, photographers

**Lighting Essentials**
*Lighting-Essentials.com*
Business and technical insights from Don Giannatti—who is never shy about sharing his thoughts, experiences, and opinions

**The Luminous Landscape**
*Luminous-Landscape.com*
Michael Reichmann's dynamic site—detailed reviews and insights

**Nice Photography Magazine**
*NicePhotoMag.com*
Don't let the name fool you. This is a great blog on photography

**OCF Gear**
*OCFGear.com*
A source for those must-have extra-long E-TTL cords and other bits of gear for Speedliters

**Photo District News**
*PDNonline.com*
The best magazine for insights on professional photography in the U.S.

**Photo Focus**
*PhotoFocus.com*
One of the most prolific sources for information about photography

**Photography-on-the-net**
*Photography-on-the.net/forum*
Home to a strong forum on Canon photography

**Photoshop Insider**
*ScottKelby.com*
Scott Kelby (and friends) cover the world of digital photography

**Picture Licensing Universal System**
*UsePlus.com*
Spearheads the international movement to standardize photo licensing

**Pixelated Image**
*PixelatedImage.com*
International photographer David duChemin's energetic blog

**PixSylated**
*PixSylated.com*
Syl Arena's randomly fed blog that wanders around the world of digital imaging

**Rob Galbraith Digital Photography Insights**
*RobGalbraith.com*
Always one of the first to break the news in the photography world

**Society for Photographic Education**
*SPEnational.org*
Resources for photography teachers in all types of environments

**Stock Artists Alliance**
*StockArtistsAlliance.org*
The international alliance of stock photographers

**Strobist**
*Strobist.com*
David Hobby started the small flash movement on the web with this informative site

**This Week In Photo**
*ThisWeekInPhoto.com*
Home of the TWiP podcast—always a good source of information about what's going on in the world of imaging

**What The Duck**
*WhatTheDuck.com*
The comic strip for photographers—seriously

**Wilhelm Imaging Research**
*Wilhelm-Research.com*
Henry Wilhelm is the final word when it comes to archival ratings for digital printing

**Zack Arias**
*Zarias.com*
Direct, passionate, informed—the energetic pro who started the One Light movement

# APPENDIX 3: CUSTOM FUNCTIONS

Custom Functions (C.Fn.) are special options that you can program into your Speedlite. Custom functions reside in the circuitry of your gear. So they will not be wiped out when you change batteries.

The sequence of custom functions has changed with each new model of Speedlite. Fortunately, when the 430EX II was introduced, the custom functions used the same numbers as those on the 580EX II.

## Setting Custom Functions

If you have a 580EX II or a 430EX II and a compatible camera body that displays the Speedlite's menu on the camera's LCD monitor, then this is the way to change the custom functions. The custom functions will be listed in plain English (or the language of your choosing) with the options listed in detail.

For the original 580EX and 430EX, or if you don't have a compatible camera under your EX II Speedlite, you will have to change the custom functions on the Speedlite's LCD. *Here's the big secret*: computers start counting with zero. The first option listed is always option 0. The second and third options are 1 and 2.

## The Must-Change Custom Function

I leave most of the custom functions in their factory default settings. The one that matters most to me is Auto Power Off—which the factory sets to 0=Enabled. For me, it's much easier to carry extra batteries than to hassle with a Speedlite that's shut itself off in the middle of a shoot. So I always disable the Auto Power Off.

- 580EX II, switch C.Fn. 01 to 1
- 430EX II, switch C.Fn. 01 to 1
- 580EX, switch C.Fn. 14 to 1
- 430EX, switch C.Fn. 01 to 1

## 580EX II

These can be set on the back of the flash or on the LCD of compatible cameras.

**00 – Distance Indicator Display**
(0 = meters, 1 = feet)

**01 – Auto Power Off**
(0 = enabled, 1 = disabled)

**02 – Modeling Flash**
(0 = enabled via depth-of-field review button, 1 = enabled via test firing button, 2 = enabled via both buttons, 3 = disabled)

**03 – FEB Auto Cancel**
(0 = enabled, 1 = disabled)

**04 – FEB Sequence**
(0 = zero-minus-plus, 1 = minus-zero-plus)

**05 – Flash Metering Mode**
(0 = E-TTL II/E-TTL, 1 = TTL, 2 = external metering: Auto, 3 = external metering: Manual)

**06 – Quickflash with Continuous Shot**
(0 = disabled, 1 = enabled)

**07 – Test Firing with Autoflash**
(0 = 1/32, 1 = full)

**08 – AF-Assist Beam Firing**
(0 = enabled, 1 = disabled)

**09 – Auto Zoom for Sensor Size**
(0 = enabled, 1 = disabled)

**10 – Slave Auto Power Off Timer**
(0 = 60 minutes, 1 = 10 minutes)

**11 – Slave Auto Power Off Cancel**
(0 = 8 hours, 1 = 1 hour)

**12 – Flash Recycle with External Power**
(0 = flash and external power, 1 = external power source) Note: flash must have charged internal batteries even when external pack is used.

**13 – Flash Exposure Metering Setting**
(0 = Speedlite button and dial, 1 = Speedlite dial only)

## 430EX ii

These can be set on the back of the flash or on the LCD of compatible cameras.

**00 – Distance Indicator Display**
(0 = meters, 1 = feet)

**01 – Auto Power Off**
(0 = enabled, 1 = disabled)

**02 – Modeling Flash**
(0 = enabled via depth-of-field review button, 1 = enabled via test firing button, 2 = enabled via both buttons, 3 = disabled)

**07 – Test Firing with Autoflash**
(0 = 1/32, 1 = full)

**08 – AF-Assist Beam Firing**
(0 = enabled, 1 = disabled)

**09 – Auto Zoom for Sensor Size**
(0 = enabled, 1 = disabled)

**10 – Slave Auto Power Off Timer**
(0 = 60 minutes, 1 = 10 minutes)

**11 – Slave Auto Power Off Cancel**
(0 = 8 hours, 1 = 1 hour)

**14 – Flash Range / Aperture Info**
(0 = Maximum distance, 1 = Aperture display)

## Canon 580 EX

These must be set on the back of the flash.

**01 – Automatic Cancellation of FEB**
(0 = enabled / 1 = disabled)

**02 – FEB Sequence**
(0 = standard/decreased/increased or 1 = decreased/standard/increased)

**03 – Flash Metering Mode**
(0 = E-TTL II / 1 = film-camera old-style TTL)

**04 – Slave Auto Power Off Time**
(0 = after 60 min. / 1 = after 10 min.)

**05 – Cancellation of Slave Auto Power Off**
(0 = 1 hour / 1 = 8 hours)

**06 – Modeling Flash**
(0 = enabled / 1 = disabled)

**07 – Recycling w/ External Battery Attached**
(0 = use both internal and external batteries / 1 = use external only) Note: flash must have charged internal batteries even when external pack is used.

**08 – Quick Flash**
(0 = disabled / 1 = enabled)

**09 – Test Firing**
(0 = 1/32 power / 1 = full power)

**10 – Modeling Flash with Test Firing Button**
(0 = disabled / 1 = enabled)

**11 – Auto Matching of Zoom to Sensor Size**
(0 = enabled / 1 = disabled)

**12 – AF-Assist Beam**
(0 = AF on / 1 = AF beam off)

**13 – FEC Setting Method**
(0 = with Set Button and Select Dial / 1 = Select Dial only)

**14 – Auto Power Off**
(0 = on / 1 = off)

## 430EX

These must be set on the back of the flash.

**01 – Auto Power Off activation**
(0 = on / 1 = off)

**02 – Slave Auto Power Off Tine**
(0 = after 60 min. / 1 = after 10 min.)

**03 – Auto Zoom for Image Size**
(0 = on / 1 = off)

**04 – AF-Assist Beam OFF**
(0 = AF on / 1 = AF beam off)

**05 – Modeling Flash**
(0 = on / 1 = off)

**06 – LCD Panel Displays @ 1/2 Shutter Button**
(0 = max. flash range / 1 = aperture)

When you are feeling paralyzed by too many things to keep in your head, use these six areas to prioritize and sort out your efforts. I have listed them in the order in which I deal with each.

### 1—Ambient

There are two types of light in a flash photograph—the light that is already there and the light that your Speedlite creates. Settle on the exposure for your ambient light before you switch on your Speedlite. I typically:

- switch the camera from Aperture Priority into Manual mode when I want to lock in the exposure over several frames.

- underexpose the ambient light so that the subject—when lit by the Speedlite(s)—will jump out a bit from the background.

---

### SPEEDLITER'S TIP

#### —Work With Intent, Then Work Instinctively—

When learning to Speedlite, it helps to have a workflow. Follow the same pattern of steps again and again until your thoughts and movements become automatic. Work with intent while learning my workflow. Then work with intent to learn the workflows of other photographers.

Along the way, you will hear the voice of inspiration saying, "Hey, what if I do this or that?" Follow those ideas to see where the path leads. As you explore your own workflow, don't be surprised if you feel the need to jump back to using a more established workflow from time to time.

If you stick with Speedliting long enough, eventually you will have your own workflow—and most certainly it will be different than my workflow. My process is based upon my vision and my resources. You'll find your own way to make the shots—in a manner built upon your vision and situation.

So, here's my final tip: when you get to the point where you have your own workflow, let it go and work instinctively. Your best work and your newest ideas will happen when your photography becomes an expression of something deep inside that you don't understand until after you see it.

---

### 2—Purpose

Ask yourself what you want the Speedlite to do? It can provide any of the following four types of light:

- **Key**—the main light on the subject. Even in bright ambient light, if you use a fast shutter, you can underexpose the ambient and use your Speedlite as the key light.

- **Fill**—a fill flash enables the camera to record details that otherwise would be lost in the shadows. An on-camera Speedlite firing in E-TTL in bright sun is a good strategy for simple fill flash. When shooting multiple Speedlites, the A:B ratio control can be used to shift the balance between the key and fill lights.

- **Rim**—if you want to provide a thin line of light that separates your subject from the background, then put a Speedlite behind the subject. Be sure to flag the Speedlite so that it does not flare into the lens.

- **Background**—you will create a more interesting photograph by lighting elements in the subject's environment rather than the subject and his environment together.

### 3—Position

With the exception of rimlight—which has to come from behind the subject—there are no rules for the best place to put your Speedlite. Here are a few ideas to consider:

- **In Front Of The Subject**—light enables you to see the shape of your subject and shadows enable you to see its depth. The farther you move your Speedlite off the axis of the lens, the wider the shadows become on your subject.

- **Behind The Subject**—when you move your Speedlite behind your subject it will appear brighter to the camera, so anticipate that you will need less power.

- **Opposition**—an easy way to craft interesting light is to face two light sources at each other and park the subject between the two.

- **Follow The Nose**—aligning the Speedlite with your subject's nose is a quick way to light a face—even with a bare Speedlite.

## 4—Shape

Think of your Speedlite as a light generator that has to be shaped. There are basically two ways to shape the light coming from your flash.

- **Increase Apparent Size**—the size of the light source relative to the size of the subject is what determines the character of the shadow line. Small light sources create hard shadows. Large light sources create soft shadows. Speedlites are relatively small when compared to the size of most subjects—especially people. Firing your Speedlite through an umbrella, softbox, or diffusion panel will increase its apparent size and create soft light. Move the modifier in closer to increase its size. Pull it out to make the shadow edge sharper. Also, know that the proximity of the modifier to the subject also determines the contrast of the shadows. A softbox that is in very tight will create lights that falls off dramatically into dark shadows. As you pull the softbox away from the subject, the light will appear more even across the subject.

- **Control Where Light Flies**—think along the lines of lighting only a portion of what the camera sees. Auto-zoom is handy for photojournalists who need to document a scene on the fly. For the rest of us, Auto-zoom is lousy for creating interesting light. So use the Zoom button on your Speedlite as a built-in modifier. Additionally, when you want to prevent the flash from flying into the lens or onto the background, flag it—with a gobo card, a bounce reflector, or even your hand. To concentrate the light into a tight, circular pattern, use a grid—⅛″ and ¹⁄₁₆″ will be the most helpful.

## 5—Color

Human vision typically cannot see the differences in the color of light produced by different sources. A white tee-shirt appears white under fluorescent light or in shade as much as it does in direct sun. Your digital camera does not record light the same way you see it.

Also, do not forget that daylight comes in many colors. The warm glow of a setting sun is different than the brilliance of sunlight at mid-day.

Your Speedlite is designed to mimic the color of noon sun. This is great for fill flash at noon. Using a bare Speedlite for fill flash at sunset will fill the shadows with cool—rather than warm—light. Likewise, firing a bare Speedlite indoors under incandescent lights will create an imbalance between flash and ambient.

Gel with intent. You can change the color of your Speedlite so that it blends it into the ambient light. Or you can change the color so that the flash jumps away from the ambient light. You will find my gelling strategies in Chapter 20, *Gelling For Effect*.

## 6—Power

The amount of light needed from your Speedlite is a function of the previous four factors—purpose, position, shape, and color.

Canon Speedlites can have the power set automatically via E-TTL or by the photographer in Manual mode. Here is a quick summary of the best uses for each:

- **E-TTL**—the camera measures the light coming back from a super-fast pre-flash and sets the power automatically. E-TTL is great for situations where the distance between the flash and subject is dynamic—such as when shooting an event. E-TTL is also very helpful when an on-camera Speedlite is being used for fill flash in brightly lit, outdoor situations.

- **Manual**—provides the reliability that the amount of light from flash to flash will be consistent. Manual is great for situations where the flash-to-subject distance is consistent across several shots and time allows for the power to be adjusted by hand. However, if you move the light or change the modifier, you will probably have to also change the power.

| | |
|---:|:---|
| **Portfolio** | SylArena.com |
| **Blog** | Speedliting.com/How-To |
| **Blog** | PixSylated.com |
| **Workshops** | PasoRoblesWorkshops.com |
| **Twitter** | Twitter.com/Syl_Arena |
| **Facebook** | Facebook.com/Syl.Arena |

## U

umbrellas, 186–191
    adapters for, 190
    collapsible, 189
    convertible, 188
    double setup for, 191
    fabrics used for, 186–187
    mounting Speedlites to, 191
    positioning, 190
    pros and cons of, 187
    reflective, 186–187, 242
    shoot-through, 186, 242, 252
    single Speedlite with, 242–243, 252–253
    sizes available for, 189
    softboxes compared to, 270
    trio of Speedlites in, 268–269
underexposed images, 36

## V

Vapor Industrial gel, 161, 285
Vari-ND filter, 301
Velcro straps, 167, 215, 286
vertical lighting, 66–67
video lights, 159
vineyard wedding, 340–341
vision, human vs. camera, 16–19

## W

water
    High-Speed Sync for freezing, 304–305
    multiple-Speedlite setup in, 274–275
weather sealing, 73
web resources, 370–371
wedding photography
    example of, 340–341
    suggestions for shooting, 339
    *See also* event photography
Welch, MD, 295, 332
Westcott products
    #2001 umbrella, 189
    Apollo softbox, 193, 199, 270
    Fast Flags, 200, 201
    Scrim Jim panels, 200, 201
*Wheels of Wellness* event, 344–345
WhiBal card, 33
white balance settings, 19, 32–33
    color temperature and, 40, 283
    list of available, 32
    mixing gels with, 287
    when to set, 33

white fabric reflectors, 202
White Fluorescent setting, 32, 287
white reflective umbrellas, 187
white softboxes, 192
wide-angle diffuser panel, 72, 74, 88, 166
wide-angle lenses, 25
window light, 266, 288
wireless flash, 118, 126–151
    2nd-curtain sync and, 85
    Auto Power Off feature and, 134
    built-in system for, 118, 127, 339
    channels used for, 134–135
    enabling/disabling, 130–131
    E-TTL as basis of, 127, 149
    free-agent setup for, 148–149
    groups used for, 136–145
    jargon related to, 127
    line-of-sight requirement for, 132, 151
    Manual mode setup for, 146–147, 260
    master unit for, 128–129, 150
    mixed-mode setup for, 148–149
    moving masters for, 150
    panning/tilting for, 91
    pros and cons of, 127
    radio triggers and, 118–119, 124–125, 151, 339
    ratios for, 137–145
    slave units for, 132–134
    studio packs and, 149
    *See also* off-camera flash
wireless menu, 127
wireless sensor, 72, 74, 132
Wizard Dual-Flash bracket, 214
workflows
    for E-TTL flash mode, 110
    for High-Speed Sync mode, 300
    for Manual flash mode, 100–101
WPF-1 Flash Bracket, 116, 336–337
WPPI convention, 339

## X

xenon gas, 71
X-Rite ColorChecker, 32–33
X-sync speed, 296

## Z

Zacuto Z-finder, 332
Ziser, David, 339
zones, metering, 30
Zoom function on Speedlites, 88–89, 166, 314, 346
Zoom/wireless button, 73, 74